Exuberance of Meaning

The Art Patronage of Catherine the Great (1762–1796)

Printed in Canada in an edition of 1,000 by Friesens.

Design: The Adsmith
Department of Publications: Hillary Brown and Mary Koon
Publications Interns: Noah Adler, Kate Douds, Elizabeth Fontaine, Claire Ruhlin, Sarah Schatz

Exuberance of meaning : the art patronage of Catherine the Great (1762/1796) / by Asen Kirin ; with contributions by Liana Paredes, Kristen Regina, and Scott Ruby.
 pages cm
 Includes bibliographical references.
 ISBN 978-0-915977-81-9 -- ISBN 0-915977-81-8
1. Art, Russian--18th century--Exhibitions. 2. Catherine II, Empress of Russia, 1729-1796--Art patronage--Exhibitions. 3. Catherine II, Empress of Russia, 1729-1796--Art collections--Exhibitions. I. Kirin, Asen, 1960- Exuberance of meaning. II. Georgia Museum of Art.
 N6986.E98 2013
 709.47'07475818--dc23
 2013029601

Partial support for the exhibitions and programs at the Georgia Museum of Art is provided by the W. Newton Morris Charitable Foundation. Individuals, foundations, and corporations provide additional support through their gifts to the University of Georgia Foundation.

EXUBERANCE OF MEANING
The Art Patronage of Catherine the Great (1762–1796)

Asen Kirin

with contributions by Liana Paredes, Kristen Regina, and Scott Ruby

September 21, 2013 – January 5, 2014

GEORGIA MUSEUM OF ART UNIVERSITY OF GEORGIA

*Еже должны бѣхомъ
сотворити, сотворихомъ**

["We have done no more than our duty"—Luke 17:10]

*The Old Church Slavonic text of the Gospel reads: "Егда имать благодатить рабу тому, яко сотвори повеления, не мню. Аще и сотворите вся повеленная вамъ, глаголите, яко раби неключимы есмы, еже должны бѣхомъ сотворити, сотворихомъ" ("Will he [the master] thank the servant because he did as he was told to do; certainly not. So with you, when you have done all you have been told to do, say, 'We are useless servants, we have done no more than our duty'" [Luke 17:9–10]).[1]

The Gospel verse used as an epigraph to this volume appeared in the correspondence between Catherine the Great and Ambrose Zertis-Kamenskii (1708–1771), whom she appointed archbishop of Moscow in 1768.[2] Writing in December of 1770 or early in the following year, the empress expressed her profound gratitude for all that the cleric had done overseeing the restoration of the late medieval frescos in the Annunciation Cathedral of the Moscow Kremlin. She had initiated this project and regarded it as very important. Upon the work's completion in the fall of 1770, Catherine proudly showed the results to Frederick the Great's younger brother, Prince Henry of Prussia (1726–1802), during his visit to Russia. In his response to the empress's letter of gratitude, Archbishop Ambrose quoted from the parable found only in the Gospel of Luke that teaches the importance of a life guided by an attitude of service and that feelings of entitlement or pride have no place in the fulfillment of one's duties.[3] The holy man was serving his sovereign, who, in turn, was working for her subjects. The quote encapsulates the sense of duty, understood in both civic and religious terms, shared by the prominent figures of the Russian Enlightenment.

Nevertheless, Catherine exceeds what is expected of a "master" in expressing her appreciation for the service rendered to her; only then does the archbishop need to respond in kind with an acknowledgment of his empress's gesture. This implicit reciprocity of gratitude manifests the new sensibility characteristic of Catherine the Great's era. The exchange between the empress and the holy man exemplifies the possibility of merging the attitudes of the Enlightenment and the old ways of Eastern Orthodoxy. Traditionally, royal patronage of the church was an act of piety and a lordly duty, intended to bring about the spiritual salvation of the ruler and all his or her subjects. Without questioning or undermining any of these concerns, the empress added a new register of meaning to her endeavor, stemming from the Enlightenment's notion of history and the social role played by traditional institutions such as the church. The Kremlin's places of worship and their frescos were now seen as monuments of history with towering political, ideological, and cultural significance.

The facility with which the two different approaches to patronage and worship coexisted in the exchanges between the empress and Archbishop Ambrose was not found in equal measure between all strata of society. A sad testimony to this truth is Ambrose's fate: he suffered a horrifyingly violent death at the hands of rioters in 1771, when Moscow experienced an outbreak of cholera. Thousands, both healthy and infected, were kissing the same miraculous icon, which the archbishop removed from public display, rendering it inaccessible for veneration.[4] In accordance with the scientific rules of hygiene, Ambrose obviously intended his action to prevent the spread of disease, but the populace misconstrued it as blasphemous, leading to his slaughter. The multiple layers of meaning in this epigraph represent one of the main themes of this exhibition that involves a lesser known side of Catherine the Great's political and intellectual pursuits. During her long reign, the empress worked to reconcile her contemporary scientific and historical frame of mind with the devotional ways of the Orthodox Church, which had long been sanctified by tradition.

Asen Kirin

1. The expression "certainly not" is added to the cited standard English text of this verse in order to convey the meaning of the Church Slavonic in which verse 17:9 ends with the expression "не мню" (literally "I do not think so"). Unless otherwise noted, quotations throughout this volume are translated from Russian, Church Slavonic, and French by Asen Kirin.
2. Cf. Levshin 1783, 16.
3. The Gospel of Luke emphasizes the theme of service, cf. 1:38, 3:22, 4:18–19, and 9:35.
4. See accounts of this event in Troyat 1980, 219–20; Rounding, 233–41; R. Massie, 389–92; Levitt, 216–21; and Proskurina, 99–108.

TABLE OF CONTENTS

Acknowledgments
Asen Kirin and William Underwood Eiland
.. 7

Important Years and Events in the Life of
Empress Catherine the Great of Russia (Reign 1762–1796)
.. 10

"Great Women Are Great Men"
Asen Kirin
.. 20

The Allure of Russian Art Inspires a Collector:
Marjorie Merriweather Post and Hillwood
Scott Ruby
.. 42

Catherine II's Religion: Liturgy, Statecraft, and Inner Life
Asen Kirin
.. 48

"The Fingertips of Sight":
Discerning Senses and Catherine's Golden Censer
Asen Kirin
.. 58

The Green Frog Service
Asen Kirin
.. 76

The Chalice with Antiques
Asen Kirin
.. 86

Catalogue of the Exhibition
Asen Kirin (AK), Liana Paredes (LP), Kristen Regina (KR), and Scott Ruby (SR)
.. 110

Bibliography
.. 214

Acknowledgments

This exhibition brings together works of art from several different sources. Developing this project took years of research, and it could not have succeeded without the support of the institutions and individuals acknowledged here. I am grateful to the professional team at the Georgia Museum of Art for allowing me to work as a guest curator and for their tireless efforts in making possible this exhibition. I offer my deepest appreciation especially to Director William Underwood Eiland, whose continuous support, encouragement, and guidance enabled the completion of this project.

Two grants from the University of Georgia (UGA) generously supported my research related to this exhibition. During 2011–2012 I benefited from the Franklin International Faculty Exchange Program by establishing a formal collaboration with the State Hermitage Museum in Saint Petersburg, Russia. My thanks go to Noel Fallows, associate dean for international affairs, and Karen Coker, administrative specialist at the office of the dean. During the summer of 2012 a research trip to Stockholm, Sweden, and Saint Petersburg was made possible by the Provost's Summer Research Grant. My gratitude goes to Jere Morehead, former provost and current president of the University of Georgia.

For supporting my research in Russia I offer my deepest appreciation to the experts and employees of the State Hermitage Museum in Saint Petersburg. In particular, I want to acknowledge Professor Mikhail B. Piotrovski, director; Svetlana B. Adaksina, deputy director for collections; Nataliia V. Kolomiets, head of the department of international relations; Ekaterina S. Medvedeva, specialist at the department of international relations; Marina N. Lopato, senior curator, West-European decorative arts; Olga Kostiuk, curator of the Treasury Galleries; Lydia Liakhova, curator of porcelain, West-European decorative arts; Anna Gueyko, curator of decorative bronze, West-European art; Mikhail Dedinkin, head of the department of drawings; and Ekaterina Orekhova, drawings room curator, West-European art.

At the Research Library of the State Hermitage, my gratitude goes to Evgeniia I. Makarova, head librarian; Alla N. Samsonova, office of readers' access; and Elena L. Doroshchenkova, Anna B. Kuz'micheva, and Ekaterina M. Lazutina, librarians. Special thanks must be given to Yuri A. Pyatnitski, senior curator of the Byzantine collection at the Hermitage, who participated in UGA's Franklin International Faculty Exchange Program and who was especially helpful with my research in Saint Petersburg.

In Sweden, at the National Museum in Stockholm, I thank Berndt Arell, director general; Magnus Olausson, director, historic castles collections; Martin Olin, project coordinator and research curator in the research department; and Wolfgang Nittnaus, department of prints and drawings.

I offer my deepest gratitude to the institutions lending works of art for this exhibition. First, at Hillwood Estate, Museum & Gardens in Washington, D.C., I want to thank Kate Markert, executive director; Liana Paredes, director of collections and chief curator; Scott Ruby, associate curator of Russian and Eastern European art; Kristen Regina, head of research collections and archivist; Lawrence Waung, head of exhibitions and collections management; M. J. Meredith, registrar; and Manuel Diaz, conservation technician.

At Dumbarton Oaks Research Library and Collection, Harvard University, Washington, D.C.: Gudrun Buehl, curator and museum director; Marta Zlotnick, registrar and curatorial assistant, Byzantine collection; John Hanson, assistant curator of the Byzantine collection; Joseph Mills, photographer; and Stephen Zwirn, former assistant curator of Byzantine art.

At the Metropolitan Museum of Art: Helen Evans, the Mary and Michael Jaharis Curator for Byzantine Art; Emily Foss, associate registrar; and Melanie Holcomb, curator, medieval art and the Cloisters department.

At the Walters Art Museum, Baltimore, Maryland: Julia Marciari-Alexander, executive director; Jo Briggs, assistant curator, eighteenth- and nineteenth-century art; Meg Craft, senior objects conservator; Lynley A. Herbert, curatorial associate in manuscripts and rare books; Chiara Valle, volunteer, manuscripts and rare books; Danielle Bennett, assistant registrar; Barbara Fegley, associate registrar; and Gary Vikan, former executive director.

At the Michael C. Carlos Museum at Emory University in Atlanta: Bonnie Speed, director; Jasper Gaunt, curator of Greek and Roman art; and Todd Lamkin, director of collections services and chief registrar.

At the Birmingham Museum of Art, Birmingham, Alabama: Gail Andrews, R. Hugh Daniel Director; Anne Forschler-Tarrasch, Marguerite Jones Harbert and John M. Harbert III Curator of Decorative Arts; Melissa Falkner Mercurio, registrar; and Mary Villadsen, associate registrar of collections and loans.

At the Chipstone Foundation: Jon Prown, executive director and chief curator, and Nancy Sazama.

At the Hargrett Rare Book and Manuscript Library of the University of Georgia: P. Toby Graham, deputy university librarian and director; Mary Ellen Brooks, curator, rare books, and director emerita; Nancy Stamper, rare books cataloguer; and Anne Meyers DeVine, bibliographic coordinator for rare books.

The contributions of private collectors who wish to remain anonymous are deeply appreciated. Also, I want to thank Daniel Bibb of Atlanta for allowing us to display works from his collection.

Others in the United States have offered special support and assistance and I would like to recognize with gratitude and affection Ibby and James T. Mills Jr. of Atlanta; Deborah Kahn of Boston; and Priscilla Roosevelt of Princeton, New Jersey. A La Vieille Russie, Inc., Mr. and Mrs. Fritz Lyons Felchlin, the Frances Wood Wilson Foundation, the Samuel H. Kress Foundation, and the W. Newton Morris Charitable Foundation also provided crucial support.

I extend special thanks to David Sider, department of classics, New York University, for his insights into the poetry of Simonides of Ceos; and David L. Hayes, department of landscape architecture, University of Illinois Urbana-Champaign, for sharing with me his knowledge of eighteenth-century French gardens. For their encouragement and helpful advice I am grateful to Mimi Hellman, Skidmore College, and Michael Yonan, University of Missouri.

I offer my deepest appreciation to those individuals at the Georgia Museum of Art whose efforts enabled all the loans, the funding, and the installation of this exhibition. In particular I want to acknowledge the in-house curator Dale Couch, curator of decorative arts; Tricia Miller, head registrar; and Caroline Maddox, director of development. My gratitude goes to Betty Alice Fowler, grants writer and assistant to the director, for her impassioned fundraising; and to Todd Rivers, chief preparator, and Larry Forte, Pierre Daura Art Handler, for their work on the installation of the exhibition.

The current volume has benefited a great deal from the efforts of the department of publications at the museum: Hillary Brown, director of communications, and Mary Koon, editor, as well as their many students who read the text, among them Kate Douds, who worked on the bibliography, and Elizabeth Fontaine, who focused in detail on consistency in transliteration.

Numerous new photographs were produced thanks to the efforts and expertise of Michael McKelvey, Atlanta; Ruth Bowler, the Walters Art Museum; and Marla DiVietro, Hillwood Museum and Gardens. The design of this volume bears testimony to the professionalism of The Adsmith and especially of Noelle Shuck. Special thanks go to the printers, Friesens Corporation of Altona, Manitoba, Canada.

At the Lamar Dodd School of Art, UGA, I thank for their interest in my work on the exhibition Gene Wright, interim director; Georgia Strange, former director; Chris Hocking, associate director; and Thom Houser, associate director. I am grateful to my fellow art historians at the school of art for their comments and suggestions: Alisa L. Luxenberg, Shelley E. Zuraw, Isabelle Wallace, Janice Simon, and Mark Abbe. At UGA's Hugh Hodgson School of Music, my appreciation goes to Dorothea Link, University of Georgia Foundation Professor in the Arts, and at the Performing Arts Center to George C. Foreman, director.

Last but not least, I want to thank my partner, Stuart Lee Brown, for not only graciously indulging my obsession with Catherine the Great but also for sharing in it.

Asen Kirin

Addendum

The staff and board of the Georgia Museum of Art join me in echoing Asen Kirin's acknowledgments of gratitude to an international consortium of friends and colleagues, patrons and collectors.

Several years ago, Professor Kirin came to me with the idea for an exhibition that would investigate patronage in eighteenth-century Russia, most particularly the perception of Byzantine culture, as he explained it, in a neoclassical era. We are used to characterizing a cosmopolite as a "Renaissance man," but Professor Kirin was presenting the Empress Catherine as a "Renaissance woman," one who demanded of her advisors and countrymen, her artists and thinkers, her craftspeople and artisans, that Russia should take its rightful place among those "enlightened lands" where rational thought and novel ideas could transform society and advance knowledge, where her ideological mandate to her nation's thinkers and creators was to link the Greek past to a new Classicism through the bridge of Byzantium. Catherine's Russia, with the Empress as chief patron and propagandist, was the guardian of Byzantine heritage, which in turn was the continuance of the highest ideals in art and thought of the ancient Greeks.

Relentless, meticulous, enthusiastic, Professor Kirin inspired all of us at the Georgia Museum of Art with his commitment to this project, with his vision of a more thorough understanding of a monarch whose stature in intellectual history—the history of ideas—is as substantial as it is in diplomatic and political history. Our deepest appreciation, then, is to Asen Kirin for allowing us to assist in his determined search for truth through the objects and ideas that sprang from the reign of this remarkable woman, one for whom, this project reminds us, multiple reasons exist to call her "The Great."

William Underwood Eiland, director

TIMELINE

Important Years and Events in the Life of Empress Catherine the Great of Russia (Reign 1762–1796)[1]

1729

APRIL 21 Born in Stettin (modern Szczecin on the territory of Poland), baptized in the Lutheran faith as Princess Sophie Fredericka Augusta Dorothea of Anhalt-Zerbst.

Father: Christian Augustus, Prince of Anhalt-Zerbst (1690–1747).

Mother: Johanna Elisabeth of Holstein-Gottorp (1712–1760); Johanna's brother Adolf Frederick was chosen to be king of Sweden (reign 1751–1771).

1742

FALL The daughter of Emperor Peter the Great (reign 1682–1725) Empress Elizabeth I of Russia (reign 1741–1761) selects her nephew Karl Peter Ulrich of Holstein-Gottorp (Sophie's second cousin, born 1728 to Elizabeth's older sister Anna Petrovna, duchess of Schleswig-Holstein-Gottorp [1708–1728]) to be the successor to the throne and her heir; he became Emperor Peter III (reign January 5–July 8, 1762).

1744

JANUARY 20 Sophie and her mother arrive in Saint Petersburg at the request of Empress Elizabeth I, who had chosen the Prussian princess as Peter Ulrich's possible future bride. A bride belonging to a powerful ruling dynasty might have brought with her a political agenda reflecting the interests of her family. Accordingly, the empress of Russia chose a young lady of ancient noble origins but whose parents had no real power or wealth.

JUNE 28 On the day before her official engagement to the future Peter III, Princess Sophie converts to Eastern Orthodoxy and becomes Catherine Alekseevna. Both her first name and her patronymic ("Alekseevna" lit. "the daughter of Aleksei") were chosen in emulation of Catherine Alekseevna (Catherine I),

Elizabeth I's mother; Peter the Great had the same patronymic, after his father Aleksei I Mikhailovich Romanov (reign 1645–1676).

1745

AUGUST 21 With her marriage to the heir of the throne, Catherine Alekseevna becomes grand duchess of Russia. In Catherine's own words, her married life consisted of "Eighteen years of boredom and solitude [which] caused her to read many books" (see the end of this timetable for the source of this quote).

1754

SEPTEMBER 20 Birth of Grand Duke Paul Petrovich, the future Paul I of Russia (reign 1796–1801). His biological father was most likely Count Sergei Vasilievich Saltykov (ca. 1726–1765), a scion of an ancient grand clan of landed gentry, chosen at the orders of Elizabeth I after she realized that the marriage between her nephew and Catherine had not been consummated. Producing an heir was essential to the stability of Elizabeth's reign. After Paul's birth, the empress separated him from his mother and took charge of his upbringing.

1756–1763

Seven Years' War, in which Russia is allied with the Holy Roman Empire.

1758 or 1759

Beginning of relationship between Catherine and Gregory G. Orlov (1734–1783).

1761

Empress Elizabeth I dies and is succeeded by Peter III.

1762

JANUARY 5 Peter III ascends to the throne and immediately changes Russia's alliances in favor of Prussia. The new Russian emperor was a great admirer of Frederick the Great (1740–1786) of Prussia, which explains his drastic actions.

APRIL 11 Catherine gives birth to her only illegitimate son, Count Aleksei Grigorievich Bobrinsky (d. 1813), fathered by Orlov. Bobrinsky's descendants lived on the Moika Embankment in a palace famous for its art collection, library, and sophisticated salon. Throughout the nineteenth and early twentieth centuries, the counts Bobrinsky distinguished themselves with scholarly achievements in archaeology and ethnography. The Orlov Service (cat. nos. 17A–B) is produced between 1762 and 1765 by the Imperial Porcelain Factory in Saint Petersburg.

MAY 5 The Treaty of Saint Petersburg, signed by Emperor Peter III, ends military action between Russia and Prussia, betraying Russia's allies in the Seven Years' War—the Holy Roman Empire and Saxony. This decision was one among several that made Peter decidedly unpopular, both in Russia and abroad, and caused his deposition from the throne.

JUNE 28 Catherine Alekseevna seizes power and deposes her husband with the decisive support of a group of conspirators, led by Gregory Orlov and his brothers, Ivan (1733–1791), Aleksei (1737–1808), Fedor (1741–1796), and Vladimir (1743–1831). After receiving the support of the Guards, the Senate, and the Holy Synod in the capital city of Saint Petersburg, Catherine led a strong regiment to the suburban palace of Oranienbaum where the deposed emperor was at the time. Dressed in the green uniform of an officer of the Guards (the Transfiguration Regiment), the new empress rode her favorite white horse. Before departure it became obvious that Catherine was missing a component of the uniform: a sword knot. A young officer audaciously stepped forward and supplied the missing item. This was the twenty-two-year-old Gregory Aleksandrovich Potemkin, whom the empress would remember from this encounter. Years later Potemkin became Catherine's lover and played an essential role in her personal life and in the governing of the Russian Empire.

JULY 6 Aleksei Orlov murders Peter III, possibly with Catherine's connivance.

AUGUST Catherine publically offers to print the *Encyclopédie, ou dictionnaire raisonné des sciences, des arts et des métiers*, by Denis Diderot (1713–1784) and Jean le Rond d'Alembert (1717–1783), in the Russian Empire, in the city of Riga. The government of France had officially suppressed its publication, but after news about Catherine's offer spread around Europe, the court of King Louis XV allowed publication to proceed.

SEPTEMBER 22 Catherine Alekseevna is crowned as Empress Catherine II in the Dormition Cathedral of the Moscow Kremlin.

European Rulers at the Time of Catherine II's Coronation

France, Louis XV (reign 1715–1774)

Holy Roman Empire, Vienna, Francis I (reign 1745–1765), spouse Maria Theresa of Austria (1717–1780)

Prussia, Frederick the Great (1740–1786)

Saxony, Frederick Augustus III, king of Poland, grand duke of Lithuania, and elector of Saxony (reign 1734–1763)

Great Britain, George III (reign 1760–1820)

Sweden, Adolf Frederick (reign 1751–1771), Catherine II's maternal uncle

Denmark and Norway, Frederick V (reign 1746–1766)

Ottoman Empire, Mustafa III (reign 1757–1774)

1763

Catherine first writes to Voltaire, marking the start of a correspondence that lasted until the philosopher's death, in 1778.

JULY 22 Catherine issues a manifesto inviting foreign immigration and guaranteeing religious freedom and tax exemptions to new settlers.

SEPTEMBER 1 On the first day of the new ecclesiastical/liturgical year, a medal is issued to commemorate the foundation of a Foundling Hospital in Moscow (see cat. no. 43A).

1764

To celebrate Russia's victory in the Seven Years' War, Catherine acquires the art collection Johann Ernst Gotzkowsky (1710–1775) assembled for Frederick the Great, due to Prussia's financial ruin in the wake of the war. The acquisition marks the founding of the Hermitage Museum in the Winter Palace of the Russian emperors in Saint Petersburg. By the end of Catherine's life, in 1796, the collection of the Hermitage includes approximately 4,000 paintings, 10,000 drawings and prints, 10,000 engraved gems, 16,000 coins and medals, and 38,000 books.

1765

Catherine acquires Diderot's library. When the time came for him to provide a dowry for his daughter, he saw no alternative but to sell his books. Hearing of his financial troubles, Catherine charged an agent in Paris to buy the library. She then requested that the philosopher retain all his books in Paris until she required them and act as her librarian with a yearly salary. This event began a close association between the empress and the philosopher, who spent some months at her court in Saint Petersburg.

1766

At the Gatchina estate, construction begins on a neoclassical palace, designed by Antonio Rinaldi (ca. 1709–1794), an Italian who lived and worked in Russia. This palace was completed in 1781 and served as a country residence for Gregory Orlov.

1767

A legislative commission is convened to overhaul Russia's entire legal system. Catherine II issues her *Nakaz* (cat. no. 24), intended to function as instructions for the work of this commission, the French edition of which is banned in France.

1768

The First Russo-Turkish War starts at the instigation of France, which encouraged the Turks to attack with the intention of quickly ending Catherine II's reign. Instead of bringing down the empress, this war, which would last until 1774, solidified her power and created the foundation for one of the most dazzling reigns in European history.

Construction of the Marble Palace on Millionnaia Street 5-1, the city residence of Gregory Orlov, begins (and will last until 1785). The architect of this neoclassical building was Antonio Rinaldi (see above).

The Orlov vase (cat. no. 49) is created by the Swiss master Jean Pierre Ador, who lived in Saint Petersburg at the time.

1769

Catherine acquires the art collection of Count Heinrich von Brühl (1700–1763), a statesman at the court of Saxony. The collection includes 600 paintings and numerous drawings and prints.

1770

JUNE 24–26 In the Battle of Chesme Bay, Count Aleksei Orlov defeats the Turkish Fleet on June 24, the day when the Orthodox Church celebrates the birth of Saint John the Baptist. After a series of naval victories, Russia wins control of large areas around the Black Sea and the Sea of Azov.

JULY AND DECEMBER The *Gentleman's Magazine* of London publishes detailed accounts of the First Russo-Turkish War, including maps of the Greek archipelago and Istanbul (see cat. nos. 62A–B).

Evgenios Voulgaris (1716–1806) prepares a Greek edition of the *Nakaz*.

The Archipelago of diminutive islands is created in the landscape garden of Tsarskoe selo, possibly in celebration of the Russian control of the Greek archipelago in the Aegean Sea.

See cat. nos. 32, 42, 43B, and 43C.

1771

Morea Column is erected in the park of Tsarskoe selo to commemorate a Russian victory on February 17, 1770.

Architect Yuri M. Fel'ten/Georg Friedrich Veldten (1730–1801), a Russified German, builds Tower Ruin in the park of Tsarskoe selo to memorialize the start of the First Russo-Turkish War.

Outbreak of cholera in Moscow. Count Gregory Orlov sent to Moscow where he successfully oversees the containment of the epidemic (see cat. no. 44).

Kagul Obelisk begins to be erected after the design of Antonio Rinaldi, in honor of the victory at the river of Kagul in Moldova on June 21, 1770 (it is completed in 1772).

Construction begins on Kekereksinen Palace/"La Grenouillère"/"The Frog Pond," after 1780 known as Chesme Palace (it will conclude in 1774).

1772

Through Diderot's negotiations, Catherine acquires the renowed collection of paintings assembled by the great French connoisseur and art collector Pierre Crozat (1661–1740), younger brother of Antoine Crozat, the marquis du Châtel (ca. 1655–1738), who was the first private owner of French Louisiana, from 1712 to 1717.

Catherine's "medallic history," modeled on Louis XIV's, is published (see cat. nos. 25 and 39).

1773

Catherine places an order for a creamware dinner and dessert set for fifty people with the English industrial potter Josiah Wedgwood (1730–1795). It will come to be known as the Green Frog Service because of the crest featured on the dishes (see cat. nos. 30 and 31).

OCTOBER 8 Diderot arrives in Saint Petersburg, where he remains until March 4, 1774; he resided at Isaac Square 9.

1774

JANUARY Prince Gregory Potemkin (1739–1791) secludes himself in a cell at the Saint Alexander Nevskii Monastery in Saint Petersburg.

FEBRUARY Potemkin becomes Catherine's lover.

JULY 10 The Peace Treaty of Kiuchuk Kainardzha is signed (see cat. no. 43D).

Potemkin becomes governor-general of the new southern provinces of Russia, gained in the course of the First Russo-Turkish War.

Construction begins on the Chesme Column in the pond of Tsarskoe selo (to conclude in 1778). The monument was designed by Antonio Rinaldi in honor of the Chesme Battle of June 24, 1770.

1775

Construction begins of temporary buildings on the Khodinskoe Field, north of Moscow, to celebrate the Treaty of Kiuchuk Kainardzha (drawings by Matvei Kazakov, 1738–1812).

SUMMER Possible morganatic marriage of Catherine and Potemkin.

See cat. no. 13.

1776

At the request of Catherine and Potemkin, the German palaeographer and classicist Christian Frederick Matthaei (1744–1811) publishes a scholarly catalogue of the Byzantine manuscripts in the library of the Russian Patriarchate in Moscow. These manuscripts contained Christian texts, as well as those by a number of ancient authors including Homer, Sophocles, Plutarch, and Aristotle, and, notably, one of the most complete versions of Aristophanes's comedy *The Frogs*. The goal of this endeavor was to demonstrate how the religious and dynastic links with Byzantium made Russia an heir of ancient Greek learning, meaning it was the duty of the court of Saint Petersburg to protect the Greeks for the sake of all Enlightened Europe (see cat. nos. 30, 31, and 46A–B).

See cat. no. 33.

1777

JUNE 6 Gustav III of Sweden, while visiting Russia, participates in the ceremony of laying the foundation for the church at Kekereksinen dedicated to the Birth of Saint John the Baptist.

The porcelain service for the Order of Saint George is produced at the Gardner Manufactory, Moscow Province (see cat. nos. 18A–B), until the end of the eighteenth century.

DECEMBER 12 Catherine's first grandson, Grand Duke Alexander Pavlovich, the future Emperor Alexander I the Blessed (1801–1825), is born.

1778

Catherine orders the Cameo Service from the Sèvres Royal Porcelain Manufactory to present to Potemkin (see cat. no. 19).

MAY 30 Voltaire dies. With Diderot's help, Catherine obtains his library from Madame Denis, Marie Louise Mignot (1712–1790), the philosopher's niece, companion, and heir. The empress paid 50,000 *écu d'or* (gold écu)/30,000 gold rubles for 6,814 volumes and 37 folders of manuscripts. A special ship delivered the acquisition to Saint Petersburg in the fall of 1779. Although the payment included the purchase of all of Catherine's letters to Voltaire, they had already become the property of the famous playwright and publisher Pierre-Augustin Caron de Beaumarchais (1732–1799). When publishing the letters, Beaumarchais honored the empress's wish to exclude certain passages.

Construction begins on the neoclassical Trinity Cathedral at the Alexander Nevskii Monastery in Saint Petersburg. The building was designed by Ivan Egorovich Starov (1745–1808). The dedication of the cathedral would take place twelve years later, on the feast of the monastery's patron saint, August 30, 1790.

1779

Catherine acquires the art collection of Sir Robert Walpole (1676–1745), the First Earl of Orford, widely celebrated as the first prime minister of Great Britain. The British Parliament attempted to raise funds to prevent the sale, but failed. The collection included 198 paintings, many well-known masterpieces of Western art.

APRIL 27 Catherine's second grandson, Grand Duke Konstantin Pavlovich (d. 1831), is born. She proceeded to groom him to become the emperor of Constantinople, even providing him with a Greek wet nurse named Helena. In addition, several Greek families were relocated from the southern provinces to Tsarskoe selo so that Konstantin would have Greek-speaking playmates and master the language of his future subjects in the most natural manner.

1780

JUNE 24 Feast of the Birth of Saint John the Baptist. Holy Roman Emperor Joseph II participates in the consecration of the church on the grounds of Kekereksinen Palace dedicated to the Birth of Saint John the Baptist.

1781

SEPTEMBER Catherine and Joseph II establish a Russo-Austrian alliance to deal with the "Eastern Question." They envisioned dividing between themselves the European territories of the Ottoman state. Catherine intended to restore the Orthodox Christian Greek empire of Constantinople and to place on its throne Konstantin Pavlovich. This general strategy became known as the Greek Project, most likely initiated by Gregory Potemkin. Understandably, Potemkin was also a great promoter of the alliance with Vienna.

The heir to the throne, Grand Duke Paul Petrovich, and his consort, Grand Duchess Maria Fedorovna (1759–1828), née Sophie Marie Dorothea Augusta Louise, duchess of Württemberg, begin a journey through Europe under the pseudonyms of "Le Comte" and "La Comtesse du Nord" (see cat. nos. 3 and 27). It will last until 1782.

Catherine acquires the art collection of Count Baudouin in Paris, which includes 119 mostly Flemish paintings, and the art collection of 5,000 drawings belonging to Count Johann Ludwig Joseph von Cobenzl (1753–1809). Count Von Cobenzl was the Holy Roman Empire's minister to the court of Saint Petersburg. Six years later, he participated in Catherine's Journey to Byzantium and wrote memoirs about his diplomatic years. In 1800, he became foreign minister of the Hapsburg court of Vienna.

1783

JANUARY 24 Catherine appoints her closest female friend, Princess Catherine Romanovna Vorontsova-Dashkova (1743–1810), as director of the Imperial Academy of Arts and Sciences. Princess Dashkova, a major figure of the Enlightenment in Russia, remained at this post until August 12, 1794.

FEBRUARY Potemkin negotiates the annexation of Crimea, which becomes the Province of Tauris, after the ancient Greek name of the region.

SEPTEMBER 30 Princess Dashkova becomes the first president of the newly formed Russian Academy, whose main purpose was the study of the Russian language. Dashkova's declared goal was to make Russian one of the great literary languages of the world.

NOVEMBER Potemkin is promoted to field marshal and president of the College of War and granted the title Serenissimus Prince of Taurida.

Construction begins on Potemkin's Tauris Palace in Saint Petersburg, after the design of architect Ivan Egorovich Starov (1745–1808). It will conclude in 1789.

1787

JANUARY 2–JULY 11 In celebration of the twenty-fifth anniversary of her ascent to the throne, Catherine II, accompanied by the diplomatic corps and foreign crowned heads, travels south to the recently annexed Crimea to inspect the progress made there. It is known as the Journey to Byzantium.

AUGUST 13 Start of the Second Russo-Turkish War, which lasted until 1792.

Catherine acquires the cameo collection of Louis Philippe Joseph, duke of Orléans (1747–1793), a.k.a., Philippe-Egalité, paying 40,000 rubles for 1,500 engraved gems. Considered one of the best collections in the world, it included the inheritance of the duke's great-great-great-great-grandmother, the Princess Palatine Elisabeth Charlotte (1652–1722), the daughter of Charles I Louis, Elector Palatine (1617–1680). She married King Louis XIV's brother Philippe I, duke of Orléans (1640–1701). The collection, as Catherine acquired it, included gems that were previously in the possession of Lorenzo de' Medici (1449–1492), Fulvio Orsini (1529–1600), Peter Paul Rubens (1577–1640), and Pierre Crozat.

1788

MAY 10 Catherine the Great's fourth granddaughter, Catherine Pavlovna (d. 1819), grand duchess of Russia, the future queen consort of Württemberg (1816–1819), is born. Catherine Pavlovna patronized Russian intellectuals, most notably the prolific writer

and historian Nikolai Mikhailovich Karamzin (1766–1826), whose *Memoir on Ancient and Modern Russia* (1811) and *History of the Russian State* (1816–26) manifest his conservatism and celebrate autocracy. Catherine Pavlovna also became famous for her extensive charitable work.

MAY 10 The Church of Saint Sophia, in the city of Sophia, just south of Tsarskoe selo, is consecrated. It was designed by architect Charles Cameron (1745–1812), a Scot who lived and worked in Saint Petersburg. Catherine conceived the city of Sofia as a neoclassical replica of Constantinople and as an allegorical statement about the future of the Christian empire of Constantinople, the restoration of which was the goal of Catherine and Potemkin's foreign policy.

DECEMBER 6 As part of the Second Russo-Turkish War, the fortress of Ochakov on the north shores of the Black Sea is conquered.

1789

JULY 14 The French Revolution begins.

SEPTEMBER Victory at Rymnik in Wallachia (Second Russo-Turkish War).

NOVEMBER Victory at Bender in Moldova (Second Russo-Turkish War).

1790

AUGUST Victory in sea battle at Cape Tendra at the north shores of the Black Sea (Second Russo-Turkish War).

SEPTEMBER–OCTOBER Victories at Keliia, Tulcha, and Isakcha, located along the lower Danube (Second Russo-Turkish War).

DECEMBER 10 Catherine issues an oral decree for the creation of two sets of liturgical gold vessels, including the Buch chalice (cat. no. 9), decorated with diamonds and cameos she selected from her extensive collection.

DECEMBER Conquest of the fortress of Izmail, on the north shores of the Black Sea (Second Russo-Turkish War).

See cat. nos. 12 and 22.

1791

APRIL 28 After returning to Saint Petersburg from the war headquarters in the South, Potemkin organizes a grandiose ball in the Tauris Palace where he entertains 3,000 guests. The famous poet Gavrila Romanovich Derzhavin (1743–1816) wrote an account of this event titled "Description of the feast on the occasion of conquering the city of Izmail given in the home of General-Fieldmarshall Prince Potemkin of Tauris." Nominally it was this recent victory that was celebrated, but Potemkin's ultimate goal was to assert his influnce with the empress. Accordingly, he reiterated the magnitude of his accomplishment in the empire's expansion to the South. The Tauris Palace's decoration for the ball affirmed the symbolic meaning of the new southern provinces as the paradisial garden of Russia.

AUGUST 29 At the all-night vigil, Catherine personally delivers the gold liturgical set including the Buch chalice to the Trinity Cathedral of the Alexander Nevskii Monastery in Saint Petersburg, at the start of the liturgical celebrations for the patron's feast day (August 30).

OCTOBER 3 Potemkin dies near the theater of war, in the new southern provinces, on the road from his headquarters in Iassu to Nikolayev, one of the neoclassical cities he founded.

1792

FEBRUARY 22 The semiweekly journal *Columbian Centinel*, established in 1790, in Boston, Massachusetts, by Benjamin Russell (1761–1845), as a continuation of his earlier *Massachusetts Centinel and the Republican Journal*, publishes an English translation of a letter from Catherine stating Russia's support for the "Army of Princes" intending to fight the French revolutionaries. At that time, the commander of the antirevolutionary army was Victor

François de Broglie, second duke de Broglie (1718–1804) (see cat. no. 36).

APRIL 28 Catherine writes her "Last Will and Testament":

> In case I should die in Tsarskoe selo, then lay me in the graveyard of the [town of] Sofia.
>
> In case—in the city of Saint Peter's—in the Saint Alexander Nevskii Monastery's cathedral or burial church.
>
> In case—in Moscow—in the Donskoy Monastery in the new city graveyard.
>
> In case—in Peterhof—in the Saint Sergius Monastery.
>
> In case—in some other place—to a graveyard nearby.
>
> The coffin shall be borne by Horse Guards and no one else.
>
> My body shall be laid out in a white dress, with a golden crown upon my head, on which my name shall stand.
>
> Mourning shall be worn for half the year but no longer; the less is the better.
>
> After the first six weeks, all popular amusements shall be permitted again.
>
> After the burial, bethrothals shall be again allowed, weddings, and music.
>
> My library including all manuscripts and all papers I bequeath to my beloved grandson, Alexander Pavlovich; likewise my jewels, and I bless him with my soul and with my heart. For the purpose of a better fulfillment, a copy of this shall be deposited in a safe place, and is already deposited, so that sooner or later shame and disgrace shall overtake him who does not fulfill my will.
>
> It is my intention to place Konstantin on the throne of the Grecian Oriental Empire.
>
> For the welfare of the Russian and the Greek Empires I advise that the Prince of Württemberg[2] be removed from the concerns and the councils of these two Empires, and that he should have as little to do with them as possible; likewise the two half-Germans should be removed from the councils.[3]

1793

See cat. no. 21.

1794

See cat. no. 23.

1796

NOVEMBER 6 Catherine II dies and is succeeded by her son Emperor Paul I (reign 1796–1801). Although she made an explicit request about her burial and composed her own epitaph, her wishes were not obeyed. This is the text that the empress wrote in French in 1788 and wanted engraved on her tomb:

> Here Lies
>
> Catherine the Second
>
> Born in Stettin on April 21/May 2, 1729
>
> In the year 1744 she went to Russia to marry Peter III. At the age of fourteen, she made the threefold resolution, to please her consort, Elizabeth, and the Nation.
>
> She neglected nothing in order to succeed in this.
>
> Eighteen years of boredom and solitude caused her to read many books.
>
> When she ascended to the throne of Russia, she wished to do good and tried to bring happiness, freedom, and prosperity to her subjects.
>
> She forgave easily and hated no one.
>
> She was good-natured, easy-going; was of a cheerful temperament, republican sentiments, and a kind heart.
>
> She had friends.
>
> Work came easy to her; she loved sociability and the arts.[4]

END NOTES

1. This chronology follows the model of Troyat 1980, 413–19, with additional information derived from Catherine the Great 1935; Kliuchevskii; Madariaga; Rounding; R. Massie; and Sebag Montefiore.
2. Ludwig Friedrich Alexander, duke of Württemberg (1756–1817), was the brother of Catherine's daughter-in-law, Grand Duchess Maria Fedorovna.
3. English translation by Katherine Anthony according to *Catherine the Great* 1925, 327–28.
4. Translation according to Anthony, 325.

ESSAYS

"Great Women Are Great Men"

ASEN KIRIN

This exhibition's assembly of imperial portraits, liturgical vessels, icons, books, and dinnerware provides insight into Russian visual culture from the second half of the eighteenth century and illustrates the complex dynamic between the collecting of historical art and the commissioning of new works of art. We invite audiences to contemplate the art collections of two extraordinary women, who could not have come from more disparate environments: Europe's old regime of absolute hereditary monarchies and the modern, industrialized United States of free enterprise.

The first of these collectors was born in Prussia as Princess Sophie Fredericka Augusta Dorothea of Anhalt-Zerbst (1729–1796) and, at the age of fifteen, upon a political betrothal, converted from the Lutheran faith in which she was baptized to Eastern Orthodoxy to marry Karl Peter Ulrich (1728–1762), the heir to the Russian throne. Thus, Princess Sophie became Catherine Alekseevna, grand duchess of Russia. Eighteen years later, in 1762, she emerged from the muddy waters of a coup-d'état as the sole autocrat of a vast empire, on the throne of which she had no hereditary rights to lay claim.

The second of these eminent women, Marjorie Merriweather Post (1887–1973), hailed from Springfield, Illinois, and was the sole heir of a multimillion-dollar business enterprise founded by her father. Both Catherine the Great and Post brought to new heights their respective domains in environments dominated by men. Such women of power and great accomplishment often utilize the arts to affirm and perpetuate their positions in society and to control public perception.

Like other distinguished women, Catherine the Great and Post accomplished what great men did in the spheres of governance, politics, and business. In addition, they continuously engaged in the realm of domesticity, which tradition had sanctioned as appropriate for respectful women. They transcended the supposed limitations of womanhood while simultaneously excelling in their feminine roles. Two of Catherine's foreign admirers acknowledged the empress's accomplishments in memorable witticisms. Louis Phillipe, comte de Ségur (1753–1830), stated that "[Catherine is] a woman who is a great man," and Charles Joseph Lamoral, the seventh prince de Ligne (1735–1814), when applying the adjective "great" to Catherine, used it in the masculine instead of the feminine gender, calling her "Catherine *le Grand*" instead of "Catherine *la Grande*."[1]

As the French feminist philosopher Simone de Beauvoir stated in 1949, the feminine in Western society is defined against the normative masculine: "she is defined and differentiated with reference to man, and not he with reference to her."[2] Even if they were almighty rulers, women were expected to fulfill their feminine duties—to keep the home, make the bed, and set the table. Certainly, when the woman in question was the empress of Russia or a top businesswoman, she inevitably

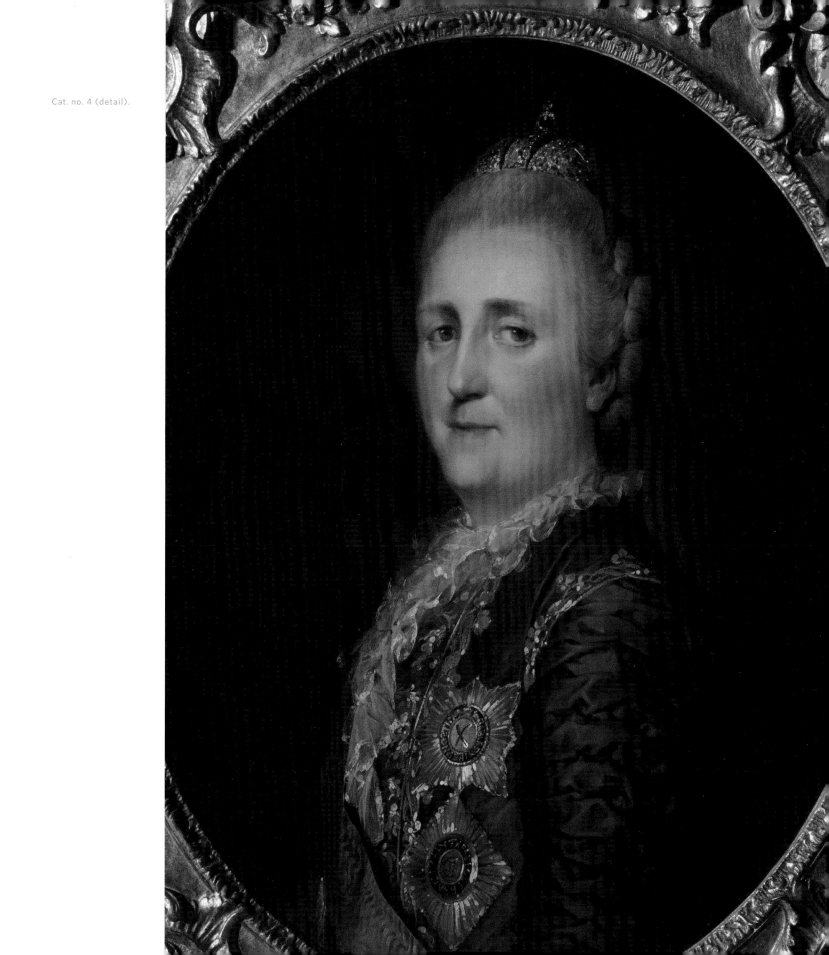

achieved these pursuits on a grander scale; in Catherine's case, the word "panache" would be an understatement. Apart from displaying great style, these notable domestic feminine activities were fueled by erudition and creativity, infused with meanings, and left a positive impact on society—both in eighteenth-century Russia and the twentieth-century United States.

Post acquired several objects of art commissioned by Catherine the Great because of both their visual appeal and historical significance.[3] Their associations with the enlightened empress, who was herself an ardent art collector, were a factor as well. The selection of objects in this exhibition from Hillwood Museum and Gardens underscores the richness of Post's remarkable collection and encapsulates the main currents in Russian visual culture from the periods before and after Emperor Peter the Great's (reign 1682–1725) reforms. By offering a historical perspective on the practice of collecting works of art, this exhibition shows new audiences the cultural significance of Post's connoisseurship and, in particular, her forward thinking about the artistic value of what, according to old taxonomies, were deemed merely "decorative" or "minor arts." At first, Post acquired objects of art because she was setting up a home for her family. Yet, ultimately, by establishing her museum, she determined the main purpose of her collection was to educate and to promote visual literacy, art appreciation, and historical knowledge.

WOMEN, HOUSES, DINING, AND VESSELS

Eighteenth-century enlightened monarchs were expected to work tirelessly for the betterment of their nations. Even by the high standards of this exclusive club, Catherine the Great labored hard. King Frederick the Great of Prussia (reign 1740–1786), himself the paragon of a hard-working, intellectual monarch, asked Kaspar von Saldern, the Russian envoy to Poland, "Is it really true that she works even more than I do?"[4] Rising early every day, she would sit at the work table with a pot of coffee and spend long hours reading and writing diplomatic correspondence, composing and editing state documents, writing works of literature or extensive reviews of recent publications, meeting with imperial officials, and studying history or making plaster casts of engraved gems from her cameo collection. The philosopher empress also did needlework, a prototypical feminine domestic activity for millennia. In the medieval era, textile icons and liturgical objects constituted a specifically feminine form of personal devotion and patronage for the church. Even the enlightened monarch saw nothing demeaning in spending time sewing and

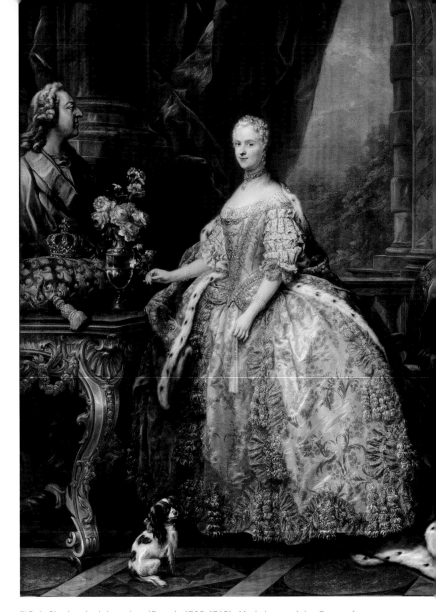

FIG. 1. Charles-André van Loo (French, 1705-1765), *Marie Leszczyńska, Queen of France (1703-1768)*, 1747. Oil on canvas. Palace of Versailles.

embroidering. She was industrious not only as was customary for a ruler of high-minded masculine ways, but also in a manner that affirmed her femininity. Therefore, one is not surprised to learn that she presented some of her handwork to her lover Prince Gregory A. Potemkin (1739–1791). On February 19, 1779, the French diplomat Marie Daniel Bourrée, baron de Corberon (1748–1810), visited Potemkin and noted in his diary the following day:

> Le 19 février, mon bon ami, j'ai été invité seul des chargés d'affaires à une fête du prince Potemkin, qu'il a donnée dans l'orangerie de sa Maison de la Perspective, qui étoit décorée

en jardin d'une manière agréable. Devant ou en face de la porte d'entrée étoit un petit temple consacré l'Amitié, avec la statue de la déesse qui tenoir le buste de l'Impératrice. Un autre petit cabinet est meublé d'un sopha pour deux personnes, d'étoffe riche brodée par l'Impératrice elle-même.

On February 19, my good friend, I was the only one [from the diplomatic mission] to be invited to a party given by Prince Potemkin in the orangery of the House of Perspective, which has a beautiful garden. In front [of Potemkin's house] was a small temple dedicated to Friendship with the statue of the goddess holding a bust of the Empress. Another little room was furnished with a sofa for two, embroidered and stuffed by the Empress herself.[5]

Every aspect of this arrangement was intended to make a statement, one apparently not lost on such perceptive viewers as the baron. Without overstating the point, his record conveys the details that allow readers to realize that this small room—"petit cabinet"—had connotations with intimate conversations and intellectual pursuits. Thus, the piece of embroidered furniture, which appears to have been its main feature, embodied not only the intimacy between the empress and Potemkin, but also their shared political and intellectual goals. This traditional feminine handwork displayed in the home's interior must have been conceived as a kind of remedy, or at the very least as partial compensation, for the reversed dynamic of a relationship in which the wife had the power, not her husband. To this point, it should be noted that Catherine and Potemkin were bound in a secret morganatic marriage in the summer of 1775. For contemporaries who were not privy to the inner spaces of this relationship and viewed it from afar, there was a different statement, also registered in Corberon's diary: the small temple dedicated to friendship and positioned next to the point of entry. An apparent synecdoche exists between the temple and the house, the latter of which emerges as a shrine to Catherine's relationship with Potemkin. This home was the receptacle of their shared life and, like other notable palaces yet to be built, was the empress's gift to her secret husband. Consistently throughout her life, Catherine expressed her commitment to her partners by presenting them with palaces and various vessels of porcelain, silver, and gold, all, with varying degrees of intensity, alluding to the essential notion of womanhood as a receptacle of life. Dishes from two such dining sets are included in the current exhibition—the Orlov Service (cat. nos. 17A–B), given to Count Gregory G. Orlov (1734–1783), and the Cameo Service (cat. no. 19), intended for Prince Potemkin.

Catherine's role as a nurturing female extended well beyond the sphere of her personal life to her entire nation. One customary way of addressing the empress was *matushka* ("beloved mother"), an expression that was simultaneously respectful and affectionate, used even by people older than Catherine as it was a matter of status, not age. The *matushka* of the empire literally made possible the setting of tables around her vast country in the most dignified, sophisticated, and meaningful way. As Dr. Marina Lopato of the State Hermitage in Saint Petersburg has demonstrated in her research, Catherine placed massive orders for formal silver dinner sets in the neoclassical style for the residences of the governors of all fourteen provinces of Russia, the largest commission of dining silver in eighteenth-century Europe, at astronomical cost. Of course, the return on this investment was correspondingly significant—formal dining throughout Catherine's empire became a rite of taste and refinement but also a statement of admiration for antiquity and affirmation of the enlightened monarchy's ideas. Catherine literally nourished her nation from prized vessels, which through their appearance alluded to the political ideas of that time.

Catherine was by far not alone in appreciating the practical and symbolic implications of patronage for porcelain and ceramic manufacturers. In fact, these commissions were customary among women of high distinction in eighteenth-century Europe.[6] Catherine's predecessor Elizabeth I (reign 1741–1761) of Russia started the porcelain factory in Saint Petersburg, while in France Madame de Pompadour (1721–1764), the official mistress (*maîtresse-en-titre*) of King Louis XV (reign 1715–1774), enabled through her patronage the rise and contributed to the fame of the Royal Porcelain Manufactory at Sèvres. In England, Queen Charlotte (1744–1818), the consort of King George III (reign 1760–1820), favored the industrial potter Josiah Wedgwood (1730–1795). Notably, Catherine placed orders with all three of these manufacturers—the Imperial Porcelain Factory in Saint Petersburg (cat. nos. 17 A–B), Wedgwood (cat. nos. 30 and 31), and Sèvres (cat. no. 19)—commissions that formed famous chapters in the history of these three venerable institutions.

Beyond the realm of formal dining, the notion of vessels as symbols of femininity manifested itself in individual commissions for objects made of precious materials, whose intricate visual programs Catherine the Great conceived. Illustrating this phenomenon are two extraordinary

Like other distinguished women, Catherine the Great and Post accomplished what great men did in the spheres of governance, politics, and business. In addition, they continuously engaged in the realm of domesticity, which tradition had sanctioned as appropriate for respectful women. They transcended the supposed limitations of womanhood while simultaneously excelling in their feminine roles.

gold vessels in this exhibition: the Orlov potpourri vase (cat. no. 49), in the collection of the Walters Art Museum, and the Buch chalice (cat. no. 9), in the collection of Hillwood Museum and Gardens, each of which receives an essay in this volume. The Orlov vase features miniature enamel scenes of pagan goddesses and ancient heroes. Its fashionable function was to perfume an interior space to enhance and elevate the activities there. The empress presented it to her long-term partner Count Gregory Orlov, thus stating her appreciation of his accomplishments and her dedication to him. Although the decoration features ancient pagan themes, the most intense personal statements that this gold vase conveys emanate from associations with liturgical poetry, the ecclesiastical calendar, and Christian iconography. The Buch chalice, on the other hand, is a liturgical object covered in diamonds and engraved gems that Catherine donated to a monastery in honor of Prince Potemkin. Its decoration engages topics that transcend the realm of liturgical symbolism and presents ideas about the continuity between ancient and Christian cultures, the unity between the East and West of Christian Europe, and the phenomenon of collecting art and thereby giving the past a new life.

Both of these gold vessels allegorically embody the empress herself; their commission and presentation amounted to symbolic gestures stating Catherine's commitment to two men who were of great importance to her during different periods of her life. In terms of chronology, these two gold vessels frame Catherine's thirty-four-year reign; the Orlov vase was

commissioned six years after her coronation, and the Buch chalice was created five years before her death. Their juxtaposition in the context of the current exhibition emphasizes a key characteristic of eighteenth-century Russian neoclassicism—namely, the deliberate effort to fuse the visual and symbolic languages of that movement and Eastern Orthodoxy.

The practice of depicting a vessel to express the notion of feminine virtue has a long history in Christian iconography, especially in images of the Holy Virgin and Mary Magdalene, among other saintly figures. In addition, this theme appears in eighteenth-century royal portraiture, as two notable examples of French painting demonstrate. In 1729, Jean-Marc Nattier (1685–1766) painted *Portrait of Marie-Anne de Bourbon-Condé at the eaux minérales at Chantilly* (Musée Condé, France).[7] Marie-Anne de Bourbon, Mademoiselle de Clermont (1697–1741), was a granddaughter of King Louis XIV (reign 1683–1715) and his official mistress, Madame de Montespan (1640–1707). The painting pictures Mademoiselle de Clermont on the grounds of her ancestral home, Château de Chantilly, in the guise of a water nymph. Reclining on an overturned urn in front of a pond, she receives a serving of mineral water from what appears to be a vessel of rock crystal. Her association with the spring of water invests her with the powers of nature and acknowledges her exalted social status. At the same time, the rock crystal vessel adds Christian connotations that link precious receptacles with the Holy Virgin and all her virtues. When this portrait was created, Marie-Anne de Bourbon had been a widow for five years; as nymph is also Greek for "bride," this image of a "goddess/ bride of a spring" who is full of moral virtue may have been conceived as an allegory of the sitter's widowhood.

The exact input of the sitter in defining this iconography remains unknown, but the image provides an intriguing link to another portrait conspicuously featuring a vessel, created in 1747, six years after Marie-Anne's death. At the very least, these two works of art testify to the relevance of the "precious receptacle" motif within the royal family of France. In 1725, Marie-Anne de Bourbon was appointed to serve as the head of the household of Queen Marie Leszczyńska (1703–1768), the Polish-born consort of Louis XV. A formal portrait of the queen painted in 1747 by Charles-André van Loo (1705–1765) constitutes a prominent example of rendering feminine virtue in the form of a rock crystal vase (fig. 1). In this painting, Marie Leszczyńska pays her respects to the king by addressing his bust, displayed on a high console table. In front of the royal bust stands a large crystal vase containing a bouquet

of flowers, including roses and lilies, which are traditionally associated with the Virgin Mary. Essentially, she is pictured presenting this vase to her husband while at her feet sits a little beribboned spaniel, a symbol of devotion and faithfulness. The queen's portrait was displayed across from a matching full-length likeness of her husband, also by Van Loo, in the Salon de Mars at the Palace of Versailles. The overall arrangement emerges as a celebration of utmost feminine virtue in a space dedicated to the Roman god of war, who embodies absolute masculinity. In ways similar to the display in the Hall of Mars with the two Van Loo portraits, the visual program of the Orlov vase juxtaposes femininity, visualized in the form of a vessel, with paragons of masculinity deliberately engaging at once pagan and Christian symbols. The iconographic program of the Buch chalice is in the same vein, with two distinct registers in which the images are grouped by themes—feminine in one and masculine in the other.

EXUBERANCE OF MEANING

The phrase "Exuberance of Meaning" refers to a crucial characteristic that distinguishes Catherine the Great's endeavors in the arts. She conceived her innumerable projects—whether a new city, a church, a liturgical vessel, or a dinner set—in a manner allowing for multiple, yet complementary interpretations covering a wide spectrum of meanings. Some of these meanings and references remained relevant only within a Russian context, thus forming unique aspects of that country's neoclassical aspirations. Catherine's goal was never to define firmly each and every shade or layer of meaning in the works she commissioned. Instead, she aimed at engaging different sets of associations and allusions that would allow for generating multiple related interpretations.

The empress strove to expand the system of cultural references in her empire, and she considered it essential to add a neoclassical stratum to Russia's material culture to promote learning about antiquity. In addition, Catherine deliberately disseminated knowledge about Russia's medieval heritage and about Byzantium, including Byzantine theology, political ideology, and history. This exhibition takes as a central theme the perception of Byzantine culture in the era of neoclassicism. One of the ambitious traits of Catherine's ideological creativity was her construction of an environment in which a learned audience would understand works of art, architecture, and literature through its proficiency in the "languages" of both classical and medieval culture. Thus, the multiplicity of meaning is the direct outcome of the empress's wish to assert her

empire as a key participant in the project of the Enlightenment, the aim of which was to reform society and advance knowledge.

This ideological directive reflected the empress's understanding of Byzantium's cultural mission to preserve and deliver Greek antiquity to the contemporary intellectual world. In the late eighteenth century, Russians had come to see themselves as the successors and guardians of Byzantine heritage and, through it, that of the ancient Greek world. Russia's religious and cultural links with medieval Constantinople acquired a new, classical dimension in the era of the Enlightenment. Omnipresent in Russian culture of Catherine's time, this vision manifested itself even in works of art seemingly lacking any overt references to Byzantium, as in, for instance, the Green Frog Service, two plates from which are included in this exhibition (cat. nos. 30 and 31).

THREE REALMS OF TRANSCENDENCE: LITURGY, SCHOLARSHIP, AND DINING

This exhibition is arranged in three sections, each dedicated to a realm of life in which works of art and scholarly pursuits enable certain forms of transcendence (i.e., the experience of overcoming the limitations of physical existence). In this context, "transcendence" means not a religious phenomenon, defined in Christian theology as God's separation and remoteness from the material world, but, with regard to cultural anthropology, an elevating activity that enriches life and surpasses the sphere of maintaining basic human existence.[8] Nonetheless, the theological and spiritual implications of the term were of great importance to the visual material at hand. Using "transcendence" vis-à-vis the current exhibition helps emphasize the centrality of the Christian religious experience in eighteenth-century European culture and illustrates how, in the secular domain of intellectual and aesthetic pursuits, the notion of reaching into new spheres of experience reflects the religious model of transcendence achieved through visions and divine revelation.[9]

SECTION ONE: PORTRAITS, BOOKS, MEDALS, AND CATHERINE'S MEDALLIC HISTORY (Cat. nos. 1–4, 6, 24–27, 37–43, 45, 52–56, and 59–64)

This section of the exhibition features likenesses of Catherine the Great in different mediums—sculpture, painting, engraved gems, and medals. The sculptural portrait (cat. no. 1) by Fedor Ivanovich Shubin (1740–1805) illustrates the neoclassical style—both the material of marble and the format of the bust strongly suggest antiquity. The empress wished to represent herself in line with the pan-European taste of the time

while reaching into the Greco-Roman past, paralleling her active interest in collecting engraved stones and coins from the ancient world. This bust expresses the notion that an enlightened monarch's positive qualities of character are a prerequisite for a successful rule. The likeness of the smiling empress bespeaks benevolence and magnanimity; she is poised and dignified but not aloof or reserved. Although similar characteristics appear in the painting (cat. no. 4) by Pierre-Étienne Falconet (1741–1791), here the artist renders the empress in a manner that deliberately understates her femininity because of its perceived incongruity with monarchical power. In this portrait the flat-chested Catherine wears what looks like a tight-fitting military jacket, perhaps because she also bears the insignia of two Russian Orders of Knighthood awarded almost exclusively to men: the Order of Saint Andrew the Apostle-the First-Called, the highest order of chivalry in the Russian empire (the blue sash and the star at the top), and the Order of Saint George (the star at the bottom).

The phrase "Exuberance of Meaning" refers to a crucial characteristic that distinguishes Catherine the Great's endeavors in the arts. She conceived her innumerable projects—whether a new city, a church, a liturgical vessel, or a dinner set—in a manner allowing for multiple, yet complementary interpretations covering a wide spectrum of meanings.

The dynamic between gender and power is on display again in the depictions of Catherine in the guise of Minerva (cat. nos. 3, 5, and 42). The ancient virgin warrior goddess of wisdom is the expected symbol, sanctioned by tradition, of a female with both might and intelligence. It is no coincidence that most of the images of Catherine as Minerva were rendered on carved stones and medals, mediums that had strong associations with antiquity and, thus, related to the realm of pagan

mythology while conveying prestige and veracity (see cat. nos. 43–46). Coins were the most accessible of ancient history's material vestiges, and they often featured portraits of illustrious persons. The Italian humanist Girolamo Ruscelli (1500–1566) asserted that "For every ancient statue that we have today we have many, many medals [i.e., coins] throughout the world."[10]

Carved gems and coins/medals conveyed a notion about the presence of antiquity in the context of eighteenth-century life. Accordingly, they were the most suitable mediums for glorifying the exploits of a ruler because he or she needed the lessons of history. The fact that the substances used to make cameos and medals endure added to these works' monetary and symbolic value; medals also could be produced for a lesser expense than gems and in great numbers. When rendered on medals, recent events solicited public contemplation in a manner both morally uplifting and aesthetically pleasing. Because they feature both visual and verbal content, they also could fulfill didactic functions. As visual enigmas that had to be deciphered, both carved gems and medals required prolonged contemplation; the reward for this effort was the gaining of insight, the acquisition of knowledge.[11]

Closely related to the medals struck to celebrate important accomplishments of Catherine's reign (cat. nos. 2 and 43A–F), is the volume of the empress's medallic history (cat. no. 25), which presents important events as designs for medals and includes both images of symbolic compositions and accompanying texts. This volume was published in 1772 in the midst of the First Russo-Turkish War (1768–1774), which was discussed in great detail in 1770 in the pages of the *Gentleman's Magazine* (cat. nos. 62A–B) and commemorated by Catherine through the construction of the Kekereksinen Palace and the commission of the Green Frog Service (cat. nos. 30 and 31). The empress followed the medallic history of King Louis XIV (reign 1643–1715), the first edition of which appeared in 1702 (cat. no. 39), as a model for her publication. When images of medals form a visual narrative about recent events, they appear consequential because they are rendered as if they already belong to the annals of history. A volume of medallic history serves as the two-dimensional equivalent of a cabinet of medals, making accessible to a wide audience the contents of a treasure chest and the virtues it embodies. A later Russian example is the publication from 1838

containing medals designed by Count Fedor Petrovich Tolstoy (1783–1873) in commemoration of the Napoleonic wars from 1812 to 1815 (cat. no. 26).

Several eighteenth-century volumes in this section of the exhibition acknowledge the fact that Catherine the Great was an avid reader and a prolific writer. By the end of her reign, she had amassed a library of approximately 38,000 volumes. As the empress herself put it succinctly, "[the] eighteen years of boredom and solitude [during her marriage to Peter III] caused her to read many books."[12] Books formed her character, her political ideas, her intellectual pursuits, and many of her endeavors involving the arts. Very few of the actual volumes that once belonged to the empress are found outside of Russia, but the books on display here are editions contemporaneous with Catherine's reign and are on loan from Hillwood Museum and Gardens and the Hargrett Rare Book and Manuscript Library at the University of Georgia.

Volumes from the original edition of the *Encyclopédie, ou dictionnaire raisonné des sciences, des arts et des métiers (Encyclopedia, or a Systematic Dictionary of the Sciences, Arts and Crafts)*, published between 1751 and 1772 in France (cat. nos. 54 and 55), represent Catherine's close associations with the great French philosophers of her time, among them Denis Diderot (1713–1784), the chief editor of and contributor to this monumental endeavor. The *Encyclopédie* embodies the conviction that advancement of knowledge can better society. Catherine ardently embraced this idea, turning her long reign into an unremitting campaign to carry it out. The ultimate purpose of the encyclopedists was the advancing, gathering, and systematizing of knowledge to disseminate it successfully among contemporaries and deliver it to future generations. In other words, this endeavor attempted to overcome the temporal limitations of human existence by transcendence through intellectual pursuits. Diderot defines the phenomenon of the "Encyclopedia" in an article within the publication itself: "Indeed, the purpose of an *encyclopedia* is to collect knowledge disseminated around the globe; to set forth its general system to the men with whom we live, and transmit it to those who will come after us, so that the work of preceding centuries will not become useless to the centuries to come; and so that our offspring, becoming better instructed, will at the same time become more virtuous and happy, and that we should not die without having rendered a service to the human race."[13]

This section of the exhibition deliberately juxtaposes examples of secular and religious transcendence, both with the imprint of the Enlightenment. One icon and two liturgical books tell an intriguing story about Catherine's ways of attaching new meanings to traditional forms of Christian devotion. The two liturgical volumes (cat. nos. 40 and 41) represent the omnipresence of Church Slavonic liturgical texts in eighteenth-century Russia and feature the old alphabet that Peter the Great replaced with a new Latinized graphic version of the Cyrillic used in all other spheres of life.[14] The icon (cat. no. 37) relates to the cult of a particular Russian holy man, Saint Dmitri of Rostov (born Daniil Savich Tuptalo, 1651–1709), an example of an enlightened ecclesiastical. As discussed later in this volume in the essay "Catherine II's Religion," in May 1763 Catherine made a pilgrimage on foot to the shrine containing his relics. This veneration was, in fact, the final chapter in the eight months of festivities celebrating her coronation.

Also in this section of the exhibition, catalogue number 24 is a copy of the French edition of Catherine's *Instruction*, which was banned in France for being excessively liberal at the order of Étienne Francois, duke de Choiseul (1719–1785), who was the chief minister of King Louis XV between 1758 and 1770. The empress composed the *Instruction* (in Russian, *Nakaz*) to guide the work of the Legislative Commission convened in 1767 in Moscow toward reforming the seventeenth-century code of laws and introducing up-to-date legislation. The *Nakaz* was a statement in twenty-two chapters and 655 clauses that Catherine embraced the ideas of enlightened monarchy. Some of the thinkers who informed Catherine's political views are represented in this exhibition in the six volumes of the writings of Charles-Louis, baron de Montesquieu (1689–1755) and Voltaire (1694–1778) (cat. nos. 59, 60A–C, and 61A–B). The work of the Legislative Commission stalled for many reasons, and the start of the First Russo-Turkish War caused its complete closure. Nonetheless, Catherine's *Nakaz* attests to the empress's enviable knowledge of history and her fluency in the contemporaneous political discourse.

The holdings of her famous library inspired many of Catherine's projects involving the arts. Richly illustrated books were the main source of disseminating knowledge about antiquity and contributed to the formation of the neoclassical style that spread across Europe. To illustrate this point, this section of the exhibition displays some of the anthologies illustrated with antiquities, publications well known to scholars and connoisseurs in the eighteenth century (cat. nos. 52A–B, 53, 56A–D, 57, and 58A–B). These lavish editions constituted, in a manner of speaking, a "Paper Museum," as Elisabeth Décultot discusses in the catalogue for a recent exhibition at the Musée du Louvre.[15] The idea of the Paper Museum, or "Museo cartaceo," relates to the collection of the Florentine scholar and patron Cassiano dal Pozzo (1588–1657), which contained drawings encompassing humanity's knowledge of nature and history.

Catherine deliberately and consistently used books compiling scholars' and antiquarians' knowledge about the ancient world to bring antiquity to life in Russia, as with her use of the large-scale, hand-colored prints of frescos in Raphael's loggia in the Vatican in Rome—*Le logge di Raffaele incide de Giovanni Ottaviani e Giovanni Volpato*.[16] The empress received this album in 1775 from Prince Nikolai Vasilievich Repnin (1734–1801), who served as the Russian minister to Istanbul from 1775 to 1776. In order to contemplate these frescos, which for her embodied the continuity between antiquity and Christianity, she commissioned exact copies of the mural and built a new wing of the Winter Palace for their display. The copy of Raphael's loggia was completed much later, between 1787 and 1792, but the empress could not wait, so she decorated a small room in her private apartments in the Zubov Wing of the Summer Palace at Tsarskoe selo with the actual etchings attached to the walls. Catherine described this extreme example of using books as a source of inspiration for architectural projects in a letter of April 13, 1778, to Baron Friedrich Melchior von Grimm (1723–1807), who served as her art agent in Paris:

> . . . il y aura à Tsaskoe-Sélo un remue-ménage terrible d'appartements. L'impératrice ne vent pius loger dans du bout de la maison; elle veut demeurer au milieu des trois jardins, elle veut jouir de ses fenêstres de la vue du grand balcon. Le grand escalier est transpoté dans le petit aile qui touché àla porte d'entrée du côté de Gatchina; elle aura dix appartements, pourl'ornament desquelles toute sa bibliotèque favorite sera épuisée, et son imagination se donne un libre cours, et le tout sera comme ces deux pages; c'est-a-dire qi'il n'y aura pas le sens commun.

> . . . there is in Tsarskoe selo a horrible set of rooms. The Empress does not wish to lodge in this side of the house. Instead she wants to stay in the midst of the three gardens, and enjoy the view framed by her windows, from the large balcony. The grand staircase is moved to a small wing which looks towards Gatchina. Here she has ten rooms for the decoration of which her entire favorite library will be used; and her imagination is given a free rein, and everything will be as with these two pages; that is to say, it will have nothing to do without any common sense.[17]

The books on display include examples of texts known to have shaped Catherine's worldview and provided her with models of an ethical and intellectual nature, such as the *Meditations* of Emperor Marcus Aurelius (reign 161–169 CE; cat. no. 63). A portrait cameo of that emperor's consort Faustina the Younger (ca. 125–175 CE; cat. no. 45) is also included. The writings of the stoic philosopher-emperor had a formative influence on the future ruler of Russia. Catherine's memoirs detail an argument she had with her instructor, who was also a pastor, when she was seven years old: "I remember several disputes with my teacher for which I was almost given the rod. The first arose from my contention that it was unjust that Titus [reign 79–81], Marcus Aurelius, and all the great men of antiquity, who were nevertheless virtuous, should be damned because they had not known salvation. I argued stubbornly and hotly and held fast to my conviction in opposition to the clergyman, who based his argument upon scriptural passages while I allowed only justice to prevail."[18]

Another writer with whom Catherine felt a strong affinity was Marie Rabutin-Chantal, marquise de Sévigné (1626–1696; cat. nos. 64A–B). It is clear from her letters that the marquise was full of wit and human insight and, as such, became a role model for the young grand duchess. The marquise had a natural disposition to look on the bright side in an unfailingly dignified manner. A woman exceedingly proud of her aristocratic descent, she was intellectually confident and independent minded. Her letters have proved persistently quotable, with *bons mots* including: "Faith creates the virtues in which it believes"; "Fortune is always on the side of the largest battalions"; and "I dislike clocks with second hands; they cut up life into too small pieces."

The eighteenth-century foreign publications about Russia and Catherine the Great in the exhibition (cat. nos. 35, 36, and 62A–B) reflect the interconnectedness of the world at the time. For instance, as mentioned above, in the early 1770s the *Gentleman's Magazine* reported in detail on the First Russo-Turkish War. The July issue of 1770 included both a thorough summary of the military actions and a map titled "An Accurate Map of the Seat of War in the Mediterranean including Morea and the Archipelago." The December issue of the same year featured an illustrated article titled "A Description of Constantinople. With a Plan of the Situation of that Magnificent City." Furthermore, the supplement for the same year included "A Review of the Present State of the War between the Russians and Turks, with an accurate Map of the Turkish Dominions in Europe, by way of illustration," which contains the following passages:

> The war between the Russians and Turks has been the chief object that has agitated the continent of Europe during the course of the year past. . . .The secret motives, by which her imperial Majesty might be led to involve her country in a contest with the Ottoman power, at a time when she was endeavoring to establish the religious liberties of a neighboring kingdom [Poland] upon a firm and equitable foundation, are not easily to be penetrated.[19]

> . . . there are other politicians, who, perhaps, with better reason, ascribe the origins of the present war to the jealousy of the Turks, and to the intrigues of the enemies of Russia, who, envious of her growing power, judged her embarrassment with Poland, a favourable opportunity to check her ambition, and put a sudden stop to the progress of her increasing greatness.

> The formidable power of this infant empire, it must be owned, was never so conspicuous as in the dispositions and arrangements of the present war. . . . By this fortunate blow [the June 26, 1770, victory at Chesme Bay], the Russians became masters of the Archipelago. They have till lately been employed in distressing the enemies' trade, seizing the provisions destined for Constantinople, and exacting tribute from the isles wherever they have power to compel obedience. . . .

> But the grand project which the empress is said to have in view is not yet ripe for execution. This project, the foundation of which was laid by Peter the Great, when he caused forty ships of the fine to be built upon the Black Sea, her present imperial Majesty has still in contemplation. It is by

means of the junction of her fleets and armies at the Thracian Bosphorus, to accomplish the conquest of Constantinople. The project is great, but not impracticable. Whoever will take a view of the present map, and compare it with the plan published in December, will be able to discover how accessible Constantinople is, both by sea and land, when once the fleet from the Archipelago has passed the Dardanelles.[20]

The presence in the Greek archipelago of the Russian fleet and its control over the islands was apparently common knowledge throughout Europe.[21] So was the role that Catherine assumed as the defender of Orthodox Christians, the supreme head of the entire Eastern/Greek Orthodox church. As early as 1770, only two years into the First Russo-Turkish War, a clear formulation emerged for Catherine's Greek Project, the purpose of which was to conquer Constantinople and restore Christian rule there. These excerpts from the magazine reflect the political alliances in Europe during the late 1760s and early 1770s. The Kingdom of Great Britain supported Russia in the war against the Ottoman Empire, which had the backing of France. In light of this alliance, it is apparent why some of Catherine's commissions intended to celebrate Russian military triumphs in the First Russo-Turkish War, such as the Green Frog Service and the Kekereksinen Palace, were conceived as tributes to Great Britain's political system, architecture, and picturesque gardens.

The two volumes of a French travelogue (cat. no. 35) included in this exhibition represent a positive view of Russia, the empress, and the accomplishments of her rule. *Voyage philosophique, politique et littéraire fait en Russie pendant les années 1788 et 1789, traduit du hollandais, avec une augmentation considérable, par le citoyen Chantreau* appeared in 1794. The author, Pierre Nicolas Chantreau (1741–1808), was known as "Don Chantreau" because he became a member of the Spanish Royal Academy after serving as a professor of French in the Royal School of Ávila. Chantreau was a historian, philologist, and journalist whose views on Russia were in sharp contrast with the toxically negative attitudes of another French traveler, Jean-Baptiste Chappe d'Auteroche, abbé Chappe d'Auteroche (1722–1769), who arrived in Russia twenty-seven years before Chantreau to observe a rare astronomical occurrence best seen from the Russian Kamchatka: the Transit of Venus between the earth and the sun

expected to occur on June 6, 1761. Seven years later, the abbé published his travelogue, *Voyage en Sibérie*, in a deliberate effort to discredit Russia at the beginning of the First Russo-Turkish War, which was largely instigated by Étienne-François, duke de Choiseul.[22]

In order to cast France in a favorable light, the abbé distorted most of what he had seen in Russia, filling his account with offensive and dismissive prejudices. After reading his work, Catherine was so thoroughly outraged that she wrote a book-long rebuttal, titled *Antidote*, unambiguously stating that the *Voyage en Sibérie* was the work of a poison pen; it was published simultaneously in French and English in 1770.[23] The anti-Choiseul circles in Paris deliberately expressed positive views toward Catherine and Russia, overtly celebrating her victories in the First Russo-Turkish War. The cameo depicting Catherine as the triumphant Minerva (cat. no. 42), which was most likely created in Paris around 1770, represents the sentiments of this more liberal French circle. Choiseul was exiled in 1770, partially because of the failure of his anti-Russian campaign. With the ascent of Louis XVI, in 1774, different voices, such as Chantreau's, came to the fore in France.

Chantreau's positive views on Russia are consistent with his liberal and progressive political stance at home, which ultimately led to his support for the French Revolution in 1789; five years later, on the title page of the *Voyage philosophique*, he is listed as "le citoyen Chantreau" ("citizen Chantreau"). The long excerpt below is representative of Chantreau's narrative and shows how ecclesiastic ritual was woven into the ceremonies of the imperial court of Saint Petersburg. His description of Catherine's demeanor, in particular her characteristic combination of dignity and sweetness, demonstrates what many of her portraits attempted to capture (see cat. nos. 1 and 4). Chantreau provides a memorable account of the excessive use of diamonds by courtiers of both sexes in Saint Petersburg, which brings to mind the similarly lavish use of precious stones on such liturgical vessels as the Buch chalice (cat. no. 9). In the context of ecclesiastic ceremony, following centuries-old tradition, gems represented a materialized eternal heavenly light. In the court of Saint Petersburg, where liturgy played an essential role, religious symbolism spilled beyond the premises of the palace cathedral and influenced courtiers to cover themselves with diamonds. Doing so might have been a display of wealth or bad taste, but this custom had a symbolic implication related to the links between the heavenly and earthly courts. The signs of eternal light displayed on the bodies of the courtiers showed that Divine Grace was

The key work in this exhibition is the cameo-studded Buch chalice, which demonstrates the particular manner in which Catherine the Great applied both her knowledge of ancient and medieval glyptic art and her actual collection of carved gems to new works of art that she commissioned.

bestowed on them—in a manner of speaking, they were chosen to be its vessels. This notion that the earthly court of the empire was but an image of the heavenly court of Christ was deeply embedded in Russian culture, originating from Byzantine sources, and was prominently displayed in the complex hierarchy of saints and living dignitaries shown or alluded to in the iconographic program of the Buch chalice.

Furthermore, the *Voyage philosophique* shows how the splendors of the court in Saint Petersburg, in particular the Summer (i.e., the "Hanging") Garden and the Winter Garden, conveyed a prominent sense of the imperial palace as a paradise on earth, a perception that applied in particular to Catherine's reign, as Countess Varvara Golovine, née Princess Galitzine (1766–1819), states in her memoirs.[24] Chantreau points out the sharp contrast between the wintry city and the eternal summer of the imperial palace and eloquently develops the image of nature itself behaving as a well-mannered courtier who pays homage to the empress by hiding his sadness and showing her only his smiling face:

> After having recovered from our fatigues, and gone the rounds our business required, we showed ourselves at court. It is more brilliant than any in the north, but to see it in all its splendour, a Gala day must be chosen, such as the anniversary of the Empress or the Grand Duke. . . . For seeing the Empress, the time when she goes to, or returns from the chapel, is commonly chosen, which is always a little before noon. She is preceded by the Great Officers of the household, twelve Chamberlains, twelve Gentlemen of the Chamber, four Aides-de-camp-Generals, the Officers of her Guards, at the head of whom, is always he, that commands the *Chevalier-Guards*; it was then Prince Potemkin. Then come the Ladies; first the Young Ladies of the Court, the Ladies or Maids of Honor, the Grand Governess, and then

the Grand Duke and Duchess. The ladies walk two by two, and form a long file, pleasant to behold. Her Majesty, as she passes, salutes every person on her way, both on the right and left hand. . . . Her air is majestic, although she is rather below than above middle size; and she has in the features of her countenance, especially when she speaks, much dignity and sweetness. . . .

The riches and splendour of the Russian Court exceed all description. Divers[e] articles of Asiatic magnificence, united to the ingenious inventions of European luxury, are there displayed. An immense retinue of Courtiers always precede and follow the Empress, whose rich and brilliant dresses are besides enriched with jewels in profusion, which produces an effect, of which the pomp of other courts can only give a feeble idea. . . . Among the objects of luxury exhibited by the Russian Nobility, none is more apt to strike foreigners, than this quantity of diamonds and jewels just mentioned; and with so much the more justice, that in all the other countries of Europe, diamonds seem almost entirely reserved for the use of the Ladies. In Russia, the gentlemen and ladies seem to vie in loading themselves most; and this expression is not over-strained, for there are many noblemen, who are almost wholly covered with them. Their buttons, their buckles, the hilts of their swords, their epaulets are of diamonds; often their very hats are edged with several rows of Jewels. . . .

The Palace of the Hermitage contains a [sic] numerous collections of pictures, chiefly purchased by her Majesty. The finest are those of Crosat's [sic] Cabinet, which the Empress got from the heirs of Baron de Thiers. Houghton's collection, whose loss all the English amateurs may deplore, have considerably enriched that of the Czarina.

A winter and summer garden contained within the boundaries of this building, is one of these objects of curiosity not to be seen in any other European palace. The summer garden, which is in the true Asiatic taste, occupies all the top of the edifice. The winter garden entirely covered and surrounded with glass windows, is a high and spacious green house, in which are gravel walks. It is ornamented with parterres, flowers, orange trees, shrubs, and stored with an infinite number of birds from different climates, which fly from tree to tree at freedom. All this produces an effect, so much the more agreeable, that it bears a singular contrast to the gloomy season of the year. But are there seasons for Kings? Is not nature, whom they manage as they will, compelled to show them a smiling countenance, while she is every where a prey to the gloomy hoar-frosts of winter. Thus the Courtier, whom

secret sufferings consign to sorrow, affects before his prince the smile of gaiety and contentment.

A rare late-eighteenth–century example of Catherine the Great and her writings appearing in the political discourse of the United States is found on the pages of the *Columbian Centinel* from February 22, 1792 (cat. no. 36), only the second year of publication for that Federalist semi-weekly paper, which ran from 1790 to 1840. The following is the English text of the letter:

LETTER

From her Majesty the EMPRESS of all the RUSSIANS, to the Marshal de BROLIO

St. Petersburg, Oct. 29, 1791

Marshal de Brolio,

I ADDRESS myself to you, to make known to the French nobility, banished and persecuted, but still unshaken in their fidelity and attachments to their Sovereign—how sensibly I have felt the sentiments, which they professed to me in their letter of 20th of September. The most illustrious of your kings glories in calling themselves the first gentlemen in their kingdom.

Henry IV was particularly desirous of bearing this title. It was not an empty compliment that he paid to your ancestors; but he thus taught them, that without nobility there could be no monarchy, and that their interest to defend and maintain it was inseparable from his. They understood the lesson, and lavished their blood and their efforts to reestablish the rights of their masters and their own. Do you, their worthy descendants, to whom the unhappy circumstances of your country open the same career, continue to tread in their steps, and let the spirit which animated them, and which you appear to inherit, be displayed in your actions.

ELIZABETH succeeded Henry IV, who triumphed over the league at the head of your ancestors.[25] The example of the Queen is worthy of being imitated by posterity; and I shall deserve to be compared to her by my perseverance in my sentiments for the descendants of the same hero, to whom I have as yet only shewn my wishes and my good intentions. In espousing the common cause of kings in that of your

monarch, I do no more that the duty of the rank which I hold on earth: I listen only to the pure dictates of a sincere and disinterested friendship for your princes, the king's brothers, and the desire of affording a constant support to every faithful servant of your sovereign.

Such are the dispositions of which I have charged Count Romanzow to assure those princes.[26] As no cause was ever more grand, more just, more noble, more deserving to excite the zeal and the courage of all who have devoted themselves to defend it and fight for it. I cannot but augur success the most fortunate and analogous to the wishes I have formed; and I pray GOD to have you, and all the French Nobility, who participate your sentiments, and adhere to your principles, in your most holy keeping.

Signed

"CATHERINE"

Catherine's letter was a statement of support for the royal family of France and for the antirevolutionary army formed by aristocratic émigrés. "The Army of Princes," as it was referred to, was commanded in 1792 by Victor François, the second duke de Broglie (1718–1804). A marshal of France, the duke distinguished himself in the course of the Seven Years' War (1756–1763) and later briefly served as the minister of war for Louis XVI, when he commanded the army at Versailles during the outbreak of the French Revolution in July 1789. He left France the same year. In 1796, the duke received an appointment in Russia, where, on October 26, 1797, Catherine's successor Emperor Paul I (reign 1796–1801) elevated him to the rank of general field marshal of the Russian army.

Catherine's letter was issued in the midst of the Second Russo-Turkish War (1787–1792) and in the wake of the Declaration of Pillnitz, from August 27, 1791, in which Austria and Prussia pledged their support for King Louis XVI. Great Britain did the same in 1792, and Russia, Spain, and Portugal followed suit after January 21, 1793, when the Revolutionary government beheaded the dethroned king of France. The developments in France and the fate of its king, who had been a major supporter of the colonies during the American Revolution, were of major importance to the public in the United States. The blow that Revolutionary France rendered to the sanctity of private property through seizing the émigrés' assets on November 11, 1791, also resonated with the American audience. The link between private property and freedom is an essential idea the

American founding fathers shared. James Otis Jr. (1725–1783) famously stated in 1761 that "a man's house is his castle," and in 1787 John Adams (1735–1826) observed that "The moment the idea is admitted into society that property is not as sacred as the laws of God, and that there is not a force of law and public justice to protect it, anarchy and tyranny commence." Among the many writings dealing with this question is James Madison's (1751–1836) *Essay on Property*, composed in March of 1792, fewer than six months after the Revolutionary assault on the property of the French émigrés.[27]

This exhibition is arranged in three sections, each dedicated to a realm of life in which works of art and scholarly pursuits enable certain forms of transcendence (i.e., the experience of overcoming the limitations of physical existence).

The following three entries from the diary of Catherine the Great's cabinet secretary Alexander Vasil'evich Khrapovitskii (1749–1801) show the circumstances in which the empress wrote her letter. She was very disappointed in the actions of the king of France, who, in her estimation, was not firm enough with the revolutionaries. Notably, she was pleased with her letter and deemed it worthy of publication:

Tsarskoe Selo

September 14,
I made a copy of Her Majesty's letter to Prince Nassau.[28] The Emperor has already had a meeting with the King of Prussia and intends to establish a treaty with him. The Court of England insisted that their minister attended the meeting. Offensive and a sign of distrust. . . . The same gentlemen met also with the Count of Artois and gave him their promise to help in the matters of France, which was witnessed by Prince Nassau. Assurance of help from her Majesty; it [the foreign

help] has to be accepted by the princes, the king and the royal family who should be consistent in their actions and not falter. I was asked: how is the letter? Strong? It has to put the soul in his [Louis XVI's] belly.

September 15

I made a copy of the letter to the Count of Artois: the same confirmation of consensus and unanimity, heroism is needed, the example of Henry IV, who was in a more difficult predic- ament, *mais it parvint à dompter la France* ["but he managed to subdue France"], as Voltaire said: *par droit de conquète et par droit de naissance* ["by the right of conquest and by the right of birth"]. Her Majesty deigned to convey to me: *que cette lettre mérite d'être imprimée* ["this letter merits publication"].

September 16

I copied the final version of the letter to the Duke de Brog- lie, which was signed [by the empress]. It does not contain anything of particular importance, because before receiv- ing the invitation for Russian employment, he accepted a Swedish appointment. Copies of the letters to [the Count of] Artois and Broglie are sent to Grimm, and all packages were sealed by me. . . . Messengers from Potemkin: his fever came back.

SECTION TWO:
LITURGY, ECCLESIASTIC ART, AND THE CAMEO COLLECTION
(Cat. nos. 7–16, 28, 29, 32, 47, 48, and 50)

The icons and liturgical vessels displayed in this gallery represent two distinct artistic idioms in eighteenth- and nineteenth-century Russian visual culture: one medieval and Byzantine in spirit (cat. nos. 7, 8, 11, 14, and 16); the other Western and neoclassical in taste (cat. nos. 9, 10, 12, 13, 15, and 32). The coexistence of the two visual idioms paralleled the simultaneous use of two alphabets—Church Slavonic and the new Latinized Cyrillic. In these pairs of opposites, one constantly renewed and reintroduced the symbolic implications of the other, but the neoclassical visual idiom had a much stronger power of denotation because it was always perceived against visual statements closely related to the medieval tradition.

The key work in this exhibition is the cameo-studded Buch chalice, which demonstrates the particular manner in which Catherine the Great applied both her knowledge of ancient and medieval glyptic art and her actual collection of carved gems to new works of art that she commissioned. Carved gems and depictions of them link the majority

of the objects in the exhibition. The display includes a deliberate juxtaposition of the Buch chalice with its reused engraved stones, forming an iconographic program of their own, and a recreation of a drawer from a *dactyliotheca*—a collector's cameo cabinet—the usual way in which scholarly minded eighteenth-century collectors organized and displayed their engraved gems. They placed these precious objects in special cabinets with drawers, grouping the stones by size, subject, and material; authors of cameo collection catalogues published during the first half of the eighteenth century followed the same principle. The carved stones in our *dactyliotheca* drawer are on loan from the collection of the Michael C. Carlos Museum at Emory University.

Catherine not only shared the Enlightenment's sentiment that carved gems were essential material vestiges from the past, but she also was fully aware of the cultural meanings associated with the practice of collecting cameos. The empress appreciated the aesthetic appeal of engraved stones and was fully cognizant that they constitute a source of knowledge about art and history. Two quotations from letters Catherine wrote to Baron Grimm illustrate her fascination with engraved gems—something she called, in jest, "stone disease" and "stone madness":

> Dieu sait quell plaisir il y a àmanier tout cela tous les jours: . . . il s'y cache des connaissances sans fin.

> Only God knows what a joy it is to handle all of them every day . . . they hold within an inexhaustible source of knowledge.[29]

Ten years later the empress wrote:

> Vous savez peut-être que dans mon immense cabinet de pierre gravées il n'y a que très peu de pâtes, et que tous les cabinets de l'Europe ne sont que des infantillages vis-à-vis du nôtre. . . . Que tout cela est rangé systématiquement en commençant par les Egyptiens et passant par toutes les mythologies, histoires fabuleuses et non fabuleuses jusqu'aujourd'hui!

> Perhaps you know that in my immense cabinet of engraved stones there are very few pastes and that all other cabinets of Europe are only child's play by comparison to ours. . . . Here everything is arranged systematically starting with the Egyp- tians and going through all the mythologies, histories both mythical and non-mythical until today.[30]

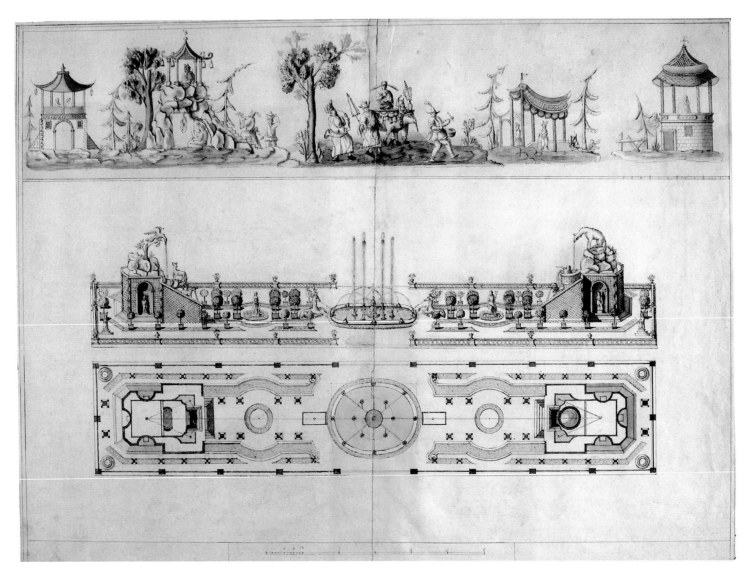

FIG. 2. Alexandre (South German/Austrian), drawing of a miniature garden centerpiece, 18th century. Dumbarton Oaks, Harvard University.

This description of the organization of Catherine's cameo cabinet demonstrates clearly that she kept up with scholarly studies of engraved gems. Here the empress describes an arrangement that is different from our makeshift *dactyliotheca* and from the common practice in the first half of the eighteenth century. Instead, by the end of Catherine's life, her collection was systematized according to the principles first advanced by the German art historian and archaeologist Johann Joachim Winckelmann (1717–1768) in his *Description des Pierres gravés du feu Baron de Stosch* (Florence, 1760). The owner of this renowned cabinet of engraved gems was Baron Philipp von Stosch (1691–1757), a Prussian antiquarian who split his time between Rome and Florence. When listing the carved stones in Stosch's collection, Winckelmann abandoned the standard method: namely, the aforementioned grouping of stones by size, subject, and/or material. In contrast, the catalogue of Baron Stosch's cameos followed the chronology of Western civilization, starting with pagan mythology (Egyptian, Greek, and Roman), then mythical history, and, finally, actual historic figures.[31] In this manner, a collection of objects of art became a narrative of times past. As with the "medallic history" discussed above, we observe the parallel between a cabinet with precious small objects and a volume containing a narrative of history (cat. nos. 25 and 39).

Catherine's passion for the au courant scholarly ways of dealing with cameos draws attention to the particularly antiquated custom she followed by placing various older engraved stones on the newly made Buch chalice. Apparently, the empress conceived this commission as a symbolic gesture that deliberately revived the centuries-old tradition of placing pagan carved stones on sacred Christian liturgical and devotional objects. This mixing of periods, religions, subjects, materials, and cultural traditions in the adornment of the Buch chalice allowed Catherine to make a complex statement. The empress's way of creating the iconographic program for the chalice is particularly intriguing when one considers an example from just five years earlier of her dismantling an older precious object encrusted with engraved stones so that she could place these gems in her scholarly *dactyliotheca*. The precious gold vessel in question was known as the Cup of Peter the Great, and until 1785 it was on display in the Kunstkamera, the museum Peter established. Both the origin of the gold cup and its demise engage some of the main themes in the current exhibition, particularly different ways of conceptualizing the collecting and displaying of art and the femininity embodied in prized gold receptacles.

On July 12, 1716, in Copenhagen, during the second trip abroad of Peter the Great, his wife Catherine Alekseevna, the future Empress Catherine I of Russia (reign 1725–1727), received as a present a gold vessel with cameos from Queen Louise of Mecklenburg-Güstrow (1667–1721), the consort of the king of Denmark and Norway, Frederick IV (reign 1699–1730). The fact that the vessel was presented as a gift from a queen to an empress was remembered even though in Russia the object was known primarily as Peter's cup. A brief article published in 1986 lists the eighteenth-century sources mentioning this cup, as collected by Oleg Neverov, art historian and curator at the State Hermitage.[32] From the memoirs of the Baron de Corberon, we learn that the cup was on display at the Academy of Sciences in February of 1776, when the French diplomat saw it and wrote about it to his brother:

> Saturday, February 10, 1776, *To my brother*:
>
> Aupres de ses rarités, se voit un superb calice donné à la femme de Pierre I par la reine de Danemark; ce calice est d'or fin incrusté de belles antiques, pierres gravées, camées présieux, etc.
>
> Among these rarities, one sees a superb cup given to the wife of Peter I by the Queen of Denmark; this cup is made of fine

gold inlaid with beautiful antiques, engraved stones, precious cameos, etc.[33]

In order to acquire this cup, Catherine the Great solicited the help of Princess Catherine Dashkova (1743–1810), who was with the future empress throughout the fateful events of the palace coup d'état in 1762. Being younger and lesser in rank than the empress, she was sometimes called Catherine the Little. Princess Dashkova was a highly educated woman who corresponded with such notables of the Enlightenment era as Diderot, Voltaire, Baron Grimm, and Benjamin Franklin (1705–1790); the latter invited the princess to become the first woman to receive membership in the American Philosophical Society. After 1783, when Catherine the Great appointed Dashkova to the post of president of the Imperial Academy of Arts and Sciences, the princess returned the gesture in her new capacity by making Franklin the first American member of this institution.

The letters exchanged between the two Catherines demonstrate that, in 1785, they negotiated a special arrangement, a kind of barter. The empress deposited a substantial collection of mineral specimens at the Academy of Sciences in exchange for the Danish cup with cameos, which she then proceeded to dismantle, adding the engraved stones to her *dactyliotheca*. As a result, some of the sixteenth- and seventeenth-century carved gems that once adorned the gold vessel are now in the collection of the State Hermitage.[34] The empress wrote to Princess Dashkova: "As to the vase and its antiques, I will receive them only from your hands, and in exchange for the cases of natural history, which Strekalof has only to withdraw from the bank, which may be done the beginning of January."[35]

The history of Peter the Great's precious cup includes four eminent eighteenth-century women, thus confirming the gender-related meanings of this precious receptacle. Nevertheless, it was dismantled. Was it broken up into pieces because the symbolism of the feminine precious vessel had exhausted its power or was deemed undesirable? Catherine's own art patronage bears abundant testimony to the contrary. Harvesting the carved stones from the cup must have been acceptable to her because she deemed the Renaissance-era cameos more valuable than the cup itself and its history.[36] The empress acted as a passionate collector living up to the demands of the current scholarly standards of organizing carved-stone cabinets. When circumstances compelled her to engage the feminine symbol of the gold vessel and to reuse engraved stones in the old-fashioned way for her own highly symbolic purposes, she did so

Catherine not only shared the Enlightenment's sentiment that carved gems were essential material vestiges from the past, but she also was fully aware of the cultural meanings associated with the practice of collecting cameos.

in the most deliberate and thoughtful manner. Catherine's dismantling of the Danish gold cup with "antiques," as engraved stones of any age were called at the time, was in essence a way of transforming the cup and its precious adornments into another form of receptacle: namely, a cameo cabinet, a container of scholarly knowledge about history, glyptic art, and ancient mythology. In their characteristic self-confident way, Catherine the Great and Catherine the Little joined forces to break apart a vessel but not obliterate it; instead, they created another one of a much higher degree of significance. Their actions allowed small damage for the purpose of gaining a greater good—to dismantle this cup meant to merge its antiques with what was, in essence, an encyclopedia of antiquity. This set of events calls to mind the story of Saints Rufina and Justa, the two pious virgin potters of Seville whose likenesses appear on a cameo that graces the Buch chalice. The righteous potters allowed the smashing of their ceramic pots and bowls, an allegory for their martyrdom at the hands of the pagan Romans and an act that shows the humble potters as precious receptacles of Christian virtue.

SECTION THREE: DINING AND TRANSCENDENCE
(Cat. nos. 5, 17–23, 30, 31, 33, 34, 44, 49, 51, and 65)

This section also includes examples of the two distinct artistic idioms in Russian art: the medieval (cat. nos. 20 and 21) and the neoclassical (cat. nos. 17A–B, 18A–B, 22, 23, and 34). Two of the plates on display here (cat. nos. 30 and 31) belong to the Green Frog Service, which in its entirety consists of 944 pieces. The service features a decoration comprising 1,222 views, all of which depict real English buildings, gardens, and natural landscapes.[37] This set of dishes resembles a substantial collection of drawings, and their use for dining evokes the act of contemplating works of art in a collector's study stocked with albums of *dessins* and *gravures*. The Cameo Service (cat. no. 19) also encourages diners to reflect on the practice of collecting art, in this case engraved stones. It

also directs dinner guests to recall the precious holy vessels used in the rituals of the Christian church, which could be embellished with actual ancient cameos. The fact that the faux engraved gems on the Cameo Service are made of porcelain paste links the ancient and the modern worlds. Both the Green Frog and the Cameo dinner sets celebrate the new industrial technologies that enabled the production of refined vessels in such large numbers.

This display intends to illuminate the ways in which dining can provide a transcendent experience. The act of nourishing the body is primordial and engages the low senses of taste and smell. One millennia-old strategy to elevate that act has been to add to the experience a visual component to contribute aesthetic appeal and intellectual substance—sight being the most cerebral of senses. Ever since the time when ancient silver and gold plate was embellished with the stories of gods, goddesses, mythical beasts, and heroes, dining vessels have been conceived to please visually and to challenge diners' knowledge to stimulate their wit, thus enabling an exciting and uplifting conversation.

In pursuing these goals, Catherine used a set of specific devices that reflected her commitment to the advancement of learning and involved promoting the knowledge of history, familiarity with ancient culture, liberal political ideas, and the importance of art for improving and enriching life. In accordance with the spirit of the time, the dining vessels that the empress commissioned emerge as the source of an Enlightenment-era form of *joie de vivre*, an experience accessible to an individual empowered by acquiring knowledge and exercising reason.[38] The combination of the high-minded with the primary pleasing sensations of taste and smell delivered an overall sense of the fullness of life by reconciling the mind, the spirit, and the flesh. While the decoration on the vessels invited contemplation of architecture, gardens, the merits of constitutional monarchy, and the virtues of ancient civilization, the dishes themselves served up vinegary savory stews, aromatic sweet fruit, or the frosty smoothness of ice cream; the preciousness and transporting powers of the latter are conveyed by the jewel-like detail and small size of the ice cream cup (cat. no. 19). Sadly, the ready availability of ice cream in our day and age prevents us from fully appreciating this effect.

As rendered on the dishes of the Green Frog Service, the multiple landscapes showing views of both the countryside and gardens allude

to the custom of dining in the midst of nature. Epitomizing the good life, this practice perpetuated the esteemed tradition of the *fête champêtre* (rural festival, or country feast), which during the eighteenth century grew into the garden party. The common way of alluding to this experience indoors was to use an elaborate centerpiece, *milieu de table*, in the form of a garden.[39] These arrangements included miniature sculptures, garden ornaments, potted trees, and fountains with jets of glass placed on a mirror that would convey the notion of a watery surface. The silver teapot *à jet d'eau* (cat. no. 33) illustrates another way of rendering a fountain for the table. Dishes and ornaments created a visual experience in which the dining or tea table was akin to a bird's-eye view of the countryside or a garden and constituted a vista of empowerment and privilege. In this manner, the illusion of physical elevation paralleled the enjoyment of nourishment and the intellectual excitement of a soaring conversation.[40] Prints and drawings served as visual references for the layout of a park or a dining table, as did volumes on gardens and fine dining, meaning the view from above also conveyed uplifting associations directly linked to the raising of the mind by means of books and works of art.

With regard to Catherine's projects, a compelling example of the connection between the architecture of garden pavilions and table ornaments is a miniature-scale porcelain rendition of her Large Caprice, also known as the Large Folly.[41] Built between 1770 and 1774 after the design of Vasilii Ivanovich Neelov (1722–1782), the Large Caprice is a hexagonal Chinese-style gazebo on top of an artificial hill located at one of the entrances into the park of Tsarskoe selo; the gazebo rises up as a look-out point with a clear view of both park and countryside. Allegedly, the garden pavilion's name originated in Catherine remarking "Let it be built; it is my caprice," when she learned about its exorbitant costs. The Large Caprice porcelain table ornament was used in the Summer Palace, near the gazebo, enhancing the experience both at the dining table and in the surrounding garden and creating a form of jovial and playful bewilderment as to whether the palace was situated in the park or the other way around.[42] Such an experience defies the confines of physical existence while emphasizing the notion of inhabiting a space of privilege. The early precedents for this arrangement come from the tradition of Italian Renaissance villas containing depictions of themselves in their interior decoration. As David R. Coffin demonstrates, this practice started with the late-fifteenth-century Villa Belvedere above the Vatican Palace.[43]

An eighteenth-century drawing (fig. 2) in the Dumbarton Oaks Research Library and Collection attests to the ubiquity of miniature garden centerpieces. Scholars have attributed this drawing to a south German or an Austrian artist known as Alexandre. The drawing in question features three registers: a frieze of *chinoiserie* scenes at the top and two designs for a *milieu de table* (a perspective view and a ground plan). The centerpiece is in the form of a parterre, with elements unambiguously alluding to the gardens at the Palace of Versailles.[44] In the center of this composition, on the garden terrace, is a rendition of the Fountain of Latona/Leto. The fountain's sculpture features the figure of Latona, the mother of Artemis and Apollo, rising in the middle of the circular pool. She is surrounded by frogs and by humans transforming into frogs, the punishment dealt to the hostile peasants of Lycia who prevented the thirsty goddess from drinking the water of a spring by stirring the mud from its bottom.[45]

At each end of the elongated composition in Alexandre's design a water feature replicates one of the thirty-nine fountains in the Labyrinth of Versailles, all of which were based on fables by Jean de la Fontaine (1621–1695): on the right is "The Fox and the Goat" (III 5), and on the left, "The Raven and Fox" (I 2). The rendition of both fountains follows the etchings of Sebastien le Clerc (1637–1714) included in Charles Perrault's (1628–1703) well-known description of the labyrinth, first published in 1677.[46] The *cabinets de verdure* ("verdant cabinets") of the labyrinth, to use Perrault's expression, provided the stages for a theater of nature in which the characters of animals enhanced the understanding of humanity. These plays in the lush greenery often featured eating and drinking, primordial actions that humans and animals share, which in their turn served as the backdrop for garden parties. The characters of fables embodied human flaws, but including the animal kingdom in the ritual of fine dining also provided a reassurance about humanity's ability to reach beyond biological needs. The Green Frog crest of Catherine's Wedgwood service generates associations with fables, which were part of a long and honored tradition.[47] Alexandre's design for a milieu de table represents several of the themes connecting the objects displayed here: the sophisticated custom of dining in nature, with all its prominent Versailles overtones; frogs as attributes of gardens and their water features; and the table-top fountain ornaments that elevate and transport the experience of dining.

WOMEN, VESSELS, AND CONTEMPORARY FEMINIST ARTISTS

In her own handwork and in her commissions for new works of art, Catherine the Great endeavored to weave together her intellectual pursuits and political goals with themes of femininity and domesticity. Due to her gender, Catherine's exalted position was much more vulnerable than is commonly acknowledged, and she perpetually had to justify and reaffirm it. This constant negotiation involved other world rulers as well as the court of Saint Petersburg, the empress's principal advisors, and even her intimate partners, lest any of them should feel emasculated. Through her art patronage, Catherine added layers of meaning to the customary association of femininity with vessels. The empress deliberately attempted to overcome the notion of passivity inherent in the symbol of a receptacle, or empty shell waiting to be filled with substance. Catherine transcended this presumption by creating circumstances in which vessels could generate sets of meanings—an exuberance of meaning—in spheres deemed relevant to the patroness herself. No matter how assertive she was in her attempts to define these strata of meanings, Catherine displayed an unfailing respect for the value system that had produced the symbol of the feminine receptacle. Rather than undermining or subverting it, the empress elaborated and expanded on this symbol.

While this exhibition provides a look into eighteenth-century visual culture, it is important to acknowledge that the set of tools available to Catherine are still employed by contemporary feminist artists, whose creations often conceptualize textiles, ceramics, and dining vessels. Notably, Judy Chicago does so in her iconic work, *The Dinner Party* (1979; Brooklyn Museum).[48] This installation's large triangular table features thirty-nine full place settings for an equal number of historically eminent women, each represented by her own textile runner, plate, goblet, and silverware. The artist acknowledges Catherine the Great's significance for the advancement of women, and although the empress did not receive a place at the table, her name appears on *The Heritage Floor*, upon which the dinner table stands. The handmade triangular porcelain tiles of the floor contain 999 names of mythical, historical, and notable women. Granted, the list is rather inclusive, but all of these women in their own ways enabled the outstanding accomplishments of the thirty-nine heroines represented at the table. Listed on the floor along with Catherine the Great are two other women closely related to her: Princess Catherine Dashkova, the president of the two Russian academies, and Catherine Pavlovna (1788–1819), grand duchess of Russia and queen consort of

Württemberg (tenure 1816–1819), who was the empress's granddaughter and the fourth daughter of Emperor Paul I of Russia.[49] Catherine Pavlovna was known all around Europe for her support of charitable institutions and as the patron of Russian intellectuals, notably the poet, writer, and historian Nikolai Mikhailovich Karamzin (1766–1826), the author of the twelve-volume *History of the Russian State* (1816–26).

While this exhibition provides a look into eighteenth-century visual culture, it is important to acknowledge that the set of tools available to Catherine are still employed by contemporary feminist artists, whose creations often conceptualize textiles, ceramics, and dining vessels.

The Dinner Party is, in essence, a grand narrative of the history of womankind, rendered in a medium strongly associated with the traditional ways in which culture constructs femininity in the realms of domesticity and nourishment. Catherine's inclusion acquires additional significance in light of this exhibition, which demonstrates how the empress-philosopher strove to elevate dining into an intellectual occurrence and define its cultural meanings against wide horizons. As conceived by Catherine, the dining experience involving the Green Frog Service on the premises of Chesme Palace provided a version of the grand narrative of history asserting her country's central place in Western civilization.

Several of the *objets d'art* featured in this exhibition, most notably the Orlov vase (cat. no. 49) and the Buch chalice (cat. no. 9), manifest the theme of a woman as a vessel maker who creates a receptacle that embodies her. In these commissions, Catherine the Great deliberately

alluded to prominent female figures associated with symbolically charged vessels: the Mother of God, herself the receptacle of the Holy Ghost, was celebrated as the ark of the Covenant, a precious vase, and a gold incense burner; Danae, who, together with her son, Perseus, was sealed in an ark and thrown in the sea but later saved; and Saints Rufina and Justa, the potters whose modest earthenware dishes were smashed at the time of their martyrdom in the late third century CE.[50]

Cindy Sherman elaborated upon the theme of the female vessel-maker in a set of works created in 1990 and consisting of porcelain services for dining (thirty pieces) and for tea (twenty-one pieces). Rendered in rococo and neoclassical style, these dishes were manufactured in limited editions of seventy-five and came in four colors characteristic of the 1700s—rose, apple green, royal blue, and yellow. Each vessel displays a photographic self-portrait of Sherman in the guise of Madame de Pompadour, Louis XV's *maîtresse-en-titre*, famous for her patronage of the Sèvres porcelain manufactory.[51] When creating her porcelain services, Sherman acted in several capacities at once: as an artist, a patroness, and a commodities entrepreneur, which is a mixing of roles worthy of a highly emancipated woman. At the same time the fact that the artist's likeness appears on the actual vessels creates a very rudimentary equation between a woman and a dish for eating or drinking, whether a soup tureen, a dinner plate, a teapot, or a cup. Thus, these porcelain sets associated with a life of elegance and sophistication convey a jarring statement: the character the artist impersonates offers herself for consumption, powdered wig, silk brocade attire, pensive attitude, and all. Sherman serves a substantial portion of tension between refinement and crudeness, subverting the symbol of the feminine vessel. In one regard, her work makes a joke about the *ancien régime* ways of defining femininity pursued by both Madame de Pompadour and Catherine the Great. The eighteenth-century, French-style dishes embody the visual culture that, since the Gilded Age in the United States, has been the standard for good taste and upper-class sophistication. It is this notion of patrician *comme il faut* that the artist parodies. On the other hand, one is reminded of the links between those who make and those who commission art and invited to contemplate the cultural significance of art patronage, for which Madame de Pompadour acquired great fame. At a time when artistic genius was a monopoly of the masculine gender, the eminent eighteenth-century patronesses of the arts—Pompadour and Catherine the Great first among them—in their own deliberate and thoughtful ways were able to enrich, order, and edit visual culture.

Catherine the Great and Catherine the Little (Princess Dashkova) destroyed a cup with antiques to make it a part of an encyclopedia of antiquity—scholarly pursuits prevailed over traditional values and corresponding symbolic meanings. Of course, theirs was a golden goblet with precious cameos that otherwise could have lasted for ages, but often vessels are literally breakable and their fragility makes possible allegorical statements. Since the medieval era, the unbroken vessel has symbolized virginity and the broken one a fallen woman.[52] The breaking of the pots made by Saints Rufina and Justa actually affirms their preserved virginity, like the splitting of the purple curtain woven by the Holy Virgin for the Holy of Holies in the Great Temple of Jerusalem.[53]

In recent years, the artist Barbara Bloom has helped Western audiences discover and appreciate the Japanese art of *kitsugi*, which uses lacquer resin infused with gold to repair shattered vessels, elevating them into a higher realm of existence.[54] As the artist herself says, "When the Japanese mend broken objects, they aggrandize the damage by filling the cracks with gold. They believe that when something's suffered damage and has history it becomes more beautiful."[55] Old ceramic vessels gain in visual appeal, intellectual content, and emotional charge when adorned with repairs that leave behind cryptograms rendered in gold. Some of the writing is clearly about the fragility of life and the seismic impact of seemingly minor traumas; yet, the physical break is not the end of the road, but a point of departure. In general, audiences are conditioned to think that what is written in gold is worth the effort to decipher. Obvious as the listed meanings might seem, the writings in gold on these vessels ultimately retain an impenetrability. One is compelled to contemplate them not so much because of the certitude of available interpretations, but for the satisfaction derived from losing oneself in an ongoing effort to attempt discovery.

The organizers of this exhibition hope that it will enable viewers to pursue a similar captivating experience.

END NOTES

1. In our display, Pierre-Étienne Falconet's canvas (cat. no. 4) alludes to this gender-play aspect of her official portraiture. See Proskurina, 13–48.

2. See de Beauvoir.

3. For more on Post's collecting philosophy, see Scott Ruby's essay in this volume.

4. Solov'ev, 27:107.

5. Corberon, 206, cited in Sebag Montefiore, 215.

6. Vincentelli.

7. See also *Mademoiselle de Clermont as a Sultana* (1733; the Wallace Collection, London, 456); I thank Dr. Jennifer Palmer from the department of history at the University of Georgia for turning my attention to these two portraits of Mademoiselle de Clermont by Jean-Marc Nattier.

8. Cf. de Beauvoir and Veltman. On the current discussion in the realm of theology see *Culture and Transcendence: A Typology of Transcendence.*

9. Clark 2007; Bushkovich; Dixon 2007; and Kerber.

10. Cunnally, 27.

11. Burke, 156–65 and 207–8.

12. This is a quote from the epitaph that the empress composed for herself, Catherine the Great 1935, 326; see also "Important Years and Events" in this volume. On the history of the imperial library of the Hermitage see Pavlova.

13. English translation Philip Steward—http://hdl.handle.net/2027/spo.did2222.0000.004.

14. See the entry for cat. no. 32 for a reference to the simultaneous use of old and new alphabets.

15. Musée du Louvre; and Freedberg.

16. *Le Logge di Raffaello*, twenty-eight plates by G. Ottaviani and G. Volpato (1722–1726) Height 43.7 inches, Width 19.3 inches (111 x 49 centimeters). Another edition appeared in Rome during 1770–77.

17. *Pis'ma Imperatritsy Ekateriny II k Grimmu*, 85–86, no. 53.

18. Catherine the Great 1935, 8.

19. The essay comments on the cruelties perpetrated by all parties throughout the theater of war: the suppression of Eastern Orthodox Christians by the Catholic Church, the resistance of the Poles against Catherine's intervention, and the cruel treatment of peaceful populations by the Russians.

20. *Gentleman's Magazine*, December 1770, 617–20.

21. See "The Green Frog Service" essay in this volume.

22. Tarle, 14–17; and Walpole 1963, 169–71.

23. D'Auteroche; and Catherine the Great 1772.

24. Countess Golovine, 9–10.

25. Catherine the Great refers to the events that evolved after the death of Henry III (reign 1574–1589) of France on August 2, 1589, when the Catholic forces attempted to prevent Henry of Navarre, the future Henry IV of France, from assuming the throne. Henry IV prevailed in the struggle for the throne to a great degree because of the help that he received from Elizabeth I (reign 1558–1603) of England, who supplied both money and troops.

26. "Count Romanzow" actually stands here for Count Nikolai Petrovich Rumiantsev (1754–1826), the son of the hero of the First Russo-Turkish War, Count Peter Aleksandrovich Rumiantsev (1725–1796). When Catherine wrote this letter, Petrovich served as the Russian ambassador to Regensburg and the German Union, a position he held between 1781 and 1793. The count was an art collector as well as the patron and doyen of a circle of learned antiquarians. His neoclassical palace in Saint Petersburg at No. 44 on the English Embankment of Neva became the famous Rumiantsev Museum with Nicholas I's (1825–1855) decree of April 10, 1828.

27. On James Otis Jr., see Cuddihy 1979 and 2009, 382; on John Adams, see "Defense of the Constitutions of Government of the United States" in *The Works of John Adams*, vol. 1, chapter 16, document 15 [http://press-pubs.uchicago.edu/founders/documents/v1ch16s15.html]; on James Madison, see "Property" in *The Papers of James Madison*, vol. 1, chapter 16, document 23 [http://press-pubs.uchicago.edu/founders/documents/v1ch16s23.html].

28. Barsukov, 219. The text is in Russian and in French; the original French is cited in italics. Apart from Henry IV, king of France (reign 1589–1610) and the duke de Broglie, the historical figures Khrapovitskii mentions are: "Prince Nassau," Henry Louis Charles Albert, Prince of Nassau-Saarbrücken (1768–1797); "The Emperor," Holy Roman Emperor Leopold II (reign 1790–1792); "King of Prussia," Frederick Wilhelm II (reign 1786–1797); "Count of Artois," the future King Charles X of France (1757–1836, reign 1824–1830), a grandson of King Louis XV and Marie Leszczyńska, and the son of Louis, dauphin of France (1729–1765).

29. *Pis'ma Imperatritsy Ekateriny II k Grimmu*, 329 (April 8, 1785), cited in *Catherine the Great: An Enlightened Empress*, 126.

30. Ibid., no. 243, 637–38 (April 6, 1795).

31. *Le destin d'une collection*, 28–31.

32. Neverov 1986, 53–54.

33. Coffin, 90–117.

34. Neverov was able to establish this fact on the basis of an etching from 1741 showing the cup and some of the cameos in great detail, see Neverov 1986. *Le Labyrinthe de Versailles* (Paris: L'Imprimerie Royale, 1677), 48–49, no. 24; 70–71, no. 35.

35. *Memoirs of the Princess Daschkow*, 91. The collection of mineral specimens for which the cup was exchanged was gathered by the Swedish scientist Erik Gustav Laxmann (1737–1796), who served at the Russian Academy of Sciences. See below in this essay the discussion of the collaboration between Catherine the Great and Princess Catherine Dashkova.

36. See cat. no. 9 and "The Chalice with Antiques" essay in this volume. On the other hand, she obviously did not see the cup as an object through which she could preserve the memory and celebrate the accomplishments of Peter the Great. His second wife was not a favorite of the enlightened empress. At her baptism in the Orthodox faith, the future Catherine II accepted both the name and the patronymic of Peter's second wife—Catherine Alekseevna—but only to please the ruling monarch at the time, Peter's daughter Elizabeth I.

37. *The Green Frog Service* in this volume's bibliography.

38. *Joie de vivre in French Literature and Culture.*

39. See examples of drawings from 1749, 1754, and 1755 documenting the arrangements of dining tables in the form of garden parterres in *Mikhail Lomonosov and the Time of Elizabeth I*, 189, no. 193.

40. Coutts and Day as well as Cassidy-Geiger.

41. Shvidkovsky 1996, 174–80, fig. 208.

42. Although I cannot, as yet, with certainty document that the Large Caprice porcelain replica was Catherine's brainchild, nor can I narrow its dating further than to sometime in the late eighteenth or early nineteenth century, it has been in use in the Summer Palace at Tsarskoe selo.

43. Coffin, 90–117.

44. Cf. Conan; I thank Dr. Michel Conan, the former director of the landscape studies program at Dumbarton Oaks, for directing my attention to this drawing and for his insight into its purpose. Furthermore, in a discussion of gardens, dining, and frogs, Conan referred me to *Rapin of Gardens*, 83–84.

45. Rosasco; Walton, 62; Pérouse de Montclos, 378–79; Whitman, 286–99, figs. 3–10.

46. *Le Labyrinthe de Versailles*, 48–49, no. 24; 70–71, no. 35.

47. In fact, three of la Fontaine's fables feature frogs: (I 3) "The Frog and the Ox," (III 4) "The Frogs Who Desired a King," and (IV 2) "The Frog and the Rat."

48. Chicago.

49. See elsewhere in this essay the discussion of the collaboration between Catherine the Great and Dashkova.

50. See "'The Fingertips of Sight': Discerning Senses and Catherine's Golden Censer," cat. no. 9, and the essay "The Chalice with Antiques" in this volume.

51. Cooper Hewitt Design Museum, MAD Museum, the Tate Museum, the Schein Joseph Museum of Ceramic Art. See also www.gagosian.com/shop/cindy-sherman—madame-de-pompadour-dinner-service—ab988csher02 last visited June 3, 2013.

52. *Furnishing the Eighteenth Century*, 170.

53. Matthew 27:50–52; cf. Exodus 26:31; Mark 15:38; and Luke 23:45.

54. I want to thank Dr. Isabelle Wallace for introducing me to the art of Barbara Bloom.

55. Hickey, Tallman, and Bloom, 183.

The Allure of Russian Art Inspires a Collector: Marjorie Merriweather Post and Hillwood

SCOTT RUBY

Perhaps Marjorie Merriweather Post's most enduring legacy to the world is her home, Hillwood, set on twenty-five acres in Washington, D.C. This storybook estate is filled with the European and Russian treasures she collected throughout her life. The Russian collection represents the most comprehensive assemblage of imperial Russian decorative and fine art outside of Russia, but Post did not set out to amass this type of material. Singular circumstances developed that set her interest in motion. Post, an heiress to a breakfast cereal empire that later evolved into the corporate giant General Foods, married Joseph E. Davies in 1935, a successful lawyer specializing in international law with a flourishing practice in Washington, D.C. Franklin Delano Roosevelt appointed him U.S. ambassador to the Soviet Union in 1936, only the second man to hold that position, as the United States did not recognize the Soviet Union diplomatically until 1933.[1] This Soviet experience planted the seed for Post's future collecting of Russian art, which remained a lifelong passion. As former Hillwood director Frederick Fisher commented, Marjorie Merriweather Post possessed in abundance the qualities of a great collector: enormous wealth, wide contacts, and a discerning eye.

From 1918 until 1937 (when Post and Davies arrived in Russia), the Soviets made an effort to market confiscated riches for hard currency to help finance the revolution and Russia's expanding industrialization. They used various methods to disperse objects, including "commission shops" where Russian and Western art dealers and members of the diplomatic corps could purchase prized items. By the time Post and Davies explored these shops, the storerooms had been thoroughly combed over by dealers and collectors. An article on post that appeared in *Life* magazine states, "The items were piled on shelves and prices were set largely on the value of the metal and jewels in them." Rare chalices went for "5¢ per gram of silver content."[2] Things were not in any kind of order. She remarks that, in the dusty tarnished heaps, "masses of icons were stacked together . . . paintings . . . books . . . and everything one could think of" and writes, "Wonderful gold tea service, silver . . . thousands of things in the most dreadful disorder."[3] Years later she wrote further about her Russian finds saying, "It was then that my collection began and ever since I have continued the search finding pieces in eleven different countries."[4] Davies was equally immersed in the excitement of collecting.

During their stay he amassed a large number of paintings and icons, which he later donated to his alma mater, the University of Wisconsin.[5]

In Davies, Post found a husband who shared her collecting enthusiasm. He was especially interested in icons and liturgical objects, such as chalices, which he hoped to save from being melted down. Davies was particularly moved by the renewed assault on the church that accompanied the purges of 1937 and asked for official permission to purchase some of these sacred items. In March 1937, he wrote, "The party is putting on a drive to destroy all except

42

the most artistic icons, priests' robes, chalices and the like. It seems a pity that these should be destroyed. I have made a request that we be allowed to purchase some of these sacred relics and I think that the permission will be allowed us. If we can do so we will save for ultimate sacred purposes some, at least, of these beautiful things of the religious life of old Russia."[6] Permission was granted and a collection of some twenty icons was put together for him. He described them as "all of the highest type of that kind of painting. . . . They were selected by the leading technical experts on icons connected with the Soviet government and particularly with the Tretyakov Museum. They were chosen because they represented the best types from various periods."[7] He later wrote, "These icons were selected from museum pieces and had been exhibited in the Kremlin, the Tretyakov, and other galleries in the Soviet Union. I was particularly fortunate in being able to purchase them from the government. I think it can be said conservatively that it is probably the most distinctive and valuable single collection of icons outside of Russia."[8]

The Russian collection represents the most comprehensive assemblage of imperial Russian decorative and fine art outside of Russia, but Post did not set out to amass this type of material.

Following their appointment to the Soviet Union, Post and Davies received a subsequent ambassadorial posting to Belgium in 1938–39, where they put their newly acquired collection on view. A period photograph taken in their Brussels residence shows the chalices exhibited in a towering cabinet and many of the icons hung on the wall above them. Post notes in a scrapbook that nine of the chalices she purchased in Moscow had been slated to be melted down.

In 1955, the couple divorced and the icons they collected were divided between the two of them. Many of the icons remain at Hillwood. An eighteenth-century icon of the Three-Handed Mother of God derives from the life of the eighth-century saint John of Damascus, whose hand was cut off by order of the caliph of Damascus for allegedly writing traitorous letters against the Greek emperor Leo. John prayed for the restoration of his severed hand and, upon waking, found that it had been miraculously reattached. In gratitude, he crafted a silver hand and attached it to the icon of the Mother of God—hence its title, "The Three Handed One" (*Troeruchitsa*). The fame of the icon spread, and in the seventeenth century a version of it was sent to a monastery near Moscow, where it had a great following among the faithful and became a much-beloved image in Russia. The Hilllwood icon was painted in 1743, and its silver-gilt and enamel cover (*oklad*) dates from 1790. Created in the era of Empress Elizabeth I (reign 1741–1761), it demonstrates some changes to the iconographic tradition. The painter rendered the Mother of God and the Christ Child with tear ducts, eyelashes, and flowing draperies to create a more lifelike appearance. The presence of a signature and date on the lower border of the icon panel reflects a new interest in the artist's individuality. An imperial decree enacted in 1710 required iconographers to sign and date their paintings, ending centuries of pious anonymity.

The icon of the Mother of God, "Promise of Those Who Suffer" (cat. no. 12), also appears in the Brussels photograph and was likely purchased in Moscow the year before. It, too, features an elaborate *oklad* (or revetment) ornamented with niello in an arch neoclassical style. Note the swags, urns, and ribbons that create the background ornament of this icon. The purchasing opportunities offered by the commission shops in Moscow helped stoke the fires of Post and Davies's interest in this new collecting area. In addition to the icons, they purchased four vestments made for the coronation of Tsar Nicholas II (reign 1894–1917), fashioned by the firm of Sapozhnikov of gold brocade woven in a pattern of imperial double-headed eagles and stylized leaves. A crown surmounted by a cross within a sunburst dominates the yoke at the back. The firm was inspired by a *sakkos* (bishop's vestment) woven for Patriarch Adrian in 1696. Post and Davies also purchased a magnificent cabinet made in 1873 that Tsar Alexander II and his wife gave to his brother Grand Duke Konstantin and sister-in-law Aleksandra Iosifovna. Ippolit Monigetti, court architect to Alexander II, designed the cabinet. Monigetti had trained at the Stroganov Institute in Moscow. The cabinet features gilt bronze mounts set against ebonized wood and lapis lazuli ornament in the form of decorative plaques. The story of the plaques gives insight into the mentality of the period: when Post and Davies originally saw the cabinet, it included portrait medallions of the emperor and empress and the cabinet's recipients; however, these were removed before delivery, visually eliminating any trace of the object's imperial connection.

Post continued to collect Russian art from Western dealers and at auction until about 1970, shortly before her death. She was by far the most significant collector of Russian art in the United States. Many émigrés managed to bring personal belongings out of Soviet Russia, and most of these collections ended up on the market, as their owners were obliged to "eat their jewels."[9] As a result, the objects Post acquired had often been through several hands.[10] The collection of Hillwood Estate, Museum, & Gardens comes from a variety of sources. Anne Odom, a former curator at Hillwood and expert on Russian art, describes as patently false the notion that Post docked her yacht, the *Sea Cloud*, in front of the Hermitage in Leningrad in 1938, loaded all the Russian art now at Hillwood on board, and sailed home. She purchased the nucleus of her collection (about 20 percent) while in Moscow but acquired most of it, including the most important works, over the next thirty years at auction and from dealers in New York, Paris, and London.[11] By the time she arrived in Moscow, Post had already assembled a fine collection of French furniture, porcelain, and gold boxes. She had trained her eye on these pieces and was able to recognize how superbly Russian furnishings complemented her French-inspired interiors. Prior to her time in Russia, she had already acquired two works by the firm of Fabergé and had met émigré Russian nobility who had fled the Soviet Union. By the late 1930s, shopping for art and antiques in Moscow required frequenting the state-run commission shops and occasionally the state storerooms when they were opened for diplomats. Here, goods were priced low, which encouraged foreign residents of the Soviet Union to buy.[12] By the time Post arrived, the once flush supplies of the commission shops had dwindled considerably. Nevertheless, during her eighteen-month stay, she purchased numerous porcelain cups and saucers; plates from the order services; silver cups, beakers, and tankards; icons, liturgical textiles, and chalices; and some furniture and porcelain vases.[13]

Icons and other religious objects, which had never previously caught Post's attention, became symbolic of her newfound interest in Russian art. She found ample supplies of vestments and altar cloths heaped in the commission shops and purchased twenty-seven, which are in Hillwood's collection. Davies clearly believed he and Post were saving many of the religious objects. He noted in his diary that "Marjorie and I shopped to 'rescue from the burning' such priests' robes as we could find in the State warehouses."[14] They also purchased at least twenty-three silver chalices at commission shops in Moscow. In one of her Moscow scrapbooks, Post describes how they discovered them:

During the early days of our stay in Russia—they were clearing State Store rooms to create new museums—to further augment the old ones—So! One day we were taken by Bender [Davies's aide and translator, who worked for the U.S. embassy but also reported to the NKVD, the People's Commissariat for Internal Affairs, or secret police] to the State Store room—Fairy tales of robber caves—had nothing on this place room after room with rough board shelves each one loaded—great boxes on the floor with lovely silver things tea-coffee pots, tankards vodka cups etc.—shelves of china & glass—priest's robes & church embroideries. It was here that we found the chalices looking like pewter—filthy dirty all pushed under a table—We were allowed to poke & dig—& pile what we wished together & the commission would sit (they were in full outside attire, caps and mufflers complete) drink tea—smoke—yell at each other & eventually we would have a price—Chalices—old-new—jeweled or not—were a ruble a gram weighed on a feed store scale.[15]

❧

In Davies, Post found a husband who shared her collecting enthusiasm. He was especially interested in icons and liturgical objects, such as chalices, which he hoped to save from being melted down.

❧

While in the Soviet Union, Post acquired several porcelain vases produced at the Imperial Porcelain Factory. She purchased a large white vase that was part of a banquet service that Alexander II ordered for his boyhood friend Field Marshal Prince Alexander Bariatinskii. The sides of the base feature a crowned ornament composed of the crossed batons of a field marshal, the chain of Saint Andrew, and the star of the Order of Saint George. Someone had attempted to sand off the crowns. Later, Post wrote about the vase, relating how she had witnessed the defacing of other objects with imperial associations. Her notation was simple: "Rule, no eagles or crowns."[16]

At Antikvariat in Moscow, a Soviet store where goods were sold for hard currency, Post purchased a pair of Imperial Porcelain vases with

pigeons roosting in foliage and tree branches. Artisans created the gold background by applying a fine, swirling vermiculated line of burnished gold onto a matte surface, producing the impression of a slightly dull gold background that contrasts vividly with the brightly painted birds.[17] The depictions of pigeons derived from hand-colored engravings by Edward Lear (1812–1888) that appeared in *The Natural History of Pigeons* by Prideaux John Selby, which was published as part of the Naturalist Library in 1835. Lear, more famous for his *Book of Nonsense* (1875), did not travel to exotic locations to paint these birds; instead, he drew them at the London Zoo and from stuffed specimens he found in other collections. The birds are all domesticated varieties, bred by pigeon fanciers. When compared to the original illustrations, it is evident that the coloration on some of the birds on the vases was enhanced, but, by and large, they are faithful copies of Lear's drawings.[18]

Hillwood has few records of what the couple acquired in the Soviet Union. One must therefore rely on the stories Post told about buying vestments and chalices as well as several other important objects. Determining what they bought there is complicated further by their extensive travels throughout Europe, where they regularly took the opportunity to shop and to indulge their newfound interest in Russian art. In the summer of 1937, they sailed from one Baltic port to another to try to obtain intelligence for President Roosevelt on the possible intentions of the German government. To this end, they visited Helsinki, Stockholm, Oslo, Tallinn, Riga, and several other cities, where they spent ample time in antiques shops. In the fall of 1937, Post traveled to Vichy, France, and found a surprising cache of imperial Russian porcelain. A leather trunk contained about twenty pieces of the rare Orlov Service, which Catherine the Great had presented to her then favorite, Gregory Orlov, as a thank you for helping her ascend the throne, in 1762.[19] The pieces were made in the early to mid-1760s and included a coffee pot, a teapot, tea caddy, and other objects. The decoration of military trophies, banners, and cannons alluded to Orlov's military career. How the set left Russia and arrived in Vichy is not known, but Odom believes it must have been in the Orlov-Davydov residence in Saint Petersburg before the revolution. She comments that the Orlov family took much of the service out of the country in the nineteenth century, so none of it was featured in an exhibition to mark the 150th anniversary of the Imperial Porcelain Factory, in 1904.

Not all the objects Davies and Post collected in the Soviet Union were purchases. In June of 1938, Paulina (Zhemchuzhina) Molotova, whose husband, Vyacheslav Molotov, became the Soviet foreign minister the next year, presented the couple with a pair of magnificent Imperial Porcelain vases as a farewell gift. The vases were painted by Nikolai Kornilov in 1836 and came from the collection of Vladimir Girshman, a Moscow businessman. The lush landscapes depicted on the bandeau panels were probably based on Netherlandish or German paintings, but a precise identification has yet to be determined. Authorities seized Girshman's collection in 1919 and temporarily turned his mansion into the Museum of Furniture. The vases were later transferred to the Museum of Ceramics at Kuskovo, although the curators there have no precise information as to when they entered that collection.

Russia continued to enthrall Marjorie Merriweather Post long after she left the Soviet Union. In 1958, she hired a curator, Marvin Ross, to help her enrich and study her collections. Already about the time of her divorce, Post had decided that her collections would become a museum and kept this thought in mind as she continued to build them. Two gold chalices evidence her continued fervor for not only Russian art but, more specifically, Russian ecclesiastical art. One is a gold and ruby chalice presented to the Kazan Cathedral in Saint Petersburg by Count Nikolai Rumiantsev in memory of his mother. In 1927, the Soviet government sold the Kazan chalice to Emmanuel Snowman, of London's Wartski art and antiques dealers, who in turn sold it to a Mr. Bradshaw in 1939. Wartski later reacquired it and sold it to Helen de Kay, a wealthy collector from Pittsburgh. Post purchased it from her estate in 1966. The other treasure is a gold chalice (cat. no. 9) Catherine the Great presented to the Saint Alexander Nevskii Monastery in 1791, as part of a set that also included a *diskos* (plate for the consecrated bread) and a *zvedista* (arched metal bands allowing the diskos to be covered with an altar cloth). It was made by the gold and silver craftsman Iver Winfeldt Buch and is ornamented with cameos and intaglios Catherine personally selected from her own collection. In 1922, it appeared on a list of objects destined for sale by the Soviets to aid in "famine relief."[20] Kenneth Snowman informed Hillwood's curators that his father, Emmanuel Snowman, brought the chalice out of the Soviet Union in 1925–26 and that it remained in the firm's collection until Post purchased it in 1967. The other components of the set, as well as another complete set made for the Kremlin's Dormition Cathedral, have disappeared.

Post also purchased a diamond nuptial crown from the De Kay estate, which was worn by the last empress of Russia, Alexandra, at her wedding

to Nicholas II. Christian Bolin, the heir apparent to the Bolin firm of jewelers, which was established in Saint Petersburg in 1790 and had a long association with the imperial Russian court, is now included as a creator of the crown. In a chapter on the Bolin firm, Ulla Tillander writes that recent archival research mentions that, in the year 1856, the Bolin firm was entrusted with work on the crown.[21] The story becomes more complicated: in 1884, for the wedding of Grand Duke Konstantin Konstantinovich and Elisabeth Marvikievna, alterations were introduced that included the application of bands of eighteenth-century diamonds sourced from a caftan belonging to Paul I. These alterations were likely carried out by the jewelers Nicholls and Plincke, whose names are marked on the fitted case that housed the crown from then on. Stephano Poppi identifies a diamond girdle with two tassels David Duval made during Catherine's reign as the likely source of the diamond bands used to create the Hillwood crown; the formation of the diamond plates on the girdle is identical in several spots with those used for the crown.

The two Fabergé eggs in Hillwood's collection were part of the material that Soviet authorities wanted to be rid of, and, in 1930, experts from Antikvariat picked eleven of them to sell. The eggs were practically brand new at the time of the sale and the Soviet authorities considered them part of the flotsam and jetsam of the imperial apartments. Armand Hammer, an art collector and CEO, purchased the Catherine the Great egg along with nine others for 8,000 rubles. He sold the Catherine egg the following year to Post's daughter Eleanor. The egg was created by Henrik Wigström, Fabergé's last head workmaster, for Nicholas II to present to his mother, the Dowager Empress Maria Fedorovna, in 1914. It is lavishly decorated with miniatures designed to suggest cameo carvings against a pink enamel ground. Enamel allegories of the arts and sciences and colored gold trophies of musical instruments and objects associated with the arts and sciences decorate its surface, which is partitioned into rectangular and ovoid reserves bordered by pearls and diamonds. According to a letter from Maria Fedorovna to her sister Queen Alexandra of England, the original surprise inside was a miniature sedan chair with a seated figure of Catherine the Great carried by two blackamoors.

Hillwood's "Twelve Monogram" egg was given by Nicholas and Alexandra to Maria Fedorovna in 1895 and has a rather sketchy history in terms of its whereabouts when the other eggs were sold, in 1930. It disappeared until 1949, when Post purchased it from Mrs. G. V. Berechielli in Italy.

Post's friend Frances Rosso, the American wife of the Italian ambassador to the Soviet Union, may have introduced the two women.

Post was particularly interested in objects with imperial histories, and they found their way to her through many different paths. She often commented that she had collected her Order Service plates in eleven different countries. Her efforts kept her at the ready at auctions in London and New York. Ross was also instrumental in helping her augment her holdings as objects came on the market. Davies and Post recognized alluring beauty in their Russian acquisitions, but they were equally fascinated and in sympathy with a rich spiritual tradition that was under threat and disappearing in Russia. They openly wrote about their desire to save and preserve ecclesiastical objects that faced certain destruction. Their journey led them to an intersection of spirituality, art, money, politics, and scholarship. All of these factors had a role in shaping Hillwood's collections and leave much for us to ponder about the discovery and collecting of Russian art then and now.

END NOTES
1. Odom and Paredes, 27.
2. "Mrs. Post's Magnificent World," *Life*, November 5, 1965, 58–59.
3. Ibid.; and Jennifer Barger, "The Kingdom of Hillwood," *Essential Washington*, 50.
4. Fisher, 27.
5. Ibid., 28.
6. Diary entry, March 21, 1937, in Joseph Edward Davies, *Mission to Moscow* (New York: Simon and Schuster, 1941), 30.
7. Ibid.
8. George Galavaris, *Icons from the Elvejem Art Center* (Madison: Elvejem Art Center, University of Wisconsin, 1973), viii.
9. Odom and Salmond, 266–67.
10. Ibid., 267.
11. Ibid.
12. Ibid., 268.
13. Ibid.
14. Ibid., quoting Library of Congress Manuscript Divison, Joseph E. Davies Papers, box 4 diary, March 15, 1937.
15. Odom and Salmond, 270, quoting Bentley Historical Library, University of Michigan, "The Log," Post Family Papers, box 38, 1937.
16. Odom and Salmond, 273.
17. Odom and Paredes, 256.
18. Ibid., 256.
19. Odom and Salmond, 273.
20. Ibid., 278.
21. Ulla Tillander, in Bolin and Bulatova.

Catherine II's Religion: Liturgy, Statecraft, and Inner Life

ASEN KIRIN

On January 20, 1744, the fourteen-year-old Princess Sophie of Anhalt-Zerbst and her mother, Joanna Elisabeth of Holstein-Gottorp (1712–1760), arrived in Saint Petersburg at the request of Empress Elizabeth I (reign 1741–1761). The empress had chosen the teenage Prussian princess to be the bride of her nephew and heir to the throne, Grand Duke Peter Ulrich (1728–1762), the future Peter III of Russia (reign January 5–July 8, 1762). He and Sophie were second cousins. A bride belonging to a powerful ruling dynasty might have brought with her a political agenda reflecting the interests of her family, so the empress of Russia chose a young lady of ancient noble origins but whose parents had no real power or wealth. Five months later, on June 28, the day before her official engagement to the future emperor, Princess Sophie converted to Eastern Orthodoxy and became Catherine Alekseevna. Both her new first name and her patronymic ("Alekseevna" translates as "the daughter of Aleksei") were chosen in emulation of Catherine Alekseevna—Catherine I (reign 1725–1727) of Russia, the mother of Elizabeth I.[1]

The young Lutheran princess enthusiastically took to the task of conversion, turning it into an educational project. Catherine expressed her dedication to her new country and to her spousal duties by carefully studying and strictly honoring the customs of the Orthodox church, learning Russian and Old Slavonic while mastering Russian history. After she ascended to the throne, in 1762, the matters of the church were an essential component of her obligations as empress, due to the principles of caesaropapism; in other words, the monarch possessed supreme authority both in the secular and the spiritual realms. At the time, Russia was the only politically independent Eastern Orthodox nation. Accordingly, its sovereign was, in essence, the head of the Eastern Orthodox or Greek Orthodox church. The empress manifested her keen awareness of this responsibility throughout her reign, during which major issues of foreign policy were developed and argued consistently with regard to the duty of Russia's ruler to protect all Eastern Orthodox Christians. Consequently, the official justifications for the divisions of Poland and the wars against the Ottoman Empire included the argument that these countries allowed extreme religious intolerance and practiced the persecution of people of the Eastern Orthodox faith. Writing her memoirs in 1771, after a series of victories in the First Russo-Turkish War (1768–1774) and while working toward the First Partition of Poland (July 1772), the empress touched upon the question of being head of the Eastern Orthodox church: "I had a master [at the age of seven] who taught me religion and instructed me in history and geography. French and German I learned from actual use. One day I asked this reverend gentleman, for my teacher was a pastor, which of the Christian Churches was oldest. He mentioned the Greek Church and said that in his opinion it corresponded most nearly to the faith of the apostles. From this time on I felt a great respect for the Greek Church and always wished very much to inform myself about its teaching and rituals. And now I am the head of this Church!"[2]

Catherine presented this episode from her childhood as being part of a lifelong project of learning and research. Being the head of the Greek church meant that she had to master its teachings, rituals, and history, which she did exceedingly well. Dutifully, she observed every rite and ritual of the church, attending lengthy liturgical celebrations and often having matins conducted in her private apartments. As expected of her, Catherine venerated the icons of every church she visited. The diary of the imperial chancellery, *Zhurnaly kamerfur'evskie*, contains detailed records of these events, consistently describing them with the Russian expression designating the proper tactile way of venerating icons. Innumerable times, the record says, "her imperial Majesty deigned 'prikladyvat'sia k ikonam,'" meaning that, after she made the sign of the cross and bowed, the empress would kiss each icon presented to her.[3]

Recent studies have emphasized theology and the delivery of sermons as the most significant forms in which the Christian religious experience manifested itself in the courts of eighteenth-century Europe, including Russia.

Catherine was known to be distinctly secular minded and remarkably intelligent, so the prevailing opinion holds that she was "fully devoid of piety."[4] The assumption is that the empress paraded her faith for her subjects, in a perpetual pageant of hypocrisy, the only goal of which was to keep a tight hold on power. Catherine's predicament, instead, emblematized the modern Western experience from the eighteenth century on: the quandary of reconciling religious spirituality with scientifically minded views of the world. By embracing the principles of cultural relativity, Catherine arrived at a solution in which religion was understood as a social phenomenon that is often at the heart of a nation's culture. She fulfilled her imperial calling by immersing herself in the culture of her adopted country and striving to enrich it. Her participation in public religious rituals constituted a part of the craft of

statesmanship. In addition, her private acts of devotion were a deeply personal experience, akin to the pantheistic spirit of the Enlightenment. This exhibition and its catalogue present new findings revealing how the empress orchestrated the circumstances that made possible this amalgamation of religion, art patronage, and personal life.

Recent studies have emphasized theology and the delivery of sermons as the most significant forms in which the Christian religious experience manifested itself in the courts of eighteenth-century Europe, including Russia.[5] Without questioning the validity of these arguments, this essay contends that liturgy remained a key component of the spiritual experience in Russia at the time, one that continued to affect deeply the country's visual culture. Liturgy was so important to the experience of daily life that it contributed to the structuring of space and time. The eighteenth century was an era of universal obsession with the charting of the globe through the geographic coordinate system. Alongside the scientific perspective existed an imagined spiritual map of the world with points of various brightness. These points corresponded to the sites of the Holy Land as well as to churches and monasteries, the *loci* where humans can approach the divine and communicate with God, experiencing a form of transcendence beyond the constraints of mortal existence. Visually, these *loci* manifested their holiness in their domes, often gilded, and in their tall belfries. Holy sites would also acoustically insert themselves into the flow of time and affirm the constancy of space through the chiming of their bells summoning the faithful to prayer or announcing a particularly solemn moment in the liturgical celebration. The same overlapping of scientific and spiritual views of the world manifested itself through the fusion of civil and liturgical calendars.

In premodern Russia, the essential service books of the Orthodox church, which contained a record of the accurate sequences of ecclesiastic rituals and their required prayers and chants, organized and defined time in its orderly passage. For instance, the *Euchologion* ("Prayer Book," Church Slavonic "Molitvoslov") includes the cycle of daily and weekly prayers, and the *Menologium* ("The Book of Months," Church Slavonic "Miasetseslov") contains the texts for commemorating different saints each day of the liturgical year (cat. nos. 40 and 41). The *Octoechos* ("The Book of Eight Tones," Church Slavonic "Osmoglasnik") contains texts for every day of the week in each of the eight tones, i.e., mode systems for religious chants. The most common shared experience of the passage of time for people of all walks of life was through prayers

and chants repeated daily, weekly, or yearly, frequently remembered in connection with individual feasts or specific saints.

This centuries-old way of structuring time was incorporated into a new, secular calendar that Peter the Great installed in Russia by the end of 1699, in time for the start of the new century. This secular calendar came with major changes, such as the replacement of the chronology starting from the creation of the world (*Anno Mundi*) with the one beginning with the Birth of Christ (*Anno Domini*). Consequently, the year 7208 AM became 1700 AD, and the first day of the year became January 1, not September 1, as in the Byzantine example; the Orthodox Church still considers September 1 the start of the liturgical annual cycle.

The first publication of the secular calendar appeared in 1709 and, in addition to all of its up-to-date scientific features containing astronomical and geographic data, it included a condensed version of the *Menologium* for all twelve months of the year. The title prominently conveyed the merging of the secular and the ecclesiastic traditions: *Calendar or Christian Menologium . . . for the year of the Incarnation of Christ 1710, from the Creation of the World 7217. Printed in Moscow in the year of Our Lord 1709,* [on a] *day in December.*[6] From 1709 to the turn of the twentieth century, this calendar was one of the most popular publications in Russia. However significant the reform appeared, it perpetuated the age-old liturgical way of experiencing the passage of time. Looking at the calendar was a way to remember which saint's feast day had arrived or was approaching and would bring to mind the *tropar*, or liturgical stanza, sung during the festive liturgy celebrating this holy man or woman. Living according to the liturgical calendar also meant following its strict requirements for abstention from food, drink, or sexual intercourse.

One revealing example about the ways in which the liturgical calendar affected the innermost spheres of private life, even for secular-minded individuals, comes from the honeymoon phase of Catherine the Great's relationship with Prince Gregory Potemkin (1739–1791). During the first month of their passionate love affair she wrote to him the following note, which is both charmingly humorous and poignant: "Farewell, my dear one, only three days are left for us to meet, and after that starts the first week of the Lent—days for penitence and prayer, during which I will not be able see you at all, because it would be bad in every way. I have to fast."[7]

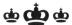

Among the best-known examples of the impact that the liturgical calendar had on late-seventeenth- and eighteenth-century Russian culture was the selection of Peter the Great's patron saint, the holy monk Isaac of Dalmatia (d. May 30, 383). This saint became the protector of Peter I, the Romanov dynasty, and the imperial city of Saint Petersburg, where one of the largest cathedrals is dedicated to him. The prominence of Saint Isaac's cult in Russia was due to Peter having been born on May 30, 1682, the day when the Orthodox Church commemorates this holy man. Viewed as a prophetic sign, it seemed to confirm the seminal principle in the Christian imperial tradition that featured many instances of distinguished ascetics delivering the wisdom of heaven to an earthly ruler. Saint Isaac, who secluded himself in a Constantinopolitan monastery, was one of those holy men; he had the audacity to speak the truth about Emperor Valens (reign 364–378), who fell into heresy by embracing Arianism. The hermit foretold Valens's demise by fire, which occurred in a battle with the Goths near the city of Adrianople in August 378. Peter the Great did not ignore the learned monks of his time. He worked closely with one of these enlightened ecclesiastical figures, Archbishop Theophan Prokopovich (1681–1736), a founding member of the Russian Academy of Sciences and the person instrumental for implementing Peter's reforms of the Russian church.

The coincidence in time between an important event like the birth of Peter the Great and the liturgical celebration of an episode from sacred Christian history was seen as a providential occurrence that manifested God's will. Occasionally, thematic or symbolic links strongly enhanced the prevailing notion about the preordained nature of such an event. Three pivotal moments in the rule of Catherine the Great reveal the deliberate ways in which the empress, her advisors, and her subjects connected current events with symbols and narratives derived from the liturgical texts for ecclesiastical feasts. The following discussion of these three examples reveals that they share a notable characteristic. The rhetorical statements associated with each of them contain two strata of imagery: first, classical antiquity, pagan mythology, and the ideas of the Enlightenment; second, the ecclesiastical calendar and liturgical poetry. The former category is better known and has attracted more scholarly attention than the latter. I assert that the overlapping of the two strata is an important feature of eighteenth-century Russian culture. It pulls back

the curtain to reveal a brightly lit stage where Mount Olympus is joined with the Holy of Holies through liturgical chants and clouds of incense.

THE NORTHERN MINERVA AND THE FEAST OF THE ICON OF "THE THREE-HANDED MOTHER OF GOD" ("TROERUCHITSA")

Two seminal events took place on the same date in Catherine the Great's life: namely, June 28, according to the Julian Calendar. On this date in 1744, the future empress was baptized in the Orthodox faith; then, on the same day, in 1762, circumstances forced her to seize the throne. In the liturgical calendar of the Orthodox Church, June 28 is the feast day of a celebrated miraculous icon of the Virgin, known as "The Three-Handed Mother of God" (Greek "Panaghia Tricherousa," Russian "Bogotoditsa Troeruchitsa").[8] The history of its cult involved the miraculous healing in 717 of Saint John of Damascus (ca. 675–749), a great religious philosopher and defender of holy images at the time of Emperor Leo III (reign 717–741). Leo III is remembered for pursuing aggressively the policy of iconoclasm and for his prolonged wars against the ever-expanding Umayyad Caliphate, the center of which was in Syria.

Syria remained unharmed by iconoclastic violence as it was beyond the reach of Constantinopolitan imperial authorities. Here, Christians were able to continue their worship of holy images without fear of persecution. Saint John, who served at the Umayyad Islamic court of Damascus, composed and disseminated treatises explaining the appropriateness of icon veneration and its essential role in the communication of the faithful with God, the Holy Virgin, and the saints of the church. After reading one of these treatises, Leo III retaliated by sending to the caliph of Damascus a forged letter allegedly written by Saint John that contained "evidence" of his spying on the Umayyad court on behalf of Constantinople. In punishment for this supposed betrayal, the caliph had John's right hand severed. The saint was able to prove his innocence with the supernatural help of an icon of the Virgin, who miraculously healed his hand. As a sign of gratitude, John attached a small silver hand to the icon, thus starting the tradition of venerating it as a performer of miracles, one that became widely known as the "Three-Handed Mother of God." In eighteenth-century Russia, Saint Dmitri of Rostov's (1651–1709) vita of Saint John of Damascus, included in the *Great Menologion* under the listing for December 4, the saint's feast day, served as a readily available source for this story (see cat. no. 37).

The feast of the Three-Handed Mother of God is a celebration of strict adherence to the true Orthodox faith, which requires the veneration of holy icons. The symbolism of this feast was of key importance for the events that occurred on June 28 in 1744 and in 1762, as both addressed concerns about Lutheran iconoclasm. The betrothed of the future Orthodox monarch of Russia, Peter III, was a Lutheran. In 1762, it was Peter III's own Protestant and iconoclastic tendencies that had to be addressed by the true Orthodox believer Catherine Alekseevna. After succeeding his aunt Elizabeth I, Peter III unapologetically displayed his disdain for the Orthodox church, despite being its head. Like Catherine he had been raised in the Lutheran faith, but, unlike her, he never truly attempted a meaningful transition. Sadly, a distaste for icons and the rituals of the church may have been the only characteristic Peter III shared with his grandfather Peter I. According to the wording of the proclamation issued on June 28, 1762, Catherine had no choice but to dethrone her husband to save the Orthodox faith.

The polymath Mikhail Vasilievich Lomonosov (1711–1765) composed a celebratory ode on the occasion of June 28, 1762, which he finished by July 8, less than two weeks after the coup d'état. At the start of one of the ten-line stanzas, Lomonosov exclaims, "The Sciences celebrate now:/Minerva has ascended the throne" (verses 231–32). Elsewhere, he contemplates the image of Catherine standing in a church in pious prayer (verses 153–54).[9] He never explicitly mentions the feast day of the icon of the Three-Handed Mother of God, but it was common knowledge that this day was meant to commemorate Saint John's miracle. In Lomonosov's verses, Catherine submits a prayer of gratitude for the salvation of her person and her people, delivered by the "strong right hand of God, that gave us our new tsaritsa and saved all of us from peril" (verses 157–60). The image of "God's strong right hand" alludes to Exodus 15:6, in which Moses thanks God for drowning the pharaoh's army in the Red Sea. It also directly and unambiguously refers to an early poetic work by Saint John of Damascus himself, composed in gratitude for the miracle of his healed right hand. This short poem appeared in the *Octoechos* as the "First Verse in Tone 1" and, ever since the eighth century, has been performed in regular weekly services. Lomonosov's ode demonstrates the era's characteristic merging of ancient pagan and Christian liturgical images, intertwining Minerva, the Mother of God, Moses, and Saint John of Damascus and making a compelling statement about the new empress's simultaneous embrace of the Enlightenment and determination to uphold the tradition of Orthodoxy. All these connections brought into sharp

focus the subtle but seminal significance of the use of liturgical images from the feast of the Three-Handed Mother of God to invest current events with meaning.

THE CORONATION FESTIVITIES OF 1762–63: FOREFEAST AND AFTERFEAST IN ORTHODOX LITURGY

Richard S. Wortman provides a detailed explanation of the themes unifying the festivities surrounding Catherine the Great's coronation, which were conceived as a demonstration of the "Love of the People" of Russia for their savior, the new empress, who delivered them from the godless actions of her unfortunate predecessor.[10] The other leitmotif was the "Triumph of Minerva," the embodiment of might and wisdom. Both themes appeared in Lomonosov's ode, but another symbolic aspect of Catherine's ascent to the throne included a scenario involving the ultimate paragon for every Christian ruler: Emperor Constantine the Great (reign 305–337). In a feat of thoughtful coordination, Catherine's coronation overlapped with the annual liturgical celebrations of Saint Constantine and Saint Helena, glorified as "Equal-of-the-Apostles" for their contribution to the Christian faith.

In general, coronations took place on the premises of the ancient Russian capital of Moscow, in the main cathedral of the Kremlin, dedicated to the Dormition of the Virgin. The new monarch would make a special journey from Saint Petersburg and remain in the old capital following the ceremony to participate in prolonged festivities. In 1762, Catherine the Great's procession entered the city of Moscow on September 13, the day when the Orthodox Church celebrates the consecration of the Holy Sepulcher Basilica in Jerusalem. According to legend, this consecration took place in 335, two years before Constantine's death. The basilica was erected at his orders after his mother, Helena, discovered the remains of the True Cross of the Crucifixion, in 326. In the liturgical calendar, September 14 commemorates the Exaltation of the True Life-Giving Cross, the public display of the True Cross on the day after the basilica's consecration. Another important event celebrated on this date is the recovery of the True Cross from the Persians in 628, when the Byzantine Emperor Heraclius (reign 610–641) redeemed this holy relic from captivity.[11]

The liturgical cycle of celebratory services for an ecclesiastical feast commences on the eve of a holy day with special vespers. In view of this practice, September 13 is a double holy day: the feast of the consecration of the Holy Sepulcher Basilica and the forefeast of the Exaltation. Yet, there is more to the timing of both Catherine's arrival in Moscow and her coronation. Individual holy days in the Orthodox Church are celebrated for a different number of days depending on the importance of the event commemorated: one day (the most common), two days (Annunciation of the Virgin, March 25), five days (Birth of the Mother of God, September 8), nine days (Epiphany, January 6), or even thirty-nine days (Easter, movable date). The Exaltation of the True Life-Giving Cross requires eight festive days, and the close of the festivities, or afterfeast, took place on September 21. Catherine's coronation was September 22. Thus, it becomes apparent that her arrival and stay in Moscow ahead of the coronation celebrated and glorified the ultimate paragons of Christian rulership, Saint Constantine and Saint Helena, as well as the True Cross, the embodiment of the Christian faith. It was very convenient that in 1762 the afterfeast for the Exaltation fell on a Saturday because a Sunday was the most suitable day for a coronation ceremony.

In her time Catherine had witnessed tragedies caused by smallpox, which added to her conviction to undergo inoculation against this disease. Her decision was also a gesture to promote scientific knowledge in helping one live with dignity by overcoming fear, prejudice, and death.

September 21 is also the date on which the Russian Orthodox Church celebrates the discovery of the holy relics of Saint Dmitri of Rostov (born Daniil Savich Tuptalo). In 1702, Peter the Great issued a decree appointing Dmitri archbishop of Rostov, a historic city located 126 miles northeast of Moscow. Forty-six years after the archbishop's death, he was canonized as a saint of the Russian Orthodox Church on April 22, 1757, at the orders of Empress Elizabeth I. Dmitri's relics remained within his diocese in the Spaso-Iakovlsii Monastery at the cathedral dedicated to the Conception of Saint Anna. Dmitri was an intellectual and a scholar who

wrote the *Great Menologion Reader*, twelve volumes detailing the vitas of saints celebrated by the Russian Orthodox Church and arranged in order of the liturgical calendar, starting with September 1. The *Great Menologion Reader* was published in four bindings of three volumes each in 1689, 1690, 1700, and 1705.[12] Dmitri also composed the first Russian opera, in 1705, an oratorio of Russian saints based on the *Menologion Reader*. One of the icons included in this exhibition relates to the cult of this Russian holy man (cat. no. 37).

During the 1700s and the 1800s the *Menologion Reader* was extremely popular and influential, not only in Russia, but also throughout southeast Europe. Because of its comprehensiveness, it fulfilled the role of an encyclopedia of the Christian faith and brought an aura of prestige and sanctity to its creator. Only two similarly large-scale compilations preceded Dmitri's. In early-eleventh-century Byzantium, Symeon Metaphrastes (i.e., the "Reteller/"Compiler"; d. ca. 1000), wrote the Greek *Menologion*, which became an essential source for saints' vitas in the Byzantine church and standard reading in monastic circles. And in the early sixteenth century, Metropolitan Macarius of Moscow (1482–1563) created a Slavonic version of the *Menologion*. Dmitri followed this revered tradition, yet lived up to the expectations of his time. In keeping with the spirit of the burgeoning Enlightenment, his writing promoted a greater knowledge about the history of the church, a better understanding of the faith, and a new appreciation of the paragons of virtuous Christian behavior.

After six months of coronation festivities, the Triumphal Minerva saw fit to humble herself by making a pilgrimage to Rostov to venerate the relics of Saint Dmitri, who had been canonized only five years earlier. Remarkably, Catherine actually did go on foot for the entire 126-mile journey, walking an average of seven miles a day; a carriage would collect her in the evening and deliver her the next morning to the same point on the road.[13] As scholars have discussed, she had important political reasons to visit Rostov, among them her desire to demonstrate her support for Elizabeth I's overturn of Peter I's prohibition of relic veneration. Venerating holy relics and icons have gone hand in hand for many centuries; in essence, the icons substitute for the missing sacred bodies of Christian saints.[14] One might say that the Rostov pilgrimage added to Catherine's plethora of symbolic gestures affirming icon veneration.

The closing chapter of the post-coronation festivities included visits to other Orthodox holy places in the vicinity of Moscow, including the Trinity Monastery of Saint Sergius, but its apex was Catherine's arrival at Rostov, her veneration of Saint Dmitri's relics, and a grand formal dinner on May 21, 1763, which coincided with the main holy day celebrating Saints Constantine and Helena.[15] The Equals-of-the-Apostles and Saint Dmitri were, thus, duly glorified both on the eve of the coronation and at the end of its six-month-long festivities. In the first of these two instances (September 21, 1762), the described overlap was determined by the prescriptions of the liturgical calendar, but the second overlap (May 21, 1763) resulted from a deliberate orchestration. This elegant symmetry is only a small part of the story. The layering of festive themes drew attention to the apostolic calling of a Christian sovereign as embodied by Constantine. Furthermore, the apostles are the paragons for all bishops of the church, including Dmitri, who exemplifies a nearly contemporaneous, enlightened apostolic service for the Russian Orthodox church. Ultimately, Catherine drew inspiration from both the oldest (Constantine) and the newest (Dmitri) of these paragons for service to the Orthodox faith. With Saint Dmitri of Rostov's erudition and remarkable capacity for work, he emerged as the encyclopedist of the Russian Orthodox church. One discovers a reflection of his notable intellectual qualities in the *troparion* sung during liturgical celebrations on his feast, which acknowledges the profound significance of his writings:

> Tone 8
> You, defender of Orthodoxy, and eradicator of quarrels,
> Russian healer and supplicant to God;
> Your writings tamed the violent and gave them knowledge;
> You, Blessed Dmitri, are a spiritual flute;
> Pray to Christ the Lord for the salvation of our souls.[16]

THE SMALLPOX INOCULATION AND THE PRESENTATION OF THE VIRGIN INTO THE TEMPLE

In the early winter of 1768, Catherine the Great submitted herself and her son Grand Duke Paul to inoculation against smallpox. Undergoing the procedure before other members of the court took courage and confidence; Catherine was particularly proud that she did not stop working even for an hour. She admired also Count Gregory G. Orlov's actions after his own inoculation, even though he was less concerned about appearing industrious. On the following day he went hunting in the deepest of snow.[17]

In her time Catherine had witnessed tragedies caused by smallpox, which added to her conviction to undergo inoculation against this disease. Her decision was also a gesture to promote scientific knowledge as helping one live with dignity by overcoming fear, prejudice, and death. Even so, because of the possible negative political fallout if it failed, the procedure was first kept in the strictest confidence. The empress made special provisions that would, in the event of her death, secure the safe departure from Saint Petersburg of the English physician Thomas Dimsdale (1712–1800), whom she hired to conduct the inoculation. Once the endeavor had proven an unquestionable success, it was made public, and the whole of Saint Petersburg joined to celebrate this triumph of science and reason, which was used to publicize disease prevention. Predictably, a cycle of what might be termed inoculation poetry emerged. In fact, "Catherine as Healer" is the title of a chapter in Vera Proskurina's book on Russian literature during the rule of the enlightened empress.[18]

Six years after the inoculation campaign in Saint Petersburg, Louis XV died of smallpox, on May 10, 1774, which gave Voltaire an opportunity to compare the enlightened decision of the Russian empress and the ignorance of the French king.[19] Catherine's confidence and pride in choosing to be inoculated manifested itself in a letter she wrote to Baron Grimm a month after Louis XV's demise:

> Surtout je n'aime point ces fréquentes consultations de médecins: ces charlatans vous font toujours plus de mal que de bien, témoin Louis XV, qui en avait dix autour de lui et qui cependant *mortus est*; or, j'opine que pour mourir de leurs mains il y en avait neuf de trop. J'opine encore qu'il est hon-teaux pour un roi de France qui vit au XVIII siècle de mourir de la petite vérole; cela est velche.

> I especially dislike the frequent visits by physicians: these charlatans do you more harm than good, behold the example of Louis XV who had ten of them around him and yet *mortus est*; I believe that to die at their hands is nothing new at all. Still, I think it is shameful for a king of France who is living during the eighteenth century to die of smallpox; this is horrendous.[20]

The fall of 1768 brought the aforementioned celebratory odes and even a ballet titled *The Triumph of Minerva, or Defeat of Prejudice*, created for the occasion of the inoculation by the Florence-born dancer and choreographer Gaspare Angiolini (1731–1803), who worked for the court

of Saint Petersburg between 1766 and 1778. As Proskurina points out, the rhetoric of the time praised Catherine's successful inoculation through the use of both pagan and biblical images including Moses, who protected his people from poisonous snakes in the desert (Numbers 2:4–9). The empress, in her public statements, used the image of the Good Shepherd "who lays down his life for the sheep." The rhetorical power of this general image derived from its very concrete manifestation. The smallpox substance used for the inoculation of some of the privileged members of the court of Saint Petersburg was gathered from the empress's own blisters. Literally, in a Christlike manner, Catherine gave her body for others.[21]

As with Catherine's conversion and coronation, the timing of her smallpox inoculation and the official steps taken to celebrate and commemorate it reveal a thoughtful coordination with the liturgical calendar. She was inoculated on October 12, 1768, the feast of the Icon of the Holy Mother of God of Jerusalem. This icon was believed to have been painted by Apostle Luke fifteen years after Christ's ascent into heaven and was said to have been brought to Russia by Grand Prince of Kiev Vladimir (reign 980–1015) after his foray to Crimea, his conquest of Cherson, and his baptism into the Christian faith in 988. During Catherine's reign, the icon was kept in the Dormition Cathedral of the Moscow Kremlin.[22] The *troparion* for the feast of the miraculous icon explicitly mentions its power to help cure illnesses:

> Tone 4
>
> You in whom God Rejoices
> Glorified by all, Mother of generous bounties,
> Most Gracious Intercessor for Mankind,
> We, your dutifully servants, submit to you our supplication,
> To your miraculous image we pray and bow with affection:
> Warmly pray to Your Son for us,
> Oh, celebrated by all, Tsaritsa of Heaven,
> So that on your behalf He saves us from all sickness and sorrow.[23]

Grand Duke Paul was inoculated on November 10, a date that does not seem to yield any substantial liturgical associations but may have been chosen to allow enough time to see whether the procedure was successful before two upcoming regular liturgical feasts: the Presentation of the Virgin into the Temple (November 21) and Saint Catherine of Alexandria

(November 24). Both these holy days became firmly linked with the inoculation through an official decree announced on November 22, 1768, when the Senate and the members of the Legislative Commission gathered at the Kazan Cathedral to attend liturgy and declare jointly the establishment of a civil holy day commemorating the successful inoculation. This day was to be celebrated yearly on November 21. The venue for this announcement had its own significance, as the Cathedral of Kazan was dedicated to the Birth of the Mother of God (September 8; see cat. no. 14) and contained a miraculous icon of the Virgin known as the Icon of Kazan (holy days July 8 and October 22; see cat. no. 11). This icon, kept in Saint Petersburg, was made on the orders of Peter the Great and reproduced a miraculous image that revealed itself to the faithful in 1579 after a fire that devastated a substantial part of the city of Kazan. The establishment of the new civil holy day connected the progress of society through science with the cult of the Virgin and a related miraculous holy image, celebrating her powers as the main intercessor before God on behalf of all humanity.

A remarkable object created during 1768, the Orlov vase (cat. no. 49), embodies the connections between a golden vessel, understood as a symbol of the Mother of God, and Saint Catherine's namesake, the empress of Russia.

One visual manifestation of this fusion of the civil and the ecclesiastical feasts taking place on November 21 appears in the iconography of a gold medal designed by Timofei Ivanovich Ivanov (1729–1803) and struck in 1772 to commemorate an anniversary of the inoculation's success. The inscription on the obverse states: "She Herself Set the Example/The 12th Day of October 1768."[24] The scene shows Catherine leading the teenage Grand Duke Paul by the hand, moving from right to left, to a woman and her two offspring. One child barely emerges from behind the rich drapery of the woman's dress; the other, nude and kneeling, extends his arms toward the empress and the grand duke, asking to be rescued. The slightly

bowing motherly figure facing the empress stands for the grateful Russia, whose children were saved thanks to the brave action of the empress. A slain dragon, embodying ignorance and prejudice, lies on the steps of a neoclassical temple rising behind Catherine. This temple of knowledge and learning, from which the empress seems to be emerging, alludes to the Great Temple of Jerusalem, where the Virgin dwelled. By the time this medal was issued, the anniversary of the inoculation had been celebrated jointly for five years with the Presentation of the Virgin into the Temple.

A prominent connection also exists between the Presentation of the Virgin into the Temple and the feast of Saint Catherine. The festivities for the former last for four days and close with an afterfeast on November 25; thus, the holy day commemorating the martyrdom of the Alexandrian Princess Catherine (November 24) always falls on the penultimate day of festivities for the Presentation of the Virgin. Both feasts celebrate the dedication of a righteous life to God leading to a more elevated state of existence. After she was presented to the Great Temple of Jerusalem, the Mother of God dwelled in the most sacred place on earth, the Holy of Holies. Similarly, after she suffered martyrdom, Saint Catherine was granted eternal life in heaven. One cannot help but notice the ideological creativity manifested in this set of events surrounding the inoculation in the winter of 1768. This festive scenario, to use Wortman's phrase, succeeded in merging the embrace of science to improve life with Christian virtue, which earns the faithful soul eternal life.

At vespers on the eve of the Presentation of the Virgin feast, the holy services require the reading of Old Testament passages (Russian "pareniia," Greek "paroimia") describing the creation of the Tabernacle, a later version of which would be the place where the Holy Virgin dwelled in the Great Temple of Jerusalem. In Exodus 40, God instructs Moses how to raise the tent and set the table with holy vessels. This feast's liturgical poetry develops further the metaphor of these gold receptacles as a prefiguration of and symbol for the Mother of God. A remarkable object created in 1768, the Orlov vase (cat. no. 49), embodies the connections between a golden vessel, understood as a symbol of the Mother of God, and Saint Catherine's namesake, the empress of Russia. The liturgical poetry performed on the feast of the Presentation of the Virgin into the Temple had a great deal to do with the meanings that this *objet d'art* conveys, even though it is merely a potpourri vase—an attribute of fashionable life of refinement (see in this volume "'The Fingertips of Sight': Discerning Senses and Catherine's Golden Censer").

The associations between the Holy Virgin, who is a celestial queen, and an earthly female monarch are most informative when one analyzes their specific manifestations, as with the festivities related to Catherine's inoculation, which have an intriguing prehistory. Catherine visited Kazan during the summer of 1767 and, while there, on May 28, she attended liturgy at the nunnery of the Holy Virgin where the icon of the Mother of God of Kazan was kept. After the end of the holy services, the empress venerated the miraculous image. In commemoration of this event, in 1768 she bestowed a new gold cover (Russian "oklad") on this icon. The cover featured a crown ornament that expressed symbolically the notion of the Virgin as the Queen of Heaven and was made from the empress's own small diamond crown. This highly symbolic gesture demonstrated both Catherine's piety and her awareness that the celestial sources of her monarchic power included the Virgin and were manifested on earth in such miracle-performing holy images as the icon of Kazan. As a student of history, the empress was fully aware of the tradition for rulers of Russia to pay special homage to this icon. Tsar Ivan IV the Terrible (reign 1547–1584) and Emperor Peter the Great (reign 1682–1725), two of Catherine's most distinguished crowned predecessors, had commissioned copies of the icon to be sent to their respective capital cities of Moscow and Saint Petersburg.[25]

The connections between Catherine's imperial persona and the Mother of God continued a particular tradition that emerged and gained popularity during Peter the Great's reign. As discussed in detail by the distinguished philologists and semioticians Yuri Mikhailovich Lotman (1922–1993) and Boris Andreevich Uspenskii (b. 1937), it involved applying quotes from liturgical poetry to the emperor, which was a manifestation of the general process of sacralizing the Russian monarch. The literature and public speech of the eighteenth and early nineteenth centuries applied the qualities of Christ to rulers, who were also called "earthly gods." This rhetorical use of liturgical quotations remained prevalent during the rule of Catherine's favorite grandson, Alexander I (reign 1801–1825), who strongly detested it. He did not enjoy listening to long speeches in which he was celebrated as Jesus Christ the Savior of the world and, because of this, in a statement to the Holy Synod of the Russian Church from October 27, 1815, he expressed his concern about the inappropriateness of this custom.

According to Uspenskii, the allegorical use of quotations from sacred texts constituted not simply a play of words, but a deliberate play of meanings. In general, the reuse of someone else's words to achieve new meanings gained popularity as a sophisticated rhetorical device.

Liturgical quotes were also used in private contexts to convey personal meanings. After Peter the Great's reforms, the increased secularization of culture made possible the emergence of this convention. According to Uspenskii, the allegorical use of quotations from sacred texts constituted not simply a play of words, but a deliberate play of meanings. In general, the reuse of someone else's words to achieve new meanings gained popularity as a sophisticated rhetorical device.[26] Uspenskii cites an intriguing example of this practice in an anecdote recorded by Iakov Iakovlevich Shtelin (Jacob von Staehlin, 1709–1785), a member of the Russian Academy of Sciences and a memoirist. Late one night, Peter the Great appeared unannounced at the residence of his advisor and trusted ally Archbishop Theophan Prokopovich. Instead of finding the cleric immersed in prayer or diligent intellectual pursuits, the emperor encountered him in the midst of most inappropriate revelry. Caught in this awkward position, the archbishop greeted his sovereign by chanting the *troparion* "Se Zhenikh griadet v polunochi": "Behold the Groom is coming at midnight; blessed are those whom he finds awake and shame befalls the ones overcome by sleep. Be watchful, my soul, do not let sleep overcome you, so that possessed by death you do not remain outside the [Heavenly] Kingdom's locked doors. Raise yourself while calling, 'Holy, Holy, Holy are you Lord, through the prayers of the Virgin bestow mercy on us.'"[27] This *troparion* belongs to a well-known and exceedingly solemn cycle of prayers sung during matins on the Monday, Tuesday, and Wednesday of the last week of the Great Lent leading into Easter. The image in the liturgical poem elaborates on the parable of the Ten Virgins and in particular on the gospel verse, "And at midnight there was a cry made, 'Behold the bridegroom comes; go you out to meet him'" (Matthew 25:6), a stern reminder of the Last Judgment and a call for righteous living, rendered allegorically as a wakeful vigil of the spirit.

The sense of solemnity associated with this chant is enhanced by the awareness that, while it is sung, the celebrant priest or bishop purifies with incense the interior of the church and the congregation gathered in it.

By singing this *troparion* in front of Peter the Great, Theophan admitted his guilt. In addition, this liturgical song offers praise for the emperor, who is both the groom in question and the wide-awake servant of God and whose sudden appearance was seen as a cause for celebration. This late-night encounter between the monarch and the archbishop produced both knowledge and joy, as liturgy itself commonly did. Theophan implied that he deserved to be forgiven for this trespass because he possessed a deep knowledge of the scripture and church rituals, all of which allowed him to discern a parable about true devotion in this situation. The most ingenious part of Theophan's performance had to do with attaching secular meanings to a sacred chant. Peter the Great forcefully promoted the secularization of Russian culture, and it was likely that he would appreciate a step in this direction from the archbishop of Saint Petersburg. The fact that it came in the form of a liturgical chant only affirmed the uninterrupted flow between old and new ways of life.[28]

In eighteenth-century Russia, liturgy continued to supply a repertory of symbolic images used in the realm beyond ecclesiastical ritual to bestow meanings on current events and material surroundings. Doing so uplifted life and added to it spiritual and intellectual dimensions. It combined the power of the communal prayer of ecclesiastical services with a private, deeply personal religious experience in a secular space and often in an everyday activity. In different ways, some of the objects this exhibition includes provide examples of engaging liturgical themes and symbols in the midst of iconographic programs reflecting the priorities of the Enlightenment and the visual vocabulary of neoclassicism. These themes are developed further in the essays dedicated to the Orlov vase (cat. no. 49), the Green Frog Service (cat. nos. 30 and 31), and the Buch chalice (cat. no. 9).

END NOTES

1. The same was the patronymic of Peter the Great, after his father Tsar Aleksei Mikhailovich Romanov (reign 1645–1676). On the future empress's conversion see Catherine the Great 1935; Troyat 1980, 35–38; Madariaga, 1; Rounding, 32–33; and R. Massie, 52–57.
2. Catherine the Great 1935, 8.
3. *Kamer-fur'evskii zhurnal 1763*, 121.
4. Wortman 1995, 120.
5. J. Clark; Bushkovitch; and Dixon 2007.
6. Filimon 1993 and 2003, 417–50.
7. Lopatin, 12, no. 15 from February 24, 1774.
8. Kondakov, 275 and 290; and Lajoye.
9. Lomonosov; and Wortman 1995, 113.
10. Wortman 1995, 110–22.
11. Whittow, 79–82.
12. *Chet'ikh-minei Sv. Dimitriia Rostovskogo*; Shliapkin; and Fedotova.
13. Wortman 1995, 121.
14. Maguire.
15. *Kamer-fur'evskii zhurnal 1763*, 86–119 and 263–64. See the detailed discussion in Proskurina.
16. http://days.pravoslavie.ru/Days/20130921.htm. Last visited July 26, 2013.
17. Solov'ev, vol. 28.
18. Proskurina, 86–108.
19. Voltaire, *De la mort de Louis XV et de la fatalité*, 1774; cited in Proskurina, 87.
20. *Pis'ma Imperatritsy Ekateriny II k Grimmu* 2–3, no. 2, June 19, 1774.
21. See the detailed discussion in Proskurina, 91–98.
22. Kondakov, 290–93.
23. http://days.pravoslavie.ru/Days/20131012.htm. Last visited July 26, 2013.
24. Piotrovski, 59, no. 64.
25. On Catherine's trip to Kazan see Dolgova, Bolotina, and Konova as well as Rounding, 200–201.
26. Uspenskii 1996, 230.
27. Nartov, 72–74, no. 107, cited in Uspenskii 1996, 230.
28. Lotman 1996, 41.

"The Fingertips of Sight": Discerning Senses and Catherine's Golden Censer

ASEN KIRIN

In a televised public lecture delivered on May 19, 2013, Andrei Leonidovich Zorin, the eminent Russian literary scholar, discussed the Westernization of the Russian nobility's senses throughout the eighteenth and nineteenth centuries. "If Peter the Great gave us a way of life, Catherine bestowed on us the soul," he said.[1] Certainly, the discussion of this development demands wide horizons and a bird's-eye view of the cultural landscape. A single object, no matter how intricate and ingenious, can never fully illustrate this point, but it can make that idea concrete and relatable. This essay contemplates a golden potpourri vase Catherine the Great commissioned from the goldsmith Jean Pierre Ador (1724–1784) (fig. 1; cat. no. 49). Appreciating it fully requires refined perceptions, knowledge of history, familiarity with both ancient and modern art, and awareness of the contemporary European discourse about the senses and ideas. This fashionable *objet d'art*, intended to perfume an interior and thereby enhance the polite interactions occurring in that room, had a specifically Russian set of associations. These involve Christian iconography and liturgical poetry performed during the solemn services of Lent.

The phrase "fingertips of sight" comes from Jean-Jacques Rousseau's novel *Julie, ou la nouvelle Héloïse* (1761), a story of the temptation, sin, and Christian redemption of a learned woman who was capable of great passion. In the passage including these words, Rousseau demonstrates how the visual experience can have the persuasiveness of its tactile counterpart. Jacqueline Lichtenstein chose the philosopher's statement about the ways in which "One sense can sometimes inform another" as an epigraph in her book *The Blind Spot*, dedicated to the dynamic among painting, sculpture, and the senses during the modern age, a study that has substantially informed the following discussion.[2]

PERFUMES FOR BEAUTY, LOVE, AND IMMORTALITY

A recipe for a potpourri blend, such as the one that the Orlov vase might have contained, appears in the novel *Abdeker: or the Art of Preserving Beauty* (1754), by Antoine Le Camus (1722–1772):

A Dry Popouri [sic], *composed for Despine Mary by her First Physician:*

Take of orange-flowers a pound; of common roses, from which separate the heels, a pound; of red daisies, deprived also of the white pedicles that are at the bottom of the leaves, half a pound; sweet marjoram, myrrh picked, of each a pound; red roses, thyme, lavender, rosemary, sage, chamomile, melilot, hyssop, sweet balm, balm-mint, of each two ounces; of laurel, fifteen or twenty leaves; of jasmine two or three handfuls; lemon-peel a good handful, and as much of green oranges; salt half a pound. Put all into a vessel, let them remain so during a month, stirring them twice every day with a wooden spoon. At the end of the month add iris in powder twelve ounces, and the like quantity of Benjamin; cloves and cinnamon in powder, of each two ounces; mace, storax, sweet-cane, the powder *Cyprus*, of each one ounce; yellow sander and cyperus [sic], of each six drachms. Mix

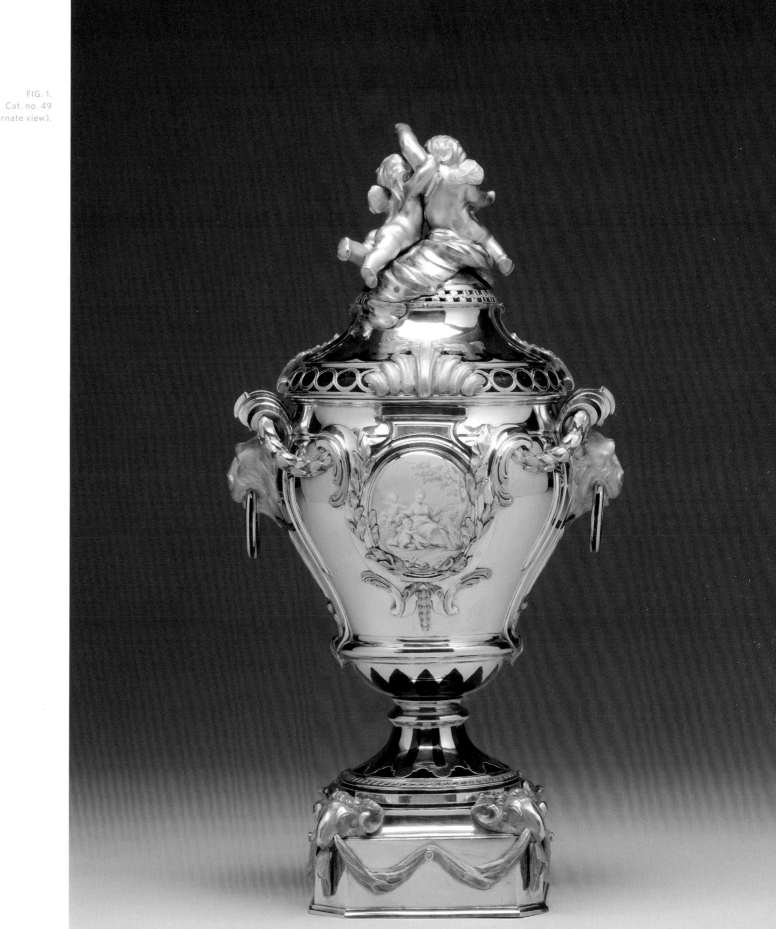

FIG. 1.
Cat. no. 49
(alternate view).

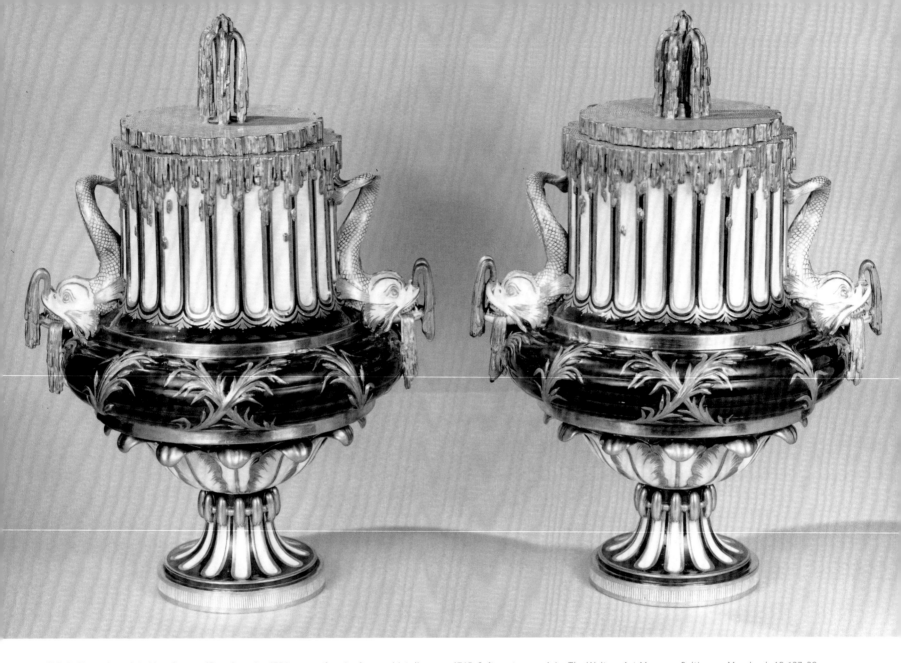

FIG. 2. Sèvres Porcelain Manufactory (French, active 1756–present), pair of vases á jet d'eau, ca. 1765. Soft-paste porcelain. The Walters Art Museum, Baltimore, Maryland, 48.637–38.

all together as before, and you will have a *Popouri* [*sic*] that will yield a very agreeable smell, and that never receives any damage by time.[3]

Satisfying olfactory sensations could not only bring pleasure, but also provide medical benefits. They could soothe the ravages of time by preserving health and beauty, which prolong love. Overcoming the temporal limitations of human life through fragrance had both

pharmaceutical and religious dimensions. One finds two separate articles under the heading "Perfume" in the eleventh volume of Denis Diderot and Jean d'Alembert's *Encyclopédie* (1765), one under "Medicine and Pharmacy" and the other under "Sacred Criticism." They read:

> *Perfume* (medicine and pharmacy). These compositions do not always emit an agreeable odor; there are pleasant and unpleasant varieties.

They are divided into liquid *perfumes* and dry *perfumes*. The liquids are like scented water or potpourri. The dry ones resemble medicinal lozenges or juniper berries that one burns in a sick person's room or in hospitals to freshen stale air.

A room may be scented with orange blossom water, vinegar, ammonia salt spirits, or wine spirits placed on a stove in a tall-rimmed vial, to better diffuse the vapors.

Cephalic perfume. Take a large piece and a half of styrax calamite and benzoin; a large piece of juniper gum and incense; two scruples of cloves and cinnamon; medium-sized bay, sage, marjoram and rosemary leaves. Make a powder of all these ingredients and throw it onto hot coals, so that the sick person breathes the fumes in through the nose.

Similar compositions can be made for other uses, to induce menstruation, salivation, etc.[4]

Perfume (sacred criticism). The use of *perfume* was popular among the Hebrews and Orientals. Moses describes the composition of two types of *perfume*, one of which was to be offered to the Lord upon the golden altar, the other, to anoint the high priest and his sons, as well as the tabernacle and any vessel intended for divine use. The law prohibited any man from using the first of these *perfumes* for personal purposes, on pain of death. It was composed of equal parts hacte, onyx, galbanum and incense; *aequalis ponderis erunt omnia*, Exod. 30:34. The *anointing balm* was made of myrrh, cinnamon, aromatic cane, cassia, and olive, Exod. 30:31. It was also prohibited for any except its intended purpose, and was not to be prepared for oneself or for others. See *Anointing Oil*.

But the Hebrews had other *perfumes* for non-religious purposes, such as those found among the treasures of King Ezechai; *ostendit eis aromata & cellam odoramentorum, & unguenti optimi*, Is. 39:2. Judith perfumed herself to appear before Holophernes. The body of King Asa was displayed on a processional bed with many *perfumes: posuerunt eum super lectum suum plenum aromatibus & unguentis meretriciis*. In short, the Hebrews loved *perfumes* so much that they considered it a great misfortune to live without them and only deprived themselves of them in times of hardship. According to Scripture, men and women alike wore them. The *perfumes* used to embalm the dead of eminent rank were apparently composed of the same substances as those used by the Egyptians, from whom the Hebrews adopted the practice of embalmment. The use of *perfumes* for the dead gave birth to the idea, among the living, of employing them for sensuality. Hebrew women doused themselves with *perfume* on their wedding day.

Such was Ruth's method to please Boz and Judith's to win Holophernes' good grace.[5]

Both Le Camus's novel and the *Encyclopédie* attest to the eighteenth-century perception that fragrance brings together refined sensual experience and religious devotion. A similar meeting of these two realms distinguishes the Orlov vase, in which form, function, and iconography please the senses and uplift the intellect.

As mentioned, the Orlov vase served as a container for potpourri, perfuming the air by allowing fragrance to escape through its perforated lid. The footed vase has an ovoid shape and rises above a square plinth with truncated corners. Resting at those corners, along the diagonals, are rams' heads holding in their mouths swags of drapery that wrap around the base. These fabric festoons appear to hang from a peg marking the middle of each side. On the bowl, the decoration is distributed in a manner that defines two perpendicular horizontal axes, each featuring a pair of enamel miniatures symmetrically positioned on opposite sides of the vessel. All four of these miniatures are painted *en camaïeu*, i.e., rendered monochromatically to appear similar to chalcedony cameos. Two are formed like medallions: one depicting Flora and two putti, tending to a garden plant with a watering can; the second featuring Ceres with two putti seated on mounds of wheat sheaves. At the corresponding spots along the other horizontal axis are two handles in the form of movable rings hanging from the mouths of protruding lion masks. Below the handles appear the other two painted enamel miniatures, featuring Milo of Croton being vanquished by a lion and Hercules killing the Nemean Lion. As they had to fit below the handles, where the vessel tapers toward the foot, these two enamels are trapezoids, narrower at the bottom, and are notably smaller than the medallions.

On the top of the lid is an elaborate finial including the figurines of two putti and a cypher escutcheon, surmounted by a small crown and framed by two laurel swags. The Cyrillic letters "GGO" (standing for "Gregory Grigiorievich Orlov") are rendered against translucent dark blue *en plein* enamel, placed on top of a gold surface engraved with radiating light. To ensure that the lid could be placed in only one strictly defined position, the master goldsmith created a knob and corresponding groove on the lip of the bowl. As a result, the cypher always faces the front of the vessel, with the medallion of Flora. Another discreet but unambiguous device

marking the face of the vessel is the signature of the goldsmith engraved on the rim of the foot, where the name Ador appears below Flora and above the peg on the plinth.

Cast and chiseled garlands and laurel branches enliven the surface of the vessel with distinct sculptural qualities. Highly integrated into the overall decorative scheme, they appear as if emerging from inside the vase. The ropelike garlands are dense and heavy, suggestive of lush greenery; suspended between the lion masks and the medallions, they seem to penetrate the body of the vase. Reinforcing this notion, similar swags dangle beneath the medallions along their main vertical axes. The laurel branches display the elasticity of fresh greenery in the delicate vigor with which they frame the medallions of Flora and Ceres. Additional vegetal motifs are engraved in the recessed areas of the gold vase, covered by translucent dark blue *en plein* enamel. The resulting visual effect implies that the garlands are submerged beneath the enamel. Adding to the visual complexity, the engraved swags on the foot point up, defying gravity. Appearing both above and below the outer walls of the vessel, the floral ornaments help create the sense that our sight is moving dynamically through the surface of the vase and its interior.

The phrase "fingertips of sight" comes from Jean-Jacques Rousseau's novel Julie, ou la nouvelle Héloïse *(1761), a story of the temptation, sin, and Christian redemption of a learned woman who was capable of great passion.*

The blue *en plein* enamel appears mainly on the foot and the lid of the vessel. On the bowl, it only adorns the rings of the handles, where it seems as if a circle of blue glass runs through each handle, sandwiched between layers of gold. This visual accent further enhances awareness that the blue enameling is concentrated on the foot and the lid. One perceives

the bowl of the vase as if it is levitating, suspended above the base and beneath the top of the lid.

Applied to the surface of the vessel are three-dimensional golden clouds of perfume. Eight separate wisps of fragrance emanate from the rim of the bowl, where the aroma of potpourri might actually emerge. Above the two handles, wave-shaped puffs curve outward, and, along the same level, groups of three small clouds surround the enamel medallions. To the left and right of each medallion are corresponding swirls of fragrance, and directly above, on the lid, a fanning ornament of striated gold creates the impression that a puff of perfume ascends. This suggested skyward movement continues along the curve of the lid and culminates in the elaborate finial where billows of fragranced air swirl up, carrying with them the levitating cypher and the putti. The putti do not have to hold the cypher; instead, they join in embrace, and each extends a free arm toward the escutcheon in a gesture of adoration. Notably, this cypher is not positioned precisely on the main vertical axis. Rather, it appears slightly to the left, as if spun by the movement of the aromatic clouds. This overall composition of scented air made visible and billowing from a vessel evokes an altar, with its offering of fragrant smoke ascending to heaven.

Both the scented smoke and the floral ornaments call to mind the notion that the walls of this receptacle are dematerializing before our eyes. The illusion affirms an overall sense of fluidity and otherworldliness and creates the impression of sensing fragrance through sight. Other visual devices suggest that through sight we experience the sense of touch. The various finishes on the vessel's surface, whether burnished, matted, or chiseled, create the illusion of tactility. Individual finishes correspond to different tones of gold: yellow, green, and red. Being glossy, the blue *en plein* enamel appears only with the highly polished yellow gold. Thus, the visual play of walls evaporating intensifies as our gaze glides over these surfaces while we experience the sensation of visually penetrating them.

In contemplating this gleaming golden receptacle, the viewer experiences how sight engages and dominates other physical faculties, which affirms the privileged status granted to vision since Aristotle's classical hierarchy of the senses.[6] In this regard, the object in question emerges as an exercise involving all the human physical faculties, both the cerebral (i.e., sight and hearing) and the remaining bodily senses. This celebration of sensual intelligence and sophistication stands for the correspondingly

elevated and refined bond between the presenter and the recipient of this precious gift. The golden censer idealizes Catherine the Great's relationship with Count Gregory Orlov but also sets in motion other storylines that contribute to a general narrative, apparently dear to Catherine, about a philosopher's duties, labors, and joys.

Ador's design for the Orlov vase, as Anne Odom points out, displays a strong connection with potpourri vases manufactured at Sèvres during the 1750s and 1760s.[7] With regard to the characteristic widening of the bowl toward the lid one must acknowledge the similarly shaped *pot pourri Hébert* and *pot pourri feuilles de mirte*.[8] The latter displays handles formed from ornaments representing wisps of scented air reminiscent of the gold clouds of perfume rendered on the surface of the Orlov vase. The overall shape of the Orlov vase is also comparable to yet another Sèvres type known as *pot pourri Pompadour* or *urne Pompadour*, designed by Jean-Claude Duplessis (1699–1774). Two of these vessels belong to the collection of the J. Paul Getty Museum; both have been studied there by Adrian Sassoon (84.DE.3.1–2).[9] The archives at Sèvres show that the factory produced multiple *pot pourri Pompadour* in four different sizes: First (42–43 centimeters), Second (28–29 centimeters), Third (22.8–25.5 centimeters), and Fourth (19–20 centimeters).[10] Certainly, these standards apply to manufactured pots, and not to unique and excessively precious objects. Still, the Orlov vase must have been perceived in connection with an array of contemporaneous porcelain potpourri vessels, which could have contributed to the appreciation of its uniqueness and rich symbolism. This solid gold vessel corresponds in size to the second largest of the four standard sizes measurements for the Pompadour potpourri vases. It would appear that, among other goals, Catherine's commission to Ador aimed at elevating and perfecting a well-known kind of vase, relatively speaking mass-produced, which was already associated with fashionable refined living. The same ambition of adding layers of meanings to current industrial products manifested itself in her other commissions, notably the Green Frog and Cameo Services (cat. nos. 19, 30, and 31).

The Getty vases display an underglaze of dark blue, or *blue lapis*, which apparently was quite popular and resembles the *en plein* enamel on the Orlov vase. Apart from the general appeal of this shade, symbolism may have helped define the choice. In this context, blue evokes both the sky and the air that transmits perfumes. Other similarities between

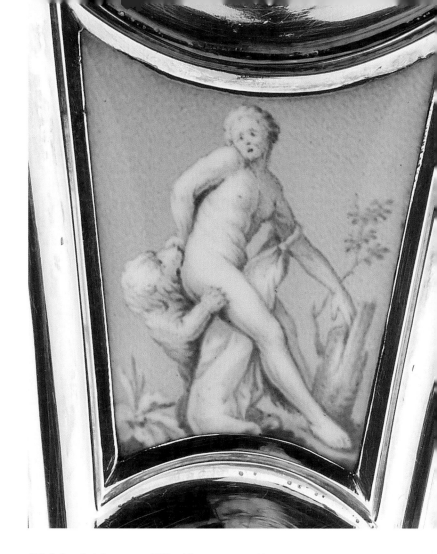

FIG. 3. Detail of the cameo of Milo of Croton, cat. no. 49.

the porcelain pots and the Orlov vase involve the inclusion of *en camaïeu* miniatures of putti. Jean-Louis Morin (1732–1787) painted the monochromatic scenes on the two Getty vases after engravings by François Boucher (1703–1770) included in his *Troisième livre de groupes d'enfants*.[11] The same sources must have informed the design for the Orlov vase's enamel medallions and putti finial.

Another French artist may have played a role in the design of the Orlov vase. In September 1766, following the advice of Melchior Grimm (1723–1807) and Diderot, Catherine the Great invited Étienne Maurice Falconet (1716–1791) to come to Saint Petersburg and take on a major commission involving the equestrian statue of Peter the Great. Falconet arrived shortly thereafter and remained in Russia for the next twenty-two years. The artist had many notable accomplishments before the start of his Russian appointment. In 1754, he had been admitted to the Académie

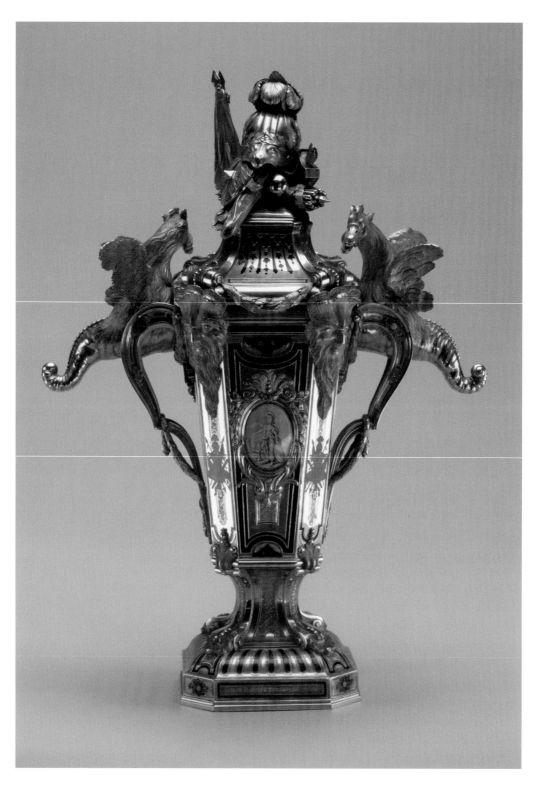

FIG. 4. Jean Pierre Ador, vase-candlestick, 1775–80. Gold and enamel. State Hermitage Museum, Saint Petersburg, Russia.

des Beaux-Arts and, approximately ten years later, in acknowledgment of his abilities as a writer, Diderot entrusted to him the essay on sculpture for the *Encyclopédie*.[12] Falconet returned to Paris in 1788 and assumed the position of director at the Académie. His son Pierre-Étienne Falconet (1741–1791) painted the portrait of Catherine the Great included in this exhibition (cat. no. 4).

The elder Falconet's presence in Saint Petersburg and his close communications with the empress when she commissioned the Orlov vase are significant for two specific reasons. First, to accept the empress's invitation, Falconet left his position as director of the sculpture studios at Sèvres, which he had held since 1757. He had detailed knowledge of its production and promoted the neoclassical style there in the creation of both figurines and vessels. A brief article from *L'Avantcoureur* in 1763 comments on a current display of Sèvres vessels and praises two of the great living artists of France, Boucher and Falconet, for their masterful designs:

> Les morceaux exécutés à la manufacture royale de porcelaïn de Sèvres sont la plûpart dignes de subsiter plus long-temps que ne le permet la fragilité de cette matière. On vient donc d'en former une suite de planches qui seront survive ces pièces à elles-mêmes; elles sont toutes de la composition de M. Boucher, & desinées par M. Falconet fils. Le burin de M. Fardieu répond parfaitement au talent des grands artistes dont il nous conserve les chefs-d'oeuvres.

> The pieces created at the Royal Porcelain Factory at Sèvres are worthy of lasting longer than the fragility of their material allows. It is therefore appropriate to create a series of etchings that will survive these objects themselves; they are all created by Mr. Boucher and designed by Mr. Falconet Jr. The engraving pen of Mr. Fardieu perfectly befits the talent of the great artists and can preserve their masterpieces.[13]

A notable departure from the Rocaille flair that distinguishes the older production of Sèvres, the new designs for vases created during Falconet's directorship displayed perfect symmetry and classical architectural elements. A good example are the vases shaped as truncated fluted columns, which also resemble water fountains (*vases à jet d'eau*; fig. 2).[14] Most likely, Falconet helped create another whimsical design in 1762 that featured very large cylindrical vases in the form of fortification towers (*vases en tour*), equipped with machicolations and cannons and surmounted by tiled domes.[15] Falconet's neoclassical vessels display a clarity and crispness that is both formal and conceptual. Their shapes are symmetrical and display architectonic vigor, as well as unambiguous and seemingly plausible representational elements, whether perfumed air made visible, a fountain, or a fortification tower. All of these qualities enhance the logical whimsy that very much applies to the Orlov vase as well.

The second piece of evidence that points to Falconet's influence on the Orlov vase is the likeness of Milo of Croton (fig. 3) rendered on one of the *en camaïeu* enamels. Falconet had taken this ancient hero as a subject frequently, with notable success. For example, in 1754 the sculptor was admitted to the Académie with a large marble group showing the demise of Milo, now at the Louvre (MR 1847).[16] The enamel miniature on the Orlov vase, however, reproduces a sculpture by Pierre Paul Puget (1620–1694) from 1682. Puget's famous marble was on display in the garden at the Château de Versailles until 1819, when it was moved to the

FIG. 5. Detail of Ador's signature, cat. no. 49.

Louvre (MR 2075). In 1760, Falconet delivered a speech at the Académie in which he discussed Puget's work, including his sculpture of Milo: "[an aspect of sculpture lacking in the works of the ancients] has been brought in our own day to a higher degree of perfection. In what Greek sculpture do we find the impression of skin, of the softness of the flesh and the fluidity of blood, so excellently rendered as in the works of this celebrated modern sculptor."[17]

In contemplating this gleaming golden receptacle, the viewer experiences how sight engages and dominates other physical faculties, which affirms the privileged status granted to vision since Aristotle's classical hierarchy of the senses.

In this lecture on the superiority of modern over ancient sculpture, Falconet argues that modern sculpture had certain qualities previously considered as belonging exclusively to the realm of painting as they involved the use of color and accordingly could be perceivable only through sight. Ultimately, the question was about the purely visual versus the tactile aspects of sculpture. The broader context in which these arguments fit concerns the reevaluation of the relationship between senses and ideas that evolved throughout the eighteenth century. Diderot asserted that all ideas derive from senses and all five senses are a form of touch. The rendition of Puget's statue of Milo on the Orlov vase brings to mind Falconet's views. This paragon of modern sculpture, with its qualities Falconet would have compared to those of painting, appears in the form of an actual painting, but one that evokes associations with engraved stones, commonly called "antiques" at the time. The layered juxtapositions of sculpture and painting, sight and touch, modernity and antiquity helped establish a conceptual framework that would enable the most meaningful experience of the Orlov vase by emphasizing the complex dynamic among sight, smell, and touch.

TWO GOLDEN VASES BY ADOR

During his stay in Saint Petersburg, Ador made two solid gold vessels of different form and function that resemble one another in size and surface decoration: the Orlov vase and a vase in the collection of the State Hermitage Museum in Saint Petersburg (Э-4448) that is equipped to serve as a two-light candelabrum (fig. 4). The candleholders of the latter are revealed only when one pulls back the upper parts of two prominent dragon ornaments; needless to say, the implicitly fire-breathing dragons as the subjects here are a wittily appropriate choice. A masterfully disguised hinge connects the movable top to the fixed bottom of these figurines. This vessel bears the goldsmith's signature prominently engraved on the front of the base ("ADOR a ST PETERSBOURG"; fig. 5), but the hallmark for the city that would also contain the year is unreadable. Olga Kostiuk, of the Hermitage, dates this work to the late 1770s.[18] The last time Ador's two gold vases were displayed together was in an exhibition of Russian treasures in Saint Petersburg in 1904. The undated vase had been in the Winter Palace confirmedly in the late eighteenth century. In the early 1900s, it was in the rooms of Empress Alexandra Fedorovna (1872–1918), who loaned the candelabrum vase to the organizers of the exhibition. At that time, the Orlov vase was in the collection of Count Anatolii Vladimirovich Orlov-Davydov (1837–1905), often spelled "Orloff-Davidoff," who was a descendant of the youngest brother of its original owner.[19] The respective ownership of these two remarkable *objets d'art* at the turn of the twentieth century can be construed as indirect evidence for their older history. It seems plausible that they descended through the families of their respective original owners—Catherine the Great and Gregory G. Orlov. Conceivably, the two objects were created at the same time, each intended for one member of this illustrious couple.

The cypher of Count Gregory Orlov confirms that Catherine the Great commissioned the potpourri vase for him. He was an officer of the imperial guard and an accomplished warrior who greatly distinguished himself in the course of the Seven Years' War (1756–1762). Orlov's cypher appears on other notable gifts that she bestowed on him, including the Marble Palace in Saint Petersburg and the Gatchina Palace in the country. The Orlov Porcelain Service, produced at the imperial factory in Saint Petersburg, displays the same monogram and includes vessels whose finials feature two embracing putti (cat. no. 17 A–B). The candelabrum vase refers to Orlov through its elaborate trophy finial, topped by a richly plumed helmet whose visor takes the form of an eagle's head—the family name Orlov derives from the Russian word for eagle. On both vessels, the

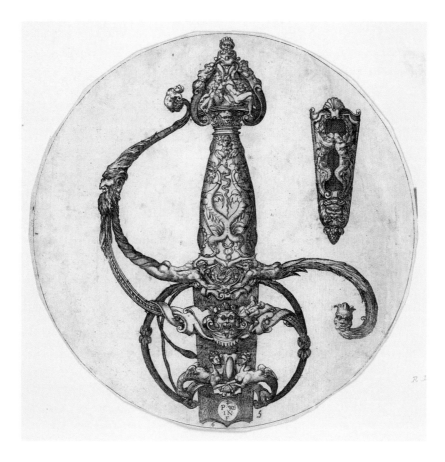

FIG. 6. Pierre Woeiriot de Bouzey (1532–1596), design for a sword hilt, 1555. Engraving. Museum of Fine Arts, Boston (30.1087)

en camaïeu enamel miniatures depict paragons of feminine and masculine virtue; it seems that the vase, more feminine in shape, was meant for the gentleman, while the second, manlier-looking vessel was designed for the lady. Thus, each of these objects would have reminded its respective owner of his or her partner, standing in for the absent beloved in a most exquisite manner.

Outside of Russia, the candelabrum vase has attracted little attention and what has been said about it consists of harsh and most undeserving judgment. The distinguished art historian Marvin Chauncey Ross wrote in 1942, "The second gold vase by Ador that formerly belonged to Empress Alexandra Fedorovna is far less pleasing and much more elaborate in design, showing very decidedly the influence of Russian taste on Ador. Although set with enameled cartouches and with the gold carefully finished in a different way, it has graceless and elaborate handles of fantastic animals flanked by heavy masks, the whole surmounted by a

group of trophies. The same skillful craftsmanship is to be found here but the pleasing rococo outlines of the Walters vase are conspicuously absent, amply justifying the belief that the Walters vase is Ador's masterpiece."[20]

Despite Ross's beliefs, it seems likely that Falconet either designed this vase or influenced its form through the knowledge he imparted of his recent and innovative creations for Sèvres, in particular the military-themed tower vases. The martial theme manifests itself in the two cameo-like enamel miniatures of Minerva and Mars. Each deity stands in the midst of a landscape with attributes alluding to his or her victories on the battlefield: Minerva in front of a fortress; Mars next to a temple front, with the conical shape of either a hill or a tent behind him (the latter appear regularly in scenes of army life). The entire vessel deliberately evokes associations with royal tents used during military campaigns. Most often rectangular or polygonal in plan, these tents commonly featured vertical stripes and roofs with scalloped edging and tassels. Although

many images document the appearance of such tents, their descriptions in written sources are fairly rare. One appears in the *Gazette de Hollande* from July 11, 1735:

> . . . on vient de faire pour le Roi une très belle tente, dans laquelle il y a plusieurs chambres. Elle est doublée de damas vert et l'on doit y ajouter des galons et des crépines d'or. Le Roi s'en servira la campagne prochaine.

> . . . we just made a very beautiful tent for the King, consisting of several rooms, it is made of green damask with added stripes and gold fringe. The King will use it in his next campaign.

Another source refers to the trophy ornaments painted on tent walls:

> Le Roy voulut qu'à cette revûë les Officiers eussent des cuirasses & des tentes peintes avec des trophées

> The King wanted to review the officers and ensure that they had breastplates and tents painted with trophies [21]

The candelabrum vase's lid has the distinct shape of a tent's roof, with what resembles fabric coming down from the high pitch and curving toward the walls. The characteristic scalloped edging appears here in dark blue *en plein* enamel. Furthermore, the front, the back, and the faces of the four truncated corners feature ornaments that look like tall and narrow boiseries (carved wood wall paneling) and refer to the fabric of tent walls. The small-scale trophies rendered in enamel reflect the custom of painting such ornaments on the walls of these tents.

The candelabrum vase features two symmetrical sets of double handles reminiscent of forged iron parts as on a mechanical device or a handheld weapon. Notably, this feature relates to another design associated with Falconet's impact on Sèvres: the model of the "metal fastened" vase or *vase ferré*.[22] These associations further emphasize the martial character of the Ador vessel, whose prominent handles might be compared to the guard of an upright sword's hilt. Both would use two expanding and curving symmetrical elements attached to the same body at two different points, very closely at one end and spaced out at the other. On the vase, these elements are the top and the bottom of the bowl, while on the hilt of a sword these points would be the pommel and on the other end of the grip—the cross-guard. Even the masks, positioned at the corners just below the vase's lid, strongly resemble certain apotropaic details seen in

FIG. 7. Electron microscope photographs of cat. no. 49.

designs for sword hilts widely known through prints, such as the work from 1555 by the French engraver Pierre Woeiriot de Bouzey (1532–1599) (fig. 6). When fully deployed as a double candelabrum, the Ador vessel might even call to mind an image of two swords of light lifted up victoriously against the darkness.

Acknowledging these references to warfare is only the first step in appreciating their significance. In fact, in a lighthearted and fanciful manner, one is invited to partake in the symbolic martial endeavor of slaying dragons. Every time one puts a light in one of the candleholders, one must break the neck of its dragon figurine where the moveable upper half is hinged to the fixed lower one. In the context of this whimsical combat, one cannot help but see light as the triumph of good over evil and appreciate the symbolic connotation of gold as materialized otherworldly light.

THE ENAMEL MINIATURES ON THE ORLOV VASE

The Russian term that applies to the enamel miniatures on the Orlov Vase is *drobnitsa*, a word that conveys the notion of something small and derives from the verb *drobit'*, which means "to fraction, to parcel, to divide." The miniature size unambiguously signifies preciousness, but the most prominent cultural connotations of the term *drobnitsa* stem from its common use in the realm of ecclesiastical art, where it refers to the various application ornaments, frequently rendered in enamel, that appear in the decoration of gospel book covers (cat. no. 15) as well as vessels and garments used in liturgical services. These enamels commonly feature strong colors and depict Christian subjects. In contrast, the miniature paintings on the Orlov vase are monochromatic, rendered to bring to mind carved stones, hence the term *en camaïeu* ("cameolike"), and present ancient pagan subjects. In spite of these differences, the act of

using the proper Russian term to designate these faux cameos brings with it a set of liturgical references and associations.

The artist who created the four *en camaïeu* enamel miniatures on the Orlov vase did not leave his signature. He could have been Jean-Pierre Ador or an enamellist who worked very closely with the goldsmith. The evidence is in the precision with which the copper plates fit the complex configuration of the vessel and the fact that the enameling of the medallions' surface reflects the precise position of the framing laurel branches. Remarkably, the areas where the laurel leaves actually overlap with the miniatures are not covered with enamel; instead, the surface of the copper plate remains exposed (fig. 7). Furthermore, the composition of at least one of the miniatures was changed midway though its creation. All these features reveal aspects of a creative process that Ador at least masterfully coordinated.

TIME OF GROWTH AND ABUNDANCE: FLORA AND CERES

On the front of the Orlov vase the enamel medallion shows Flora, the pagan goddess of spring and vegetation, accompanied by two putti (fig. 8). The goddess holds a watering can and is tending to a garden plant with large leaves reminiscent of an acanthus. To the right, the architectural background features a façade with superimposed engaged columns, while to the left is an unattached arcade, akin to an aqueduct. Traces of under-drawing, rendered in blue, show that the original intention was to have symmetrical façades on both sides of the background, but instead to the left the arcade was painted.[23] This change made Flora's gesture of wielding the watering pot the unambiguous focal point of the composition, without any distractions or confusion caused by overlapping minuscule details. The aqueduct supports the idea of the goddess as bearer of vital bounty while providing the literal source for the water she pours. As if performing a ceremony at an altar, Flora faces a large urn on top of a plinth that occupies the composition's left middle ground. The urn strongly resembles the Orlov vase in shape, so one might say this *en camaïeu* enamel depicts the vessel it adorns. The miniature, which is the focal point of the vase's iconographic program, deliberately brings together the images of two vessels with the figure of the life-giving goddess of growth and greenery, thus rendering visually the notion of femininity as the receptacle of life.

The medallion on the back of the vase shows another maternal deity, Ceres, goddess of agricultural fertility, grain crops, marriage, and

FIG. 8. Detail of the cameo of Flora, cat. no. 49.

nourishment, again with two putti (fig. 9). Holding a sickle in her right hand, Ceres wears a wheat wreath on her head and reclines on wheat sheaves after an apparently abundant harvest. Predictably, after growth during the spring (Flora) comes harvest in the summer (Ceres). The composition also explains the sources of abundance and prosperity. One of the putti holds calipers or compasses, the measuring instruments used in architecture, cartography, and astronomy. Calipers are the traditional attribute of the rule-bound genius, and they stand for rational philosophy and mathematical order, the tool with which order can be imposed upon chaos.[24] In medieval art, God the Father appears with calipers in hand during the creation of the world.

The calipers are not a standard attribute of Ceres, so their inclusion in this composition calls for explanation. It would appear that recent events informed this choice. The *Nakaz* or *Instruction of Her Imperial Majesty*

Catherine the Second for the Commission Charged with Preparing a Project of a New Code of Laws (cat. no. 24), which the empress wrote over the course of two years, starting in 1765, embodied her commitment to rational philosophy, science, and the rule of law. In 1766, while still composing this extensive treatise, Catherine showed it first to her partner, Count Gregory Orlov, and then to her advisor Count Nikita Panin (1718–1783). Only after their input did she send the text in German translation to Frederick the Great (reign 1740–1786) of Prussia and in French to Voltaire (1694–1778). On December 14, 1766, she issued an imperial decree calling for the formation of a legislative commission charged to convene in Moscow in order to overhaul Russia's entire legal system. This commission was called "all-Russian" because it included members representing the entire vast empire, encompassing many creeds, ranks, and occupations although not serfs. These were the representatives of all free estates of the realm, namely the nobles, townspeople, merchants, and state peasants. Remarkably, this was the precise topical association between Catherine the Great and Ceres. This goddess served as the protector of the plebeian laws of the Concilium Plebis, i.e., the People's Assembly of Rome. This ancient Roman institution survived the fall of the Republic and became completely dominated by the emperors of Rome. For Catherine, the figure of Ceres exemplified the important function of bringing together the themes of femininity, prosperity, and good government through the assembly of people in the realm.[25]

During the time Catherine was composing the *Nakaz*, with her strong encouragement, Orlov founded the Free Economic Society (Vol'noe Ekonomicheskoe Obshchestvo) as the very first public institution of the Russian Empire, abolished only in 1918 after the Bolshevik revolution. The Free Economic Society was officially established on January 1, 1766, to improve Russian agriculture.[26] Shortly after, the society received a letter sent by a concerned person who signed with the Cyrillic "I.E." These initials stood for "Imperatritsa Ekaterina" ("Empress Catherine"), who posed the question "What is more beneficial for society—for a peasant to own his own land or only movable property; how far should a peasant's rights extend with regard to each of these two types of property?" Even before the Legislative Commission convened, Catherine knew that her liberal program for gradually freeing the serfs would not work. Indeed, she wrote into the *Nakaz* a proposal to allow serfs to save money in order to buy their freedom with the permission of their owners, but these paragraphs were struck during preliminary discussions with advisors and senators. Even so, the virulent opposition of the

conservative aristocratic majority to any attempt at bettering the lives of serfs was astounding to her. Preparing for this battle and hoping to influence public opinion, Catherine and Orlov embarked on a program of educating a larger audience through the work of the Free Economic Society. In response to her question, the organization announced an international competition to write a treatise to answer it. The winner of the award was Beardé de l'Abbaye (ca. 1735–1771), a French agricultural writer from the Académie de Dijon. De l'Abbaye promoted the idea that peasants must be freed from the bonds of the land to ensure successful agriculture. Count Gregory Orlov and his brother Vladimir Grigorievich, both of whom shared Catherine's conviction that serfs should be freed, even though they owned thousands of them, paid for the treatise to be published in both the original French and in a Russian translation. Remarkably, the Orlov vase descended through the heirs of Vladimir Grigorievich.

The writing of the *Nakaz* and the summoning of the Legislative Commission was one of the triumphs during the early years of Catherine's reign. Delegates to this assembly jointly decided to bestow on her the title "the Great." Count Orlov and two of his brothers were members of the all-Russian assembly, and the empress associated this entire endeavor closely with her partner at that time. As the vase was a gift for Orlov, it is hardly a surprise that it would emphasize their bond. Of course, there was much that linked them by that time. They had a son, Aleksei Grigorievich Bobrinskii (1762–1813), born April 11, only three months before the coup d'état on June 28. The son's age was to parallel the length of her reign. In 1768, at the time when the empress commissioned the Orlov vase, Aleksei was reaching the age when a child would leave the nursery and begin to wear men's clothes. On the occasion of his seventh birthday, Catherine commissioned a formal portrait by Carl Ludwig Christineck (1732–1794), now in the collection of the Hermitage (ЭЖ 1407).[27]

Gregory Orlov and his four brothers were ardently loyal to the empress, but their sudden rise to wealth and prominence was widely resented; there was even a conspiracy to assassinate all five of the Orlovs. A great deal of tension between Catherine and Gregory Orlov existed on account of his insistence to marry her. Now that she was an empress and her first husband was dead, Orlov felt that he had earned the right to marry the mother of his son. Inquiries were made in the hope of discovering a precedent in the secret morganatic marriage of Empress Elizabeth (reign 1741–1761) to Count Aleksei Grigorievich Razumovkii

FIG. 9. Detail of the cameo of Ceres, cat. no. 49.

FIG. 10. Detail of the cameo of Hercules, cat. no. 49.

(1706–1771). Of course, Catherine understood very well that a marriage would damage her power. Some of her advisors spoke quite candidly; Panin famously said, "Madame Orlov can never be an empress."[28] Accordingly, Madame Orlov never came to be. To soothe her partner's feelings, Catherine showered him with gifts and honors. She was Orlov's unwed wife and, as she admitted, she would have remained faithful to him—she was by all accounts a serial monogamist—were it not for his impatience and numerous flagrant indiscretions. In addition, there was the issue of intellectual disparity: Orlov was not a match for Catherine's erudition, wide knowledge, and scholarly ambitions. Indeed, one of the most appealing aspects of his persona was his sincere and ardent desire to compensate and live up to her standards.[29] He became the patron of the most prominent scholar and poet of Russia, Mikhail Vasilievich Lomonosov (1711–1765). In December 1766, Orlov even reached out to Rousseau, who had been exiled from France the previous year, to offer him asylum at his residence in Gatchina. Rousseau politely declined,

blaming his advanced age and poor health. Orlov wanted his efforts at becoming a man of letters and pursuing science to impress Catherine and make her appreciate his accomplishments. All four of the *en camaïeu* enamel miniatures reflect these complex circumstances.

In the Ceres medallion, the second of the putti sits atop a mound of wheat sheaves and holds upright a simple tree branch. This attribute alludes to the sacred functions of the goddess in the course of wedding ceremonies.[30] In Rome, during bridal processions, in which men could not participate, a young boy would carry a torch made from the branch of a May tree, or hawthorn. Pliny the Elder states that this tree was the symbol of Ceres because of its associations with fertility. The two medallions depict feminine virtue and emphasize the fact that Catherine was the mother of Orlov's son and that she was his wife in all but name. The two smaller enamels display images celebrating male heroism and show the empress's desire to express her appreciation for Orlov's character and achievements.

MILO OF CROTON, HERCULES, AND DAVID

The two miniatures below the lion-mask handles of the vase depict Milo of Croton vanquished by a lion (fig. 3) and Hercules slaying the Nemean lion (fig. 10). The iconography of the former, as mentioned, repeats Puget's famous marble statue, alluding to the mid-eighteenth-century discourse about the senses and ideas to which Étienne Maurice Falconet contributed. In addition, the story of Milo was relevant in its own right. One of the most famous athletes of antiquity, he was born in south Italy in an ancient Greek colony and achieved the rare distinction of being a six-time wrestling champion, at the sixtieth and from the sixty-second to the sixty-sixth Olympiads, 532 to 516 BCE. The Greek philosopher and geographer Strabo (64 BCE–24 CE) called Milo "The most illustrious of athletes."[31] Several notable works of art interpret Milo's demise, including a ceremonial shield by Antonio del Pollaiolo (1429–1498), a bronze sculpture by Alessandro Vittoria (1525–1608), Puget's marble, Falconet's marble, and a painting by Joseph-Benoit Suvée (1743–1807).[32]

As the story goes, after reaching an advanced age, Milo caused his own death by attempting to prove to himself that he still possessed immense strength. While in a forest he encountered a tree, the trunk of which had been partially split by workers who had inserted wedges into it. Milo attempted to finish the job with his bare hands. His initial success in slightly separating the stump allowed the wedges to fall out, but as it

sprang back together his hands were caught, leaving him easy prey for a lion or a pack of wolves, depending on the source. The Greek historian Diodorus Siculus (active 60–30 BCE) summarized the moral of this story: "It is no great thing to possess strength, whatever kind it is, but to use it as one should. For of what advantage to Milo of Croton was his enormous strength of body."[33] Another example of a statement encapsulating the valuable lesson derived from Milo's fate is found on Pollaiolo's shield, on which the Latin inscription reads, "It is a wise man's [part] to rest after victory. For nothing is so secure that it is not endangered by weakness."[34]

The layering of associations and allusions ultimately affirms a very traditional and predictable form of devotion: a Christian prayer.

Certainly the story of Milo's death is a cautionary tale about ignoring the limitations of human nature and failing to be happy with what has already been achieved, a stern message from Catherine to her lover. Yet, there was also an uplifting aspect to her multilayered statement. Milo serves as a paragon of dedication to heroic exploits; a true hero never misses an opportunity to challenge himself and to accomplish a notable deed even if doing so leads to a tragic outcome. At the end of his life, Milo's heroism was solely for the sake of heroism itself—*héroïsme pour l'héroïsme*. Furthermore, Milo's combination of physical strength and athletic prowess with intellectual accomplishments made him stand out among the heroes of the ancient world. He was a friend and a student of Pythagoras (ca. 750–ca. 495 BCE). That great mathematician and philosopher founded an esoteric religious movement based on metaphysical beliefs that included, among other principles, the first theory and practice of vegetarianism. Milo is credited with saving the life of Pythagoras and some of his followers during a fire at a house where they were gathered. The hero is said to have supported with his shoulders the collapsing roof, thus enabling all to escape.

Milo was also a fearless warrior, who took to combat on behalf of his fellow citizens of Croton against the attacking Sybarites. Wearing his

Olympic crowns, he entered this battle in the guise of Hercules, dressed with a lion's skin and wielding a club. His defeat by a lion may have been caused by his presumption that he was equal to a divine hero. This last story sheds light on the iconography of the small enamel placed below the right handle of the Orlov vase, which shows a man slaying a lion, a direct reference to Hercules's first labor. The hero, however, is already wearing a lion skin, which Hercules obtained as his trophy only after killing the Nemean beast. The traditional iconography of Hercules's first exploit features him in hand-to-hand combat with his animal adversary. In contrast, the lion on the *en camaïeu* enamel, seemingly oblivious to the impending danger, strikes a graceful heraldic pose. This detail adds an emblematic character to the miniature, which, along with the element of chronological incongruity, invites allegorical readings. The two enamels that appear below the lion masks (Milo and Hercules) together suggest the limitations of physical strength deprived of divine support. King David, the essential Christian lion-slayer, also comes to mind. Saul considered the seemingly weak youth unfit for combat with the powerful Philistine warrior Goliath, to which David replied that while tending to his herd he had slaughtered attacking lions and bears.[35] God had chosen David—"a man after My own heart, who will do all My will"—and thereby enabled these feats.[36] In return, David employed his genius for prayer in the Book of Psalms. The Hebrew king famously compared one of his invocations to the burning of incense, its smoke billowing toward the sky: "May my prayer be set before you like incense; May the lifting up of my hands be like the evening sacrifice."[37]

THE ORLOV GOLD CENSER AND ITS LITURGICAL CONNOTATIONS

This psalm provides the lyrics for one of the most popular ecclesiastical chants, performed regularly at vespers at least since the fourth century CE. Following the Old Testament tradition, at sunset Christians make an offering of incense, light a lamp, and pray in the hope that their faithful souls will survive the darkness of the night and be able to meet the new day. The verses of this psalm have been sung to multiple tunes over the centuries, but in the Russian Orthodox church one of the most popular versions of the chant was composed by a musician Catherine the Great employed, Dmitrii Stepanovich Bortnianskii (1751–1825), who served as the master of the Saint Petersburg Court Capella.[38]

The overall design of the Orlov vase represents that memorable image from the psalm, a column of perfumed smoke ascending into heaven and understood as the embodiment of prayer. Even the expressive lifting of

the hands is incorporated into this complex composition in the form of the putti's gesture of adoration. The layering of associations and allusions ultimately affirms a very traditional and predictable form of devotion: a Christian prayer. While an act of supplication to God is hardly an innovation, one must bear in mind that we have arrived to it while contemplating this remarkable *objet d'art*, and in doing so we satisfied our discerning senses, challenged our knowledge of mythology, history, and economics, and provoked our wit.

The meanings that a cloud of perfume surrounding a potpourri vase can convey in a refined eighteenth-century interior may have had a specifically Russian component. In Russian the same word (*kuril'nitsa*, a noun derived from the verb *kurit'*, meaning "to smoke, to fume") designates a potpourri vase and a censer, whether used in a church or at home in front of family icons. Thus, the Russian language contains the link between a fashionable vase for dry perfumes and a liturgical censer. Well-known and often performed works of liturgical poetry in which the trope of a golden censer symbolized the Holy Virgin perpetually reinforced awareness of this connection. Along with other Old Testament prefigurations of the Mother of God, this imagery comes mostly from the text of Exodus 25, in which God instructs Moses how to set the tabernacle and an altar with the appropriate sacred vessels. The image of a censer appears in the liturgical services for all three of the great feasts dedicated to the Holy Virgin: Dormition of the Virgin, August 15 ("candelabrum of immaterial light, a golden censer of the divine ember"); Birth of the Virgin, September 8 ("golden censer, with the ember of the Word of God"); and Presentation of the Virgin into the Temple, November 21 ("scent of the perfume of righteousness").[39]

Another liturgical poem, the presumed author of which is the eighth-century patriarch of Constantinople Saint Germanos and known as "From Above the Prophets," contains a list of the most popular prefigurations of the Holy Virgin, often interpreted visually in icon and mural paintings:

> From above the prophets foretold you, O, Maiden:
> A vessel, a scepter, a tablet [of the law], an ark, a candelabrum,
> An altar, a mountain, golden censer

> A tabernacle, a closed door,
> A palace and ladder and a Lord's throne.

Similarly, the Akathist hymn ("Unseated hymn"), possibly a seventh-century Byzantine composition, contains numerous salutations to the Mother of God, almost all rendered in metaphor. Two of these images relate to the notion of fragrance and incense: "Hail, acceptable incense of intercession" (stanza 5, verse 14); "Hail, scent of Christ's fragrance" (stanza 21, verse 16). The hymn deliberately uses different images of the Virgin and strictly avoids repetition, except for one verse that recurs. The entire hymn contains 306 verses divided into twenty-seven stanzas, fifteen of which conclude with the salutation "Hail, bride unwedded."[40] It is difficult to imagine that this popular liturgical poem and its most repeated verse did not inform Catherine's conception for the Orlov vase. After all, she was indeed the unwed bride of the man who received this precious vessel as a gift. The golden receptacle affirmed the bond between the two partners but also emphatically stated Catherine's exalted status through her association with the Mother of God as an empress and as the head of the Orthodox church. In addition, both the Akathist hymn and Germanos's poem were performed only during periods of strict fasting, when church rules do not allow such joyous ceremonies as weddings, reinforcing the notion that the marriage was impossible.

In presenting this golden vase, Catherine allegorically offered her femininity to Orlov. Her evocation of prayer affirmed their spiritual bond, as if the two of them made a joint supplication, hoping to meet the new day together. Still, however blissful the couple's union became, at its best, it would never be an actual marriage. In the conception and perception of this neoclassical *objet d'art*, liturgical symbolism and the ecclesiastical calendar played an essential role. The Orlov vase shows how various images associated with communal prayer became the source of private spiritual experiences in the domestic sphere, adding yet another layer of intrinsic brilliance to the sophisticated life of enlightened individuals in the later part of the eighteenth century.

END NOTES

1. www.aif.ru/culture/article/34576. Last visited July 26, 2013.

2. Lichtenstein.

3. Le Camus, 103–4. I thank Dr. Mimi Hellman for the reference to *Abdeker*. For a recent discussion of Le Camus's novel see Vigarello.

4. Trans. Gillian Stumpf. http://quod.lib.umich.edu/cgi/t/text/text-idx?c=did;cc=did;rgn=main;view=text;idno=did2222.0002.571. Last visited July 26, 2013.

5. Trans. Gillian Stumpf. http://quod.lib.umich.edu/cgi/t/text/text-idx?c=did;cc=did;rgn=main;view=text;idno=did2222.0002.570. Last visited July 26, 2013.

6. Sorabji.

7. Odom 1996, 96.

8. For the former, see Wallace Collection C254, C255; Walters 48.577. For the latter, see Wallace Collection C257–8; Huntington 27.27, 27.28; also one such vessel, missing its lid, is in the Hermitage.

9. Sassoon 1991, 12–19.

10. Ibid., 16 n. 1.

11. Ibid., 14.

12. http://quod.lib.umich.edu/cgi/t/text/text-idx?c=did;cc=did;rgn=main;view=text;idno=did2222.0000.166. Last visited July 26, 2013.

13. *L'Avantcoureur: feuille hebdomadaire* 129 (1763), 102. This article refers to "M. Falconet fils" ("Mr. Falconet Son"); indeed Étienne Maurice Falconet had a son who was an artist—Pierre-Étienne Falconet (1741–1791; see cat. no. 4). Still, it was the father who designed vessels for Sèvres; on this topic see Ennès.

14. Ennès 1987 and 2001; see also Muriel Barbier on the website of the Musée du Louvre, www.louvre.fr/en/oeuvre-notices/pair-fountain-vases, last visited July 26, 2013.

15. Huntington 27.31, 27.32; Metropolitan Museum of Art 56.80.1a–c.

16. Schenker, 23–28, 196–97, and 324 n. 15.

17. *Réflexions sur la sculpture: Lues à l'Académie royale de peinture et de sculpture, le 7 juin 1760* (Paris: Prault, 1761), 32–33; cited according to Lichtenstein 79, trans. Chris Miller.

18. Kostiuk, 154.

19. Orlov-Davydov was the son of Vladimir Petrovich Davydov (1809–1882), who in 1856 was granted the title of Count Orlov as he was the last descendant of this clan through Countess Natalia Orlova (1782–1819), the daughter of Vladimir Grigorievich Orlov (1743–1831), youngest of the five Orlov brothers. The brothers' rise to wealth and prominence was due to their active role in the 1762 coup d'état that secured Catherine II's ascent to the throne. Vladimir Petrovich, the first Count Orlov-Davydov, was a famous art collector. Count Aleksei Anatol'evich Orlov-Davydov (1871–1935), son and heir of Anatolii Vladimirovich, died in Paris, where he emigrated after the Bolshevik Revolution in 1917. It is possible that, like many other émigrés, he was able to take with him some family treasures.

20. Ross 1942, 124.

21. Daniel, 2:397–98.

22. Louvre, 1763, and Wallace, late 1760s.

23. This intriguing detail concerning the evolution of this composition was revealed during a close examination of the Orlov vase with an electron microscope at the Conservation Studio of the Walter Art Museum in January of 2013. I wish to express my gratitude to Meg Craft and Jo Briggs, who made possible and carried out this examination.

24. Menaker.

25. Spaeth, 84–91.

26. Shinkarenko.

27. Piotrovski, 40–41, no. 8.

28. Troyat 1980, 169–72; Madariaga, 208–10; Rounding, 168–70; and R. Massie, 313–21.

29. *Mikhail Lomonosov and the Time of Elizabeth I*, 217–35.

30. Spaeth, 43–47.

31. *Geography*, 6.1.12.

32. Pollaiolo: Musée du Louvre, painted and gilded gesso on leather covered wood; Vittoria: bronze, ca. 1590, Galleria Franchetti, Ca' d'Oro, Venice; Puget: Musée du Louvre; Suvée: oil on canvas, 1763, Groeningemuseum, Bruges, Belgium.

33. Historical Library, 9.14.1. A translation into Russian appeared shortly after the Orlov vase was created, cf. Ivan Alekseevich Alekseev (1735–1779), Diodorus Siculus 1774–1775.

34. Wright, 296, no. 62, and 526–27.

35. Cf. 1 Samuel 17:33–35: "And Saul said to David, You are not able to go against this Philistine to fight with him: for you are but a youth, and he is a man of war from his youth. /And David said to Saul, Your servant kept his father's sheep, and there came a lion or a bear, and took a lamb out of the flock. /And I went out after him, and smote him, and delivered it out of his mouth . . . and slew him."

36. Acts 13:22.

37. Psalms 141:1–2.

38. Before assuming this position, in 1779, Bortnianskii was sent to Italy for musical education, where he worked in the retinue of Count Aleksei G. Orlov as an interpreter and a diplomat in the course of the First Rosso-Turkish War (1768–1774). See Kovalev-Sluchevskii.

39. On the symbolism of the golden censer in connection with Byzantine depictions of the Dormition of the Virgin, see Evangelatou.

40. Peltomaa, 1–19.

THE GREEN FROG SERVICE

ASEN KIRIN

In 1773, Catherine the Great placed an order with the English industrial potter Josiah Wedgwood (1730–1795) for a creamware dinner and dessert set for fifty people. The Green Frog Service, as it came to be known because of the crest featured on the dishes (fig. 1), is now in the collection of the State Hermitage in Saint Petersburg. Very few pieces are found outside of Russia, and we are fortunate to have on display in this exhibition two of the plates located in the United States (cat. nos. 30 and 31). The Green Frog Service has attracted a great deal of attention from scholars and collectors, including Michael Raeburn, who published a magnificent volume in 1998 with Liudmila Voronikhina and Andrew Nurnberg that remains the most comprehensive study on this topic.[1]

Created around 1750 in Staffordshire, England, cream-colored earthenware was fairly affordable and similar in appearance to porcelain, which was highly desirable but extravagantly expensive. Throughout the 1760s, Wedgwood successfully experimented with creamware to meet the growing demands of an emerging middle-class market.[2] Found all over Europe, creamware commanded universal appeal and, accordingly, appeared not only in modest dwellings and inns, but also in palaces. For Catherine, the attraction was the great popularity and perceived modesty of creamware. She required it, however, to be adorned with painting that infused the dishes with multiple layers of meaning. She conceived the combination of modest material and sophisticated decoration as a gesture celebrating a refined simplicity widely appreciated during the Enlightenment. Certainly, any elaborate dinner set fits into the millennia-old tradition of creating vessels of visual appeal to be used in formal dining as conversation pieces, thus elevating the overall experience. The novel aspect of the Green Frog Service was the deliberate choices Catherine made in accomplishing this goal.

Catherine the Great's specific requirements for this commission made it a truly monumental task and Wedgwood's most famed endeavor. This service consists of 952 pieces on which, in a monochromatic manner, 1,222 different views of England were painted without a single one repeated. The scenes depict real landscapes, gardens, natural wonders, and numerous buildings (castles, churches, palaces, bridges)—many but not all in the Gothic style. Ultimately, this visual program elevated the humble earthenware dishes and made them akin to a collection of drawings or etchings.

Catherine collected drawings and prints and loved poring over them. Her fascination with the hand-colored prints of the frescos in the Vatican Loggia is well documented and much discussed because it inspired her to make new commissions in art and architecture. Viewing her collection of etchings was one of the great privileges enjoyed by guests granted the utmost honor of being included in the informal small private gatherings in the Hermitage at the Winter Palace in Saint Petersburg. Late in Catherine's long reign, the young Countess

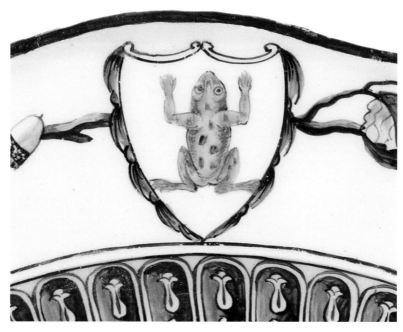

FIG. 1. Detail of the Green Frog crest, cat. no. 30.

Varvara Nikolaevna Golovine (née Princess Galitzine, 1766–1819) included in her memoirs a description of the gatherings she attended there. Together with a few other guests, the countess was able to look at prints in the Diamond Room—the special chamber in the empress's private apartments where the crown jewels and other state treasures were kept.[3] This episode illustrates the high esteem attached to intimate forms of contemplating art, unambiguously manifested in the empress's choice of place for this activity. Looking at the most affordable form of art in the midst of a candlelit imperial treasury is a remarkable arrangement. Diamonds, gems of all colors, enamels, and gold would have been set aglow by lambent taper flames, yet remained in the background because something more enticing was taking place. One would bring close to one's eyes leaves of heavy, finely textured paper on which the ink had left pyrotechnical streaks of artistry. The dents produced by the copper plates on the paper would have seemed like traces of the impact of one's own gaze on the surface of the print. Certainly, such a transporting visual experience would have made an overt didactic statement in the pedagogical spirit of the Enlightenment. Power and material wealth met

intellectual pursuit and aesthetic pleasure, presumably to all-around mutual affirmation. In a similar vein, through its assembly of "drawings," the Green Frog Service added to a dining experience a dimension of heightened visual aesthetic pleasure paired with intellectual intensity and a solid dose of politics.

Scholars argue convincingly that the main reasons behind Catherine's commission of the service were her interest in Gothic architecture, her love for English landscape gardens, her admiration of the English political system of parliamentary monarchy, and, last but not least, her gratitude for the staunch support that Great Britain provided during the First Russo-Turkish War (1768–1774).[4]

THE PALACE OF KEKEREKSINEN

Catherine intended the Green Frog Service for a small, yet elaborate neo-Gothic palace complex she had built between 1773 and 1780. Originally, this architectural ensemble was called Kekereksinen Palace or Dacha ("Kekereksinkii dvorets" or "Kekereksinskaia dacha"), a name

that originated from the Finnish toponym of this site on the southern outskirts of Saint Petersburg. The Finnish name means "Frog Pond" or "Frog Marsh," which is why the empress also called it La Grenouillère (from the French *grenouille*, "frog"). After 1780, the complex was named Chesme Palace in honor of the battle of 1770 in which a fairly small Russian flotilla, commanded by Count Aleksei Grigorievich Orlov (1737–1808), annihilated almost the entire Ottoman fleet in the Chesme Bay of the Aegean Sea, near the island of Chios and off the coast of Asia Minor (fig. 2). The battle started on June 24, the feast when the Orthodox church celebrates the birth of Saint John the Baptist. Accordingly, it was assumed that this astounding and somewhat unexpected victory in a sea combat in which the Ottomans had every obvious advantage occurred due to the miraculous help of the Precursor, who possesses special powers over the waters of the world.[5]

Kekereksinen stood at the seventh mile ("verst") south of Saint Petersburg along the Moscow Road, and its position evoked associations with a famous suburban imperial palace outside the fortification walls of Constantinople: the Byzantine Hebdomon, the name of which derived from the Greek numeral "seven," referring to the number of the closest milestone.[6] Hebdomon had vanished by the early thirteenth century, but its fame survived in written sources. The Byzantine palace was admired for its safe port, magnificent architecture, and attractive setting. It had two churches, dedicated to Saint John the Evangelist and Saint John the Baptist, the latter originally containing the Baptist's head, which had come to rest in the cathedral of Amiens in France. The Hebdomon complex included also a palace, a tribunal, and extensive grounds used by the army for camping and exercising. Its location—outside the fortification walls, yet close to the Golden Gate, which was the ceremonial entry into the city—made Hebdomon the starting point of imperial triumphal processions.[7]

Thus, remarkably, in both Byzantium and Russia there was a palace at the seventh mile on the road connecting the new metropolis with the old imperial capital. Hebdomon stood along the famous road Via Egnatia, connecting Constantinople with Rome, while by the road connecting Saint Petersburg with Moscow stood the Kekereksinen or Chesme Palace. Both palace complexes included central-plan churches dedicated to Saint John the Baptist. The parallels transcend the realm of formal similarity as Kekereksinen's role as a triumphal monument to a military victory reflected the functions that Hebdomon once fulfilled.

Hebdomon's association with imperial coronations opens yet another perspective on the significance of this Byzantine prototype in Catherine's building program. The Chesme victory, celebrated in the creation of Kekereksinen, not only started a chain of military successes, but also eliminated any doubts regarding the legitimacy of Catherine's rule; it was, in a manner of speaking, the empress's second coronation. Both in Russia and all around Europe, the Chesme victory silenced Catherine's enemies and those who doubted her right and ability to govern. Outside of Russia, in acknowledgment and acclamation of her military triumphs, the empress's portraits were sought after and made available in different mediums. One of the works of art on display in this exhibition, the large two-color chalcedony cameo of Catherine as Minerva (cat. no. 42), represents this phenomenon. This large cameo very likely was made around 1770 in Paris, where numerous portraits of the empress originated. Curiously, even in France, where the idea to encourage the Ottomans to wage a war against Russia arose, many dignitaries were jubilant at the results, because they had views opposing the conservative royal advisors. Catherine's victory rendered a blow to this circle and its leader, Duke Étienne François de Choiseul (1758–1770). As Choiseul saw it, the purpose of the war against Russia was to topple an incapable usurper woman; instead, it built the foundation for one of the most remarkable reigns in European history.[8]

Catherine and Yuri M. Fel'ten (1730–1801), the architect of Kekereksinen, appear to have made a deliberate effort to base the design of the church dedicated to the birth of Saint John the Baptist on literary sources.[9] The most explicit description of Hebdomon comes from the sixth-century treatise *De edificiis* (*The Buildings* [of Emperor Justinian]), composed by the Byzantine historian Procopius of Caesarea (ca. 500–565). Procopius refers to Hebdomon's Church of Saint John the Baptist as a circular building expanding into apses and surmounted by a dome, a general and vague account.[10] Building a church based on this reference required relating the text to actual structures. Both the empress and Fel'ten knew the quatrefoil church design popular during the Russian baroque, which merged Western models with the sixteenth-century Muscovite tent-shaped church; well-known examples include the Church of the Intercession of the Virgin at Fili (1690–93) and the Church of the Virgin of the Sign ("Znamenie") in Dubrovitsy (1690–1704). Apart from their design, these two churches may have been chosen as models because of

the history of their commissions. Both related to the circle of Peter the Great: one built by his uncle, the other by his tutor.[11] Catherine seized every opportunity to associate herself with Russia's great reformer.

This service consists of 952 pieces on which, in a monochromatic manner, 1,222 different views of England were painted without a single one repeated.

When it comes to the actual building of the palace at Hebdomon, the Byzantine sources have nothing to offer. This lack of evidence led to what initially seems an unexpected choice for a direct architectural prototype for the Kekereksinen palace building: Longford Castle, in Wiltshire, England, which dates to the Renaissance. An image of this castle is conspicuously included in the Green Frog Service, on a fourteen-inch-round dish cover.[12] Catherine and Fel'ten could have seen Longford Castle in volume four of *Vitruvius Britannicus*. From the captions accompanying the prints depicting this building, they could have learned that, in his *New Arcadia*, the poet Sir Philip Sidney featured Longford Castle by referring to it as the castle of Amphialus, the birthplace of the eponymous protagonist: "**Longford Castle in Wiltshire**. The seat of the right honorable the Earl of Randor. It is situated in a park, on the banks of a most beautiful river, about three miles from Salisbury; it commands a pleasing prospect terminated by irregular hills, finely diversified. This structure, which is finished in 1591, is triangular, each angle finishing with a large circular tower, which gives the whole a very castellain appearance. . . . The architect is unknown. It is described in Sir Philip Sidney's *Arcadia*, under the title of Amphiolus's [*sic*] castle"[13]

Whether or not the empress was familiar with the *New Arcadia* directly remains unclear, but it seems unlikely that she would have failed to realize the opportunity this connection stated in *Vitruvius Britannicus* would present: an actual English historic building, associated with a major work of English Renaissance literature telling a story set in ancient Greece and

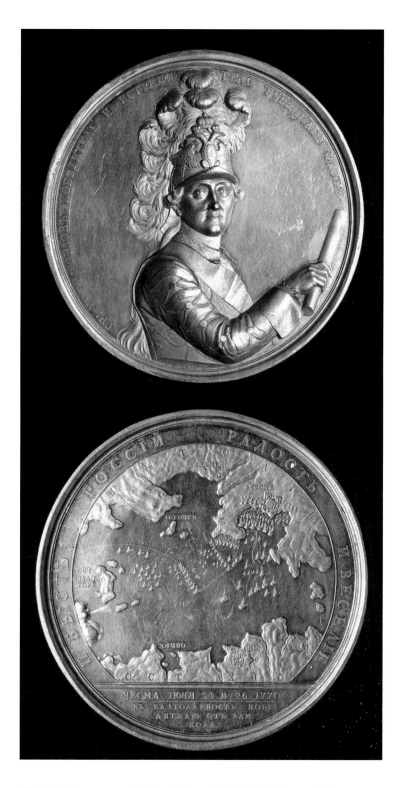

FIG. 2. Medal commemorating Count Orlov and the Battle of Chesme, 1770.

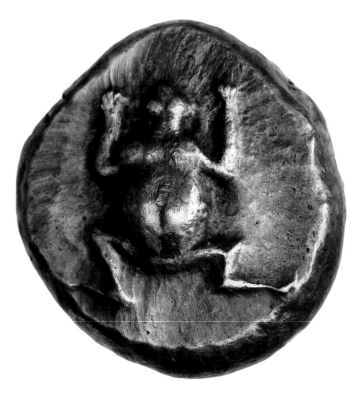

FIG. 3. Coin with frog, Seriphos, Aegean Islands, 530–500 BC. American Numismatic Society, 1967.152.286.

featuring a building that supposedly existed in ancient Arcadia. Basing the design of the palace on an English model further emphasized the overall message that the decoration of the dinner set conveyed: Catherine's gesture of gratitude recognizing the pivotal role England had played in securing the Russian victory at Chesme.[14] It also expressed admiration for the British form of government, which the empress aspired to emulate. The Green Frog Service, featuring dozens of Gothic buildings, both "old" and "modern," and the neo-Gothic architecture of Kekereksinen were in full unison. They both emphasized all that England and Russia shared: Gothic-style architecture, a fascination with ancient Greece, and a common victory over the Ottoman Empire and its ally France, the instigator of the war. The empress saw the victory at Chesme Bay as a triumph of good government over tyranny—the constitutional monarchy of England and Catherine's enlightened rule defeating oppressive absolutism.

THE GREEN FROG SERVICE IN USE

During Catherine's reign, at least two important occasions featured festivities in honor of foreign crowned heads at Kekereksinen that amounted to highly staged performances conveying forceful political messages expressed by the architecture and decoration of this palace complex. In both cases, the guests dined from the Green Frog Service. The first was King Gustav III (reign 1771–1792) of Sweden, who, on June 6, 1777, during a visit to Saint Petersburg, attended the ceremony for laying the foundations of the church at Kekereksinen dedicated to the Birth of Saint John the Baptist.[15] After the ecclesiastical ritual, a banquet in Gustav's honor was held in the palace. To memorialize the visit, Catherine presented to the king a gift of a large album with architectural drawings documenting the Kekereksinen.

Three years later, Kekereksinen once again became the stage set for a similar lofty diplomatic play, this time at the consecration of the Chesme church. As before, following the religious ceremony was a banquet at which the Green Frog Service was used. This time the guest was Joseph II, the Holy Roman Emperor (reign 1765–1790). In honor of this event, Catherine had a marble plaque engraved and attached to the exterior wall of the church, reading: "This temple was erected in the name of the Holy Prophet Forerunner and Baptist of Our Lord John in memory of the victory over the Turkish fleet at Chesme in 1770 on the day of his birth. The foundation was placed in the 15th year of reign of Catherine II in the presence of King Gustav III of Sweden [visiting] under the name of Count Gotland and consecrated on June 24, 1780, in the presence of Holy Roman Emperor Joseph II [visiting] under the name of Count [von] Falkenstein."[16]

Kekereksinen provided a suitable space for the entertainment of crowned heads because of its resemblance to medieval castles, boasting pointed-arch windows, towers, turrets, and battlements. As scholars mention, its neo-Gothic design evoked the notions of chivalry and noble ancestry while endorsing aristocratic ideals and hereditary rule, all affirming the legitimacy of the empress who had ascended to the throne under less than commendable circumstances.[17] More important, Gustav III's and Joseph II's partaking in the commemoration of the Chesme Bay victory reflected the fact that, in the course of the 1770s, this maritime triumph had emerged as one of the foundations of Catherine's Greek Project. The dedication of the church to Saint John the Baptist at Kekereksinen emphatically affirmed the link with both Chesme and Hebdomon,

thus making the palace on the Moscow Road an embodiment of the essential goals of the empress's rule: the transformation of Russia into the enlightened successor of the Eastern Roman Empire, embracing and perpetuating both its medieval Eastern Orthodox tradition and its ancient Greek heritage. Receiving royal guests from the West on grounds re-creating an esteemed Constantinopolitan monument was a gesture declaring the line of succession between the old and new Eastern Empires. It also invited Sweden and the western Holy Roman Empire to join forces with Russia in pursuing common goals. These festivities at Kekereksinen amounted to a symbolic induction into the new political order the empress had envisioned. On a grander scale, the famous Journey to Byzantium, in which the court of Saint Petersburg, European crowned heads, and the diplomatic corps traveled with Catherine to Crimea in 1787 to visit the newly conquered territories along Russia's southern sea, enacted a related scenario.

"GREEN AND LOUD" RENDERED "GREEN AND VOICELESS"

Frogs have an impressive dossier in Western literature and art. They were noted for their striking green color and regarded as a symbol of fecundity. They were also notorious for being loud, and many narratives involving frogs feature a recurring theme of a hero of supernatural power who can silence the noisy creatures. The Green Frog crest alludes to the literary topos of silencing the frogs and allegorically celebrates Russian military triumphs while simultaneously reiterating the goals and accomplishments of Catherine the Great's reign.

The most famous literary amphibians are the ones in Aristophanes' play *The Frogs*. In this comedy, the chorus of the frogs sings:

> Brekekekex-koax-koax. Brekekekex-koax-koax.
> Brekekekex-koax-koax. Brekekekex-koax-koax.[18]

The homophony of these lyrics and the toponym Kekereksinen is quite apparent. The Finnish word "kekereksinen" predates Peter the Great's conquest of this territory, and, although they are both onomatopoeic, the frog song and the toponym are unrelated. Nonetheless, the empress and her advisors played with the similarity, allowing for a chain of allusions and associations stemming from the palace's name and reaffirmed by its crest: a green frog depicted against the outline of a shield with pairs of crossed oak or ivy branches (fig. 1).

The Green Frog crest alludes to the literary topos of silencing the frogs and allegorically celebrates Russian military triumphs while simultaneously reiterating the goals and accomplishments of Catherine the Great's reign.

The imperial court aimed to promote knowledge about antiquity, and the obvious way of accomplishing this goal was through commissioning Russian language renditions of classical texts—a "torrent of translations . . . poured off the presses during Catherine II's reign."[19] Aristophanes' *The Frogs* was particularly significant. One of the best preserved copies of its text appears in a seventeenth-century Byzantine manuscript belonging to the library of the Russian Patriarchate in Moscow.[20] The Patriarchal library contained numerous Byzantine manuscripts with Christian texts as well as ancient authors including—apart from Aristophanes—Homer, Sophocles, Plutarch, and Aristotle. These manuscripts were delivered to Moscow in 1655, during the reign of Peter the Great's father, Tsar Aleksei Mikhailovich Romanov (reign 1645–1676), by Arsenii Sukhanov (1600–1668), a diplomat and a monk from the famed Trinity Monastery established by Saint Sergius of Radonezh (1314–1392).[21] The liturgical codices were needed "for preparing translations into Church Slavonic of genuine Orthodox nature," and the classical texts were to be used for teaching Greek.[22] In the early 1770s, in the midst of the First Russo-Turkish War, which boasted as one of its goals the liberation of the Greeks, Catherine and Prince Gregory Potemkin commissioned a scholarly catalogue of this group of manuscripts and hired for the task the German palaeographer and classicist Christian Frederick Matthaei (1744–1811), whose work was published in 1776.[23] The goal of this endeavor was to demonstrate how the religious links with Byzantium made Russia an heir of ancient Greek learning, and, consequently, how it was the duty of the court of Saint Petersburg to protect the Greeks for the sake of all of Enlightened Europe.

FROGS AND THE ISLAND OF SERIPHUS

Images of frogs appear in various formats and materials throughout the Mediterranean world.[24] There exists a rich tradition of making miniature

three-dimensional objects that functioned as talismans in the form of frogs out of such precious or semiprecious stones as amethyst, jade, and rock crystal. This exhibition includes two examples of this kind, belonging to the collection of the Michael C. Carlos Museum at Emory University in Atlanta, Georgia (cat. nos. 46 A–B). One is a small scarablike object made from bloodstone, and the other, significantly larger, is carved with notable skill and precision in rock crystal. Both display evidence of having been suspended on a cord or chain; the first one features drilled bead holes, and the second has traces of a gold suspension device. The specific cultural traditions to which these two remarkable objects belong are indeterminate, but they clearly illustrate the popularity of the frog and the frequent use of precious material for making frog images in the Mediterranean region.

The Green Frog crest on the dishes of Catherine's Wedgwood service is distinguished by a view from above, depicting the amphibian in a heraldic pose, in which its folded legs and body form a recognizable silhouette, precisely the manner in which ancient coins and engraved gems pictured frogs. Frog coins were issued in two different places at very different times and with no known connection: Greek silver coins dating to ca. 500 BCE (fig. 3) and issued on Seriphus (one of the Cycladic islands) and second-century BCE bronze coins from ancient Tuder (modern Todi) in central Italy. It is highly unlikely that either Catherine the Great or her advisors would have been aware of these coins.[25] There existed, however, numerous examples of the same iconography on engraved gems, and the enlightened audiences of that time knew very well the stories informing the frog iconography, the ultimate source of which was the belief that the island of Seriphus was the home of a rare species of "silent frogs" (*batrachoi aphonoi*). Ancient authors, among them Antigonos of Carystus (third century BCE) and Pliny the Elder (23–79 CE), wrote about these voiceless frogs, which originated in the era of mythical heroes. As legend has it, Perseus grew up on Seriphus and returned to the island after slaying Medusa to take a well-earned repose. Unfortunately, the relentless croaking of the island's frogs upset the hero's sleep. Perseus pleaded with Zeus to grant him the power to silence the frogs so he could rest, and Zeus obliged. The silent frogs of Seriphus symbolize a major heroic achievement, and, in that vein, scholars have compared them to representations of Medusa's head.[26]

In the late 1760s and early 1770s, Catherine the Great was very much engaged not only with Seriphus, but also with several of the other Cyclades islands, which for four years were considered a territory of the Russian Empire by the local Greek population and the court of Saint Petersburg. The town of Naousa on the island of Paros was the main base for Count Aleksei Orlov and the command of the Russian fleet. After the Chesme Bay victory, the fleet remained in the Aegean Sea until 1774, when the Peace Treaty between Russia and the Ottomans was signed at the village of Kiuchuk Kainardzha.[27] Rear-Admiral Stepan Petrovich Khmetevskii (1730–1800), one of the heroes of the Chesme battle, kept a diary during most of the Aegean campaign, which was published in 1844. He cites a letter signed by five of the Greek Orthodox bishops of the Cycladic islands: "We present our tearful plea to Your Imperial Majesty, to take under eternal defense and protection our woeful Archipelago, and through Your order to place all of us under the governance of the Russian Holy Synod, because we have placed all our hopes on the power of the autocratic Russian Empire; in confirmation of our voluntary diligence we place our signatures, February 13, 1771, in the Archipelago."[28]

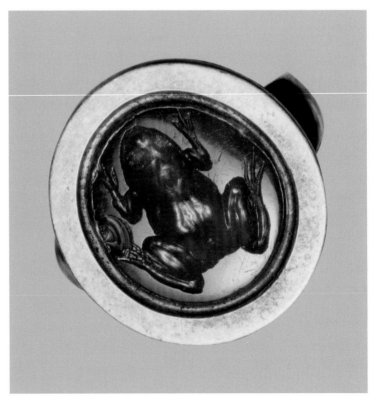

FIG. 4. Intaglio on finger ring of Maecaenas. State Hermitage Museum, Saint Petersburg, Russia.

The tone of this letter conveys the dread of the Greek population of the Cyclades who, although fully aware of how unforgiving the Ottomans would be in their retribution, had no choice but to support the Russians. Only a year earlier, this danger had become obvious in the bloody events of the Russian-led Greek uprising in Morea, or the Peloponnese peninsula, where the Greeks' worst fears came true after Count Orlov's fleet departed. These sad developments apart, in Russia the victories of the war were ceaselessly celebrated. The empire's access to the land and waters of Greek antiquity had a great deal of symbolic power as it merged Byzantine Orthodoxy and ancient Greek learning to form the core of the new Russian sense of cultural identity; as Andrei L. Zorin succinctly puts it, "The Russians are [now] Greeks."[29]

The landscape garden of Tsarskoe selo, the tsars' summer residence just south of Saint Petersburg, is dotted with monuments celebrating the major victories of the First Russo-Turkish War. Most of these objects are well known and quite unambiguous, taking the traditional shapes of triumphal arch, column, or obelisk.[30] In addition, a feature in the landscape design, usually not considered a form of a war memorial, may have been conceived as one. In 1770, in the midst of the war, an artificial cluster of seven islands was built in a pond next to the large lake. The number of the islands clearly refers to the Heptanese/Eptanisa (literally, "seven islands"), also known as the Ionian Islands, after the eponymous sea. The garden feature is known as the Swan Islands, an association with the Cyclades. Both connections celebrate the Russian presence in the waters of the ancient Greeks and in particular the Greek archipelago. "Cyclades" comes from the Greek word for "circle," as the islands of this group surround the main one—Delos, the sacred place of Apollo, the site of his birth, and the habitat of his sacred bird, the swan. Thus, the garden of Tsarskoe selo emerges as a re-creation of Hyperborea, the northern land Apollo would visit to avoid the heat of the summer on Delos, traveling in a swan-drawn chariot. The small archipelago of swan islands, among other parts of Catherine's landscape park, demonstrate that the whole of it was conceived as a model of the empire.

SILENT FROGS BEYOND SERIPHUS

A notable example of the history of the heraldic frog iconography seen on the Wedgwood service is a first-century CE carnelian intaglio, likely a reproduction of the famous gem used as a personal seal by Maecenas (70–8 BCE), the great Roman statesman and literary benefactor whose name became synonymous with art patronage (fig. 4).[31] Catherine

the Great acquired this engraved stone in 1787, fourteen years after commissioning the Green Frog Service, but it is very likely that as early as 1770 she already knew about it. Before Catherine purchased it, the intaglio belonged to the great French connoisseur and art collector Pierre Crozat (1661–1740), the younger brother of Antoine Crozat, marquis du Châtel (ca. 1655–1738), the first private owner of French Louisiana, from 1712 to 1717. Pierre Crozat's collection of drawings and paintings was published in two volumes by 1742, and the catalogue of his engraved stones appeared in 1748. Since 1770, with the expert assistance of Denis Diderot (1713–1784), Catherine had been negotiating the acquisition of Crozat's collection, part of which became available after the death of Antoine's son and Pierre's nephew, Louis Antoine Crozat (1700–1770), the count of Beaumanoir. In 1772, she purchased Crozat's paintings, and in 1787 his engraved gems.[32]

Maecenas' personal seal is well known from the text of Pliny the Elder's *Natural History*, which also includes the account about the origins of the silent frogs of Seriphus. Book 37 of this opus deals with gems and contains a brief discussion of the frog signet, which Pliny tells us caused great terror (*magno terrore*) when received on a letter at the time of tax collecting.[33] The terror caused by the frog signet revealed the power that Maecenas had over his fellow Romans. It is hardly a leap of imagination to think of a Roman statesman who, in asserting his status, affiliated himself with a mythical hero who could command nature. This hypothesis finds support in an episode from the biography of Maecenas' patron Augustus (reign 27 BCE–14 CE). In his life of Octavius Augustus, Suetonius (ca. 69–after 122 CE) included a story about Augustus, as a toddler, silencing the croaking frogs that prevented him from sleeping: "When he first began to speak, he ordered the frogs that happened to make a troublesome noise, upon an estate belonging to the family near the town, to be silent; and there goes a report that frogs never croaked there since that time" (94:7).

The frog emblem potentially evoked a great number of allusions and associations, from the biblical frogs of the Second Plague to the frogs of Versailles on the Latona Fountain to the decidedly uncomplimentary term referring to the French. The Homeric hymn entitled "Batrachomyomachia" ("The Battle of the Frogs and the Mice"), an epic poem including an account of certain noisy frogs, was well known

in eighteenth-century Russia. As the story goes, when the Olympian gods gathered to decide what to do about the ongoing war between the frogs and the mice, Zeus assumed that Athena would support the frogs. He thought that the mice could not rely on her help because they were making so much mischief in the goddess's temple, above all eating the meat from the sacrifice. The goddess added that the mice were also ruining lamps because of the tasty oil they contained, damaging garlands, and chewing on her peplos: "And I was particularly stung by this that they did—they chewed up my robe that I wove with much effort from the fine wool and I had spun a long warp for it, and they made holes." She added, "I won't be wanting to help the frogs, for they're not sensible creatures either. The other day I came back from battle, worn out and needing to sleep; they wouldn't let me close my eyes for a little with their racket; I lay there sleepless with an aching head till the cock crowed."[34]

This Homeric hymn is of particular importance in the discussion of Catherine's Green Frog Service because Athena is its protagonist. In the literature and the political rhetoric of Catherine's reign, the empress was praised as the Northern Minerva, the obvious archetype for an unwedded female figure invested with immense authority.[35] In Russia, an excerpt of the hymn was published first during 1699, in a book entitled *A Short and Useful Introduction to Arithmetic*, printed in Amsterdam. The hymn's first unabridged Russian translation appeared in 1700 and was reprinted in 1712 and 1717—all during the lifetime of Peter the Great. As Marinus Wes points out, the emperor may have personally liked the text—Peter was very fond of fables and would frequently refer to the writing of Aesop.[36] As Catherine made every effort to affiliate herself with Peter, it is likely that she did not neglect the potential that this text offered to enrich the message conveyed by the Northern Minerva's Frog Palace. Invoking this image from a classical text that became popular in Russia at the time of Peter the Great, while celebrating the victory at Chesme Bay, was a playful tribute to the great reformer of Russia. Peter's effort to secure his country's access to a southern sea had failed, but Catherine's fleet was sailing through the Aegean by the shores of Seriphus.

Furthermore, the native land of the voiceless frogs was now (briefly) a territory of the Russian crown. While in the Homeric hymn the goddess Athena was simply annoyed by all the croaking, the empress took action and through her military triumph silenced the frogs.

Just as topography, architectural design, and building prototypes connected Kekereksinen to Byzantium and ancient Greece, so did the Green Frog crest. Its abundant classical connotations helped form the basis for a leap into Byzantine culture. The awareness that Kekereksinen Palace was a replica of the Hebdomon was not obscured by the abundant classical allusions. On the contrary, the theme of silencing frogs made a somewhat unexpected yet prominent connection with Byzantium by alluding to the feast-day liturgy performed every year in the church of Kekereksinen Palace. As mentioned above, the patron feast of this church, the Birth of Saint John the Baptist, is celebrated on June 24, the date of the Russian naval victory at Chesme Bay. The lection from the scripture for this day's liturgy includes passages from the first chapter of the Gospel of Luke that relate a story about Saint John the Baptist's father, Priest Zacharia. The priest was burning incense and praying in the temple's sanctuary when Archangel Gabriel brought him the good news about the birth of his son. As Zacharia and his wife, Elizabeth, were of advanced age, he did not believe the good news, and the archangel punished Zacharia for his disbelief by depriving him of the ability to speak. It was only after John's birth that Zacharia could speak again (Luke 1:8–20). The works of liturgical poetry recited on June 24 develop this theme:

> Tone 4: Why are you so bewildered, old man, you stand and do not believe the angel in the image of man who tells you that you will be mute until the Voice of the Word is born.

> Tone 4: We properly praise you, Prophet and Precursor of Christ, and venerate you with love, while still bewildered by the miracle of your glorious and righteous birth, which redeemed [your mother's] barrenness and your father's voice-lessness, thus preaching to the world the Incarnation of the Son of God.

> Tone 4: Zacharia's silence concludes with John's birth, since it is improper for the father to hold his voice after the Voice has arrived; the one who first silenced him for the lack of faith revealed himself again and released the father giving him the good news that the Voice of the Word [of God] was born, and the Precursor of Light, pray for our souls.[37]

Russian liturgical books prescribe the homily on the Birth of Saint John the Baptist composed by Saint John Chrysostom (ca. 347–407), the late-

fourth- and early-fifth-century bishop of Constantinople. As Saint John Chrysostom himself puts it in the opening sentence of his text, "on this most festive occasion all of us think of Archangel Gabriel's service and of the silencing of Zacharia for his lack of faith."[38]

Recalling the frogs of Perseus and Augustus while listening to the Gospel of Luke and to Saint John Chrysostom's sermon on the birth of the Baptist is a pleasure we owe to Catherine II, who organized this array of allusions as a playful and erudite way of showing that Russia belonged to

the Western world. Above all, Catherine may have had in mind a line from Plato's *Phaedo* delivered by Socrates: "We all live around the sea like frogs around a pond." Indeed, for centuries the classical world was huddled around the Mediterranean as if it were merely a pond.[39] What Socrates implied was that the world was much bigger than certain presumptions would have it. It seems that a statement about this enlightened new world is what we hear in the croaking of the Russian frogs on the shores of that pond, now so much vaster. One imagines that this particular frog song would have been the sweetest music to the ears of the Northern Minerva.

END NOTES

1. *The Green Frog Service.*
2. Adams 1992, 33–45.
3. Countess Golovine, 8 and 32–33.
4. Tarle, 11–91.
5. Kirin 2012.
6. One verst = 1.0668 kilometers = 3,500 feet.
7. *Byzance retrouvée: Érudits et voyageurs français, XVI–XVIII siècles* (Paris, 2001), cat. 28, fig. 28, 66–70, features a set of drawings attributed to Franco Battista il Samolei (1510–1561)—the sixteenth-century Venetian painter and draughtsman—that show a triumphal procession of Emperor Theodosius the Great, purportedly originating at Hebdomon and passing through the Golden Gate. The drawings, now at the Louvre, supposedly document the reliefs on the lost triumphal column of Theodosius that once stood at the forum of this emperor in Constantinople.
8. Walpole, 169–71; and Tarle, 14–17.
9. Fel'ten was a Russified German, Georg Friedrich Veldten.
10. Procopius, 73, *Buildings* I, 8:9–19.
11. His uncle was Prince Lev Kirillovich Naryshkin (1664–1705), and his tutor was Prince Boris Alekseevich Golitsyn (1654–1714). For a recent discussion of the architecture of these two monuments, see Shvidkovsky 2007, 185–96.
12. *The Green Frog Service*, 361, no. 957.
13. Badeslade and Rocque, 2:94–98.
14. M. Raeburn, "Catherine the Great and the Image of Britain," in *The Green Frog Service*, 42–56. This insightful essay explains the many levels of meaning associated with English landscape gardens and architecture in Russian culture from the time of Catherine's reign.
15. V. Fedorov, B. Jangfeldt, and M. Olausson, "The Count of Gotland visits St. Petersburg," in *Catherine the Great & Gustav III*, 153–64, cat. 128 and 129; and Olausson, 164ff, fig. 215.
16. Translation mine from Batorevich, 61.
17. Shvidkovsky 1996, 187–88; Khachaturov, 108–12; and Shvidkovsky 2007, 238.
18. "The species whose cries most nearly resemble brekekekex koax koax is the Marsh Frog, *Rana ridibunda*," see Aristophanes, *Frogs*, 57 and 219.
19. Zuliani; Wes; and Kahn.
20. No. 225, *codex quarto*, seventeenth-century paper, containing also Hesiod's *Theogony*; cf. Matthaei 1776 and 1780.
21. Belokurov, 326–420. Sukhanov traveled south on two separate missions. During his trip of 1651–53, he visited Constantinople, Alexandria, and Jerusalem (where he stayed for Lent and Easter). His mission was to gather information and assess the liturgical practices of the Greeks, which were apparently not terribly impressive to him. Between 1653 and 1655, Sukhanov journeyed south with the explicit purpose of purchasing Greek-language manuscripts. For this task he was equipped with a gold-seal charter and the appropriate funds in gold and furs. He visited the monastic center of Mount Athos where he fulfilled his mission. According to a document dating to 1658 and prepared in

the offices of the Patriarchate, Sukhanov purchased a total of 395 manuscripts, but other estimates say he bought 423 of them.
22. This was part of a campaign started by Patriarch Nikon (1605–1681) who aimed at revising Russian ecclesiastic service books in order to bring them closer to the Byzantine tradition; see Belokurov, 330–31.
23. Matthaei 1776 and 1780.
24. See examples of intaglios depicting frogs on carnelian and agate: Brandt and Schmidt, nos. 909 and 2428; Carnegie, 190–93, nos. 78–80; Fossing, nos. 1504 and 1505; Furtwängler, nos. 52, 59, and 60; King, 30; *Le destin d'une collection*, no. 267/85; Walters 1926, no. 556. For frog-shaped scarabs, see C. Andrews, 63, figs. 28h, 45h, 54b, and 93b; Boardman, no. 512; Neverov 1988, 177–78, nos. 481–83; Walters 1926, no. 348, fig. 23; Zwierlein-Diehl 1973, no. 534. Miniature three-dimensional renditions of frogs appear on ancient Greek pins (Jacobsthal, nos. 255 and 257).
25. The images of frogs in ancient art are the subject of discussion in Toynbee, 216–17.
26. Svoronos; Richter, 232; Oleson, no. 8; and Sheedy, 41–47 and 175–77. On the issues of Roman Republican coins with frogs, see Akerman, 14.
27. Pliny, *Natural History* 159 (Book 7: 83): "At Cyrene the frogs were silent, and though croaking frogs have been imported from the mainland the silent breed goes on. Frogs are also silent on the island of Seriphus, but the same frogs croak when removed to some other place, which is also said to happen in the Siccanean Lake in Thessaly." Trans. H. Rackham. See also Svoronos and Arnould.
28. Madariaga, 38–39; Sebag Montefiore, 76–93; and R. Massie, 371–83.
29. Khmetevskii, 63–64.
30. Zorin 2001, 31–64, "Russkie kak greki"; and Proskurina, 150–81, "The War in Greek Garb."
31. Shvidkovsky 1996, 101–6; and Schönle 2002.
32. Rich, 126–27; and King, 148–50.
33. Mariette, *Description sommaire des pierres gravées* 51, no. 814; and *Catalogue des pierres gravées du cabinet de . . . Duc D'Orléans*, 96, no. 861.
34. Notably, Baron Philipp von Stosch (1691–1757) owned two carnelian intaglios depicting frogs. The catalogue of this renowned collection associates this iconography with the signet ring of Maecenas, see Winckelmann, 553, nos. 125 and 126.
35. Isager, 212–19.
36. *Homeric Hymns*, 280–81.
37. Wortman 1995, 110–65, esp. 127. See also Bruess, 42–43; Batalden, 22–23 and 44–45; and Troyat 1980, 306 and 312.
38. Wes, 15; On Catherine's attitudes to Peter the Great, see Rasmussen and Proskurina, 109–49.
39. www.pravoslavie.ru/docs/jun24-3e9d2f. Last visited July 26, 2013.
40. *Zhitiia sviatykh*, 527.
41. Plato, 90; Phaedo, 109 a–b; and Brown, 11.

The Chalice with Antiques

ASEN KIRIN

On August 29, 1791, Catherine the Great presented a set of liturgical gold vessels, including this chalice, a paten, an asterisk, two plates, a spoon, and a spear to the Holy Trinity Cathedral of Saint Alexander Nevskii Monastery in Saint Petersburg. After delivering the precious gifts to the cathedral's altar, the empress attended vespers. Alexander V. Khrapovitskii (1749–1801), Catherine's secretary, documents this visit in his diary: "A trip to the Nevskii Monastery for the all-night vigil; deposited in the church a large silver chandelier, a gold [oil] lamp for the relics, and gold [liturgical] vessels with antiques and diamonds."[1] On the eve of the patron feast, Catherine bestowed these gifts on the Alexander Nevskii Monastery, exactly one year after the consecration of its new cathedral, built under her auspices. On August 30, the Russian Orthodox Church commemorates the transfer of Saint Alexander Nevskii's relics from the medieval capital city of Vladimir to Saint Petersburg. According to the liturgical practice of the Orthodox Church, the celebration of a significant feast begins with a special vespers service on the eve of the actual holy day, which would explain the timing of Catherine's visit. As usual, the empress's actions were the result of thoughtful planning.

THE TIME AND BACKGROUND OF THE COMMISSION

Catherine originally commissioned from Iver Windfeldt Buch two liturgical sets decorated with engraved gems, which she selected personally from her famous collection, numbering more than ten thousand stones by 1790. The other set went to the Cathedral of the Dormition of the Mother of God in the Moscow Kremlin, and its current whereabouts remain unknown. Scholars have pointed out that, from the several liturgical sets executed by Buch, only three separate objects survive.[2] Among these, the most elaborate is the chalice in the collection of Hillwood Museum and Gardens.

The records preserved in the Central State Historical Archives of Russia help establish a timeline for this commission. The chronology offered in this essay is based on thirteen documents, partially transcribed in 1992 by Lilia Kuznetsova from the Department of Historical Documentation at the State Hermitage in Saint Petersburg. Kuznetsova presented her findings to Hillwood in response to an inquiry by Anne Odom, then curator of Russian art.[3] These documents demonstrate that Catherine made the decision to order the two liturgical sets in early fall of 1790. A decree concerning the expenditure for the liturgical sets was issued on November 23, and by December 10 the empress had already reviewed and approved of the design drawings Buch presented to her. A written record documents her oral order to proceed with the execution: "On Oral Decree of Catherine the Great, conveyed to the Cabinet on December 12, 1790: Her Imperial Majesty exaltedly ordered, according to the drawings presented by Master Buch, two gold chalices with their accompanying pieces, [she requested] to place on them the engraved gems selected by Her Imperial Majesty, and to plentifully cover them with diamonds; for this purpose it will be necessary to use one pood of gold [16.38 kilograms, or 36.11 pounds], which will be provided, as it was allowed to convey to Buch. December 10 1790, Peter Soimonov."

As a document preserved in the Historical Archive states, "Fabricant Buch" received a preliminary payment of 2,000 rubles for production expenses on February 28, 1791. By the end of spring he had completed the first set, intended for the Dormition Cathedral in the Moscow Kremlin. On April 10, Buch submitted a bill in response to which an oral decree from May 30 allowed for a full payment of 28,174 rubles and 94 kopeikas. The timing must have taken into account the need to send this liturgical set to Moscow and present it to the Dormition Cathedral before the patron feast celebrations on August 15. Very thoughtfully, the empress allowed four months for this shipment. The remaining part of the commission, i.e., the second liturgical set including the Hillwood chalice, was finished by late summer, and

FIG. 1. Detail of the cameo of Archangel Michael, cat. no. 9.

another oral decree, from August 24, ordered the payment for it in the amount of 27,913 rubles and 44 kopeikas. Apparently, the second set was finished not longer than a month before the day when it was to be placed on the altar of the Cathedral at Saint Alexander Nevskii Monastery in Saint Petersburg.

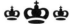

Catherine made this commission during a decisive phase in the ongoing Second Russo-Turkish War (1787–1792).[4] The war began on August 13, 1787, barely a month after the empress completed a long trip to Crimea known as the Journey to Byzantium. The purpose of this sojourn was to inspect the progress of the new southern Russian provinces gained in the course of the First Russo-Turkish War (1768–1774). Since 1774 the provinces' governor general, Prince Gregory A. Potemkin (1739–1791), had founded four major new cities (Kherson, Nikolayev, Sevastopol, and Ekaretinoslav) and promoted industries and commerce while overseeing the construction of a Black Sea fleet. In 1783, he successfully negotiated the annexation of the Crimean Peninsula, the territory of the Tatar Khanate, which since the fifteenth century had been a protectorate of the Ottoman Empire. In reward for this achievement, Catherine bestowed on him the title Serenissimus Prince of Taurida, after the Greek "Tauric Chersonese" ("Tauric peninsula"), the ancient name of this land, where by the fifth century BCE the Greeks had already established several colonies. Potemkin deliberately promoted a rhetoric presenting Crimea as Russia's "earthly paradise."[5]

Known as Cherson in the medieval era, for centuries before its annexation Crimea was considered the cradle of Russia's Christian culture. The Byzantine presence in the former ancient Greek colonies transformed Cherson into an essential Christian center for the vast regions north of the Black Sea. According to legend, the ruler who introduced Christianity to the Russian medieval state, Prince Vladimir I of Kiev (reign 980–1015), visited Cherson and brought back certain holy objects now preserved in the Moscow Kremlin and revered as the oldest Christian antiquities in Russia—"The Cherson holies" ("korsunskie sviatyni").[6] In the eighteenth century, the neoclassical interpretation of medieval Russian history emphasized the connections between Byzantium and ancient Greece. In the time of the Enlightenment, because of Russia's religious and cultural ties with Byzantium, the country represented itself as the heir of ancient Greek learning. To a great degree this positioning was the result of Catherine the Great's ideological creativity.[7] Accordingly, in Catherine's neoclassical Christian Orthodox empire, Crimea/Cherson was considered a primordial land and the Journey to Byzantium was thought of as a symbolic homecoming. Territorial expansion to the South was a major geopolitical development, promoted as a sort of cultural *nostos* (Greek for "homecoming"), simultaneously affirming Russia's links with Byzantium and ancient Greece and charting the empress's plans for this part of the world.

Potemkin conceived, organized, and supervised the details of Catherine's journey to Crimea. The empress traveled with select members of her court and in the company of the diplomatic corps and crowned heads, most important her ally against the Ottomans, the Holy Roman Emperor Joseph II (1764–1790).[8] Russia's presence at the Black Sea and the alliance with Vienna threatened not only the sultan, but also European powers. In addition to this anxiety shared by the Ottoman Empire, France, England, and Prussia, there was an increased awareness about Catherine the Great's Greek Project, a geopolitical model that envisioned dividing the European lands of the Ottoman Empire by establishing different Christian states under Russia's aegis. The intent was to conquer Constantinople and install on its throne the empress's second grandson, Grand Duke Konstantin Pavlovich (1779–1831). The resulting Second Russo-Turkish War would determine control over Crimea, the existence of Russia's Black Sea fleet, and the future of the Greek Project.

After initial setbacks in the war, Russia achieved a series of military successes. Over the course of three years, Catherine rewarded the men responsible for these triumphs with orders, titles, and decrees of promotion. The period during which the empress must have contemplated the commission of the two sets of gold liturgical vessels— namely, the summer and fall of 1790—brought a series of victories. First came the battle by the Cape of Tendra at the north shores of the Black Sea on August 28–29, where Admiral Fedor F. Ushakov (1745–1817) commanded the Russian fleet. After this strategically important victory, which secured Russian control over Dniester's estuary, Potemkin ordered an offensive by land and sea, resulting in the successive conquests of four important Ottoman fortresses: Keliia, Tul'cha, Isakcha, and finally Izmail. In a letter from November 12, Catherine thanked Potemkin for the conquest of Keliia, which had taken place in October, and informed him about the celebratory rounds of cannon fire she ordered on this occasion.[9] By December 12, when the chancellery recorded the empress's

commission of the two sets of gold liturgical vessels, Catherine had learned about the fall of Tul'cha and Isakcha, yet she could not have been aware that the supposedly impenetrable fortress of Izmail was being conquered on December 11, exactly when she finalized the arrangement of her commission. Potemkin first reported to the empress the conquest of Izmail in a letter from December 18, and the news of this most consequential victory could have only confirmed the appropriateness of Catherine's decision to order the precious gifts.

GOLD VESSELS WITH "ANTIQUES AND DIAMONDS" FOR TWO IMPERIAL CATHEDRALS

Major military victories were customarily celebrated with jubilant thanksgiving ecclesiastical services. On such occasions the Te Deum was performed, and notable gifts were presented to churches. The place of the religious ceremonies, just like the timing of the gift and the selection of the recipient, reflected the specific circumstances of the events celebrated.

The empress had a great deal of experience scripting and orchestrating elaborate festive campaigns. For instance, during the First Russo-Turkish War, she marked the most significant military success of her reign, the brilliant, unexpected Russian triumph over the Ottoman fleet in the Chesme Bay off the coast of Asia Minor, in June 1770. On this occasion, she ordered the Te Deum celebrated in a palace church on the shore of the Baltic Sea (Peterhof Palace) and in a cathedral on an island in the river Neva (Cathedral of Saints Peter and Paul in Saint Petersburg).[10] Founded by Peter the Great (reign 1682–1725), both the palace and the cathedral were viewed in general as the embodiment of his success in transforming Russia into a maritime power. The thanksgiving services that Catherine arranged demonstrated that she not only continued, but also brought to new heights this major endeavor initiated by her revered predecessor.[11] Maritime associations also explain her decision to donate a gold chalice to the Cathedral of Saint Nicholas of the Sea in Saint Petersburg celebrating the same victory. Saint Nicholas is the patron saint of seafaring, and this church was affiliated with Saint Petersburg's Department of the Imperial Navy.

The empress's choices for delivering her prayers of thankfulness to God through the mediation of Saints Peter, Paul, and Nicholas not only activated meanings involving the Chesme battle and recent Russian history, but also addressed general concerns of religion and imperial ideology. Tradition had sanctioned the need to follow strict procedures

when communicating with God, even when conveying gratitude. In the heavenly court of Christ, just like in the one over which Catherine herself reigned, selecting the appropriate intercessor was essential for the success of any supplication. The empress's gestures of gratitude emerge as sweeping statements simultaneously celebrating, affirming, and explaining the ways in which the structure of the state mirrored the celestial hierarchy and how the two of them connected. This essentially Byzantine notion about the association between the celestial and the earthly courts was embedded in the Orthodox faith of the Russian state. In Saint Petersburg during the late eighteenth century, as Countess Varvara N. Golovine (1766–1819) assures us, a substantial segment of the population believed that "heavenly paradise" was located in the Winter Palace.[12] Even for people less easily impressed, such as the empress and her enlightened inner circle, the idea that the celestial court was the prototype for the earthly one was not irrelevant—it was a constituent part of a revered tradition that was to be perpetuated.

The challenge came from the ways in which the Enlightenment, through its deistic approach to religion and prioritizing of the personal exercise of reason, undermined the habitual ways of affirming tradition. Faith in Christ no longer automatically extended to ecclesiastic bodies and royal courts, and the wisdom of custom was meant to be doubted and challenged. Catherine's way of reconciling this tension was to historicize, intellectualize, and add personal meanings to traditional ritual and ceremony. She deliberately sought ways to present the links between the celestial and earthly courts as less a matter of faith and more one of national history. While the empress's commissions of works of religious art and architecture did comply with tradition, they also unfailingly set off entire strata of new meanings that transformed the act of devotion into an intellectual exercise of knowledge and erudition. Furthermore, she always strove to add a set of personal connotations. For Catherine the Great, affirming and continuing monarchy was an extended historiographical exercise, the ultimate goal of which was to educate the people of her domain. This goal accorded with the expectation that an enlightened monarch would be an agent of advancing knowledge, improving government, and bettering life. All her life, the empress studied and wrote about history. Less attention has been paid to the fact that her patronage for the arts was equally historiographic, both in terms of content and implications, and served as a manifestation of the Age of Reason's seminal conviction that the arts can educate and elevate entire nations.

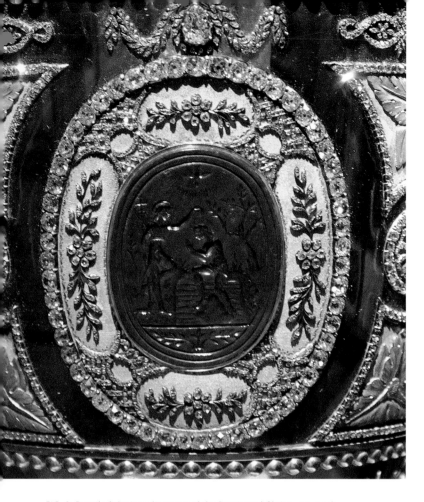

FIG. 2. Detail of the intaglio stone of the Baptism of Christ, cat. no. 9.

So, what is the significance of Catherine's decision to celebrate the victories of her army from 1789 to 1790 by donating liturgical sets specifically to the Dormition Cathedral of the Moscow Kremlin and the Cathedral of the Alexander Nevskii Monastery in Saint Petersburg? The presence of the gold vessels in these two churches' sanctuaries was a form of perpetual silent celebration of the recent victories—in other words, an eternally repeated prayer of gratitude. The historiographical significance of the donation relates to Catherine's intention to inscribe the new accomplishments of the imperial army and fleet in the annals of Russian history. For this purpose, Catherine chose the oldest cathedral in the ancient Russian capital, built by Ivan III (reign 1462–1505) and consecrated in 1479. Ivan considered this church the concrete expression of continuity between Moscow and the preceding royal sees of Vladimir-Suzdal and, through them, to the very first medieval capital, Kiev.[13]

Her choice of the Saint Alexander Nevskii Monastery asserted the link between medieval Russia and Saint Petersburg in a similar manner. In

1710, Peter the Great established the monastery on the site where, during the winter of 1240, Prince Alexander Iaroslavovich won a battle against the Swedish. Peter moved the sainted prince's relics from the city of Vladimir to the new monastery to emphasize that the land Peter had recently won from Sweden had already been hallowed by the exploits of his crowned predecessors. Alexander Nevskii was a scion of the Riurik dynasty of Kiev and Novgorod and a great grandson of Prince Yuri Dolgorukii (reign 1149–1151), the founder of Moscow. Catherine's knowledge of history and understanding of the symbolism of past royal patronage became her tools to convey a clear statement that the tradition of statehood was received, acknowledged, affirmed, and expanded.

The two liturgical sets convey yet another layer of meaning due to their neoclassical design and engraved gems. Both these features make a poignant statement about the appreciation of classical antiquity, even though the actual gems are from neither the classical period nor late antiquity. Indeed, on the Buch chalice, the oldest cameo is Middle Byzantine (twelfth or thirteenth century). During the centuries before this commission was executed, the very medium of glyptic art (engraving stones) had become emblematic of ancient culture. In his diary, referring to the Buch chalice, Alexander Khrapovitskii calls the carved stones "antiques," which indicates the general perception of the glyptic medium as the quintessence of antiquity. Carved stones were seen as the alluring material vestiges of a much admired past.[14]

The fact that the gems on the liturgical sets came from Catherine's collection is essential for defining the meanings that these vessels initiate. The empress's famous cameo collection was an expression of wealth and power, yet it was also a manifestation of passionate connoisseurship and of intellectual pursuits, stimulated by a reverence for art. Catherine read studies about the stones, lost herself in the visual pleasure of examining them, and made casts of them herself to document their iconography and to understand it better. Her knowledge, sophistication, and cosmopolitanism elevated and advanced her subjects just as her piety determined their spiritual salvation. The former did not exclude or invalidate the latter.

Across Europe, craftspeople encrusted devotional or liturgical objects with carved stones from different historical periods and associated with different religious traditions, both pagan and Christian.[15] With the rise of scholarly approaches to collecting carved stones in the late 1600s

The empress's famous cameo collection was an expression of wealth and power, yet it was also a manifestation of passionate connoisseurship and of intellectual pursuits, stimulated by a reverence for art.

and throughout the 1700s, this practice became obsolete. Notably, less than a decade before commissioning the two liturgical sets, Catherine the Great had removed the Renaissance-era carved stones from a cup presented in 1716 to Peter the Great by King Christian VI (1699–1746; reign 1730–1746) of Denmark. The goal of the empress's harvesting these carved stones was to allow for their display in the cabinets containing her famed cameo collection, which must have been arranged by theme and shape. This scholarly approach to engraved gems is documented by actual cabinets containing stones and by the published catalogues of cameo collections.[16] Catherine's deliberate return to an earlier custom when commissioning the Buch chalice expresses her determination to preserve, honor, and rethink the past. By delivering these gems into a new world in which the past was revived and transformed, she demonstrated how she cherished the material vestiges of history and succeeded in giving them a new life.[17]

Catherine's cameo collection, like its predecessors, mixed old and new stones, pagan and Christian subjects. The intrinsic monetary value and the enduring aesthetic appeal of gems transcended boundaries and defied taxonomies, allowing for the combination of antique, medieval, Renaissance, Baroque, and neoclassical works. This inherent characteristic of cameo collections affirmed the notion of a continuous tradition and a shared European heritage, which Catherine the Great was then claiming for Russia. Of course, Catherine manifested this ambition not only in amassing thousands of engraved gems, but also in all other aspects of her collecting and in the various ways she patronized the arts.

The Buch chalice demonstrates how the empress herself conceptualized the mixing of themes and historical periods. Its engraved stones show pagan and Christian subjects; these gems come from Eastern and Western Europe and date from the twelfth to the eighteenth century. The result is a visual statement that asserts a notion of cultural continuity from a referenced antiquity to Byzantium, medieval Russia, and finally Catherine's neoclassical empire, all colored by historicism and cosmopolitanism.

PERSONAL MEANINGS: ANGELS, MONKS, AND WARRIOR PRINCES

Catherine conceived of the visual program of the Buch chalice as an homage to and a prayer on behalf of Prince Gregory A. Potemkin. In 1775, as most scholars now agree, during a wedding ceremony conducted in the strictest confidence, Potemkin became Catherine's morganatic husband.[18] Although their romantic connection faded over time, their emotional and intellectual bond was for life and so were their shared political ambitions. Potemkin, who remained Catherine's partner-in-power, was most certainly the main originator and chief executor of the Greek Project. In his youth, he pursued theology and, in preparation for joining the ecclesiastic ranks, mastered Greek, Latin, and several other languages. Instead, he later joined the army, where he distinguished himself and caught Catherine's interest; through his collaboration with her, he became one of eighteenth-century Europe's most accomplished statesmen.[19]

During 1790, regardless of Russian victories on the battlefield, great dangers were looming. In February, Holy Roman Emperor Joseph II died and was succeeded by his younger brother Leopold II (reign 1790–1792), the former grand duke of Tuscany, who was significantly less committed to the war with the Ottomans.[20] In addition, there was unrest in Poland, where an influential patriotic clique was aspiring to overturn Russian dominance. England, France, and Prussia supported both Turkey and Poland. Sweden was preparing to attack from the North. To settle these severe problems, the empress relied on Potemkin, who in name and in practice was Russia's supreme commander.[21]

Catherine's donation of a chalice to the Nevskii Monastery engaged meanings involving Potemkin, who, like the patron saint of this monastic establishment, was a warrior prince. In fact, since 1775, when Potemkin became a knight of the Order of Saint Alexander Nevskii, he had been helping the empress run this organization. A consummate soldier, Prince Alexander Nevskii was also known for his piety; on his deathbed, he accepted the ascetic vows and with them the "monastic name" or "angelic name" of Alexis. The latter term was commonly used in the Orthodox tradition as monks were considered earthly angels, or angelic beings in the flesh.

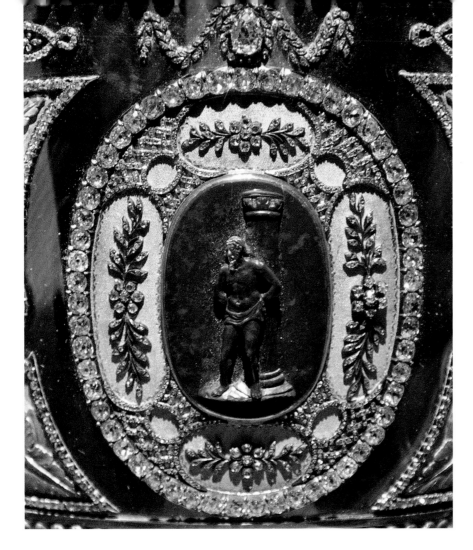

FIG. 3. Detail of the cameo of the Flagellation, cat. no. 9.

The short pictorial cycle on the bowl relates to the devotion of Christ, while the scenes on the foot reflect the cult of the Virgin and include the themes of the Incarnation and maternity. Each scene on the foot has a counterpart above it on the bowl, revealing a deliberate correspondence between the masculine upper register and the lower feminine one.

Potemkin also had strong ascetic tendencies and extravagantly alternated spells of solitude, seclusion, and abstinence with fits of sybaritic excess and sensual overindulgence. One revealing episode involved the Saint Alexander Nevskii Monastery and marked the start of a new phase in Catherine's relationship with Potemkin. During the winter of 1774/5, he had already fallen in love with Catherine, but she was keeping her distance. Potemkin demonstrated his despair by announcing his intention to take monastic vows. Accordingly, he retreated to the Nevskii Monastery in the capital city, which, of all the potential places he could have chosen for ascetic seclusion and isolation, was most suitable, as it allowed the empress to communicate with him without interruption. Her confidants delivered her letters and made regular visits to Potemkin's monastic cell.[22] This dramatic gesture precipitated the start of Potemkin's amorous relationship with Catherine. His ascetic tendencies remained a recurrent theme in their exchanges, alluding to their shared history and expressing a sense of closeness. A letter from the time of the Second Russo-Turkish War, dated November 25, 1789, features Catherine chastising Potemkin for failing to take proper care of himself while living close to the theater of war: "Monsieur le moine, point de moinerie!" ("Mr. Monk, no more monkishness!").[23] The ironic, yet loving tenor of this reprimand reaffirms their trusting relationship.

From the time they met, Catherine was aware of Potemkin's piety and extensive knowledge of ecclesiastical matters. In appreciation of this quality, fairly rare for an officer of the imperial guard, in 1763 the empress

gave Potemkin his first appointment when she charged him to sit on the council of the Holy Synod of Russia's Orthodox Church. This happened during the year after her ascent to the throne, when he was only twenty-four years old. Less than a decade later, still before they became lovers, Potemkin presented her with a gift of a True Cross reliquary from the spoils of the First Russo-Turkish War. Although he clearly wanted to be noticed and gain her favor, his method of achieving this goal was truly exceptional for it avowed her imperial dignity through the gift of a holy object conveying the strongest imperial connotations. The cult of the True Cross was associated with Emperor Constantine the Great (272–337) and his mother, Helena (246/50–330). The gift also affirmed the declared goal of the war in which it was obtained—namely, to protect the rights of Orthodox Christians living under Islamic rule in the Ottoman Empire. Conveying to the empress this holy object infused with the miraculous power of the True Cross showed Potemkin as not simply a loyal servant, but also a protector of the empress. By emphasizing his bravery, faith, and knowledge, Potemkin recommended himself to Catherine as a sort of imperial theologian and ideologist. None of these implied statements remained unnoticed or unappreciated by the empress. She deposited the young officer's sacred offering at the Cathedral of the Winter Palace in Saint Petersburg, the official residence of the rulers of Russia, mimicking Helena's possession of a relic of the True Cross in her own abode (the Sessorian Palace of Rome).

In 1790, precisely at the time when Catherine's idea about the gold liturgical vessels with "antiques and diamonds" must have been taking shape, Potemkin displayed his love and knowledge of monastic life again. While the empress was showering him with gifts and honors, he pleaded with her to grant him a monetarily inconsequential piece of land, which he called a "dacha" ("villa"). In fact, the dacha was the Sviatogosrskaia Uspenskaia Lavra in the new southern provinces, a former monastery closed in 1787 under Catherine's decree for the secularization of ecclesiastic properties. In his letter to Catherine, Potemkin admits that he already owned vast tracts of land and thousands of serfs, yet he also asserts, "there is no other place on earth [apart from the Sviatogosrskaia Uspenskaia Lavra] where I would more gladly rest my weary head. . . . I plead with you, My Dear Mother [Empress], grant me this dacha, for thus you will render me the greatest mercy."[24]

The monastery in question, north of the Azov Sea along the river Severnyi Donets ("Northern Donets"), a tributary of the Don, must have risen in the fourteenth or fifteenth century, when ascetics settled in the caves perched high in the rocky cliffs above the river. Hermits customarily selected such sites because of their seclusion, isolation, and elevation, perceived in symbolic terms as proximity to heaven. Their breathtaking vistas revealed the spiritual nature of such places and contributed to the intensity of meditation and prayer.[25] The beauty of the landscape and the awareness that this site was hallowed by centuries of perpetual spiritual practice must have appealed to Potemkin's sensibility. A great admirer of English picturesque gardens, the Serenissimus was fully aware that nature is "living antiquity" and, hence, an admiration of nature was allegorically equivalent to the admiration of antiquity. He must have found this monastery attractive as an obvious example of Christian appreciation for the beauty of this ancient land.[26] Layered allusions to antique villas and medieval monasteries explain the allure that the new southern provinces held for Potemkin, the empress, and the enlightened circles in Russia at the time.

Potemkin's ambition to save this holy site by making it his villa stemmed from his understanding of the illustrious model of the past in which the abode of a powerful lord was akin to a monastic establishment. The house of Christ was the proper dwelling place for a true grandee—whether a Byzantine potentate, a tsar of Moscow, or the Serenissimus Prince of Taurida.[27] The residence of the tsars in the Moscow Kremlin was along the same lines but without any overt connotations of antiquity. Potemkin's villa set in a monastery brought together the ancient pagan and the medieval Christian notions of living a good life in unison with nature and served as another manifestation of his ambition to promote the sunny southern land of the new provinces as Russia's earthly paradise.[28]

Saint Petersburg is a northern city, where autumn arrives early. By August 29, 1791, when Catherine deposited her precious gifts at the cathedral of the Nevskii Monastery, all the news from the South appeared to be as somber as the season in the capital. The negotiations for peace with the Ottomans were not advancing, and Potemkin's health kept deteriorating. The empress's letters to him are full of emotion and concern for his well-being. When the news about Potemkin's health was discouraging, Catherine's secretary Khrapovitskii would enter one word in his diary: "Tears."[29] In light of these developments, Catherine's donation of liturgical gold vessels to the Nevskii Monastery, first intended to celebrate

military victories, acquired the additional dimension of a plea for saving her partner, her guardian angel.

The ritual performed on the evening of August 29, 1791, when the precious gifts were delivered, was a standard one established centuries earlier. The service honors the sainted warrior prince Alexander Nevskii, celebrating him as an ascetic, emphasizing his piety and monastic vows. The ritual follows a pattern according to which the services for each and every ecclesiastic feast enact the sacred history of mankind. The liturgical day begins with vespers, celebrated on the eve of a holy day, as a prelude to the main part of the ritual, which takes place the following morning at liturgy. Accordingly, vespers engage the Old Testament, and the liturgy reenacts the New Testament, in particular the Passion of Christ. At vespers on August 29, the readings in honor of Saint Alexander Nevskii include verses from Chapters 60, 62, 61, and 67 from the Book of Isaiah. These excerpts involve the images of weddings, brides, and grooms as allegories for ascetics' dedication to God—monks are married to the Church and to Christ.[30]

The notion of service to God metaphorically presented as a marriage must have had special resonance for Catherine, who had just delivered the chalice and was attending vespers, praying for her partner. This entire event amounted to a discreet public acknowledgment and celebration of the empress's marital bond. It would appear that on August 29, 1791, Catherine orchestrated a thoughtful tribute to the lover of liturgy, the ascetically minded warrior prince with whom she knew personal happiness and fulfillment and with whom she pursued the grandest endeavors of their shared lives.

During the summer of 1791, the physically frail Potemkin did not simply pray in church like an ordinary faithful, but, in his characteristically grandiose manner, composed an entire liturgical canon, an invocational poem dedicated to the Mother of God that includes the following verses: "Incessantly my anxious soul gazes at the abyss of my iniquities and longs for help, yet does not achieve it. Extend to me, you Immaculate Virgin, your hand, which held my Savior, and let not my soul perish for ever." This poetic creation was met with admiration by the high society in Saint Petersburg, whose members acknowledged that it would be suitable to put his verses to music. The great music lover Count Andrei K. Razumovsky (1752–1836), the Russian ambassador to Vienna, had in mind just the right composer for this task.[31] He promptly contacted Wolfgang Amadeus

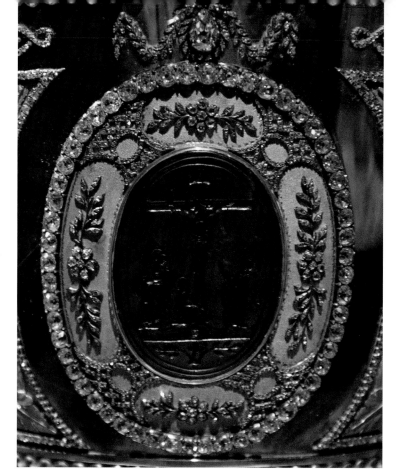

FIG. 4. Detail of the intaglio stone of the Crucifixion, cat. no. 9.

Mozart (1756–1791), who was in Prague at that time and expressed his desire to join the court of Potemkin. Sadly, within months both the poet and the composer would pass away. Potemkin died on October 3, lying on the ground in the open steppe by the road en route from Iassu, the site of the war headquarters, to Nikolayev, one of the cities he founded in the new southern provinces.

The souls of the departed as they embark on their final journey meet Archangel Michael, who weighs their good and bad deeds; depictions of this action are often included in scenes of the Last Judgment. Notably, a miniature icon, a cameo, of this archangel clad in military garb graces the Buch chalice, deposited at the monastery only a month earlier. The vessel's iconographic program is remarkably intricate, and Catherine conceived the object as a tribute to Potemkin because of his rich knowledge of history, enthusiasm for theology, and love of liturgy.

THE CHALICE AT THE TRINITY CATHEDRAL OF SAINT ALEXANDER NEVSKII MONASTERY

The golden liturgical set was a part of numerous contributions that Catherine the Great made to the imperial monastery of Saint Alexander Nevskii. These bequests expressed both the empress's piety and her adherence to the program of political reform launched by Peter the Great. During Catherine's reign, the monastery emerged as an embodiment of the empress's ambition to bring the Orthodox traditions of Russia and its medieval history into the new enlightened world she was building.[32] Accordingly, Catherine commissioned the neoclassical cathedral at the monastery, which was consecrated on the feast day of Saint Alexander Nevskii.

The empress's determination to pay respect to the Orthodox liturgical tradition while embracing the present is subtly yet poignantly manifested in the lettering on the rim of the Buch chalice's bowl. The inscription quotes the Slavonic text of Matthew 26:27–28, but the script is not the traditional Old Church Slavonic. Instead, it is the modern Cyrillic, deliberately Latinized typeface introduced in 1708 during Peter's reforms.[33] Another sign of the new times is the manner of marking the start of the inscription with an asterisk instead of the customary cross. When placed ahead of a written statement, the cross functions as a symbolic invocation of the faith (*invocatio simbolica*), replacing "In the name of the Father, of the Son, and of the Holy Spirit." The use of the asterisk connects the inscription not with the tradition of medieval writing but with contemporary practices in typography.

The eight carved stones on the chalice have diamond frames with swags, flowers, and a trelliswork pattern, in which the preciousness of the mount makes an emphatic statement about the importance of the image within it. These eight gems are divided into two subsets: four on the bowl and four, arranged in a corresponding manner, on the foot. Within each of these subsets the specific placement reflects the chronological sequence of the depicted scenes, progressing counterclockwise. The engraved stones on the bowl of the chalice are the following:

1. Archangel Michael (cameo, gray chalcedony, Constantinople, 12th–13th century, fig. 1);

2. The Baptism of Christ (intaglio, bloodstone, 17th century, fig. 2);

3. The Flagellation (cameo, bloodstone, 18th century, fig. 3);

4. The Crucifixion (intaglio, bloodstone, 17th century, fig. 4).

On the chalice's foot, starting below Archangel Michael, are:

5. Saints Rufina and Justa (cameo, glass paste, 17th–18th century, fig. 5);

6. Annunciation (cameo, nephrite, 16th–17th century, fig. 6);

7. Madonna and Child (cameo, carnelian, 16th century, fig. 7);

8. Unidentified ancient pagan subject (cameo, white chalcedony, possibly 16th century, fig. 8).

The apparent focus of this vessel's visual program is its oldest engraved gem, the cameo of Archangel Michael, a radiant gray chalcedony that stands out among the seventeenth- and eighteenth-century bloodstones on the bowl of the chalice. Below the archangel is the cameo of Saints Rufina and Justa. The intense blue of its glass paste makes for a focal point on the foot of the chalice, helping mark the main vertical axis of the iconographic program, as does the inscription containing the name of the master, with "Buch" deliberately engraved precisely below the cameo. It was the practice of the renowned goldsmiths working for the court of Saint Petersburg to engrave a signature visibly on the foot at the front of an object.[34]

The use of bloodstone, symbolic of Christ's self-sacrifice, on the chalice's bowl reflects both the function of this vessel and the material's liturgical connotations. In addition, two of these carved gems (the Flagellation and the Crucifixion) depict events from the Passion of Christ, which the liturgy reenacts. The symbolism of the material and the images rendered on it coincide closely. A slightly different dynamic is evident in the intaglio that features the Baptism, in which the liturgical and sacrificial meaning of the bloodstone is paired with the theme of Epiphany, when the divine revealed itself to humanity. This choice also befits a chalice as the ritual of liturgy culminates in a divine revelation, when the Holy Spirit descends from heaven and transforms the bread and wine, offered by the faithful, into the body and blood of Christ. While the Flagellation and Crucifixion emphasize Christ's humanity, the Baptism is a testimony to his divinity; thus, these three bloodstones jointly convey a statement about the self-sacrifice of the Son of God and its ritual reenactment in the liturgy as essential components of the Divine Economy for human salvation.

The short pictorial cycle on the bowl relates to the devotion of Christ, while the scenes on the foot reflect the cult of the Virgin and include the themes of the Incarnation and maternity. Each scene on the foot has a counterpart above it on the bowl, revealing a deliberate correspondence

between the masculine upper register and the lower feminine one. The pair that includes the Baptism and the Annunciation serves to promote contemplation of two joyous events, both involving a theophany. The Flagellation and the Madonna and Child emphasize Christ's humanity and relate to the Virgin and Child's shared awareness of the pending tragedy. The same juxtaposition of motherhood with suffering, death, and possible redemption may explain the pairing of the Crucifixion bloodstone and the white chalcedony cameo depicting events involving a mother and her infant child (see the more detailed discussion below).

The connections within and between the two registers are evident yet, in each, one image stands out by being less integrated into this web of associations. On the bowl, it is Archangel Michael, and on the foot it is Saints Rufina and Justa. Both cameos fit the general framework only loosely, mainly in terms of gender (a male figure in the upper register and female ones below). At the same time, these two cameos form the main vertical axis in the iconographic program, thus making it abundantly clear that they are the key to decoding the empress's statements. The only element of the chalice's decoration that does not seem to conform to the main vertical axis is the inscription at the top. Commonly, the lettering would start at the front of an object, which would result in the central placement of the symbolic invocation of the faith. Here, the engraved quote starts on one side, and the asterisk marking its beginning appears above the bloodstone intaglio of the Crucifixion. This arrangement emphasizes the liturgical symbolism of the scene and affects the main vertical axis of the iconographic program. Consequently, the section of the inscription reading "СІЯ ЕСТЬ КРОВЬ МОЯ" ("This is my blood") appears right above the cameo of Archangel Michael. The reference to Christ's corporeality in conjunction with the image of a bodiless, and hence "bloodless," archangel invites the contemplation of a seeming paradox, a certain implied reversed hierarchy: should an archangel, the emanation of pure celestial power, not be superior to one possessing a human body? On one hand, this traditional rhetorical device constructs an incongruity that reflects the limitations of common thinking and is easily overcome by true understanding of religion. The anticipated Christian response would involve the elevation of human nature to the pinnacle of sanctity in heaven through the miracle of the Incarnation. On the other hand, the appearance of error summons scrutiny, bringing forth various layers of meaning that amount to an intense intellectual exercise relevant to the vessel's august commissioner. The individual cameos offer further insight into this exuberance of connotations.

CAMEO OF ARCHANGEL MICHAEL

Archangel Michael is rendered in a full-length frontal view with his long wings extending to the left and right. Next to his halo appear Greek letter ligatures "ОАХ" (Archangel) and "МИХ" (Michael). He wears a military costume without a helmet, and a cloak covers his left shoulder and arm. His right arm, bent at the elbow, holds an unsheathed sword whose flat side rests upon his shoulder. Neither sheath nor shield is included in the composition. The highly polished surface of this miniature relief is treated in a manner suggestive of different textures. The carver rendered multiple folds at the upper chest, where presumably a fibula holds the cloak in place. Clearly visible are the scales of the knee-length armor and the feathers on the wings—short at the top and emphatically longer below.

The figure seems suspended in the air as his feet do not touch the ground, unlike the other two examples of cameos with similar iconography included in this exhibition (cat. nos. 28 and 50). On the gray chalcedony, the composition conveys a sense of movement through the subtle tilting of the figure and the asymmetrical appearance of his wings. The right one is rendered slightly larger as it is extended—we are witnessing the end of a flight and imagine that in a moment the wing will fold into place and the archangel will pause. Such visual devices create the impression that the viewer is witnessing a divine apparition—namely, the archangel's instantaneous descent from heaven. This composition reflects the Byzantine belief that Saint Michael the Archangel is a watchful protector capable of rescuing faithful Christians from danger at any time. Accordingly, people carried depictions of the archangel as amulets, and the material on which the images were rendered enhanced their apotropaic functions.[35] For instance, the gray chalcedony was believed to have special prophylactic and curative powers.

Michael is celebrated as the "Prince" and "Commander" of the celestial hosts and a protector of the people of Israel (Daniel 10:13, 10:21, and 12:1). In the Revelation of Saint John the Evangelist, Michael leads the celestial hosts in the battle defeating Satan (12:7–9). In his homily *De Angelis*, Saint Basil (329–379) places Saint Michael over all archangels.[36] The cameo's iconography reduces to a one-figure composition an episode from the Book of Joshua associated with the archangel's assistance in the conquest of the Promised Land.[37] Saint Michael appeared with a drawn sword in front of Joshua, the leader of the Israelites after the death of Moses. Joshua kneeled to worship the archangel, who subsequently provided his miraculous help in the battle for the city of Jericho (Joshua 5:13–15). The prostration of

Rufina and Justa refused to sell their wares for use in pagan sacrifices to Venus. For disrespecting the goddess of sensual love, the two Christian virgins were martyred, and all their earthenware goods were broken to pieces. The cameo refers to these events with a pitcher and a bowl in the foreground between the saints, who hold palm branches, a sign of martyrdom.

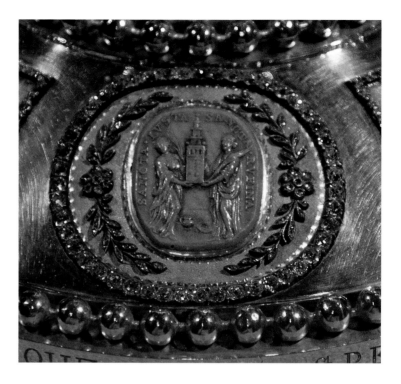

FIG. 5. Detail of the cameo of Saints Rufina and Justa, cat. no. 9.

Joshua before Archangel Michael is a well-known theme in Byzantine art and, as discussed below, it appears in historically important Russian icons kept in the royal cathedrals of the Moscow Kremlin.[38] Rendered alone, the figure of Saint Michael in military garb holding an unsheathed sword makes a direct allusion to the episode with Joshua as well as a more general statement about the archangel as a protector and guardian.

Following Joshua's example, in Byzantium and all around the domain of its religious and cultural influence, members of the military aristocracy paid special homage to Michael.[39] The veneration of the archangel had close links to the worship of military saints; the popularity of this practice is manifested clearly in the double-sided bloodstone cameo from the Walters Art Museum included in this exhibition (cat. no. 50) on which the image of Archangel Michael on the obverse is matched by the depiction of Saint Theodore on the reverse. Catherine the Great's decision to place the Archangel Michael cameo on the chalice intended for the main church of the Nevskii Monastery reflects this ancient practice based on the taxonomy of saints. The archangels, being celestial warriors, were the paragons for military saints, who were one of the several holy choirs of apostles, ascetics, and righteous women, all of them together

forming the court of heaven. The notion of the hierarchical scale that enables communication between earth and heaven was the foundation for every Christian monarchy. Catherine applied it to the Buch chalice, deliberately setting off a chain of associations beginning with the visual program featuring Christ, the Mother of God, and Archangel Michael and extending to involve figures not included in this vessel's iconography: Saint Alexander Nevskii and finally the supplicant empress, praying on behalf of Prince Gregory Potemkin. In this hierarchical scale, the occupant of each station relied on the authority immediately above him or her when seeking mediation and protection. Not skipping steps in the ranks of holiness was an assurance for the success of any supplication to God.[40]

Catherine's inclusion of a Byzantine cameo in the visual program of a neoclassical chalice expressed her intent to perpetuate and celebrate the tradition of worship in the Greek church. It also asserted continuity between the courts of Constantinople and those of Saint Petersburg. The empress not only understood these connections in religious, ecclesiastical, and dynastic terms, but also saw them in intellectual terms. For the perception of the Buch chalice it was essential that the Byzantine

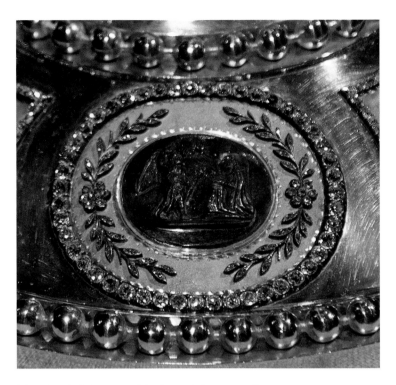

FIG. 6. Detail of the cameo of the Annunciation, cat. no. 9.

1185–1195), the first ruler of the Angeloi dynasty (cat. no. 29).⁴² This composition refers to the same biblical episode before the battle of Jericho and asserts the miraculous help of the commander of the celestial hosts. It is not, however, a simple reenactment of Joshua's supplication to the archangel. The emperor is not kneeling in prayer but stands next to the archangel; Isaac wears imperial regalia and receives a sword from the angel, a sign of his duty to serve God as a military commander. The image makes a broad statement about the conveyance of imperial authority from its heavenly source to the earthly ruler. This transference reveals the hierarchy of the celestial court, at the pinnacle of which is Christ (the ultimate source of authority in the Christian universe), through the Mother of God (the link between the earthly and heavenly realms; her likeness is on the coin's obverse), and finally through the Archangel Michael (a messenger of God and the commander of the celestial hosts) to the emperor.

The cameo of Saint Michael allowed Catherine the Great to emphasize the continuity between Byzantium and Russia by evoking the popularity of the archangel's cult in her country. In medieval Russia, from the very start of its Christian tradition, the cult of Archangel Michael acquired prominent royal connotations manifested in the naming of princes as well as the dedication and decoration of churches and monasteries they established. The likeness of the archangel appears on numerous amulets, devotional objects, and even on royal armor.⁴³ In this rich tradition, three examples stand out because of the following reasons: their iconography, which is identical to that on the gray chalcedony cameo; the symbolic statements they convey; and the specific narratives associated with these works of art.

An altar silver cross, commissioned by Tsar Ivan IV the Terrible (reign 1547–1584), prominently features a reused fragment from a fourteenth-century Byzantine ivory panel in which Archangel Michael is clad in military attire and holds an unsheathed sword. The cross was displayed in the sanctuary of the Dormition Cathedral of the Moscow Kremlin, and it is likely that Catherine the Great was familiar with this object. It provided an example of royal patronage conveying the symbolic link between Moscow and Constantinople by reusing a Byzantine work of art in a newly commissioned devotional object.⁴⁴ Such a statement must have been relevant for Ivan IV, officially crowned by the patriarch of Constantinople as the first Russian tsar and an acknowledged successor of the Byzantine emperors.⁴⁵

engraved stone on this vessel came from the collection of the empress herself. In addition to the historical links between Byzantium and Russia, Catherine added a new argument reflecting the values of the era of Enlightenment, manifesting Russia's claim on Byzantine cultural heritage through the phenomenon of art collecting and its characteristic merger of connoisseurship and the study of history. As a passionate collector of engraved stones, Catherine must have been aware that the gray chalcedony cameo most likely originated in Constantinople and belonged to a member of the Byzantine imperial family. This carved stone dates to a period when the cult of Saint Michael had special imperial connotations in Constantinople, which between the years 1185 and 1204 was ruled by the Angeloi ("Angels") dynasty.⁴¹

The coins issued by the emperors of the Angeloi family illustrate the significance of the cult of Saint Michael. Coins were a vehicle for disseminating images that encapsulated essential notions of the politics and ideology of their time. Thus, on the reverse of a *hyperpyron*, a Byzantine gold coin replacing the Roman *solidus*, the Archangel Michael is depicted presenting a sword to Emperor Isaac II Angelos (reign

Two Russian medieval chronicles contain accounts involving icons of Archangel Michael that had special significance in Russian history because of their association with royalty. Both icons are believed to have survived and were largely kept in the Moscow Kremlin. The earlier, now in the Dormition Cathedral, was likely the personal devotional icon of Prince Michael Iaroslavich Khorobrit [the Brave] (ca. 1229–1248), who ruled Moscow from 1246 to 1248 and built a church dedicated to Archangel Michael on the site of the present Saint Michael Cathedral in the Kremlin. The icon depicts the appearance of Archangel Michael to Joshua and its iconography is very similar to the gray chalcedony cameo but includes a kneeling figure of Joshua rendered much smaller, in the left foreground at the feet of the archangel.[46] His inclusion deliberately conflates the identities of Joshua and the warrior prince who commissioned this work. The account that refers to this icon appears in the *Primary Chronicle*, a twelfth-century historical text surviving in later manuscripts that contain additions to the original narrative. Of the numerous publications, translations, and scholarly studies of this seminal work of historiography in Russia, the earliest printed edition appeared in 1767, during the fifth year of Catherine's reign.[47]

The second icon of Saint Michael dates to the last decade of the fourteenth or the turn of the fifteenth century and depicts an entire cycle of scenes with the miracles he performed. This icon features two examples of the same iconography as on the gray chalcedony cameo: the main figure in the central pictorial field, where the archangel stands alone, and one of the eighteen small scenes within the visual narrative framing the central figure, which depicts the Appearance of Archangel Michael to Joshua. The icon, commissioned by the Grand Duchess Eudoxia of Moscow (d. 1407), the widow of Grand Duke Dimitri of Don (1350–1389), comes from Saint Michael's Cathedral but originally was deposited in the palace church dedicated to the Birth of the Virgin.[48]

The story of Eudoxia's icon brings together several themes applicable to the Buch chalice. Catherine followed the example of the wise and pious Eudoxia by selecting an iconic image of Archangel Michael to celebrate the victories of a heroic husband, to declare her devotion to him, and to express her deep Christian faith. Eudoxia appears twice in the first Russian work of modern historiography, written by an associate of Peter the Great, Vasilii Nikitich Tatishchev (1686–1750), a direct descendant of the Varangian chieftain Riurik (reign 864–879), the founder of Kievan Rus'. Tatishchev's five-volume *Russian History Dating Back to the Most*

Ancient Times was published posthumously in 1768, during the sixth year of Catherine the Great's reign. This work contains brief accounts of two of Eudoxia's deeds, both involving her patronage. In 1383, she founded a church dedicated to the Birth of the Virgin and located in the women's wing of the Moscow Kremlin to celebrate her husband's most important military victory, the Battle of Kulikovo, which took place on September 8, 1380. This victory over the Golden Horde ended the Mongol domination over Russian lands and established Moscow as an imperial center for the following three centuries. The dedication of Eudoxia's church reflects the fact that the battle took place on the day when the Orthodox church celebrates the birth of the Mother of God. Tatishchev's history also mentions Eudoxia founding a nunnery on the premises of the royal citadel of the Kremlin, the Monastery of the Ascension of Christ. Eudoxia retired there in 1407, at the very end of her life, after becoming a nun and accepting the name Euphrosyne.[49]

Tatishchev left out other important details of Eudoxia's life, even though they render the grand duchess a paragon of Christian aristocratic womanhood. Eudoxia was revered for her piety, her notable patronage of the arts, and her ability to maintain a refined and splendid court. Her grand style generated idle speculation of impropriety and consequently met with disapproval by her sons. This development must have resonated with Catherine, whose life, after becoming empress, involved a perpetual effort to address the resentment and outright hostility of her son, the future Emperor Paul I (reign 1796–1801).

Catherine knew "An Account About Eudoxia," a text included in *The Book of Degrees of Royal Genealogy*, or *Stepennaia kniga*.[50] Composed around 1560, during the reign of Ivan IV, this important work in the tradition of Russian historiography was published in two volumes in 1775. While working on her own historiographical project, *Notes on Russian History*, the empress pored over a copy of the *Book of Degrees*. Catherine's intense reading of this treatise compelled Khrapovitskii to make an entry in his diary on November 31, 1791, reading, "Twice I was summoned for a discussion of *Russian History*. [Her Majesty is] very pleased after discovering in *The Book of Degrees* the name of the tutor of Valdemar I of Sweden against whom Saint Alexander Nevskii fought."[51]

According to the "Account About Eudoxia," she and Dimitri enjoyed twenty-two years of devoted married life, during which she bore thirteen offspring, including the future grand duke of Moscow Basil I (reign

1389–1425). After her husband's death in 1389, even though she continued to fulfill her courtly duties and wore precious ceremonial costumes, she secretly dedicated herself to pious spiritual existence, depriving her body and nurturing her soul through prayer and meditation. The outward lavishness of her existence angered many of her subjects and, as mentioned, offended her sons, who confronted their mother and demanded an explanation. In response, she removed parts of her courtly attire to reveal under it a hair robe, ascetic chains, and her emaciated wrinkled body. After proving her virtue to her children, she requested that they keep her secret as she considered it her royal vocation to suffer the spiteful rumors in the name of Christ. For this act of ultimate piety, Eudoxia was granted a vision of an angel delivering the news that the end of her suffering was near. Overwhelmed by witnessing the divine presence, the grand duchess lost her ability to speak and had to communicate through gestures with the painters she summoned to paint an icon of her vision. After many attempts to render a likeness of the divine messenger who visited her, Eudoxia recognized Archangel Michael in the work one of the painters created at her command and, at that moment, she regained the ability to speak. The vision compelled her to withdraw to the nunnery she established, where she soon died. Notably, the icon of Archangel Michael was deposited not in the Monastery of the Ascension but in the Church of the Birth of the Virgin. Although the vision rendered on the icon led to her ascetic seclusion, Eudoxia considered it essential that the likeness of the commander of the celestial host go to the church celebrating the exploits of her warrior-prince husband.[52]

The associations between Eudoxia and Catherine the Great remain understated and esoteric, especially against the background of official celebratory phraseology with its omnipresent explicit images of Catherine as the "Minerva," "Semiramis," "Felitsa," and even the gender-challenged "New Justinian." Nevertheless, the story of Eudoxia confirms that Catherine deliberately perpetuated forms of patronage and acts of devotion that had obvious Muscovite prototypes; in so doing, the empress successfully linked Byzantine imperial ideology, medieval Russia, and the neoclassical empire over which Catherine ruled. The parallel with Eudoxia also reveals that the empress's commission of the Buch chalice emphasized her position as a faithful member of the Orthodox church and a woman who was bound (in her own idiosyncratic way) to her larger-than-life heroic spouse.

From the start, Catherine planned to deposit her gift of gold liturgical vessels to the main church of Saint Alexander Nevskii Monastery in time for its patron's feast, on August 30. This feast celebrating the transfer of Saint Alexander Nevskii's relics from Vladimir to Saint Petersburg falls on the penultimate day of the Orthodox liturgical year, which starts on September 1. Everyone following the ecclesiastical calendar would have been fully aware of the important upcoming feasts because the faithful would have had to prepare properly for them by fasting (if needed), praying, and reading about the approaching holy days. The feast of Archangel Michael is on September 6, only a week after Alexander Nevskii's, and their proximity in the liturgical calendar is yet another way in which the two figures are related in the minds of Orthodox Christians.[53] As with every feast day, certain popular prayers performed during the holy services would readily come to mind. The enamel icon of Prophet Elijah in this exhibition (cat. no. 32) demonstrates this connection between prayers and feast days through the inscription in gold on its back, a stanza from a liturgical poem performed during holy services on July 20, Elijah's feast. The following stanzas from such poetry associated with the liturgical celebrations on August 30 and September 6 provide examples of well-known and commonly remembered prayers addressing Saint Alexander Nevskii and Archangel Michael:

Saint Alexander Nevskii:

Voice 6: You, faithful Prince Alexander, since youth you loved the Lord and wore His wreath, while rightness and truth were shining on you; through mercy and purity you rendered yourself into the spacious dwelling place of the Holy Spirit, to Whom we ask you to pray ceaselessly for saving your land and making it unassailable by the enemy, and to save the sons of Russia.[54]

Archangel Michael:

Voice 2: Leader of the heavenly Hosts, commander of angels and mentor of men, pray for us and plead on our behalf for great mercy since you are the General of the bodiless [celestial powers].

Voice 4: We pray to you, the commander of all heavenly warriors, to shield us with your prayers and to shelter us below the roof formed by the wings of your spiritual glory,

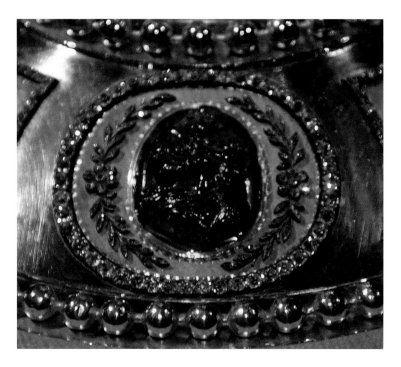

protect us who kneel in dutiful prayer and call ardently on you; save us from misfortune, you who command the heavenly hosts.[55]

CAMEO OF SAINTS RUFINA AND JUSTA

These martyred sisters were celebrated as patronesses of the city of Seville in Spain, where their miraculous intervention during an earthquake in 1504 is believed to have saved the famous Giralda, the twelfth-century bell tower of the cathedral. Since then, the tower of Seville has been a notable attribute in these saints' iconography, as seen on this blue glass-paste cameo.[56] Ecclesiastical authorities and citizens of Seville alike sought the saintly sisters' protection again in 1649, when a plague devastated the city, and local tradition says they saved both the Giralda and the cathedral itself during the Lisbon earthquake of 1755. The city of Seville became a destination for pilgrims showing their devotion to these two saints. The cameo Catherine the Great selected for the Buch chalice is likely an example of a pilgrim token, due to its being both affordable and transportable.[57] The question is why the empress of Russia chose to juxtapose a modest pilgrim token depicting a pair of local

Roman Catholic saints from distant Seville with the exceedingly rare and precious gray chalcedony cameo of Archangel Michael that most likely originated in Constantinople and belonged to a member of the Byzantine imperial family?

The Orthodox Church of Russia did not celebrate Saints Rufina and Justa, and their vita was not included in the great collection of saints' lives Saint Dmitri of Rostov (cat. no. 37) compiled in the early eighteenth century, but they were indeed distinguished as third-century sufferers for Christ in the classic age of martyrdom. Catherine's homage to Rufina and Justa emphasized the early church and reflected the empress's intense and prolonged study of history. Depicting these local Spanish saints on a chalice for the monastery of the local Russian saint Alexander Nevskii seems to imply a unified Christian tradition. One must bear in mind the endless foreign indictments of the Russian church and its practices as an aberration of true religion, which incensed the empress and made her seek ways of demonstrating that Russian Orthodoxy was indeed a current in the tide of Christianity in Europe.[58] In an age obsessed with scientific geography and precise mapping, the extreme physical separation of Seville and Saint Petersburg, at two diagonally opposite ends of the Continent, could not have been overlooked. Hence, precisely because of the great distance between these two cities, the connection between them emerges as relevant. Ecumenical sentiments and scholarly inclinations together contributed to making Catherine's favorite argument: "Russia is a European country."[59]

The vita of Rufina and Justa points to other meaningful factors in Catherine the Great's decision to include their likenesses on the chalice. Born in Seville, the sisters took a vow of chastity early in their lives. Their worldly occupation was to make and sell simple earthenware vessels; though this work brought them modest earnings, the pious maidens still shared with the poor in their city. The sisters suffered martyrdom under Emperor Diocletian (reign 285–305 CE) in 287 at the ages of nineteen (Rufina) and twenty-one (Justa). The Roman Catholic Church celebrates their memory on July 19. Rufina and Justa refused to sell their wares for use in pagan sacrifices to Venus. For disrespecting the goddess of sensual love, the two Christian virgins were martyred, and all their earthenware goods were broken to pieces. The cameo refers to these events with a pitcher and a bowl in the foreground between the saints, who hold palm branches, a sign of martyrdom. Their occupation in their earthly life made Rufina and Justa the patron saints of potters, and their example instructs

us that dispensable earthenware is akin to the mortal bodies of humans. Nevertheless, what is made of clay can transcend its natural limitations and serve a higher spiritual purpose.

Adorning the chalice with the depiction of a pitcher and a bowl invites contemplation of the symbolism of vessels. As discussed in a preceding essay, Catherine the Great deliberately created circumstances in which she emerged as a quintessential vessel maker.[60] The Buch chalice is only one of many examples in which the empress's patronage for the arts engages the customary concept of vessels as symbols of femininity. Here, as a person of Christian faith, Catherine follows the example of the chaste potters from Seville because making a vessel is a gesture expressing a specifically feminine form of piety. It might seem a glaring discrepancy between Rufina and Justa's modest earthenware and Catherine's dazzling and lavishly precious chalice, but this apparent contrast provokes a deeper look and further contemplation. We realize that the empress's exalted status obliges her to create an object worthy of partaking in the act of transcendence between the earthly and the heavenly realms. The millennia-old notion that gold and precious stones are materialized eternal light emerges newly strengthened and made fresh precisely due to the initial doubt of its appropriateness; the symbolic properties of the precious materials explicate and facilitate the sacred ritual. For all intents and purposes, this symbolism is presented to us as a historical phenomenon, due to the many nonliturgical layers of meaning; its neoclassical design; the engraved gems used as "spolia"; the references to Byzantine iconography and imperial ideology, as well as Russian medieval history; and, last but not least, the personal meanings associated with Prince Gregory Potemkin.

Catherine's interest in Seville had a great deal to do with the Serenissimus Prince of Taurida. His great-great-grand uncle Peter Ivanovich Potemkin (1617–1700) had been a diplomat in the courts of Tsar Aleksei I Romanov (reign 1645–1676) and Tsar Fedor III Romanov (reign 1676–1682), the father and the half-brother of Peter the Great. Peter Potemkin led an embassy to Spain and France during 1667 and 1668, which resulted in the establishment of regular diplomatic relations between Russia and Spain.[61] Peter's colorful manner and extravagantly rich attire compelled the king of Spain Charles II Habsburg (reign 1665–1700) to commission the diplomat's portrait, which was painted by Juan Carreño de Miranda (1614–1685).[62] The full-length, life-size likeness of the Russian envoy had the rare distinction of being displayed in the Spanish royal palace.[63] After his return home, Peter Potemkin wrote an account of his travels in which he described with terse eloquence the city of Seville and in particular the Giralda and the cathedral. His stories must have prompted the empress to see in a new light the blue glass pilgrim token from Seville. The first publication of Peter Potemkin's diplomatic travelogue was in the series *Ancient Russian Library*, favored by the empress and intended to inform Russian audiences about the history of their country. The account of the Spanish embassy appeared in 1790, the year before the Buch chalice was created.[64] A similar flavor pervades anecdotes about the two Potemkins, both fiercely loyal to the crown of Russia and both finding ways to present their eccentricities and excesses as a form of service to their sovereigns. We have already seen how Catherine strove to include recently published books in the current intellectual discourse by creating circumstances that would stimulate engagement with these texts. Her inclusion of this cameo featuring two Spanish saints and alluding to Peter Potemkin's travelogue is yet another example of a similar effort.

WHITE CHALCEDONY CAMEO

This gem likely dates to the sixteenth century as it shares formal qualities with other examples of engraved stones of the era. These similarities include the depth and the subtlety of the carving, the graceful proportions of the figures, the animated dense compositions, and the delicate distinctions between differently textured surfaces.[65] The subject of the scene rendered on the white chalcedony cameo has not been identified until now.[66] The composition features two registers suggestive of two different moments in a continuous narrative. In the foreground, a kneeling mother holds her infant in her left arm and raises her right arm in a gesture expressing her woeful predicament and acknowledging the two figures approaching from the left, a bearded man followed by a woman. The man addresses the kneeling mother; as if blessing her, he extends his right arm in her direction. In the center of the foreground, between the two groups of figures, is a small vessel, positioned immediately below two matching objects suspended from the man's left hand. The bottom of this vessel appears to be submerged in shallow water, suggested by the rippling surface of the area around it.

In the background, two rock formations mark the high horizon line. On the left is a wind-blown tree, and on the right the mother sits in front of a rock. This part of the cameo shows what must have occurred after the initial encounter, and distress and angst have been supplanted by comfort and repose. No longer clasping each other, the mother and child

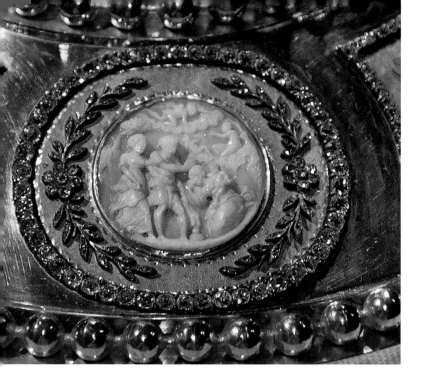

FIG. 8. Detail of the white chalcedony cameo, cat. no. 9.

This gem likely dates to the sixteenth century as it shares formal qualities with other examples of engraved stones of the era. These similarities include the depth and the subtlety of the carving, the graceful proportions of the figures, the animated dense compositions, and the delicate distinctions between differently textured surfaces.

are now reclining. Facing her offspring, the woman addresses a winged figure rendered in a dynamic pose above a billowing cloud at the very top of the composition.

The object in the center of the foreground, reminiscent of a box set in shallow water, seems to be the ark (λάρναξ) in which Acrisius, the mythical king of Argos, locked his daughter Danae and the infant Perseus, the son of Zeus. Acrisius then had the ark thrown in the sea because of a prophecy that Danae's son would one day kill his grandfather. The vessel became caught in the fishing nets of Dictys, the brother of King Polydectes of the island of Seriphus. Pausanias asserted that there were two rescuers on the shores of Seriphus (Dictys and Clymene) and probably served as a source for the scene due to the presence of Dictys's female companion on the cameo.[67]

Dictys holds two objects in his left hand, suspended immediately above the ark and close to Danae and Perseus, a clear signal that they are essential to the story. They may allude to the fishing nets that caught the ark and refer to the name of Perseus's savior (in Greek, "dictys" means "net"). On the other hand, they may be slings, one bigger than the other; the sling was an attribute of Perseus and appears on carved gems featuring the hero holding the head of Medusa.[68] With regard to Dictys, the slings could be construed

as an expression of the paternal role he played in Perseus's life. In antiquity, future warriors started training very young, and the first weapon they mastered was the sling.[69] The winged figure at the top of the composition is very likely a personification of the wind that steered the chest containing mother and child toward the island of their salvation.

Two works of ancient literature involving the story of Danae and Perseus may have served as a point of reference for Catherine the Great. Apollodorus's *Library*, which had two Russian editions (1725 and 1787), contains the following passage:

> 2.4.1: When Acrisius inquired of the oracle how he should get male children, the god said that his daughter would give birth to a son who would kill him. Fearing that, Acrisius built a brazen chamber under ground and there guarded Danae. However, she was seduced, as some say, by Proetus, whence arose the quarrel between them; but some say that Zeus had intercourse with her in the shape of a stream of gold which poured through the roof into Danae's lap. When Acrisius afterwards learned that she had got a child Perseus, he would not believe that she had been seduced by Zeus, and putting his daughter with the child in a chest, he cast it into the sea. The chest was washed ashore on Seriphus, and Dictys took up the boy and reared him.

The second source readily available to Catherine would have been one of Lucian's Dialogues, the full set of which was translated into Russian between 1775 and 1784. The twelfth *Dialogue of Sea Gods* involves two sea nymphs, Doris and her daughter Thetis, who recount the cruel treatment of Danae and Perseus by Acrisius and, touched to tears, decide to save the mother and child whose ark has already been safely steered toward the shores of Seriphus:

> DORIS: Then why should we not save them? We can put the chest into those fishermen's nets, look; and then of course they will be hauled in, and come safe to shore.

> THETIS: The very thing. She shall not die; nor the child, sweet treasure![70]

As discussed in the Green Frog Service essay in this volume, Seriphus belongs to the Cycladic group of islands in the Aegean archipelago, which had special topical connotations in Russia during Catherine's reign. For nearly four years, in the course of the First Russo-Turkish War, in particular after the victory over the Ottoman fleet at the Chesme Bay in June of 1770, several of the Cycladic islands were considered a territory of the Russian crown because the islands were under the control of the Russian fleet, commanded by Count Aleksei Grigorievich Orlov.[71] The war brought substantial gains for Russia and marked the beginning of an era of strong Russian influence in this part of the world. In addition, Saint Petersburg's control over the Cyclades, although temporary, was a symbolically charged act asserting Russian affiliation with and ownership of the cultural heritage of ancient Greece, a central theme in the grand narrative of Catherine the Great's Greek Project.

The carved gems on the Buch chalice encourage consideration of the rescue of Danae and Perseus in the context of the Christian scenes. Consequently, Danae's ark emerges as a symbol of motherhood that purposely calls to mind the Mother of God, to whom the visual cycle on the chalice's foot is dedicated. In works of poetry and visual arts, the Mother of God is celebrated as the Ark of the Covenant, a sacred chest, a gold container holding the Word of God.[72] The meanings activated by the white chalcedony cameo on the Buch chalice deliberately engage pagan and Christian statements about feminine nature and virtue expressed through the image of a vessel or receptacle. Catherine devised an arrangement that presents us with a cameo involving a mother in an ark on a liturgical vessel, representing the same symbol in triplicate and

asserting that both the ark and the chalice are instruments of deliverance and salvation. Furthermore, it acknowledges that the ark as a symbol of the Mother of God has ancient pagan sources as well as the obvious Old Testament ones.

Catherine's ambition to reshape Russian culture by infusing meanings, associations, and allusions related to pagan antiquity into its Orthodox Christian core was an undertaking of massive proportions and long-lasting impact.

The placement of the Danae cameo immediately below that of the Crucifixion is a neoclassical take on a traditional device in Byzantine visual rhetoric: the pairing of the depiction of Christ's death on the Cross with the scene of the Resurrection, one of the most succinct ways to convey in images the essence of Christian faith. On the Buch chalice, the pagan content of the scene signifying salvation makes a statement about the element of learning that amends and enriches faith. The rescue of Danae and Perseus prefigures Christ's victory over death. Obvious parallels exist between Perseus and Christ. Both are saviors of the world who vanquished malevolent adversaries, and both were sons of virgins and supreme celestial deities.

The preoccupation of Christian thinkers with the ancient pagan and Old Testament prefigurations of Christ was already evident with the pre-Nicean Church Fathers, notably Saint Justin the Martyr (ca. 100–165 CE). Beginning in the ninth century, the Eastern Orthodox Church celebrated this saint's memory on June 1. Furthermore, in the era of the Enlightenment in Russia, Justin's arguments resounded with a special ring as they showed ways of envisioning the continuity between pagan and Christian traditions. In an era when familiarity with ancient culture was a universal measure of enlightenment, the vita of Saint Justin had a lot to offer. Saint Dmitri of Rostov's collection of saints' lives contains a

detailed account of the martyred philosopher that abounds with examples of Justin's insight into ancient learning, especially Platonism, in addition to his mastery of the text of the Old Testament and the teachings of the Christian church. Nor was this vita the only readily available source of knowledge about the saint. In 1783, eight years before the Buch chalice was created, a selection of Saint Justin's writings was published in Moscow, including the famous *First and Second Apology*, which include discussions of the parallels among stories of pagan gods and heroes, Old Testament figures, and Christ.[73]

By understanding the parallel between Christ and Perseus, appreciating its importance, and finding a way to express it on the chalice, the philosopher-empress paid homage to the martyred philosopher Saint Justin. One cannot help but think of all the rich neoclassical overtones discernible to those who shared her ideas and knowledge when eighteenth-century audiences listened to the famous chant performed on the feast day of Saint Justin. With her extraordinary memory and knowledge of liturgy, the empress most likely remembered it by heart: "The Holy Church adorns Herself with the Wisdom of your Divine words, oh Justin; the light of your life brightens the world; for the sake of your spilled blood the crown [of martyrdom] was bestowed on you, and [we beg of you] pray ceaselessly for us when with the angels you stand before Christ." The neoclassical material environment, which Catherine the Great introduced and immensely enriched throughout her reign, inevitably added a new prism for the perception of widely known traditional liturgical texts. An entire stratum of new meanings emerged from the old Orthodox chants.

The cameo depicting the rescue of Danae and Perseus also makes an understated yet unambiguous allusion to Catherine the Great's perilous predicament from the time immediately before her ascent to the throne,

when she and her son faced exile and perhaps death at the hands of Peter III.[74] The chalice's message suggests why the empress was saved and why she would ultimately achieve spiritual salvation. Her strong faith in God was buttressed by her scholarly knowledge of history, manifested in her keen understanding of the continuity between the intellectual traditions of the ancient pagan and the Christian eras.

Catherine's ambition to reshape Russian culture by infusing meanings, associations, and allusions related to pagan antiquity into its Orthodox Christian core was an undertaking of massive proportions and long-lasting impact. In the last years of her long reign, this endeavor had acquired nearly a quarter century of history, which had also a profoundly personal dimension involving Prince Potemkin. In the course of the First Russo-Turkish War, the two of them initiated a project to show the civilized world that Russia was a repository of Greek manuscripts containing works of ancient science and literature. As discussed elsewhere in this volume, Catherine sponsored research on the Greek manuscripts of the joint collection of three libraries in Moscow (the Patriarchate, the Holy Synod, and the Synod's Typography). The German classicist Christian Matthaei revealed in a catalogue published in 1776 that the Patriarchal library contained numerous Byzantine texts as well as works by a great number of ancient authors including Homer, Sophocles, Plutarch, Aristotle, and Aristophanes. This discovery was one "the like of which had not occurred since the days of Italian Humanism."[75] Matthaei's opus, in addition to making a contribution to classical philology, demonstrated to all of enlightened Europe how profound the links were among medieval Russia, Byzantium, and ancient Greece. The awareness that the very heart of Russia's Orthodox church cradled the wisdom of classical antiquity inspired the empress and Potemkin. It is with the Buch chalice that this notion finds a poignant expression, celebration, and commemoration.

END NOTES

1. Barsukov, 218. On Catherine II's lifelong association with the Monastery of Alexander Nevskii, see Pitiurko.

2. I. W. Buch was a Norwegian-born goldsmith who moved to Saint Petersburg from Sweden. On his life and work see Terekhova; and Odom 1998, 212–14, no. 104.

3. The correspondence between Odom and Kuznetsova is kept in the archives of the Hillwood Estate, Museum & Gardens. I would like to thank the curators at this institution who enabled my work with these documents.

4. Venturi 1991, 764–947; Troyat 1980, 329–41; Madariaga, 162–75; Rounding, 349–76; Sebag Montefiore, 388–455; and R. Massie, 503–19.

5. Baehr, 65–89; and Schönle 2001.

6. *Christian Relics in the Moscow Kremlin*, 14–16.

7. Kirin 2010 and 2012.

8. *Zhurnal vysochaishago puteshestviia eia Velichestva*; see also Troyat 1980, 309–28; Rounding, 425–49; Sebag Montefiore, 351–87; and R. Massie, 489–503.

9. Lopatin, 440, no. 1093, November 12, 1790.

10. *Kamer-fur'evskii zhurnal* 1770.

11. Much later in her reign, the empress states emphatically, "I have always paid close attention to all matters concerning our fleet." See Lopatin, 434–35, no. 1085, September 16, 1790.

12. Countess Golovine, 9–10.

13. The church was based on prototypes from Vladimir. The architect and builder of this church, Aristotele Fioravanti, was sent to Vladimir to study the architecture there. See Zabelin; Snegirev; Tolstaia; and Zemtsov.

14. Evans; King; and Isager, 212–20.

15. Heckscher; and Zwierlein-Diehl 1997.

16. Winckelmann; Mariette, *Description sommaire des pierres gravées*; *Le destin d'une collection*, 10–36; and Musée du Louvre.

17. See "Great Women Are Great Men," in this volume.

18. Sebag Montefiore, 136–50.

19. Ibid., 13–62.

20. The Holy Roman Emperor signed the Sistova Treaty with the sultan on August 4, 1791.

21. Sebag Montefiore, 417–29.

22. Ibid., 94–105.

23. Lopatin, 386, no. 1018, November 25, 1789.

24. Ibid., 432, no. 1081, September 10, 1790; and 436, no. 1089, October 1, 1790. The estate was passed to his heirs who, during the rule of Catherine's grandson Emperor Nicholas I (reign 1825–1855), restored the monastery while maintaining their Palladian villa on its grounds. Notably, throughout the nineteenth century the family's neoclassical dacha was mistaken for a church by pilgrims to the monastery, who would piously make the sign of the cross when passing by. For a discussion of the general links between the houses of the earthly and heavenly lord, see Lavin.

25. Kirin 2005.

26. Woodbridge.

27. The Byzantine monastery was "the alter ego of the secular *oikos* [house, home]"; Magdalino, 102; Kirin 2005; on the same tradition in the west of Europe, in particular the residence of the king of Spain San Lorenzo de El Escorial, see Kamen.

28. In the course of the nineteenth century, writers would make pilgrimages to this area, celebrating the beauty of the land, most prominently in the 1895 short story "Sviatye gory"/"Holy Mountains" by Ivan Alekseevich Bunin (1870–1953), the first Russian writer to win the Nobel Prize for Literature, in 1933. The appeal was an amalgamation of land and spirit, of worldly and monastic that enhanced the notion of continuity between ancient pagan and medieval Christian traditions. As in many other regards, Catherine and Potemkin were way ahead of their time for recognizing and promoting this sense of continuity. http://ru.wikisource.org/wiki/Святые_горы_(Бунин), last visited July 28, 2013.

29. Barsukov, 220, entry for October 11, 1791.

30. Isaiah, 61:10: "I will greatly rejoice in Jehovah, my soul shall be joyful in my God; for he hath clothed me with the garments of salvation, he hath covered me with the robe of righteousness, as a bridegroom decketh himself with a garland, and as a bride adorneth herself with her jewels." 61:11: "For as the earth bringeth forth its bud, and as the garden causeth the things that are sown in it to spring forth; so the Lord Jehovah will cause righteousness and praise to spring forth before all the nations." 62:4: "Thou shalt no more be termed Forsaken; neither shall thy land any more be termed Desolate: but thou shalt be called Hephzi-bah, and thy land Beulah; for Jehovah delighteth in thee, and thy land shall be married." 62:5: "For as a young man marrieth a virgin, so shall thy sons marry thee; and as the bridegroom rejoiceth over the bride, so shall thy God rejoice over thee."

31. Sebag Montefiore, 482–83. Count Razumovsky was the great patron of music for whom in 1806 Ludwig van Beethoven (1770–1827) composed String Quartets Nos. 7-9, Opus 59.

32. See "Great Women Are Great Men" and "Catherine II's Religion: Liturgy, Statecraft, and Inner Life," in this volume.

33. The lettering on the back of the enamel icon of Prophet Elijah fulfills a similar function (cat. no. 32).

34. Kostiuk 2010, 154.

35. Spier 1993. Even today, in both Eastern and Catholic churches, Archangel Michael remains one of the most popular subjects for Christian amulets along with Christ, the Virgin, and Saint Christopher. A simple search on eBay provides abundant evidence for this assertion.

36. "To you, o Michael, general of the celestial spirits, who by his honor and dignity is placed in front of all other heavenly spirits, to you I supplicate. . . ."

37. **13** Now when Joshua was near Jericho, he looked up and saw a man standing in front of him with a drawn sword in his hand. Joshua went up to him and asked, "Are you for us or for our enemies?" **14** "Neither," he replied, "but as commander of the army of the Lord I have now come." Then Joshua fell facedown to the ground in reverence, and asked him, "What message does my Lord have for his servant?" **15** The commander of the Lord's army replied, "Take off your sandals, for the place where you are standing is holy." And Joshua did so.

38. Lazarev, no. 27; *Zhivopis' domongol'skoi Rusi*, 118–20; Tolstaia, 46, fig. 75; and Mashnina.

39. Djurić; and Gabelić.

40. On "representativeness" as a phenomenon of medieval culture see Cutler.

41. The members of the Angelos family were female-line descendants of the older imperial dynasty of the Komnenoi, see *Oxford Dictionary of Byzantium 1*, 97–98.

42. Cat. no. 29; Dumbarton Oaks Library and Collection acc. no. BZC.1948.17.3534.

43. Teteriatnikov.

44. Sterligova.

45. Solov'ev, vol. 6.

46. Lazarev, no. 27; *Zhivopis' domongol'skoi Rusi*, 118–20; and Tolstaia, 46, fig. 75.

47. *Povest' vremennykh let*.

48. Mashnina; and Iakovleva, especially 281, fig. 3.

49. Tatishchev, 5:173–74 (husband's last testament), 184 (foundation of the church dedicated to the Birth of the Mother of God), and 207–8 (foundation of the Ascension Nunnery). About the Ascension Nunnery see also Evgeniia, 15–16 and 21–30.

50. *Stepennaia kniga*, 1:513–14.

51. Barsukov, 223; Birder (ca. 1200–1266), Jarl of Sweden, was active during the reigns of Eric XI (reign 1222–1229 and 1234–1250) and Valdemar (reign 1250–1275) and was the founder of Stockholm; he participated in the Neva Battle/Battle on the Ice, where, according to a sixteenth-century Russian legend recorded in the *Book of Degrees*, Alexander Nevskii wounded him in the face during a duel.

52. See above note 49.

53. September 6 is the next major feast of the Orthodox Church, namely the day of Archangel Michael, celebrating the Miracle at Chonae when the archangel saved the life of an ascetic living in seclusion in a hermitage that was about to be swept away by flood waters. See http://days.pravoslavie.ru/Days/20130906.htm, last visited July 28, 2013.

54. Ibid.

55. Ibid.

56. Among other works of art, this iconography was rendered in a famous painting from 1666 by Bartolomé Esteban Murillo (1617–1682), see Íñiguez, no. 64, figs. 236 and 237.

57. Vikan, 19–33.

58. An example of this is the empress's passionate response on behalf of the "Greek Religion," summarily dismissed by L'Abbé Chappe D'Auteroche, see Catherine the Great 1772, 179–202.

59. *Nakaz/Instruction*, 1:6.

60. See "Great Women Are Great Men" and "'The Fingertips of Sight': Discerning Senses and Catherine's Golden Censer," in this volume.

61. The order for this diplomatic mission was given by Tsar Aleksei Mikhailovich (reign 1645–1676). See www.vostlit.info/Texts/Dokumenty/Spain/XVII/1660-1680/Tajnyj_Nakaz/text8.htm, last visited July, 28, 2013.

62. According to legend, Peter Potemkin insisted that King Charles II of Spain take off his hat every time the diplomat mentioned the Russian tsar. In France, King Louis XIV (reign 1643–1715), who was recovering from sickness, received the envoy lying in bed. Allegedly, Potemkin ordered a second bed delivered to the royal chamber so that both parties could converse reclining as a sign of the equal footing of France and Russia in the negotiations.

63. The portrait dates to 1681 and is currently on display in the Prado in Madrid (Museo Nacional del Prado, no. P00645, 207.2 x 122.8 centimeters).

64. Petr Potemkin's travel notes were first published in *Drevniaia Russiiskaiia Vifliotfika*, vol. 4 (Moscow 1790), 457–546; cited according to T. P. Kaptereva, *Sady Ispanii*, http://litrus.net/book/read/89599/Sady_Ispanii, last visited July 29, 2013.

65. *Le destin d'une collection*, nos. 181/84, 292/110, 319/137, 320/138, 337/156, and 338/155.

66. In 1996, during a visit to Washington, D.C., in connection with the Center for Advanced Study in the Visual Arts symposium, Iulia Kagan of the State Hermitage in Saint Petersburg commented on this carved gem, acknowledging that its subject remains unknown but mentioning that it was discussed in conversations during the conference. Kagan suggested as a possible topic the Triumph of Bacchus. See the handwritten notes in the dossier of the Buch chalice at Hillwood Estate, Museum & Gardens.

67. See Pausanias 2.18.1. Clymene was most likely a Nereid, assisting the rescue of the faithful ark. See note 70 below.

68. *Le destin d'une collection*, 134, no. 241/59, an intaglio from the 1st century CE.

69. Venetius, *De Re Militari* 1, www.pvv.ntnu.no/-madsb/home/war/vegetius/dere03.php#14, last visited July 29, 2013; and Strabo, *Geography* 3:5, http://penelope.uchicago.edu/Thayer/E/Roman/Texts/Strabo/3E*.html, last visited July 29, 2013.

70. The citation is according to Lucian, *Dialogues of Sea Gods* 12, trans. H. W. and F. G. Fowler; see the full bibliographic entry for the eighteenth-century Russian edition under Lucian, *Dialogues*.

71. Tarle, 11–91.

72. Esbroeck.

73. Христомафиа, или Выбранные места из св. мученика и философа *Иустина*, служащие полезным нравоучением. — М., 1783. — 147 с. The *First Apology* addressed to Antoninus Pius, his sons, and the Roman Senate; the *Second Apology* addressed to the Roman Senate.

74. She acquired Rembrandt's *Danae* in 1772, tenth anniversary of the deliverance of Catherine and her son, who was eight years old at the time of their perilous situation.

75. Wes, 70–71.

CATALOGUE

ENTRIES BY ASEN KIRIN (AK), LIANA
PAREDES (LP), KRISTEN REGINA (KR),
AND SCOTT RUBY (SR)

No. 1.

Bust of Catherine II

Fedor Ivanovich Shubin (1740–1805)
Marble
h. 66 centimeters (26 inches)
Hillwood Museum and Gardens
acc. no. 22.12
Bequest of Marjorie Merriweather Post, 1973

We know very little concerning Shubin's early work. He was the son of a peasant, born in a village near Kholmogory. Inspired by the example of his neighbor Mikhail Lomonosov, he walked all the way to Saint Petersburg at the age of eighteen. Lomonosov was impressed by Shubin's talent in walrus ivory carving (a folk craft practiced in Kholmogory) and helped him join the newly established Imperial Academy of Arts, where his instructor, Nicholas-François Gillet, awarded him a gold medal. This prized honor afforded him the opportunity to further his education abroad.

Through the help of the artist Étienne Maurice Falconet, in 1767 he joined the Paris atelier of the great sculptor Jean-Baptiste Pigalle, before moving to Rome three years later. Upon his return to Russia in 1772, Shubin became the most fashionable and sought-after sculptor in the country. In the 1770s and 1780s, he executed numerous works for the Marble Palace and the Alexander Nevskii Lavra, designed fifty-eight medallions representing all the Russian sovereigns from Riurik on, and was admitted into the Academy of Arts.

Like other artists of the period, Shubin looked to nature as an inspiring force. The art of antiquity, it was believed, was the key to understanding nature. Denis Diderot emphasized the connection between antiquity and nature in his writings. In the eighteenth century, art patrons and appreciators believed that sculpture, whether in bronze, marble, or stone, should be animated, lively, and impassioned. For Shubin, nature remained the primary source of his inspiration, a preoccupation evident in this portrait bust of the empress. Here, Catherine almost seems ready to speak. She faces forward and slightly to the side. On her head is a wreath of laurel leaves and a small Russian headdress known as a kokoshnik. Her hair is combed straight back from her forehead, and curls fall on each shoulder. Due to his skill at producing exquisite works like this one, Shubin enjoyed great success both at the Russian court and at the highest levels of society.

SR

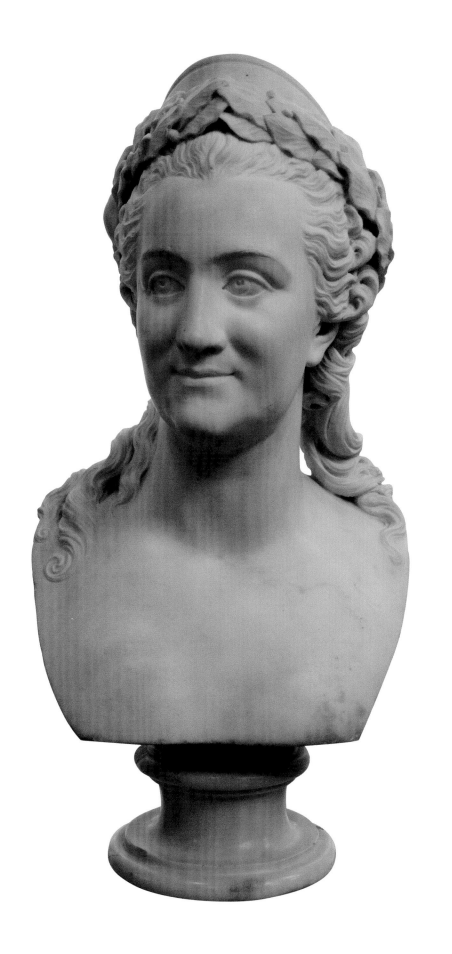

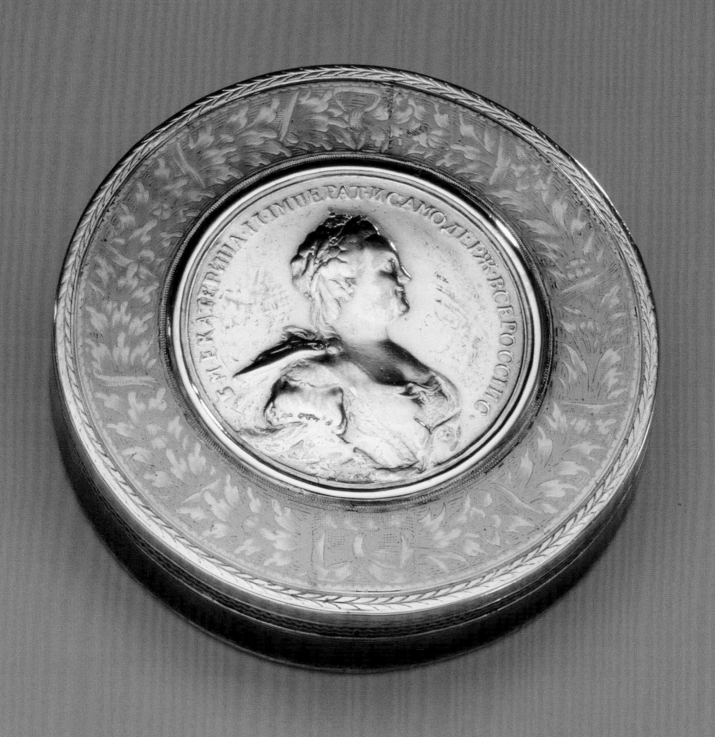

No. 2.
Round box set with a medal of Catherine II

Box: Iakov Gerasimov Moiseev
Medal: Samoila Iudin (attr.) after Johann Balthasar Gass (active, Saint Petersburg, ca. 1768–1793)
Velikii Ustiug, ca. 1800
Silver, niello, gilding
8.9 centimeters (diameter) (3 1/2 inches)
Hillwood Museum and Gardens
acc. no. 13.119.1–2
Bequest of Marjorie Merriweather Post, 1973

This small box is known as a bonbonnière, or sweetmeat box, a term used to describe small boxes without hinges, differentiating them from caskets or pillboxes. Boxes of this type, perhaps because of the frisson generated by the promise of secret treasures hidden within, were exceptionally fashionable in the eighteenth and early nineteenth century. The cover is set with a medal of Catherine the Great that features her portrait in silhouette on the front with an inscription identifying her as Empress Catherine II, and the artist's signature. A myrtle branch penetrating a laurel wreath and an inscription honoring the peace with Sweden of August 3, 1790, appear on the back of the medal (visible when the box is open).

The craftsman Iakov Gerasimov Moiseev, a gold- and silversmith born in 1773 who worked in silver and niello between 1799 and 1811, made the box. Samuel Iudin, also known as Samuel Juditsch, made the medallion. Iudin was born in Saint Petersburg in 1730 and entered the School of Engraving at the Saint Petersburg Mint in 1741. He based the medallion on an engraving by Johann Balthasar Gass, who worked for Catherine on a number of projects.

SR

Actual Size

№. 3.
Round box with Catherine II as Minerva

Paris, 1781–82
Gold and *verre églomisé*
7.3 centimeters (diameter) (2 7/8 inches)
Hillwood Museum and Gardens
acc. no. 11.17-1-2
Bequest of Marjorie Merriweather Post, 1973

This stylish Parisian gold box features a reverse-painted glass plaque (*verre églomisé*) with a portrait of Catherine II in the guise of Minerva. The connection between the two stemmed from a carefully orchestrated series of allegories that alluded to Catherine's virtues and strengths as a ruler. The image of Minerva fused the belligerent aspects of Catherine's rule, on which her authority partly rested, with the classical virtues of reason and wisdom the Enlightenment championed.

The inscription on the inner rim of the box associates it with the most fashionable shop in Paris at the time: Au Petit Dunkerke. The store was named for the town of Dunkirk in northern France, the birthplace of its shrewd owner, Charles-Raymond Granchez, a maverick in marketing novelties and all sorts of trinkets among the Parisian elite and illustrious foreign visitors.

This box is typical of the shop's output, which included many objects with images of famous people and commemorative events. On May 18, 1782, Maria Fedorovna and Paul I arrived in Paris incognito as the Comte and Comtesse du Nord (see cat. no. 27). The baroness d'Oberkirch vividly recalls in her memoirs the visit she made with Maria Fedorovna to Granchez's establishment, where they purchased numerous trinkets and gifts.[1] Could this box have been created to commemorate the visit? Catherine the Great's daughter-in-law Maria Fedorovna, a talented artist, used the same image when she carved a cameo profile of the empress to present to Catherine on her birthday (see cat. no. 5).

LP

Actual Size

Selected bibliography: Taylor, fig. 50; Odom and Paredes, cat. no. 50, 142; Arend, 110–12; Prince, 109; Dixon 2009, 388.

1. Von Waldner, 1:277.

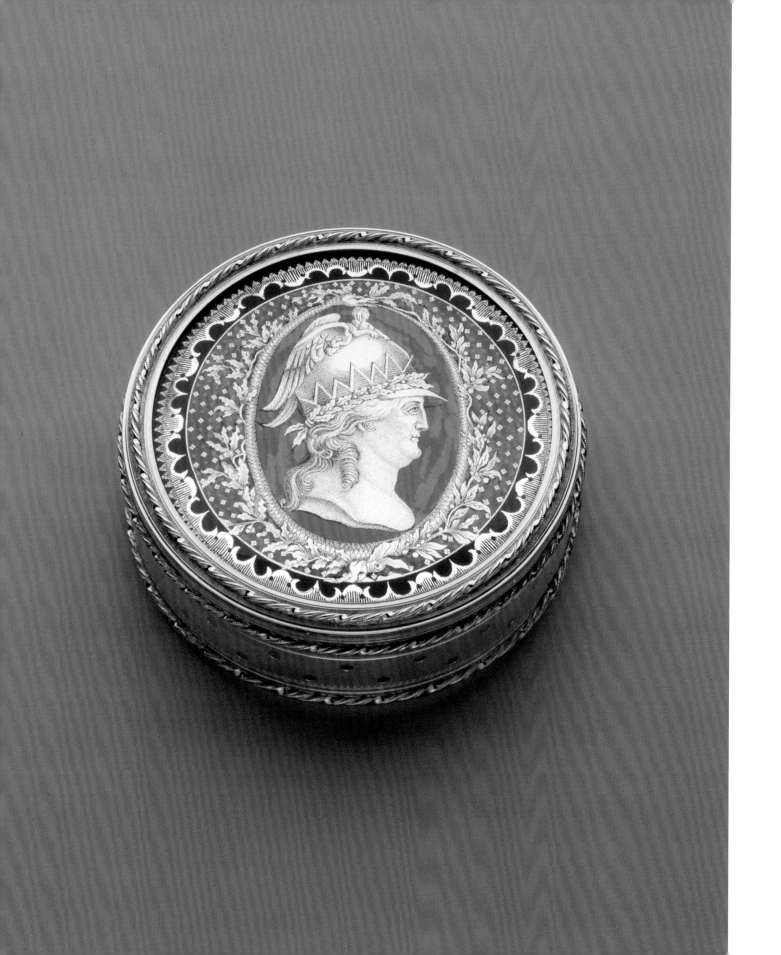

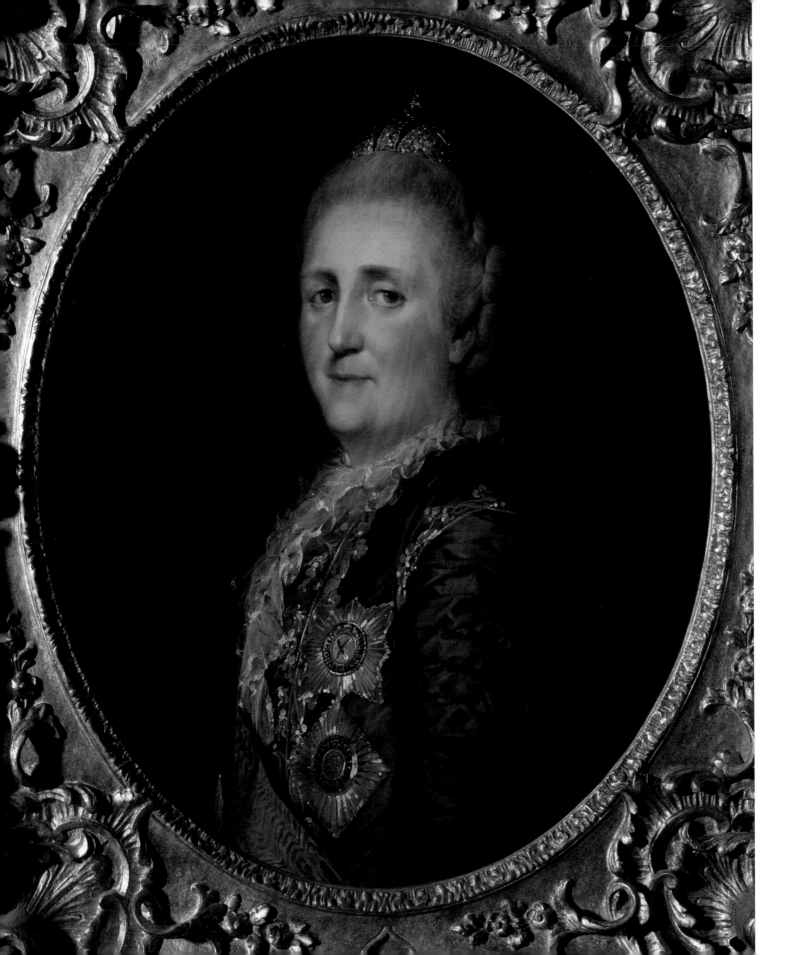

No. 4.
Portrait of Catherine II

Pierre-Étienne Falconet (1741–1791)
Oil on canvas
73.7 x 55.9 centimeters (27 x 22 inches)
Hillwood Museum and Gardens
acc. no. 51.60
Bequest of Marjorie Merriweather Post, 1973

Pierre-Étienne Falconet was the only son of famed French sculptor Étienne-Maurice Falconet (1716–1791), from whom Catherine II commissioned *The Bronze Horseman*, the celebrated equestrian monument to Peter the Great in Saint Petersburg. Prior to joining his father at Catherine's court, Pierre-Étienne studied in Paris with the English engraver John Ingram and from 1767 to 1772 as an apprentice in the London studio of Sir Joshua Reynolds. He arrived in the Russian capital in 1773 and through his father's connections soon secured a commission to paint the empress from life. The resulting full-length portrait of Catherine with her pet whippet hung in the Hermitage before the 1917 revolution. This painting is an abbreviated version of it, showing the empress in half length.

Far removed from the large parade and estate portraits, this image of the empress is more intimate in scale. Her body is set almost at a right angle to the oval frame, and her head is turned sharply toward the viewer. A small diamond crown is set well back on her gray, simply dressed hair. The immediacy of her expression, with its rather suspicious stare and sharp features, is unusual among official portraits.

Concerning this painting, scholars note that "her face, with its rather suspicious stare and sharp features, projects neither the benign softness nor the regal poise of the better-known portraits by [Aleksei] Antropov, [Fedor] Rokotov, and [Johann Baptist] Lampi that won Catherine's approval. Whether for this reason, or because the empress took exception to the 'exorbitant' price the painter charged her for this portrait and for a pair of her son Paul and his wife Maria Fedorovna, copies of Falconet's portrait are extremely rare."[1]

LP, SR

Selected bibliography: Taylor, fig. 8; Odom and Paredes, cat. no. 102, 207.

1. Odom and Paredes, 207.

No. 5.
Catherine II in the Guise of Minerva

Maria Fedorovna (designer); Glassworks of Prince Potemkin
Ozerki, Russia, 1789
Glass paste (*pâte de verre*)
6 x 4.6 centimeters (2 3/8 x 1 13/16 inches)
Hillwood Museum and Gardens
acc. no. 23.27
Bequest of Marjorie Merriweather Post, 1973

Catherine was known for her intensely passionate interest in carved gemstones, cameos, and intaglios. She even referred to her zeal for this type of object as "gluttony" or "cameo fever." When workmen had to transfer her collection to another area of the Hermitage, "four men had trouble carrying it in two baskets filled with drawers containing roughly half the collection; so that you should have no doubt, you should know that these baskets were those used here in the winter to carry [fire] wood to the rooms."[1] Catherine did much to encourage cameo carving in her close circles. Carl Leberecht, the court engraver, instructed Catherine's daughter-in-law Maria Fedorovna in the art of gem carving. This glass cameo is based on one of Maria's best achievements, a carved Siberian jasper produced in 1789 for Catherine's name day. The image depicted Catherine as the goddess Minerva wearing a helmet decorated with a winged sphinx crown and laurel wreath (see also cat. nos. 3 and 42). Copies of the cameo were immediately made in porcelain, glass, plaster, and even prints. Outside Russia, the work was mass produced by Josiah Wedgwood in Jasperware.

SR

Selected bibliography: Odom and Paredes, fig. 74, 142.

1. Yulia Kagan and Oleg Neverov, "An Imperial Affair," in Piotrovski, quoting *Sbornik imperatorskogo russkogo istoricheskogo obschestva*, vol. 22 (1878), 341.

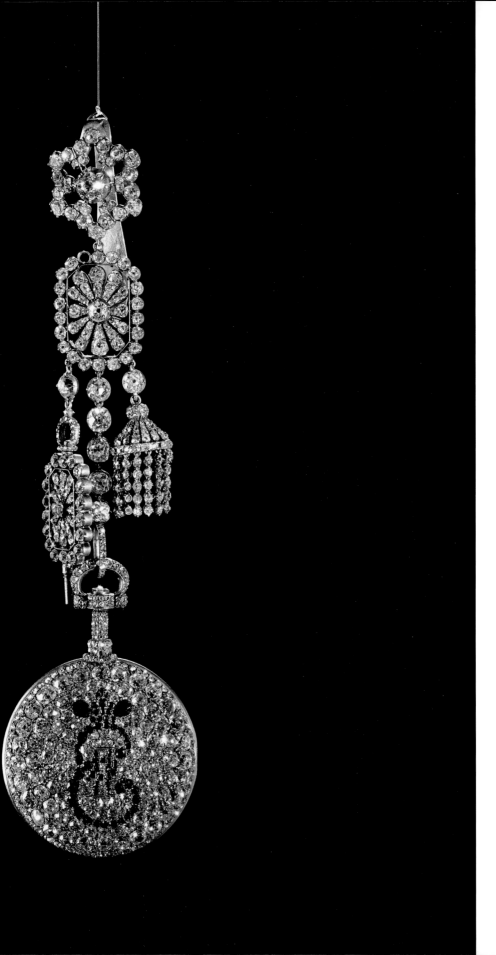

No. 6.
Pendant watch with cipher of Catherine II

D. T. Mussard, Saint Petersburg (marks on movement)
Saint Petersburg, 1786–96
Gold, diamonds, and rubies
h. 15.2 centimeters, dia. 4.1 centimeters (6 x 1 5/8 inches)
Hillwood Museum and Gardens
acc. no. 16.10
Bequest of Marjorie Merriweather Post, 1973

This diamond-studded pendant watch hangs from a diamond-encrusted chatelaine, which includes a tassel and a key decorated with a sunburst. Chatelaines hung from a belt and supported watches, sewing accessories, etc. At the center of the watch case is Catherine's cipher surmounted by the imperial crown, all in rubies. Little is known about the watchmaker D. T. Mussard. He is listed in G. H. Baillie's *Watchmakers and Clockmakers of the World* (London, 1951) as having worked in Saint Petersburg around 1820, which would make this watch one of his early pieces. It has a rather unusual Swiss-style movement and probably a cylinder escapement. It was brought out of Russia by Catherine's granddaughter, Grand Duchess Maria Pavlovna, in 1804, when she married Karl Friedrich, grand duke of Saxe-Weimar. The watch descended through four generations of the family to Prince Karl August of Saxe-Weimar, who sold it to the New York jewelry and fine art dealer A La Vieille Russie, from whom Mrs. Post acquired it.

The term "chatelaine" comes from the French and means keeper of the fort or castle, keeper of the keys, mistress of the chateau, or castellan (the wife of the keeper). It is the combination of the French words château and laine ("wool"), the latter of which was kept locked in the linen closet or armoire with other valuables. Chatelaines have been used since the fourteenth century for hanging articles of everyday necessity, including keys, knives, buttonhooks, magnifying glasses, and whistles.

SR

Selected bibliography: Rice, no. 186; Ross 1965, pl. 70, 220; Odom and Paredes, cat. no. 56, 147; "Reverence for Red," fig. 2, 103–6.

No. 7.
Chalice

Russian, 1666
Silver and parcel gilt
h. 22.5 centimeters, w. of bowl 12.5 centimeters,
w. of base 14 centimeters (8 7/8 x 4 15/16 x 5 1/2
inches)
Hillwood Museum and Gardens
acc. no. 12.82
Bequest of Marjorie Merriweather Post, 1973

This silver and silver gilt chalice features lightly engraved images of the Deesis—an image of Christ flanked by the Mother of God and Saint John the Baptist, who bow to him in supplication—arranged across the bowl's front and identified by inscriptions. On the other side of the bowl is a round medallion, gilded and engraved, with the Cross of Golgotha. These decorative elements overlap the Old Church Slavonic text around the lip of the chalice, which translates, "Drink from this, everyone; this is my blood of the New Testament, which for you and many others was poured out in remission of sins." The central portion has a knop for ease in gripping that is gilded and engraved with a foliate pattern. The base is decorated with a scale pattern and ovoid cartouches, each gilded, engraved with floral motifs, and surmounted with a fleur-de-lis. Around the base runs a long inscription that reads, "In the year 7174 [old style for 1666] on the 2nd of November the holy father Seth, Archbishop of Astrakhan had this cup made for the Church of Saint Nicholas, November 6, 1666." Astrakhan was a major commercial center on the lower Volga River.

SR

Selected bibliography: Taylor, 56; Odom and Paredes, cat. no. 7, 92–93; Odom 2011, fig. 13, 37–38.

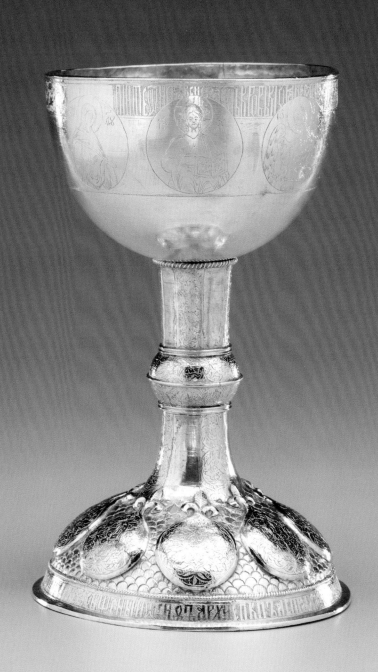

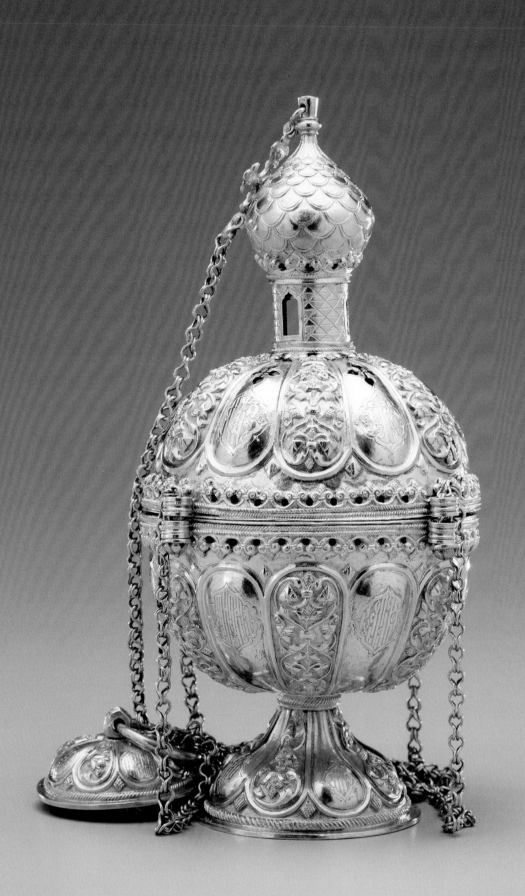

No. 8.
Censer, Russian

Late-17th-century silver
Kremlin Workshops (?)
Parcel gilt
h. 16.5 centimeters (10 1/2 inches)
Hillwood Museum and Gardens
acc. no. 12.2.1–2
Bequest of Marjorie Merriweather Post, 1973

This superlative silver gilt censer, with its lobed sections featuring high relief and inscriptions, is a high point of Hillwood's seventeenth-century metalwork collection. Here, inscriptions play not only an informative role but also a decorative one; such elaborate *viaz* (i.e., highly stylized) inscriptions are often used in other media such as icon painting and embroidery. The inscription translates as "In 1681 Abbot Joseph of the Monastery of the Savior in Staraia Russa gave this censer to the House of the Holy Life-giving Trinity and the Holy Mother of God in the Mogilev Monastery in remembrance of his soul and of his parents." The abbot was from a monastery in northern Russia, near Novgorod, but the recipient was the Trinity Monastery, located near Smolensk, nearly 400 miles south. Abbot Joseph also gave a nearly identical censer (now in the State Kremlin Museum) to the Monastery of the Raising of the Cross, on the Isle of Kiy. The latter monastery received many important religious artifacts, such as a cross acquired by Patriarch Nikon in Palestine, which he gave in 1656. The Kremlin's censer is nearly identical in form, resembling a small bulbous-domed church with lobe-shaped sections of ornament and inscriptions. Each is surmounted by an onion dome with small "windows" in the dome's drum support and cross-shaped openings in the section beneath to allow incense to escape. The superb quality of Hillwood's censer and the fact that people other than the tsar and his family could order pieces from the Kremlin Workshops, which would have offered the highest level of craftsmanship available in the period, support the possibility that it was produced by the workshops.

SR

Selected bibliography: Odom and Paredes, cat. no. 8, 93–94; Odom 2011, fig. 15, 38–39.

No. 9.
Chalice

Iver Windfeldt Buch (1749–1811)
Saint Petersburg, 1791
Gold, diamonds, chalcedony, bloodstone, nephrite, carnelian, and cast glass
h. 33 centimeters, dia. 18 centimeters (13 x 7 1/16 inches)
Hillwood Museum and Gardens
acc. no. 11.223
Bequest of Marjorie Merriweather Post, 1973

INSCRIPTIONS: On the rim of the bowl in Old Church Slavonic: "*Drink from it all of you, this is my blood of the covenant, which is poured out for many for the forgiveness of sins." (Matthew 26:27–28)

ON THE SIDE OF THE FOOT IN FRENCH: "Fabrique de Buch a Saint Petersbourg ao 1791"

HALLMARKS: Three crossed anchors for Saint Petersburg, 80 designating gold content, N M in Cyrillic for the assayer of precious metals Nikifor Moshchalkin.

Selected bibliography: Makarenko, 37; *Exhibition of Russian Art*, no. 489; Postnikova-Loseva, Platonova, and Ul'ianova, 98; Taylor, 58; Stuart, 358; Odom and Paredes, cat. no. 104, 212–14; Kettering, 98–99; Odom and Salmond, fig. 11.9, 276–78; Odom 2011, fig. 89, 118–19.

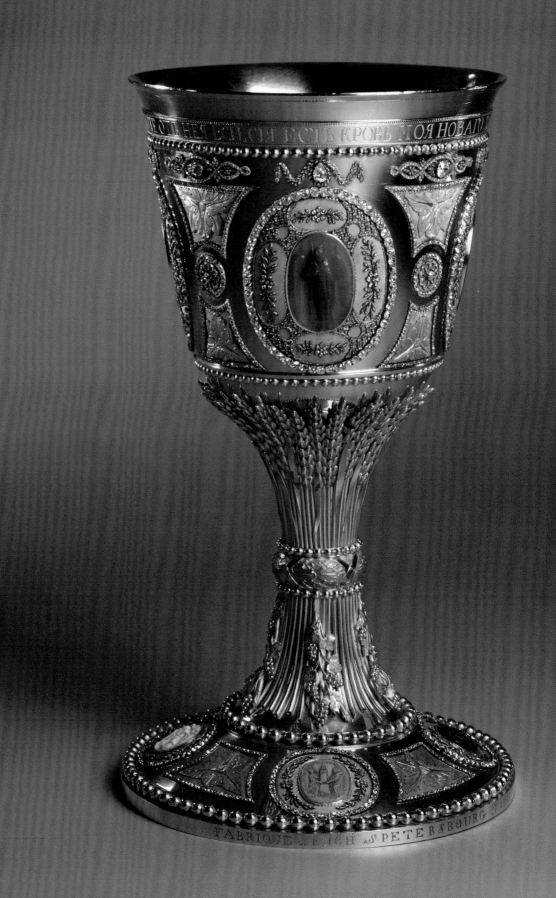

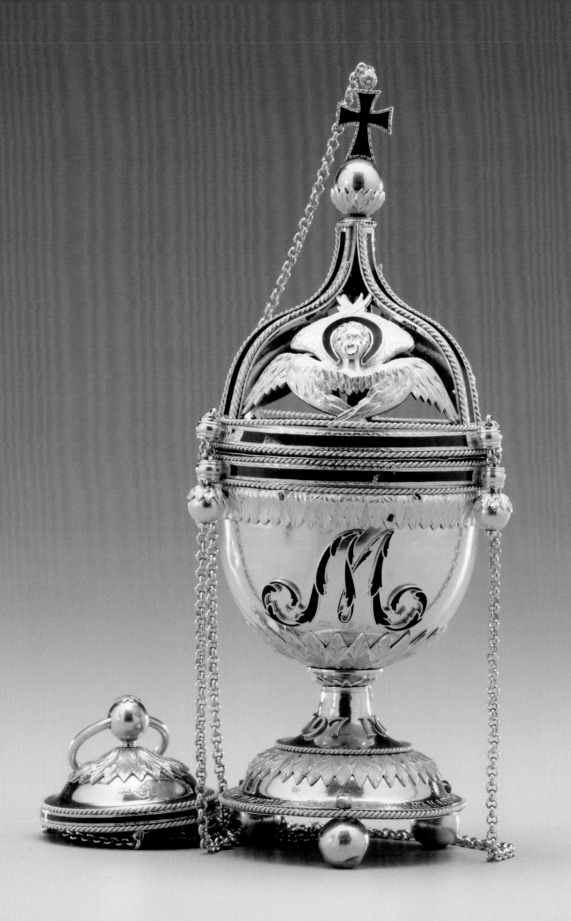

No. 10.
Censer

I. P. Krag
Moscow, 1797
Silver gilt and enamel
h. 8.5 centimeters (8 3/8 inches)
Hillwood Museum and Gardens
acc. no. 12.596
Bequest of Marjorie Merriweather Post, 1973

This silver gilt and enamel censer was originally a gift from Metropolitan Platon, of Moscow, who served as a spiritual advisor and tutor to Catherine the Great's son Paul as well as performing the coronation ceremonies for Paul after his mother's death. The enameled Cyrillic letters M and P were previously believed to stand for the initials of Emperor Paul and Empress Maria but now have been identified as standing for Metropolitan Platon himself. The censer was presented to the now-destroyed Chudov Monastery in the Kremlin in commemoration of Platon's sixtieth birthday, in 1797. The monastery was destroyed by order of Joseph Stalin in 1929–30, and many of its priceless treasures were sold, although some remain in the Kremlin Armory. The censer demonstrates the importance that neoclassicism had for traditional Russian forms. Older censers were often fashioned in the form of small churches to symbolize prayer and accord with the idea expressed in Orthodox chants based on Psalm 141: "Let my prayer arise in Thy sight as incense. And the lifting of my hands be an evening sacrifice."

SR

Selected bibliography: *Exhibition of Russian Art*, no. 487; Odom and Paredes, cat. no. 105, 214–15; Odom 2011, fig. 91, 120–21.

Icon of the Kazan Mother of God

Russian, 1600–50
Tempera on wood with gilding; silver gilt icon cover with glass paste gemstones
33.7 x 27.3 centimeters (13 1/4 x 10 3/4 inches)
Hillwood Museum and Gardens
acc. no. 54.7
Bequest of Marjorie Merriweather Post, 1973

This image rose from the realm of a relatively obscure cult image to the level of national importance after it was found in the ashes of a burned building by the daughter of one of the tsar's soldiers, guided to its location in a dream. Immediately upon its discovery, miraculous cures and healings began to take place, which were attributed to the icon's intercession. The icon was also known for its protection of Russia against invaders, as when Dmitrii Pozharskii and his supporters routed the Poles in 1612. Increasingly, the icon became a symbol of almost nationalistic fervor as it was credited with the preservation and continuation of the state. Its reputation as a healing image par excellence also firmly established its presence as one of the most revered icons in Russia.

SR

Selected bibliography: Salmond 1998, fig. 7, 26–27; Salmond 2004, pl. 1, 33, no. 27, 52; Odom 2011, fig. 12, 36–37.

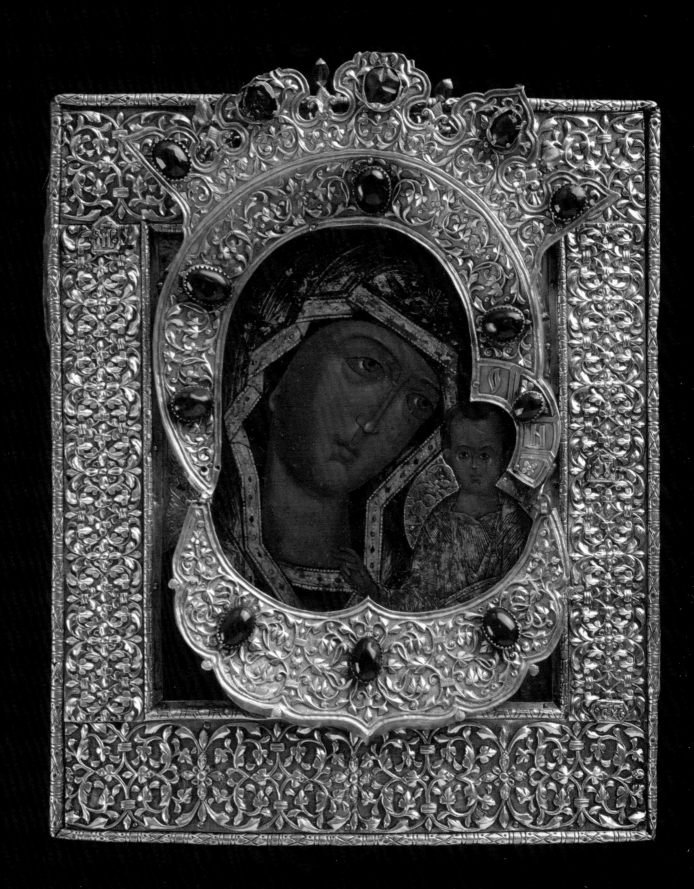

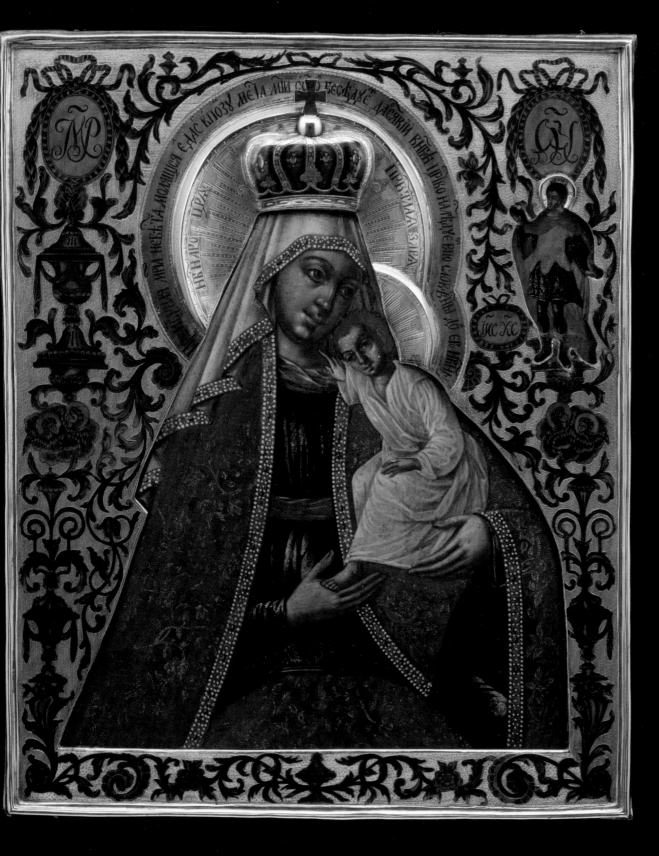

Mother of God "Promise of Those Who Suffer"

Moscow, 1790–95 (icon) 1795 (icon cover)
Tempera on wood with gilding, silver gilt, and niello
31.8 x 27.3 centimeters (12 1/2 x 10 5/8 inches)
Hillwood Museum and Gardens
acc. no. 54.15
Bequest of Marjorie Merriweather Post, 1973

The original version of this icon came to light in the period of Catherine the Great. Although known in English as "Seeker of the Lost," its Russian title, *обетъ страждущихъ* ("Vow of the Suffering"), seems closer to its origins. The story concerns a pious peasant, Fedot Obukhov, who lived in the village of Bor, near Moscow. While departing town in his sleigh on the Feast of the Epiphany, he lost his way in a blizzard. His horse wandered off the road in the blinding snow and nearly fell into a ravine. Lost and seeing no escape, Obukhov resigned himself to death and lay down in his sleigh to await his fate. In these terrible moments, he prayed and vowed that, if rescued, he would commission a special icon of the Mother of God, which he would donate to the local church. Miraculously, a peasant in a nearby hut heard a voice outside his window saying, "Take him." When the peasant ventured outside to investigate, he noticed the half-frozen Obukhov and took him home, where he nursed him back to health. When recovered, Obukhov immediately fulfilled his vow.

This version of the icon reveals many stylistic details of eighteenth-century décor. The niello and silver gilt cover that surrounds the painted figures is replete with neoclassical urns, swags, and ribbons that tie it to the antique-inspired decoration and architecture Catherine loved.

SR

Selected bibliography: Salmond 1998, fig. 24, 50–51; Salmond 2003, 121, 123; Salmond 2004, pl. 4, 40, no. 24, 50; Odom 2011, fig. 83, 111–12.

No. 13.
Azov Mother of God

Russian, 1775–80
Tempera on wood
37.5 x 28.8 centimeters (14 5/8 x 11 3/8 inches)
Hillwood Museum and Gardens
acc. no. 54.19
Bequest of Marjorie Merriweather Post, 1973

This rare and unusual icon reflects Russia's long struggle with Turkey for control of the port of Azov and strategic naval access to the Black Sea. Hillwood's greatly simplified version dates from the time of Catherine the Great, when a renewed campaign against Turkey resulted in a decisive victory for Russia in 1774. Western influences are evident in several aspects of the iconography, notably the uncovered head of the Mother of God, the tiny split crown she wears, and the disconcertingly realistic rendition of the double-headed eagle, which acts as a kind of frame for the icon. This device demonstrates the power of the empire. The crescent of Islam that lies at the Virgin's feet alludes to the triumph of Christian forces in the liberation of Azov.

SR

Selected bibliography: Salmond 2004, no. 29, 53.

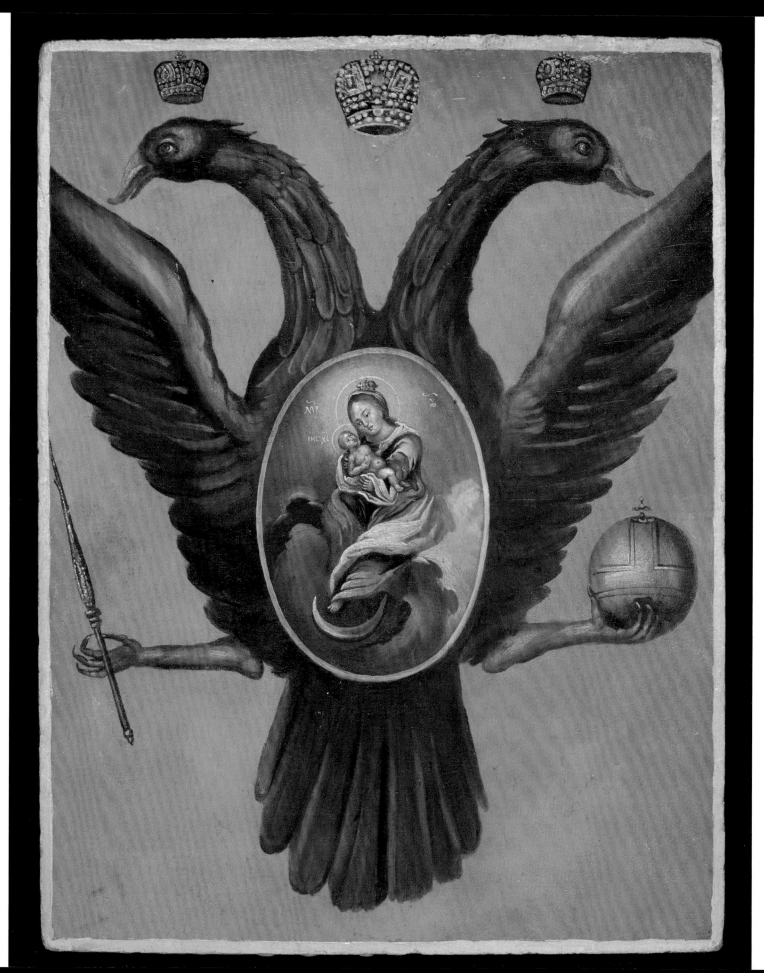

135

No. 14.
Icon of the Nativity of the Mother of God

Russia, 16th–17th century
Egg tempera on wood with gilding, silver gilt, and semiprecious stones
32.6 x 27.3 centimeters (12 13/16 x 10 3/8 inches)
Hillwood Museum and Gardens
acc. no. 54.8
Bequest of Marjorie Merriweather Post, 1973

This icon illustrates one of the twelve great feasts of the church. The principal action is in the lower left section, showing Saint Anne, who has just given birth, and the tiny Virgin Mary, who is being attended to by midwives. What makes this icon so captivating are the two other scenes included at the top and lower right portions of the panel. These scenes from the life of the Virgin come from the Gospel of the Infancy of Jesus Christ and the Protevangelium of James, noncanonical texts written in early Christian times that were highly influential in terms of art hymnography and liturgics and that shaped devotion to the Virgin. The scene at the top illustrates the disheartened couple whose temple offering has been rejected by the priest because of their sterility. Joachim retreats to the desert to pray, where he receives angelic news of a child who will be born to him and his wife. Unbeknownst to Joachim, Anne receives the same news while in her garden. The icon depicts her at the right within a walled structure. The bottom right scene shows the overjoyed couple with their newly born child in a scene referred to as the Virgin Caressed by Her Parents. These scenes are separated by beautifully delineated architectural elements that also tie them together. The frequent iconographic technique of compressing multiple scenes of a story within one panel is known as continuous narrative. This fine sixteenth- or seventeenth-century icon is further embellished by a silver gilt *riza* (partial icon cover) decorated with semiprecious stones.

SR

Selected bibliography: Odom and Paredes, cat. no. 6, 91–92; Salmond 1998, fig. 180, 41–42; Salmond 2004, no. 20, 49.

Icon of the Resurrection and the Twelve Great Feasts of the Church

Fedor Stroganov
Moscow, 1857
Silver gilt with painted enamel on copper and paste gemstones
36.2 x 31.6 centimeters (14 1/4 x 12 7/16 inches)
Hillwood Museum and Gardens
acc. no. 54.28
Bequest of Marjorie Merriweather Post, 1973

This nineteenth-century Rostov enamel and silver gilt icon depicts the Resurrection at the center and the twelve great feasts of the church surrounding it. What is unusual is the Western-style interpretation of the Resurrection, with Christ actually rising from the tomb. According to traditional Russian iconography, this specific image of Christ should not be depicted because no one actually witnessed Christ rising from the dead. Icons of this type demonstrate the persistence of Western imagery into the second half of the nineteenth century, just as the Russian revival, a reaction to these forms, was about to take hold.

SR

Selected bibliography: Odom 1996, 78; Salmond 2004, no. 7, 35.

БЖСТКО ПНТНЕ БЦЕ ВХ...ЖЕНIЕ БЖНЕБО ХРТБО
ПРЕТЫА БЦЫ · · · НIЕ ПРЕТЫХ БЦЫ

Срѣтенiе гдне

Бгоявленiе гдне

Вхадъ бо Iерусалимъ гда

Преображенiе гдне

Вознесенiе гдне

Воскрнiе хрстбо

Воздвиженiе чтнаго крста гдне

Стаа Тронца · Успенiе прстыа бцы

Icon of the Resurrection and the Twelve Great Feasts of the Church

Mstera, Russia (icon); Moscow (icon cover)
1840-50 (icon); 1842 (icon cover)
Egg tempera on panel with gilding and silver
31.1 x 27.7 centimeters (12 9/16 x 10 13/16 inches)
Hillwood Museum and Gardens
acc. no. 54.76
Gift of Madame Augusto Rosso, 1968

This icon depicts at center the Resurrection of Christ surrounded by icons of the twelve great feasts of the Church: the Birth of the Virgin, the Presentation of the Virgin into the Temple, the Annunciation, the Nativity of Christ, the Presentation of the Christ Child in the Temple, the Baptism of Christ, Christ's Entry into Jerusalem, the Transfiguration, the Ascension of Christ, the Old Testament Trinity, the Dormition of the Mother of God, and the Raising of the True Cross. The icon was produced in the nineteenth century in the village of Mstera, one of several towns that became noted for icon painting during the seventeenth century. The artists in Mstera favored delicately painted gold highlights and extremely fine painting techniques related to the tsar's Kremlin Workshops and the Stroganov School. The icon tradition of Mstera was ideologically related to the Old Believers, a group who opposed the reforms of Patriarch Nikon in the seventeenth century and who tenaciously defended and guarded the traditions of icon painting.

SR

Selected bibliography: Salmond 1998, fig. 37, 79–81; Salmond 2004, no. 5, 35.

№. 17 A,B.
Vessels from the Orlov Service

Saint Petersburg, 1762–65
Hard-paste porcelain
Hillwood Museum and Gardens
17A. Teapot, h. 14.5 centimeters (5 1/4 inches), acc. no. 25.233.1-2
17B. Plate, dia. 24.13 centimeters (9 1/2 inches), acc. no. 25.231.2
Bequest of Marjorie Merriweather Post, 1973

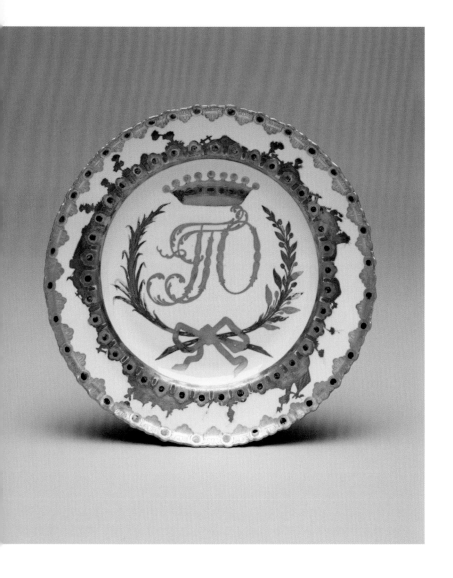

Catherine requested that the Imperial Porcelain Factory manufacture this expansive porcelain service for Count Gregory Grigoryevich Orlov (1734–1783). The factory was founded by Empress Elizabeth in 1744 to compete with the European porcelain trade and has been in continuous production since. The Orlov Service represents an important transitional phase for the factory between its early Vinogradov period and its later sophisticated production under Catherine.

The Orlov Service is designed in the Catherinian Classicist style, which combines classical elements with Russian landscapes and iconography. The artillery and military references indicate that Catherine may have ordered the service as a gift to Orlov on the occasion of his promotion to Grand Master of Ordnance, or Chief of Artillery, which happened sometime between 1760 and 1765. Gavrila I. Kozlov's original sketches for the service may have included several types of period artillery, including *edinorogs* and *mortiers*. The presence of the count's nine-pointed coronet on several of the pieces and its absence on others indicate that the set was created over the course of several years, both before and after Orlov was ennobled, in 1762.

Many of the lids in the service are topped with miniature putti engaged in playful amorous activities. Their whimsical coupling alludes to Orlov's intimate relationship with Catherine, which began when she was still a grand duchess married to Emperor Peter III. Their affair produced two children, the second born just months before the July 1762 coup d'état that solidified Catherine's position as empress of Russia.

Surviving account sheets describe the set as a "toilette service." Because the extensive morning preparations of the European aristocracy in the eighteenth century could take several hours, this service combined personal toiletry items with breakfast necessities like teacups, saucers, coffee pots, and petite serving trays.

SR

Selected bibliography: Odom and Paredes, cat. no. 62, 152–53; Odom 1999, no. 16, 24–27.

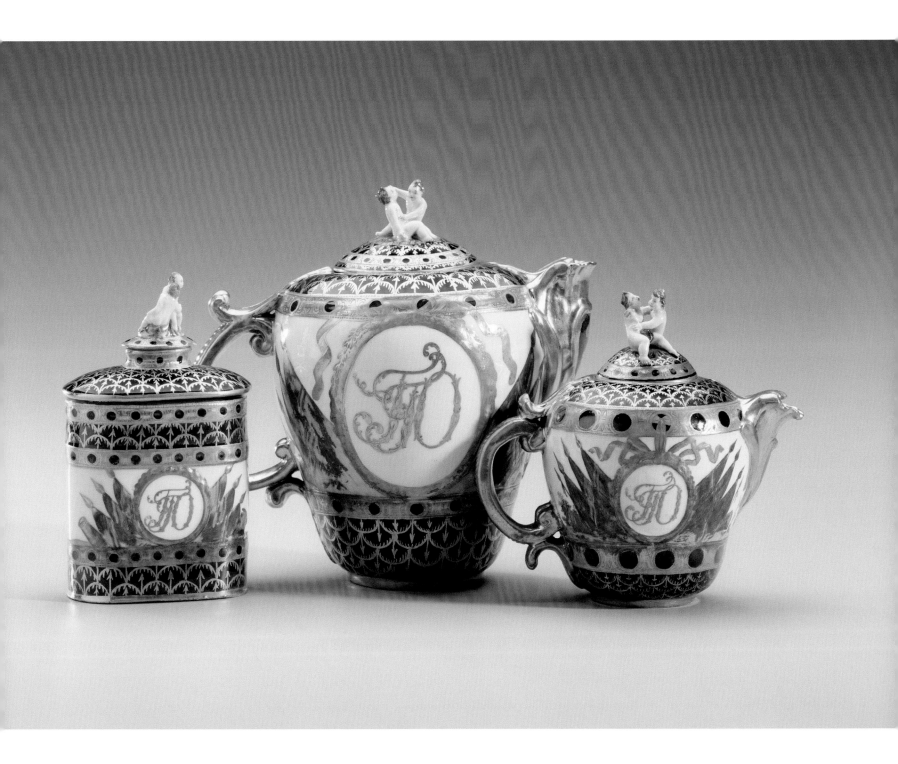

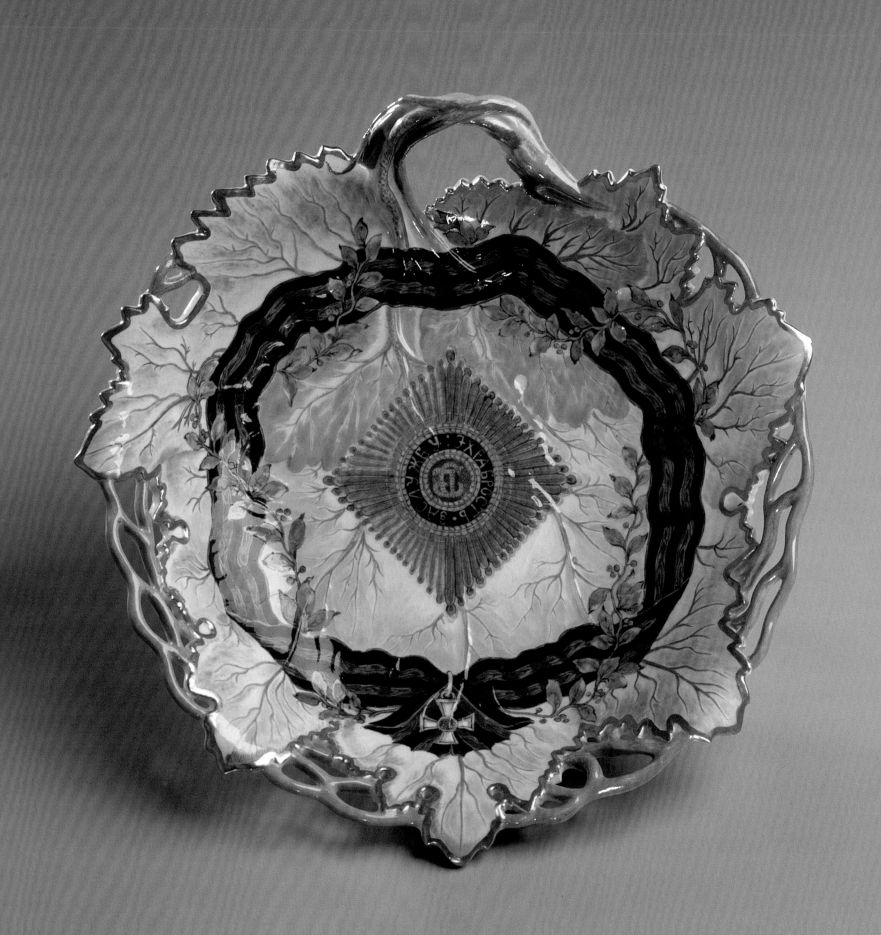

№. 18 A,B.
Pieces from the dessert service for the Order of Saint George

Gardner Factory
Verbilki, 1777–1800
Hard-paste porcelain
Hillwood Museum and Gardens
18A. Leaf-shaped dish, dia. 26 centimeters (10 1/8 inches), acc. no. 25.6.10
18B. Ice cup, h. 12 centimeters (4 3/4 inches), acc. no. 25.4.15, 25.4.8
Bequest of Marjorie Merriweather Post, 1973

From the beginning of its manufacture in Europe, in the early eighteenth century, porcelain served as a tool of diplomacy and statecraft, but it developed a more pointed political message in eighteenth-century Russia, where it displayed the various insignias of the most prestigious military and state orders awarded. This plate and ice cup embellished the banquet tables of the knights of the order who gathered each year to commemorate the saint to whom their service was dedicated. Catherine herself established the Order of Saint George in 1769, and for many years it remained the highest military distinction Russia offered. Catherine ordered the first porcelain service incorporating the insignia of the order in 1777, and it was first used on Saint George's Day in 1778. The service was originally used only for the dessert course, and the leaf-shaped dish would most likely have held fruit. It is modeled in the form of a grape leaf, with naturalistic veins running through the foliage.

SR

Selected bibliography: Ross 1968, color pl. VI, 13, 40, 71, black-and-white pl. 2, 54, 71–72; Odom and Paredes, cat. no. 63, 154–56; Ruby, fig. 2.

Ice cup from the Cameo Service of Empress Catherine the Great

Sèvres Porcelain Manufactory, 1778-79
Soft-paste porcelain
h. 8.9 centimeters (3 1/2 inches)
Hillwood Museum and Gardens
acc. no. 24.64

Relative size at 15% scale

This object is part of a large service of about eight hundred pieces Catherine commissioned in 1776. The luminous turquoise blue (*bleu celeste*) ground color was a hallmark of the French royal porcelain factory since 1753, the year it was developed. The cameos prominently featured in every piece of this service reference Catherine's interest in and collection of carved gems. In addition to the laboriousness of firing a perfectly deep and bright ground color and the technical challenge of inserting the hard-paste cameos in a soft-paste object, the service is also remarkable for the novelty of its shapes, which, in the words of Prince Ivan Sergeevich Bariatinskii, Russian ambassador to Versailles and intermediary for the commission (see cat. no. 24), had to be "in the newest and best style . . . after models taken from the Antique with cameo reproductions." The service took three years to produce; the empress did not finish paying the installments until 1792.

LP

Selected bibliography: Ross 1968, color pl. LXXXVI, 383, 389–90; Odom and Paredes, cat. no. 73, 167; Paredes, no. 56, 81–83.

1. See Savill, 304–11.

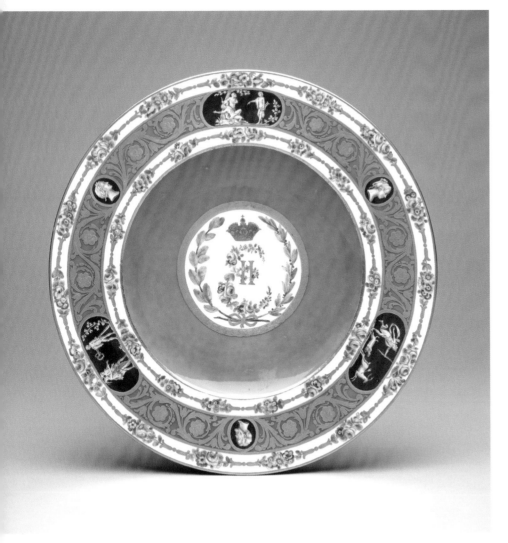

Sèvres Porcelain Manufactory, dinner plate from the Cameo Service, 1778. Soft-paste porcelain. The Museum of Fine Arts, Houston. The Rienzi Collection, museum purchase with funds provided by the Rienzi Society.

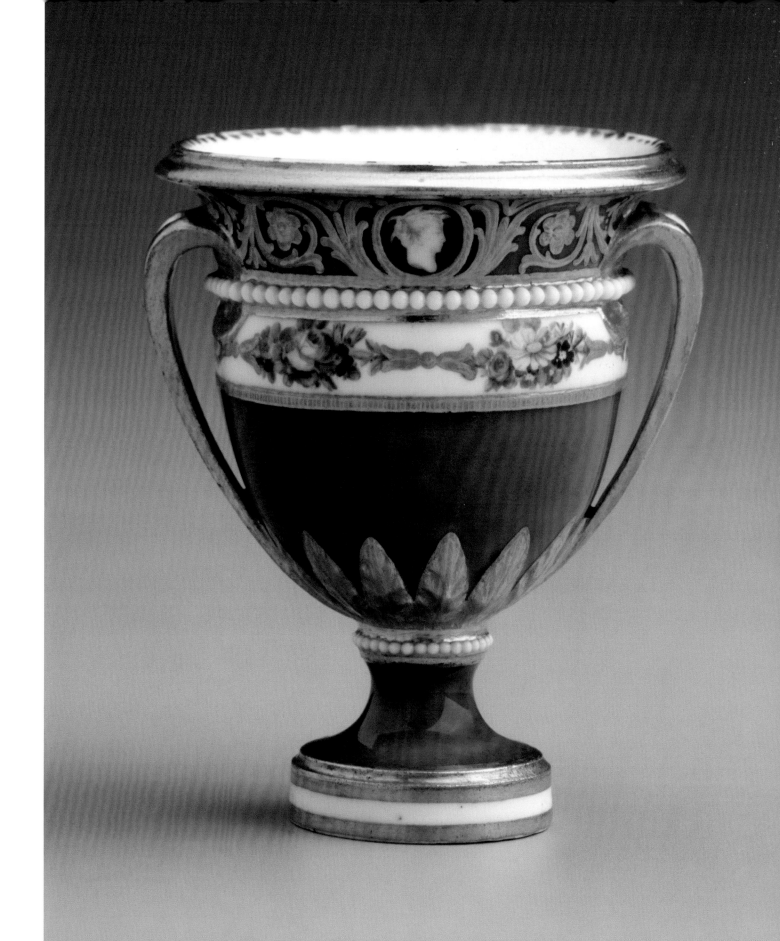

No. 20.
Bratina

Russian, early 17th century
Silver gilt
h. 14 centimeters, dia. 12 centimeters (5 1/2 x 4 7/8 inches)
Hillwood Museum and Gardens
acc. no. 12.581
Museum purchase, 1987

This bulbous seventeenth-century drinking cup is known as a *bratina* and was passed around the table at the end of a meal to drink to the health of the host. The word comes from the Russian *brat*, meaning "brother." The purpose of the cup is further driven home by its inscription, rendered in a stylized and elaborately conceived manner. It translates, "Bratina of an Honest Man, Drink from it to your Health." Drinking in Russia engendered a rich material culture that included an extended array of special drinking vessels. There was a theatricality associated with the consumption of beverages, and the container was as important as its contents.

SR

Selected bibliography: Odom and Paredes, cat. no. 9, 94; Odom 2007, no. 2, 27; Odom 2011, fig. 18, 40–41.

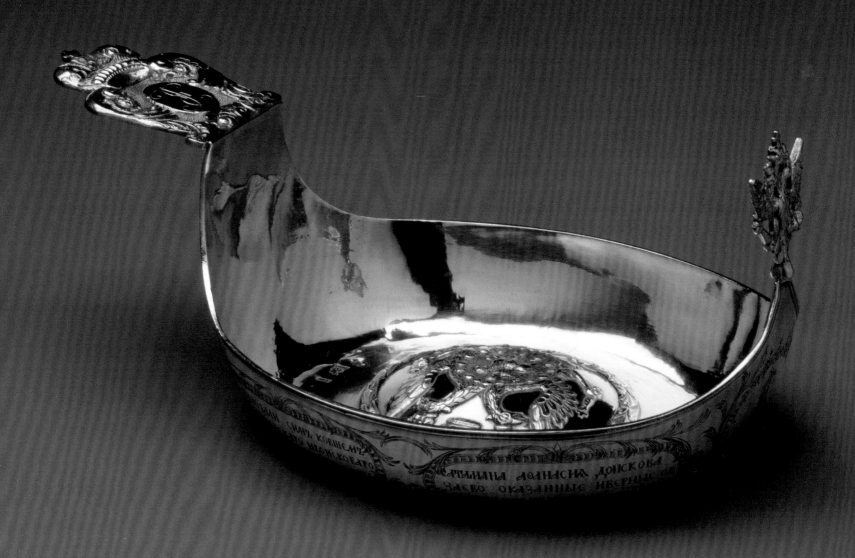

Kovsh with monogram of Catherine the Great

Alexander Bogdanov Gil'debrand (active 1753–1793)
Russia, 1793
Silver gilt
9.5 x 14.6 x 26.4 centimeters (3 3/4 x 5 3/4 x 10 3/8 inches)
Hillwood Museum and Gardens
acc. no. 12.65
Bequest of Marjorie Merriweather Post, 1973

This magnificent silver-gilt kovsh has a special significance for this exhibition as it was a gift from Catherine to the head of her winter garrison. The kovsh is replete with imperial symbolism, as the double-headed eagle is mounted opposite the handle and a portrait of the empress graces the front. Of particular importance is the inscription, which translates: "By the grace of God, We Catherine the Second, Empress and Autocrat of all Russia, etc. etc. etc. awarded this kovsh to the starshina [head] of the winter garrison of the Urals troop, Afanasii Donskoi for his demonstrated and true service, Saint Petersburg, March 1793."

The kovsh as a form bears some similarity to a swimming waterfowl. At first, they were made of wood, but in the sixteenth and seventeenth centuries, the artisans of the Moscow Kremlin began to fashion them of gold and silver. The kovsh was most often associated with mead, a fruit-based alcoholic beverage made in seemingly endless variations. For example, Adam Olearius, a seventeenth-century visitor to Russia, relates that "They brew excellent and very tasty mead from raspberries, black-berries, cherries, and other fruits. We enjoyed raspberry mead best of all for its bouquet and taste."[1]

SR

1. Adam Olearius, *The Travels of Olearius in Seventeenth-Century Russia* (Stanford, CA: Stanford University Press, 1967), 157.

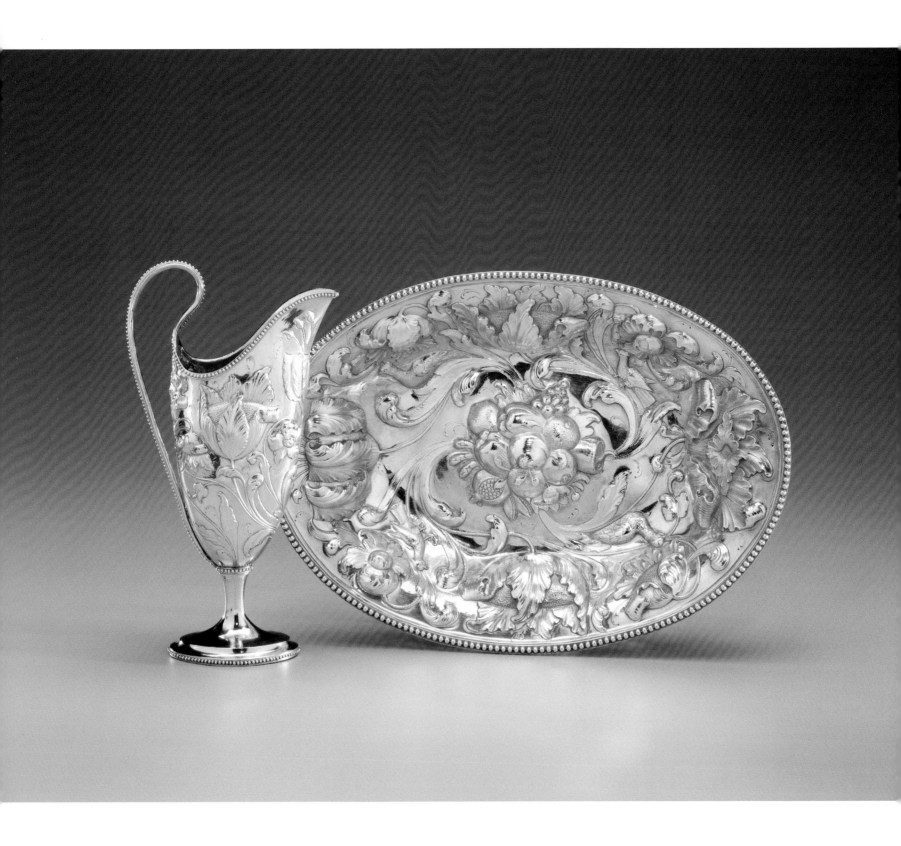

No. 22.
Basin

Carl Fredrik Bredenberg (?)
Saint Petersburg, ca. 1790
Silver and parcel gilt
w. 41 centimeters, d. 28.5 centimeters (16 1/8 x
11 1/4 inches)
Hillwood Museum and Gardens
acc. no. 12.49
Bequest of Marjorie Merriweather Post, 1973

No. 23.
Ewer

Erik Hitelin
Saint Petersburg, 1794
Silver and parcel gilt
h. 29.5 centimeters, w. 16.5 centimeters (11 5/8 x
6 1/2 inches)
Hillwood Museum and Gardens
acc. no. 12.48
Bequest of Marjorie Merriweather Post, 1973

Very similar in appearance, this silver gilt basin
and ewer are not part of a set, but were made by
two different silversmiths in the 1790s. Although
the beaded edge decoration of both pieces and
the helmet-shaped ewer reflect neoclassical
motifs, the exuberant repoussé birds, fruit,
flowers, and coiling leaves signal a baroque-era
décor that might seem at odds with their date.
In fact, the so-called "floral style" was popular
throughout the eighteenth century and continued
to flourish alongside neoclassical ornament.[1]

SR

Selected bibliography: Odom and Paredes, cat. nos. 29 and 60, 150;
Odom 2011, fig. 73, 98–101.

1. *Moscow: Treasures and Traditions*, 102.

No. 24.

Instructions adressées par sa majesté l'imperatrice de toutes les russies, à la commission établie pour travailler à l'exécution du projet d'un nouveau code de lois

1769
Catherine II (1729-1796)
Paper, leather, and ink
17 x 10 centimeters (6 1/2 x 4 inches)
Label: Sr. D. José Lopez Romero
Gift of George Dunning in 2001 to the Hillwood Estate,
Museum & Gardens Art Research Library
JN 6515.A34 1769

This modest book known as the *Nakaz* ("Instruction") is perhaps one of the greatest legacies of Catherine's reign. Early on, Catherine sought to streamline and improve the way in which Russia was governed as it was stymied by hundreds of contradictory, obsolete, and ambiguous laws. She began this process by studying and thinking about other European nations' laws, philosophies, and writings, upon which she drew heavily, in particular French writers such as Montesquieu. The result of her work was the *Nakaz*, first published in 1767. As an outline of a legal philosophy of enlightened despotism, she intended it to be used to guide the reform of the laws—and, ultimately, the society—of Russia. It consists of 526 articles and covers social issues from finance and taxation to crime and punishment, serfdom, equality, and liberty.

When her plan was ready, Catherine called for the election of delegates to a legislative commission made up of nobles, townsmen, Cossacks, and peasants from across the empire. She wished to bring the people of her vast nation together to "listen to their complaints and invite them to propose new laws to correct these flaws."[1] When the commission gathered, its members were given copies of the *Nakaz* and heard it read aloud to guide their efforts. The daunting task of overhauling years of obsolete and disjointed yet well-entrenched laws, the diversity of regional perspectives, and the prevailing hierarchies of Russian society proved too much. The council did not enact reforms, but Catherine was able to understand better and gather information about her empire, which she used to inform later legislation.[2]

Catherine clearly intended for her work, composed primarily in French, to be read widely. Published in Russian, French, German, English, Latin, Dutch, and Swedish, twenty-six editions appeared between 1767 and 1797—the span of her lifetime.[3] She used it for internal reforms and to help establish herself as an enlightened ruler across Europe. This widespread understanding and reading of Catherine's philosophical rule of law quite literally supported her self-portrayal as Minerva the lawgiver.

KR

1. R. Massie, 344. See also, generally, Madariaga, 151–83.
2. Butler and Tomsinov, 23.
3. Ibid., 521–23.

INSTRUCTION

POUR LA COMMISSION

Établie par Sa Majesté, pour travailler à l'exécution du projet d'un NOUVEAU CODE DE LOIS.

1. LA Religion Chrétienne nous apprend à nous faire les uns aux autres autant de bien qu'il nous est possible.

2. Si nous envisageons ce précepte de notre Religion, comme étant une regle déjà gravée dans le cœur de tous les Peuples, ou feulement comme une regle qu'il importe d'y graver, il fuivra tou-

A iij

INSTRUCTIONS

ADRESSÉES PAR SA MAJESTÉ

L'IMPÉRATRICE

DE TOUTES LES RUSSIES

A la Commission établie pour travailler à l'exécution du projet d'un NOUVEAU CODE DE LOIS.

TRADUIT DE L'ALLEMAND.

Seigneur Dieu ! donne-moi les lumieres & l'intelligence nécessaires pour juger ton Peuple suivant ta sainte Loi & suivant la vérité !

A PÉTERSBOURG.

M. DCC. LXIX.

1769

CODE

DE

CATHERINE.

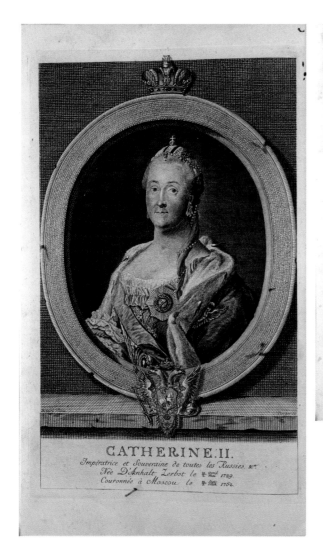

CATHERINE. II.
Impératrice et Souveraine de toutes les Russies &c.
Née D'Anhalt Zerbst le 2 Mai 1729.
Couronnée à Moscou le 22 Sept. 1762.

MÉDAILLES

SUR

LES PRINCIPAUX ÉVÉNEMENS

DE L'EMPIRE DE RUSSIE

DEPUIS LE RÈGNE

DE

PIERRE LE GRAND

JUSQU'À CELUI

DE

CATHERINE II.

AVEC

DES EXPLICATIONS HISTORIQUES

PAR

P. RICAUD DE TIREGALE,
LIEUT. COLONEL INGÉNIEUR AU SERVICE DE S. M. LE ROI DE PRUSSE.

À POTSDAM,
CHÉS SOMMER IMPRIMEUR DE LA COUR.
MDCCLXXII.

1772

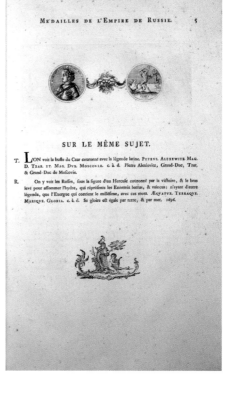

SUR LE MÊME SUJET.

T. L'ON voit le buste du Czar couronné avec la légende latine. PETRVS. ALEXEWITZ MAG. D. TZAR. ET. MAG. DVX. MOSCOVIÆ. c. à d. Pierre Alexiéviz, Grand-Duc, Tzar, & Grand-Duc de Moscovie.

R. On y voit les Russes, sous la figure d'un Hercule couronné par la victoire, & le bras levé pour assommer l'hydre, qui représente les Ennemis battus, & vaincus; n'ayant d'autre légende, que l'Exergue qui contient le millésime, avec ces mots. ÆQVATVR. TERRAQVE. MARIQVE. GLORIA. c. à d. Sa gloire est égale par terre, & par mer, 1696.

Mèdailles sur les principaux évènemens de l'Empire de Russie depuis le règne de Pierre le Grand jusqu'à celui de Catherine II avec des explications historiques

1772
Pierre Ricaud de Tiregale (unknown)
Paper, leather, and ink
38 x 23 centimeters (15 x 9 inches)
Gift of George Dunning in 2001 to the Hillwood Estate, Museum & Gardens Art Research Library
CJ 6245.R87 R52 1772

Peter the Great introduced the European practice of bestowing medals, badges, and other material symbols of favor upon individuals who made significant contributions to the empire. To support this practice he founded the first mechanized mint for striking coins and medals in Moscow in 1701 and invited European work masters to Russia to train in and develop this art form. Peter recognized the importance of medals as historical documents and would make suggestions for their subject matter and designs. Catherine built upon Peter's foundations, establishing more orders and further refining the imperial award system. As such, the purpose of this volume was to illustrate medals she had created and present the continuity of her reign with Peter's.

To illustrate properly and elevate the many changes, accomplishments, and medals of Catherine's period, the Russian *Mèdailles* was based on the monumental French publication *Mèdailles sur les principaux évènemens du règne de Louis le Grand*, first published in 1702 by order of King Louis XIV. Both publications present the history and greatness of their respective country through the imagery and description of their medals. Only slightly larger than Catherine's publication in dimensions, Louis's *Mèdailles* measured 43 by 25 centimeters. Both books present a medal—front and back—with a page of descriptive text printed together on one side of the sheet of paper, with the back of the sheet left blank. This decision maintained the integrity of the image of the engraved medal at the top of the page, which could have been disrupted by printing another medal or text on the reverse.

Comparisons between the two volumes end there. Louis's publication is more than twice as long (with 286 leaves of printed text), has far more elaborate borders and decorative motifs, and was printed with great care and impressions that are "strikingly sharp" and "the registration between the copper plates and the letterpress very accurate." In Catherine's *Mèdailles*, printed in Potsdam, the images and text are not carefully aligned and the decorative vignettes are found at the bottom of each page only, lacking the borders and other fanciful embellishments. Although not necessarily equal in quality or magnitude to the French *Mèdailles*, Catherine's publication is still monumental for Russia at this time and is perhaps only surpassed by the coronation album of Empress Elizabeth Petrovna (1744) for a book of such size, scope, and presentation in eighteenth-century Russia.

KR

1. Spasskii and Shchukina, 5–40; and Shchukina, 7. See also Mosley 2008, 296–348; Scarisbrick; and Tillander.
2. Mosley 2011, 50.

No. 26.

Medaliony v pamiat voennykh sobytii 1812, 1813, 1814 i 1815 godov, izobretennye grafom F. Tolstym, i vygravirovannye na stali, po sposobu Beta, N. Mentsovym c Vysochaishchago soizvoleniia izdany Arkheograficheskoiu Kommissieiu

1838
Count Fedor Petrovich Tolstoy (1783–1873); Nikolai Mentsov, engraver
Paper, leather, and ink
30 x 33 centimeters (11.8 x 13 inches)
Purple ink stamp "Printed in USSR (Russia)" on pastedown; handwritten notations 6434 and 737/ "T" 52 on title page; two labels of book dealer V. I. Klochkov,
Saint Petersburg, one on verso title page and one on lower cover pastedown; workshop label of N. V. Gaevskii on lower cover pastedown
From the Avinoff-Shoumatoff Collection, purchased in 2000 by the Hillwood Estate, Museum & Gardens Art Research Library
CJ6246.T6 1838

Continuing the tradition Catherine established in *Mèdailles sur les principaux évènemens de l'Empire de Russie depuis le règne de Pierre le Grand jusqu'à celui de Catherine II avec des explications historiques* (cat. no. 25), grand medal books were created in the nineteenth century. This outstanding and finely printed book was created to celebrate the Russian victory over the French in 1812, to spread the study of numismatics, and to introduce a new printing technology to Russia.

The engravings in this publication are after a series of plaster-of-paris medallions created from 1814 to 1836 by vice president of the Academy of Arts Count Fedor Tolstoy. These medallions allegorically portray such events of the war as the liberation of Berlin from French forces in 1813. Documenting these events, this book was intended to spread the science and study of numismatics through a recently developed method of engraving. The British optician and mechanic John Bet perfected a device in 1836 that allowed engravings to be made from the surface of convex objects, thus providing the ability to create lifelike, dynamic, and faithful reproductions of medals. The result of the first Russian experiment utilizing such technology is this publication of high-quality printing. Text and images are meticulously aligned on the heavy cotton pages and the large engraved medallions have light and dark shadows that capture the bas-relief of the original plaster images in fine sculptural detail.

KR

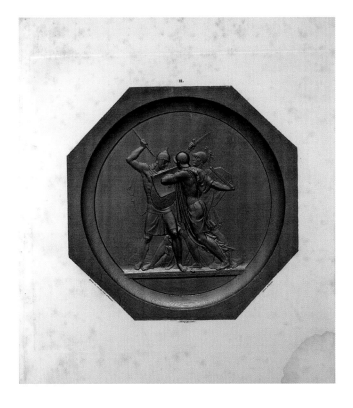

н.

МЕДАЛІОНЫ

ВЪ ПАМЯТЬ ВОЕННЫХЪ СОБЫТІЙ

1812, 1813, 1814 и 1815

ГОДОВЪ,

ИЗОБРѢТЕННЫЕ

ГРАФОМЪ Ѳ. ТОЛСТЫМЪ,

и

ВЫГРАВИРОВАННЫЕ НА СТАЛИ, ПО СПОСОБУ БЕТА,

и. менцовымъ.

Съ Высочайшаго соизволенія

ИЗДАНЫ

АРХЕОГРАФИЧЕСКОЮ КОММИССІЕЮ.

САНКТПЕТЕРБУРГЪ.
ПЕЧАТАНО ВЪ ВОЕННОЙ ТИПОГРАФІИ.
1838.

No. 27.

Le comte et la comtesse du nord: anecdote russe mise au jour

1782
Louis Philippe de Briere, Chevalier du Coudray
Paper and ink
8.5 x 11.5 centimeters (3 3/8 x 4 1/2 inches)
Ex-Libris C. Narischkine and inventory label; ink stamp "Bibliotheque C. Narischkine No. 1532 V"
Hillwood Estate, Museum & Gardens Art Research Library
DK186.B74 1782

This book recounts the visit to France of the "Count and Countess of the North"—Catherine the Great's son Grand Duke Paul and his wife Maria Fedorovna. Marking the first time since Peter the Great's reign that members of the imperial family traveled to the West, Paul and Maria's Grand Tour followed the prescribed eighteenth-century ritual and focused on artistic, architectural, and historic studies.

Setting out in September 1781, the entourage traveled through Poland to Austria, Italy, and France, returning in November 1782. They were warmly welcomed wherever they went, with lavish banquets, festivities, and sometimes fireworks. In Rome, they were guided by Johann Friedrich Reiffenstine, director of the Russian Academy of Art there. They sat for artists to paint their portraits,

purchased paintings, and visited the studios of Angelica Kauffmann, Philipp Hackert, and Giovanni Volpato, among others.[1] While in Paris they visited the court of Versailles several times, where Louis XVI and Marie Antoinette gave them exceptional gifts of four tapestries from the Gobelins factory and a dressing set from the Sèvres porcelain manufactory.

The couple absorbed all the latest European styles in art and architecture and made purchases in every city they visited. This experience would profoundly affect their ideas about the building and decoration of their new palace at Pavlovsk. Catherine gave Paul and Maria land at Pavlovsk and commissioned the Scottish architect Charles Cameron to build a house there for the young couple because she was so pleased with the birth of her first grandson, the future

Tsar Alexander I. This happy event was a rare moment of detente in the strained relations between Catherine and Paul. Perhaps sending Paul to the West was an opportunity for the two to spend some time apart, but the trip also could have been a further effort by Catherine to bolster the image of Russia abroad.

The Russian Grand Tour in general "had become an opportunity to parade Russian refinement in the West, as well as to absorb Western culture."[2] Although Paul and Catherine's relations did not improve after his return, Paul and Maria had made a favorable impression on Europeans, one of which is the account of the Chevalier du Coudray in this publication.

KR

1. Wilton and Bignamini, 140. See also S. Massie, 22–29; Von Waldner; and Odom and Paredes, 75–76.
2. Catriona Kelly, "Pushkin's Vicarious Grand Tour: A Neo-Sociological Interpretation of 'K vel'mozhe' (1830)," *Slavonic and East European Review* 77, no. 1 (January 1999): 9.

LE COMTE
ET
LA COMTESSE
DU NORD;
ANECDOTE RUSSE,

MISE AU JOUR

Par M. le Chevalier DU COUDRAY.

Delectando pariterque monendo.

A PARIS,

Chez BELIN, Libraire.

Et se trouve à Bruxelles,

Chez LEMAIRE, Libraire.

M. DCC. LXXXII.

Avec l'Approbation.

PRÉFACE.

*L*ORS *du séjour de l'Empereur* JOSEPH II *dans notre Capitale, en 1777, je m'empressai à recueillir les traits de générosité, de bienfaisance & d'humanité de ce grand Prince ; avec les différentes pieces de Vers que les Muses Françaises lui avoient offertes : cette Brochure excita les murmures de l'envie & de la médiocrité, elles ne voulurent point me tenir compte de mon zele ni de ma bonne volonté.*

J'eus beau leur dire que mon but seul étoit de plaire à notre auguste Souveraine, en prenant la liberté de mettre sous ses yeux les belles actions d'un Frere qu'elle chérit ; j'eus beau naïvement leur avouer mon insuffisance, mon incapacité pour un pareil Ouvrage ; ajoutant même que beaucoup de Gens de Lettres se seroient mieux acquittés de ce travail, ces harpies ne me surent nul gré de ma franchise : elles me firent même une espece de crime de mon entreprise, ou plutôt de son

A 2

No. 28.

Cameo with the Archangel Michael

Late 14th century
Sardonyx
2.8 x 2.1 x 0.4 centimeters (1 1/8 x 13/16 x 3 1/6 inches)
Metropolitan Museum of Art, The Milton Weil Collection, 1940
acc. no. 40.20.58

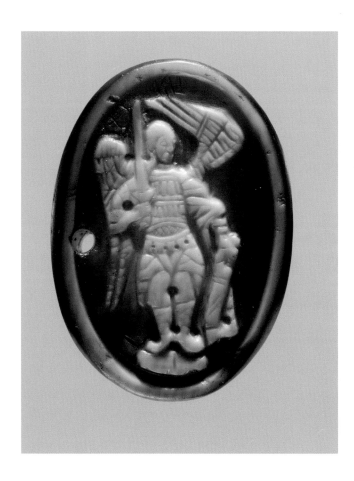

Selected Bibliography: Leopold Seligmann collection, sale catalogue, Ball & Graupe, Berlin, 1930, no. 52 (this piece called Byzantine, XI century; gives dimensions: H. 2,8, W. 2 cm), pl. XIV (ill.); Ernst Kris, *Catalogue of Postclassical Cameos in the Milton Weil Collection* (Vienna: Schroll, 1932), no. 4, 13; Preston Remington, "The Milton Weil Collection of Cameos and Intaglios," *Metropolitan Museum of Art Bulletin* 35 (1940): 76–77; Helen C. Evans, ed., *Byzantium: Faith and Power* (1261-1557), exh. cat. (New York: Metropolitan Museum of Art and Yale University Press, 2004), cat. no. 14, 239 (entry by Edmund C. Ryder); James David Draper, "Cameo Appearances," *Metropolitan Museum of Art Bulletin* 65, no. 3 (2008), cat. no. 27, 17.

Hyperpyron of Emperor Isaac II Angelos

1185–1195
Gold
2.9 centimeters (diameter) (1 1/8 inches)
Byzantine Collection, Dumbarton Oaks, Washington, D.C.
BZC.1948.17.3531 (DOC IV/1, 1b.6)

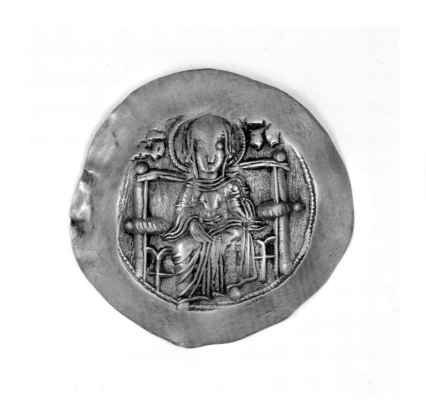

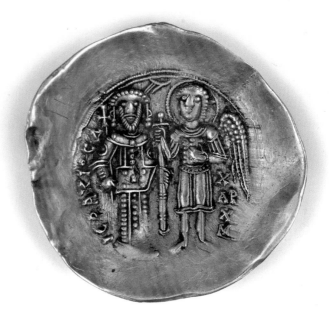

No. 30.
"Green Frog Service" flat plate[1]

1773-74
Wedgwood & Bentley Staffordshire, England
Lead-glazed earthenware and creamware with sepia and green enamel
2.2 x 24.8 centimeters (7/8 x 9 3/4 inches)
Collection of the Birmingham Museum of Art; Gift of Mrs. Byron Born in honor of Mr. Byron Born
Acc. No. 1986.638

An oak-branch wreath with acorns and leaves features a Green Frog crest at the top and forms the plate's border. The scene in the main field shows an east view of the Saint Briavels Castle in Gloucestershire. The original fortress on this site was built under the auspices of King Edward I (reign 1272–1307). Even though this castle is well fortified, its history relates not to military affairs but to hunting outings in the Forest of Dean.

See earlier in this volume the discussion of the Green Frog Service on pages 76–85.

AK

Selected Bibliography: Adams 1992, 48, color plate 26; *The Green Frog Service*, 281 and 401—Appendix A1.

1. The terms applied to the different types of dishes from the service follow the nomenclature of *The Green Frog Service*, 409–11.

No. 31.
"Green Frog Service" dessert plate[1]

1773-74
Wedgwood & Bentley Staffordshire, England
Lead-glazed earthenware and creamware with sepia and green enamel
22.86 centimeters (diameter) (9 inches)
Lent by the Chipstone Foundation, CF2001.80 L90.2008

This plate is slightly larger than the other dessert plates from the Green Frog Service (diameter 22 centimeters) and features an acorn-and-oak-leaf border framing a view of a dilapidated building. This scene is almost identical to the one that appears on a flat plate (diameter 24.5 centimeters) in Saint Petersburg (Hermitage 8886) on which the Burstall Priory near Hull in Yorkshire is rendered viewed from the south. The medieval monastery on this land must have ceased to exist before the end of the fourteenth century. During the second quarter of the sixteenth century a manor house was erected on the site, which in turn fell into decay and was demolished in 1765.

See earlier in this volume the discussion of the Green Frog Service on pages 76–85.

AK

Selected Bibliography: On the plate that features the same subject and belongs to the State Hermitage Museum see *The Green Frog Service*, 365, and 410, no. 392.

1. The terms applied to the different types of dishes from the service follow the nomenclature of *The Green Frog Service*, 412–13.

No. 32.

Icon of Prophet Elijah in the Wilderness

Saint Petersburg, 1760–70
Enamel on copper with silver-gilt frame
12.8 x 16.2 centimeters (5 1/16 x 6 3/8 inches)
Private collection, Georgia, previously unpublished

This portable icon was intended for the personal devotion of a dignitary, very likely serving in Catherine the Great's court. Presumably, the original owner's patron saint was Elijah. The enamel painting, preserved in excellent condition, covers two slightly convex plates of either copper or gold. The silver-gilt frame keeps these two plates together, and a liner in the form of a silver strip, shaped as miniature bead molding, makes possible the tight and secure fit. A certain solid heavy substance, possibly lead, fills the hollow enclosed space, thus providing additional support for the enamel plates.[1]

The full-length figure of Prophet Elijah is depicted frontally, towering against the low horizon and forming the central vertical axis of the composition. Head uncovered and barefoot, he wears the typical *al antique* costume consisting of a *chiton* (tunic) and *chimation* or *pallium* (cloak). Standard in Christian iconography, these items of clothing are rendered here with notable sumptuousness. The lavish heavy fabric forms large sculptural folds whose luxurious surface shimmers in an entire gamut of related hues. The tunic is mauve, and the cloak is yellow; the artist adds a stylish touch to this striking and sophisticated color combination by making the exposed lining of the tunic's neckline yellow, too. This elegant outfit

1. On enamel icons and miniature portraits in Russia during the eighteenth and early nineteenth centuries see Komelova 1986 and 1995; and Odom 1996, esp. 70–75.

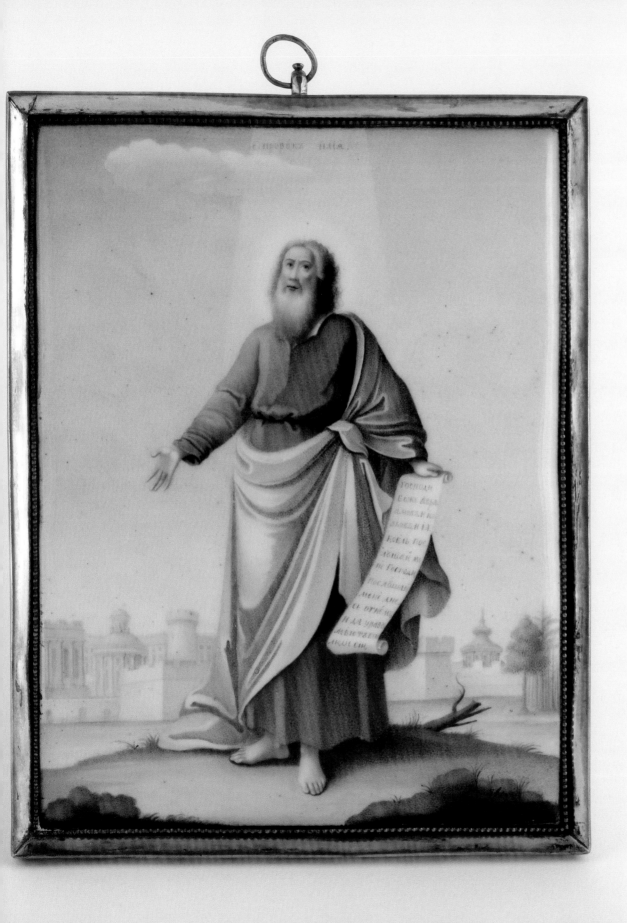

is a far cry from the well-known iconography of the prophet, who often is depicted wearing a sheepskin (2 Kings 2:6–15). This icon is distinguished by masterful enamel work—minuscule detail of the greatest refinement abounds in the rendition of the saint's face and hair. Even though the color of the saint's halo is only slightly different from the background, it still stands out for it is rendered three-dimensionally with rays of light emanating from the prophet's head.

Above the saint's halo is the diminutive, most scrupulously rendered black lettering of a caption in Old Church Slavonic that reads "S[aint] Prophet Elijah." The same script appears on the unrolled scroll displayed in his left hand, which paraphrases the following passage:

> Lord God of Abraham, Isaac, and of Israel, let it be known this day that thou art God of Israel, and that I am thy servant, and that I have done all these things at thy word. Hear me, O LORD, hear me, that this people may know that thou art the LORD God, and that thou hast turned their heart back again. Then the fire of the LORD fell, and consumed the burnt sacrifice, and the wood and the stones, and the dust, and licked up the water that was in the trench. And when all the people saw it, they fell on their faces: and they said, The LORD, he is the God; the LORD, he is the God. [1 Kings 18:36–39]

This inscription not only summarizes a pivotal moment of the confrontation between Elijah and King Ahab at the Mount Carmel Corral (1 Kings 18:1–46), but also directs the beholder's thought to one of the most famous citations of these Old Testament verses in the text of the Gospel—namely Matthew 22:32, "'I am the God of Abraham, the God of Isaac, and the God of Jacob.' He is not the God of the dead but of the living." In doing so the iconographer expresses a most heartwarming reassurance of the upcoming resurrection of the dead.

Elijah stands on a knoll in the wilderness, rendered briefly by means of rounded shrubs in the foreground, sparse clusters of grass—each blade drawn with microscopic precision—in the middle ground, and the outskirts of a forest to the right of the figure. The most poignant sign of uncultivated land is the fallen dry tree in the distance. The brown hues of the landscape bespeak an extreme aridity, thus alluding to Elijah's supernatural ability to exercise power over rain (1 Kings 17:1–5). The prophet's head is turning slightly to his right in unison with the gesture of his right arm. This arm, slightly raised, displays the palm of the hand with fingers extended in a configuration typical for the neoclassical period, the middle and the ring fingers pressed against each other. Subtly, yet unambiguously, the figure's stance and gesture show the prophet turning his back on the parched wilderness and drawing the viewer's gaze to the ideal city

emerging in the background as a vision of pearl-hued light. Bulwarks with crenellations and a defense tower enclose a neoclassical city where two rotundas stand in front of a large structure with imposing Tuscan Order porticoes. This architectural fantasy evokes associations with the designs for temporary buildings erected in the vicinity of Moscow in 1775 for the celebration of the Peace Treaty with the Ottoman Empire.[2]

The back of the icon features a *troparion* (a stanza from a liturgical hymn) performed on the prophet's feast day, July 20. This inscription is rendered in gold in a flowing, uniform cursive:

> (Tone 4)
>
> An angel in the flesh and the cornerstone of the prophets,
>
> The second forerunner of the coming of Christ,
>
> Glorious Elijah sent grace from on high to Elisha,
>
> To dispel diseases and to cleanse lepers.
>
> Therefore, he pours forth healings on those who honor him.[3]

This icon's inscriptions juxtapose two different scripts in a deliberate and thoughtful arrangement. On the front, the quote from the Old Testament is in the form of traditional formal script associated with liturgical books and seen in older icons and frescoes. In contrast, the liturgical poem on the back appears in contemporary cursive, otherwise used in all aspects of everyday life. In this manner, the icon conveys a notion of both the solemnity of communal holy liturgy and the intimacy of private prayer.

AK

2. Shvidkovsky 1996, 191–96, figs. 221–24.
3. English text according to the Orthodox Church of America, http://oca.org/FStropars.asp?SID=13&ID=102060; last visited November 23, 2012.

No. 33.
Teapot "à jet d'eau"

Moscow, 1776
Silver
h. 16.5 centimeters, w. (spout to handle) 13.5 centimeters, diameter (base and top of the urn) 7 centimeters
(6 1/2 x 5 5/16 x 2 3/4 inches)
Silver, cast, embossed, chased, engraved, and gilded
Monogram with the letter B framed by two palm branches, forming a medallion
The rim of the base on the lid bears hallmarks [1781? A•T] and Saint George Lancing the Dragon in a field the shape of which
follows the outline of the equestrian figure, possibly the work of Aleksei I. Torlov (1734–1809, active in Moscow, 1768–1809).
Old repair secured the joint between the main vessels and the base of the teapot.
Private collection, Georgia, previously unpublished

This fairly small vessel displays the great ambition of a silversmith who apparently had a flair for au courant design and the ability for masterful execution. The ubiquitous form of classical urn is interpreted with the greatest regard for the design's aesthetic impact—graceful proportions and symmetry were the dominant concerns. Although a teapot cannot have a fully symmetrical shape, the articulation of the handle and the spout contribute to the sense of balance and preserve the association with classical urns distinguished by the obligatory pair of symmetrical handles.

The ultimate creative accomplishment here is the successful fusion of the neoclassical taste with the fluid forms in the spirit of the rococo. In fact, the overall composition of this vessel was conceived as a representation of a fountain of water featuring three jets and two superimposed circular spilling pools. The main vertical jet emanates from the foot and culminates in the finial of the lid, rendered to evoke the bobbing peaks of water. The two curving strings of silver, which join to form a surprisingly ergonomic handle, also allude to jets of water. The arches of the handle and the spout convey the notion of two side water jets almost reaching the height of the central one, yet descending in opposite directions as they curve symmetrically (cat. no. 34). Another allusion to the realm of water is the unmistakably ichthyic character of the spout. The shape of the teapot's lid continues the theme of downward flow. The urn's top and foot are reminiscent of spilling pools, both featuring undulating surfaces and a rim articulated with a wave pattern, thus recalling slightly agitated overflowing water.[1]

1. Notably, a similar treatment involving a neoclassical form and naturalistic detail appears on a porcelain teapot from the Orlov Service, created at the orders of Catherine the Great by the Imperial Porcelain Factory, Saint Petersburg, 1765–70. Here, too, the depiction of flowing water is found on the lid, spout, and handle. See *Treasures of Imperial Russia*, 22; and Ivanova, figs. 76 and 77, cat. no. 93.

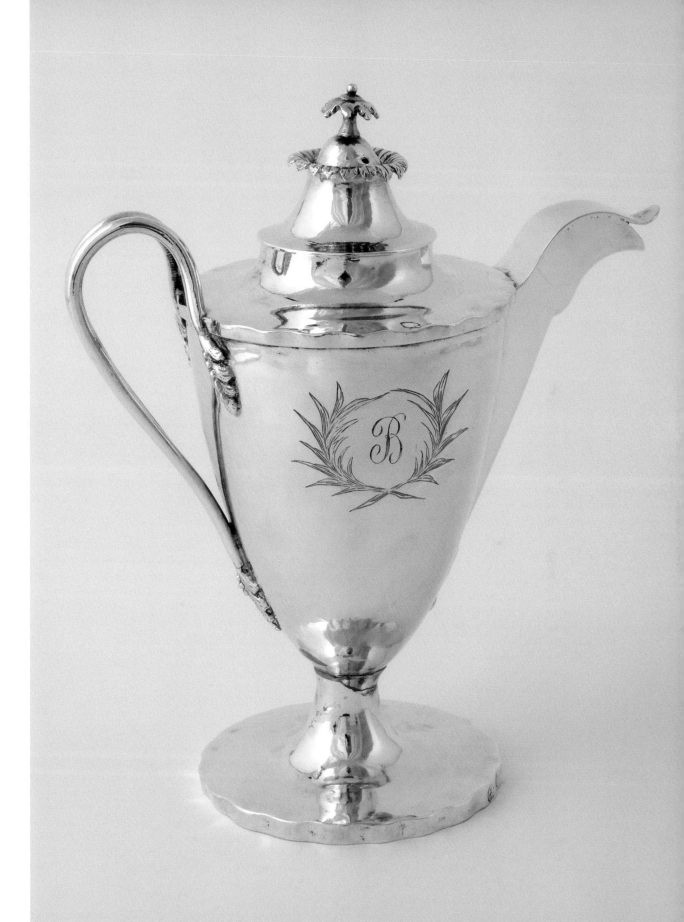

In the rendition of the finial, the spilling water takes the shape of small acanthus leaves. Congruently, the four points where the two cords forming the handle are attached to the pot feature laurel leaf-and-berry swags. These minuscule garlands pick up the silver jets' movement and bring it to a pleasing pause. The metamorphosis of aquatic forms into floral ones, profusely used in rococo design, conveys a complex feeling of otherworldliness and abundance.

All the representational tendencies notwithstanding, in this design one finds no traces of the overtly jocular and florid rococo ways and the correspondent anti-architectural inclusion of naturalistic ornaments. Instead, the details here are rendered in a manner deferential to the tectonic form, very much in the spirit of the Sèvres vases "à jet d'eau" with dolphins from 1765. Louis XV (1710–1774, reign from 1715) commissioned these on the occasion of the future Louis XVI (1754–1793, reign 1774–1791) becoming the dauphin, or successor to the throne, that year.[2] The aesthetic of these vases reflects the ascent of neoclassical design based on architectural elements from the classical orders and promoted by Étienne-Maurice Falconet, who had been in charge of sculpting models at the factory of Sèvres since 1747.[3] By September of 1766, one year after the creation of these vases, Falconet had already arrived in Saint Petersburg, where he remained until 1788. A Moscow silversmith working in the late 1770s and early 1780s could have found inspiration and design ideas in the works of Falconet but also in images such as engravings of fountains made popular by participants in the Grand Tour. Examples of such well-liked images are found in the oeuvre of the Roman architect and artist Giovanni Battista Falda (ca. 1640–1678) and the German engraver Jeremias Wolff (1663–1724) (cat. no. 34). In this regard, it is important to note that the fountains of Rome were used as prototypes for water features in the park of Peterhof.[4]

Rendering a teapot as a fountain is a way to lure and dazzle viewers and, even more, an invitation for contemplation and discovery of meanings. In this case, those meanings include the perennial fascination with fountains, which for millennia exemplified humanity's ability to tame nature. The neoclassical form, distinguished by refined proportions, graceful restraint, and overall balance, adds an additional layer of meaning, seeming to allude to the almost supernatural power emanating from knowledge of antiquity and the embrace of its values. The inclusion of an object of such heightened visual complexity in the experience of taking tea manifests both the need for transcendence and a mastery over the ways of achieving it particularly within the realm of quotidian life.

AK

2. There are three pairs of Louis XV dolphin vases, one in each of the following museums: the Wallace Collection (C284–85), Walters Art Museum (48.637–38), and the Louvre (OA 11025–26). Ennès 1987.
3. See the article by Muriel Barbier, "Pair of 'fountain' vases," on the website of the Louvre, www.louvre.fr/en/oeuvre-notices/pair-fountain-vases.
4. Orloff and Chvidkovski, 324.

No. 34.

Fontana nella Piazza di S. Giacomo Scossacavallo, nel Rione di Borgo, Architettura del C. du Carlo Maderno (Fountain on the Piazza Scossa Cavalli today. In Piazza S. Andrea della Valle)

ca. 1700
Jeremias Wolff (German, 1663–1724)
Etching
19 x 30 centimeters (7 1/2 x 11 13/16 inches)
Private collection, Georgia

Fontana nella Piazza di S. Giacomo Scossacavallo.
nel Rione di Borgo, Architettura del C. du Carlo Maderno.

I. Wolff excud. Aug. Vind.

Fontana nella Piazza di S. Giacomo Scossacavallo.
nel Rione di Borgo, Architettura del C. du Carlo Maderno.

Philosophical, Political, and Literary Travels in Russia, During the Years 1788 & 1789 First edition 1794 in French, vols. 1 and 2

ORIGINAL TITLE: *Voyage philosophique, politique et littéraire fait en Russie pendant les années 1788 et 1789, traduit du hollandais, avec une augmentation considérable, par le citoyen Chantreau*

Pierre-Nicolas Chantreau (don Chantreau)
(French, 1741–1808)
Private collection, Georgia

(37)

CHAPITRE IV.

Cour de l'Impératrice. — Gardes des appartemens, — Salle d'audience. — Suite de l'Impératrice lorsqu'elle va à sa chapelle. — Son costume les jours de Gala, — Notice sur la famille royale. — Richesse des seigneurs russes dans leurs habits. — Leur passion pour les diamans. — Les différens ordres dont ils sont décorés. — Notice historique. — Bals d'hiver. — Palais de l'hermitage. — L'étiquette en est bannie. — Cela est-il vrai ou possible en Russie ? — Collection de tableaux dans ce palais. — Jardin d'hiver, féerie à voir. — Distribution que l'Impératrice fait de son tems. — Spectacles de la Cour.

A PRÈS nous être remis de nos fatigues, et fait les courses qu'exigoient nos affaires, nous nous présentâmes à la cour ; elle est brillante plus qu'aucune autre du Nord ; mais pour la voir dans tout son éclat il faut choisir un jour de Gala, tel que celui de l'anniversaire de l'impératrice ou du grand duc etc. Ce qui nous frappa d'abord, furent les deux

C 3

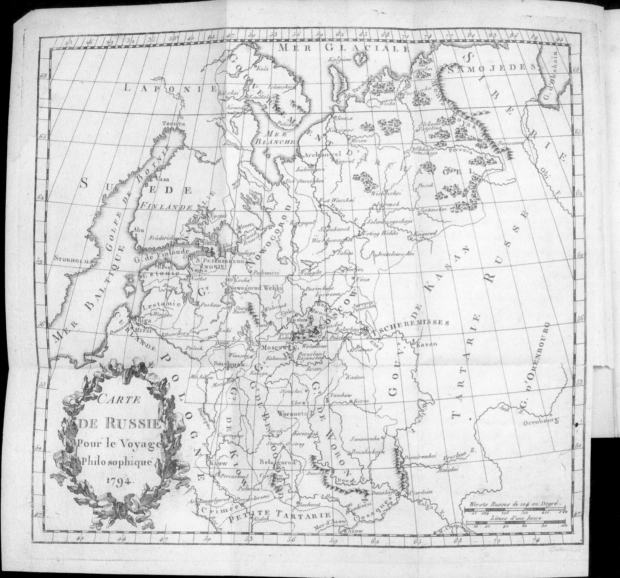

Carte
DE RUSSIE
Pour le Voyage
Philosophique
1794.

VOYAGE PHILOSOPHIQUE,

POLITIQUE ET LITTERAIRE,

FAIT EN RUSSIE

PENDANT LES ANNEES 1788 ET 1789.

CHAPITRE PREMIER.

Entrée en Russie par la Finlande Suedoise — Friédericscham — Wiborg, Capitale de la Finlande russe — Détails sur cette province et les Fennois — Voyage de Wiborg à St. Petersbourg — Chemins. — Auberges russes — Traineaux — Description de ces voitures.

Les motifs de Commerce qui nous avoient conduits en Suede nous déterminèrent à faire un voyage en Russie. M. Wieder, Cosmopolite philosophe, qui, dans nos différentes courses, avoit été notre compagnon de voyage, accepta avec transport le projet de parcourir la Russie.

Tome I. A

An original copy of the *Columbian Centinel*, February 22, 1792, published in Boston, Massachusetts, containing a letter from Catherine the Great

Columbian Centinel.

Printed and published, on WEDNESDAYS and SATURDAYS, by BENJAMIN RUSSELL, in *State-Street*, BOSTON, MASSACHUSETTS.

Whole No. 817.] *WEDNESDAY, FEBRUARY 22, 1792.* [No. 47, *of* VOL. XVI.

MISCELLANY.

From the NATIONAL GAZETTE.

FURTHER AND CONCLUDING
THOUGHTS on the INDIAN WAR.

[*By* H. H. Brackenridge, *of Pittsburg.*]

I CAN easily excuse those, who, from motives of humanity, call in question the justness of our cause in the war against the Indians. But could I make my observations theirs with respect to the ruthful disposition of a savage, that is not soothed continually by good offices, or kept down by fear; could I give my knowledge, recollection, and impression of the accumulated instances of homicide committed by the tribes with whom we are at war, the humane would be more humane, for their feelings would be more awake, not in favour of these people, but of the persons butchered by them in cold blood, or dragged to that pole seen by the soldiers under General HARMAR, by the Miami village, where the ground was beat like a pavement by the miserable victims moving round the stake to avoid the still pursuing tortures, which the circle of black coals, at a distance from the piles burned, shewed whence they brought their brands or heated gun-barrels to afflict the object. All this, though there have been but three instances since the conclusion of the war with Britain, where an Indian has been hurt on our part; one on the Susquehanna, and two on the Ohio; with respect to one of which instances, that of M'GUIRE and BRADY, it is a doubt whether they were hostile or peaceable.

I consider men who are unacquainted with the savages, like young women who have read romances, and have as improper an idea of the Indian character in the one case, as the female mind has of real life in the other. The philosopher, weary of the vices of refined life, thinks to find perfect virtue in the simplicity of the unimproved state. He sees green fields and meadows in the customs and virtues of the savages. It is experience only can relieve from this calenture of the intellect. All that is good and great in man results from education; and an uncivilized Indian is but a little way removed from a beast, who, when incensed, can only tear and devour, but the savage applies the ingenuity of man to torture and inflict anguish.

Some years ago, two French gentlemen, a Botanist and Mineralist, Monsieur SOGRAIN and M. PIKE, the Botanist a very learned man, and truly a philosopher—but his brain turned with *Jean Jacques Rosseau's*, and other rhapsodies—the man of nature was his darling favourite. He had the Indians with him at his chamber every day. Fitting out a small boat on the Ohio, with only three other persons on board, and without arms he descended. It was in vain to explain the danger and dissuade him. He was conscious to himself of loving Indians, and doubtless they could wish him no harm. But approaching the Scioto river, a party came out in a canoe, as he thought to pay their respects to him; but the first circumstance of ceremony when they came on board, was to impress the tomahawk, and take off the scalp of the philosopher.

A great dependence seems to be placed on Cornplanter and his party. I know Cornplanter, and Big-Tree, and Half-Town; they are good, as Indians, and are well disposed to us, because they can be of little or no account on the other side. BRANDT treats them with contempt, and adheres to the British. Instead of bringing them down at a great expense, and presenting them in Philadelphia, and appropriating 800 dollars for their maintenance and vestment, with things put upon a right footing, and Presq'isle garrisoned, we should have no more occasion for Cornplanter, or Big-Tree, or Half-Town, than they would have for us; and if we gave them goods, they would give us furs.

As to Cornplanter's speech, I have known myself, a speech made for him, that he never heard. I know a little of

the mystery of agent-craft, and the mummery of Indian speechifying. An Indian Chief in the hands of a good interpreter and agent, is a more profitable property, than a tame bear or a lion presented for a show. I have seen Indian princes in Pittsburg, as plenty as in the time of *Adonibezak*, who had three score and ten kings under his table. Many a Chief I have seen driven out of a kitchen by a maid with a broomstick, lest he should steal a tin cup or a table spoon. I have seen a certain blind Sam, so called, because blind of an eye, taken down to this city, passed for a warrior, dining with clubs, and have heard of him presented at a ball on his way down; the favoured ladies looking upon themselves as beatified in receiving the salute of a king. When he returned, with a laced waistcoat, the vulgar Indians that before thought him one of them, laughed immoderately at the farce.

I say, the business with the Indians is war and reduction, and after that, away with the system of agents and interpreters, and leading Indians down to your capitals like pet-beasts. Let them stay in their woods and negociate an equal trade. This trade may certainly be a very great object. When the line of savages, that are at present hostile, is removed, our way is open to peaceable and remote nations. I have conversed with those, who, in behalf of great trading companies, had been four years on discovery for the purposes of trade, had penetrated many thousand miles, traversed the country beyond the source of the Missouri, but were delicate in their communications of the route and advantages of trade with the myriads of the natives in those woods: they, however, gave me to understand, that most of the trading companies of Britain were turning their attention to it.

Of the vast nations of Indians that are ready to trade with us, were the Miami and Wabash Indians peaceable, there is no conception. It will cost but one effective armament to accomplish this object, and why employ years in doing that which may be done at once? No longer any starved campaign!—but I am disposed to believe that Presq'isle is the route. Let others calculate and explain the saving of expence by this route, I only touch the advantage of beginning with the Six Nations in our rear.—It is said, that the persons interested in our funds are against an effective armament, as it may turn away the revenue from the payment of their interest. I could give them a small hint on this head. Be careful not to check the spirit of the people. It is electrical, and if confined may burst. Let it have an egress in acquisitions to the westward, and you may rest safe.

It is considered as a great sacrifice to publick credit, to have provided for the discharge of the publick debt, without discrimination, and it is a prevailing opinion, that the monied interests thus constituted, are a dead weight, by their extracts of letters and paragraphs in the papers, on the wheels of government, and all this to secure the payment of their interest. But the maxim is, *ne quid minis*, nothing too much: They may overshoot themselves and cause the people to revolt, and call in question the original justice of their claim.

As these are desultory observations, I remark and conclude that some think me rather rash in presuming that the king of Britain has given any countenance, directly or indirectly to the Indian depredations or armaments. I should be sorry to do injustice to any power, and it was with great difficulty that I admitted the idea, but I have been convinced of it, and can have no doubt, because that government could not but have heard of the hostilities, and by one single word of the commandant of Detroit to M'KEE and BRANDT, we should have had a perfect peace. But M'KEE and BRANDT, when messengers were sent to call the Indians to the treaties at Muskingum and at the Miami, advised them not to go: Witness—I shall suppress my authorities. It may perhaps injure these men in their future trade with the Indians or connexions at Detroit. Good God! that an island

where I drew my first breath, where a MILTON and a HUME have lived, where a HOWARD has sacrificed to humanity—there can be those who can aid, at least not disarm, what may be in their power, the savage of his axe, battered on the skulls of their species, in the cottage or the field of the settlements adjoining their province—they could do this by the surrender of the posts, for at that moment I proclaim peace to the westward, and ensure safety.

But the posts are not surrendered, and the Indians are supported.—Nay more; I would not wonder if the British gold has found its way into our states; and some of these sentiments against effectual measures, that are thrown out, may come from this source. We are thus between two fires, seduction at home and invasion from abroad!

The chiefs of the western nation, elated with their victory, are at this moment at the mouth of Buffaloe-Creek, which empties into lake Erie, at no great distance from the post of Niagara, under the auspices of the government of Canada, soliciting and convening the chiefs of the Six Nations to a council. The chiefs are actually convening, and the populace are clamorous for a war. They talk with irony and sarcasm of the attachment of Cornplanter, Half-Town, and Big-Tree to these States. They exult in the victory obtained: For Indian loves Indian, and like a bone out of joint, they wish to find their proper place, and coalesce with a like people. It is true, the northern and western Indians have been formerly hostile to each other; but it is well known that the Six Nations were reduced by the campaign under Gen. SULLIVAN, and ever since submit. It is in spite of nature; and could they have the least chance of success in revolt, they would join their brethren, and the long confined indignancy of their resentment would burst forth. I think this is the occasion, and I am disposed to believe they will think so. A force in their front, a garrison at Presq'isle is the talismanic charm in this case. It will intercept the communication of the Indians, who are at present open and avowed enemies, and we shall hear no more of council fires at Buffaloe Creek; or talks sent to Cornplanter and his people, of shaking him by the head, and the like, unless he joins them in their warfare. Presq'isle, Presq'isle is the object, and ought to be seized instantly, and made the foothold from whence, as with the mechanism of an ARCHIMEDES, the whole system of the western affairs may be moved and directed.

It may be thought that I am inhumane in my sentiments towards the savages: It is a mistake; I am inhumane to no man or men; but in order to be humane, let me have it in my power. Let myself first be safe, and then I can shew what humanity dictates. The question is, Whether we shall submit ourselves to the savages, or they to us? I say, let us conquer because we cannot depend upon them, for the weaker ever distrusts the mightier; and the unenlightened man, the sensible; but when we shall have it in our power, let us dispense treaties on principles of reciprocity (to use the terms of the diplomatists) and let them know that we are not about to purchase a treaty, but to make one and preserve it. These principles, founded in nature and truth, will strike the mind of the savage, that we ask no more than he ought to give, or that we give more than he has a right to ask. By the immortal gods! (a Roman oath, but sworn with Christian devotion) if this principle could be made the basis of our negociations, we should govern not only these people, but all the world with whom we have to do. When I say govern, I mean command of them all, that is our right on principles of the laws of nations or of nature. But in our affairs with the western Indians, we have for a series of years pursued a sickly tampering system of half peace, half war, from which nothing could result but half success. A told and decisive act of effective hostility at the conclusion of the war with Britain would have composed these Indians and pre-

served in existence the countless numbers that have fallen victims to torture or death on the bourne of the wilderness. It was therefore inhumane not to have adopted this system, which would have been effectual. But I saw, and lamented the circumstance of the Congress besieged with candidates for agencies and commissionships, and messengers and runners, to negociate with these tribes.

There was not a thing that had ever seen a squaw, or a half king, or a chief, or had heard the guttural sound of a Kickapoo, or a Delaware, but would have it that he understood fifty Indian languages, and could interpret, and could draw all the tribes after him just as a boy would whistle pigeons. Hence, treaty and not war. It is not to be supposed that men at the helm know every thing; they are just as ignorant, with respect to affairs beyond their reach, as other people. It is the man on the extremity of any government, as I have been, that sees the most absurdities. I shall say no more at present; for I wish all things conducted well, and would rather help forward, what ought to be done, than blame what has been transacted.

Philad. Feb. 4.

FOR THE CENTINEL.

OUR PRESENT BY-LAWS.

MR. PRINTER.

MUCH, very much, was lately said, in Fanueil-Hall, *about* that Monster of Monsters, the " *Work-House* and *House of Correction !*"—And it was frankly said, that the greatest *evil*, in the *evil* Report of the Committee, was this same *Monster!* But, Mr. PRINTER, can it be true, that those who call themselves Freeholders of the town of *Boston* can be so ignorant, as not to know that this Monster already exists ? Cannot they read—or did they never take pains to peruse their *present* boasted, *until By-Laws*—now in force in *Boston* ? Let them read if they have not, and then let them reply to the Question. What think ye of your present By-Laws? And whether they do not think the Reform contemplated by the Committee would have bettered the situation of the town.

In page 5, of the present Code of By-Laws, enacted in 1785, and 1786, is a Law of which the following are Extracts :—

After the preamble, and a permission for the erection of *Work Houses*, or *Houses of Correction*, in each town, it is

Enacted, " That the Justices of the Peace in every County, at the General Sessions of the Peace, to be holden for the same County; from time to time, may nominate and appoint at their will and pleasure, an honest fit person to be the master of such House of Correction. And it shall and may be lawful to and for the said Court, or any one Justice of the Peace, out of Court, to send and commit unto the said House, to be kept and governed according to the Rules and Orders thereof, all Rogues, Vagabonds, and idle Persons, going about in any Town or County, begging, or persons using any subtle craft, or juggling or unlawful games or plays, or feigning themselves to have knowledge in physiognomy, palmestry; or pretending that they can tell destinies or fortunes, or discover where lost or stolen goods may be found; common pipers, fidlers, runaways, stubborn servants or children, common drunkards, common night walkers, pilferers, wanton and lascivious persons, either in speech or behaviour; common railers or brawlers; such as neglect their callings, misspend what they earn, and do not provide for themselves, or the support of their families; upon due conviction of any of the offences or disorders aforesaid."

And by said Act or Law it is further enacted, " That the master of such house of correction to be appointed as aforesaid, shall have power and authority, and shall set all such Rogues, Vagabonds, Beggars and other lewd, idle and disorderly persons, as aforesaid, that shall be duly sent or committed unto his custody, to work and labour (if they be able) for such time as they shall continue and re-

№ 37.

Saint Dmitri (Demetrius) of Rostov

Tempera on wood
18th century
27.9 x 35.2 x 2.5 centimeters
(11 x 13 7/8 x 1 inches)
Private collection, previously unpublished

A prominent historical figure, Dmitri of Rostov, born Daniil Savich Tuptalo (1651–1709), was appointed archbishop of the city of Rostov by Emperor Peter in 1702. The cleric was canonized to the post as a saint of the Russian Orthodox church in 1757. The greatest accomplishment of this prelate's life is the twelve volumes containing the vitas of saints celebrated in the Orthodox church. He embarked on this endeavor in 1684 and finished in 1705 by publishing the last of four volumes, each covering three months of the liturgical calendar. By making detailed accounts of the saints' lives, Dmitri's work was immensely influential throughout Russia and the entire Southeast of Europe. Major nineteenth-century Russian authors, among them Pushkin (1799–1837) and Dostoevsky (1821–1881), acknowledged the impact these texts had on them.

AK

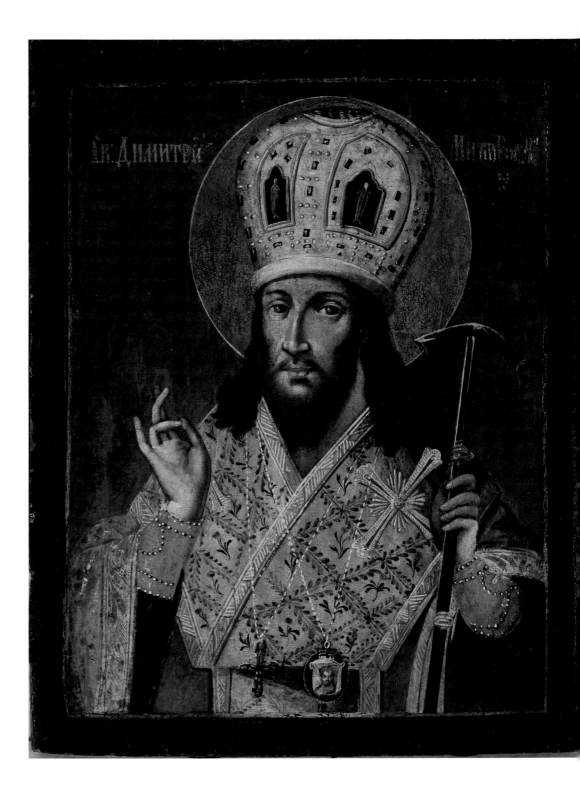

№ 38.
Icon of the Holy Cloth

Tempera on wood
18th century
5.7 x 6.35 x 1.27 centimeters (2 1/4 x 2 1/2 x 1/2 inches)
Private collection, previously unpublished

With regard to both its size and subject matter, this miniature icon is similar to the *enkolpion*, i.e. pectoral pendant, that forms a part of Dmitri of Rostov's costume (as seen in cat. no. 37). The *enkolpion* signifies Dmitri's rank of primate. The Church Slavonic inscription rendered in red across the drapery reads "Sviatyi ubrus" ("The Holy Cloth"; Greek—"mandylion") and refers to the miraculous image that Christ made by pressing his face against a towel. Once created, the Holy Cloth was sent to the city of Edessa in upper Mesopotamia to cure its ailing ruler King Abgar. The belief that the image of the Holy Cloth possesses miraculous powers explains its use on a protective pendant.

On its back, this icon bears an inscription from 1858, stating that this relic had descended through a clan's male heirs.

AK

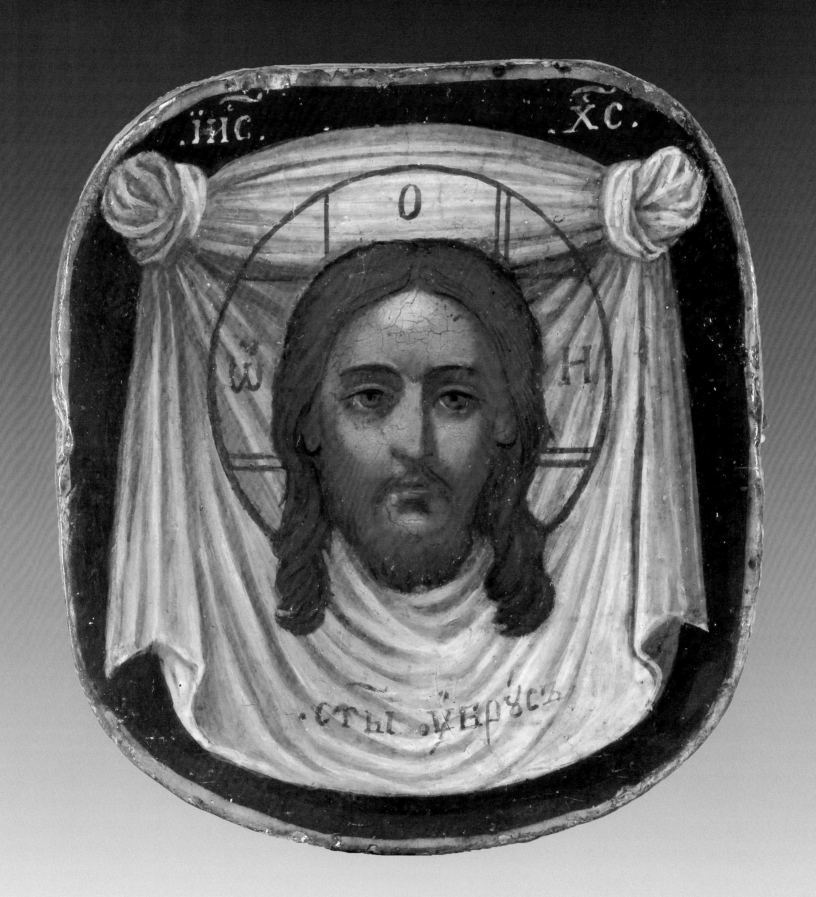

No. 39.

Medailles sur les Principaux Evenements du Regne de Louis le Grand (Louis XIV)

22.86 x 29.21 x 5.08 centimeters (9 x 11 1/2 x 2 inches)
Paris, L'Imprimerie Royale, 1702
The front of the leather-bound volume bears the armorial crest of Louis XIV
22.86 x 29.21 x 5.08 centimeters (9 x 11 1/2 x 2 inches)
Collection of Daniel Bibb

This medallic history demonstrates how the knowledge of humanities and antiquity was harnessed to reaffirm the power of the monarch. The content of this volume is the product of the efforts of the Académie royale des Inscriptions et Médailles (later known as the Académie des Inscriptions et Belles-Lettres), established in 1663. Its original mission was to compose inscriptions in Latin to place on public monuments and medals celebrating the king's accomplishments. (See pages 26–27 and cat. no. 25.)

AK

No. 40.
Book of Psalms

Russian Orthodox leather-bound ecclesiastical book
16th or 17th century
17.78 x 22.22 x 6.35 centimeters (7 x 8 3/4 x 2 1/2 inches)
Collection of Daniel Bibb

This is a Book of Psalms (Russian—*Psaltir'*; Greek—*Psaltirion*) intended for use in church services. Specific psalms are firmly associated with particular parts of the daily liturgical cycle. In the Orthodox church, following an old monastic tradition of perpetually reciting all the psalms, the Book of Psalms is divided into twenty sections called "kathisma." All kathismas are approximately equal in length, which is why they contain a different number of psalms—for instance Kathisma One, 1–8; Kathisma Two, 9–19, Kathisma Three, 17–23, etc.

AK

No. 41.
Sluzhebnik

Russian Orthodox leather-bound liturgical book
1877
19.05 x 24.13 x 3.81 centimeters (7 1/2 x 9 1/2 x 1 1/2 inches)
Collection of Daniel Bibb

This book was published during the reign of Catherine II's great grandson Emperor Alexander II (reign 1855–1881). A *Sluzhebnik* (Greek *Ieratikon*) is a volume containing the texts read by priests and deacons celebrating the ritual of liturgy. It includes the Divine Liturgy according to Saint John Chrysostom and Saint Basil the Great and the Liturgy of the Presanctified Gifts, performed on weekdays during Lent. This volume also includes a full liturgical calendar starting with the month of September and ending with August.

AK

№. 42.
Catherine the Great as Minerva

ca. 1770
Paris (?)
8.25 x 7.62 x 1.27 centimeters (3 1/4 x 3 x 1/2 inches)
Two-layered onyx large cameo set in a later gold and enamel mount
Formerly in the collection of Baron Cassell
Private collection, previously unpublished

The cameo faithfully reproduces the iconography of a
medal designed by Johann Georg Waechter and struck
in 1762 to commemorate Catherine II's ascent to the
Russian throne.[1] Its origin is visible in the details of
the helmet with its owl and animated plumage, the
cuirass, and the imperial mantel with ermine fur and silk
brocade embellished with gold-embroidered double-
headed eagles. The carver made two notable departures
from the original. First, the empress is facing right,
not left as in Waechter's design. Also, the details of
Catherine's profile are highly idealized.

It is possible that the cameo was created in Paris on the
occasion of the Russian military triumphs in the First
Russo-Turkish War (see page 78).

AK

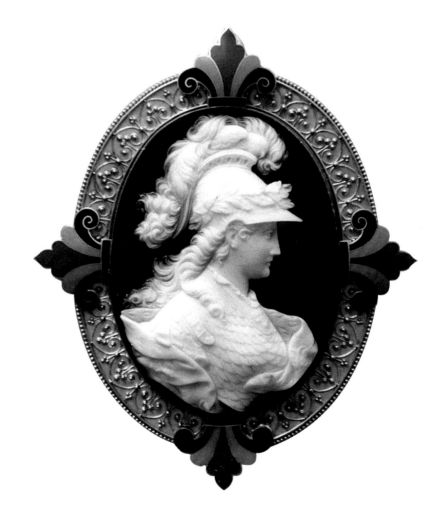

1. *Treasures of Imperial Russia*, 42, no. 4; and Piotrovski, 56–57, nos. 54–55.

№ 43 A.
Bronze medal

Obverse: Catherine II, profile (looking right)
Reverse: inscribed "Chesme. 1770 year. June 26," "Byl" ("There was"/"It happened")
Private collection

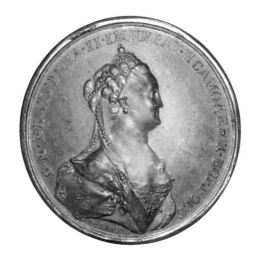 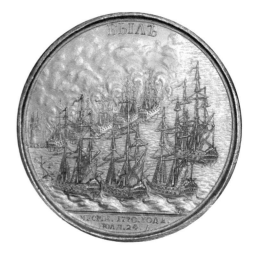

№ 43 B.
Bronze medal

Obverse: Catherine II, profile (looking right)
Reverse: Personification of Faith blessing a kneeling mother holding an infant
inscribed: "September 1, 1763/And you will be Alive"
Private collection

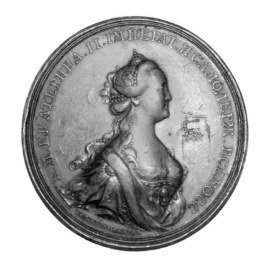 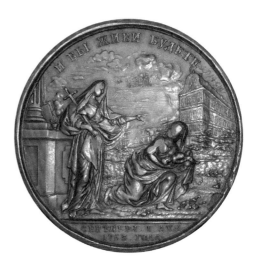

№ 43 C.
Bronze medal

Obverse: Catherine II, profile (looking left)
Reverse: The relocation of Thunder rock, inscribed "January, 20 1770"
Private collection

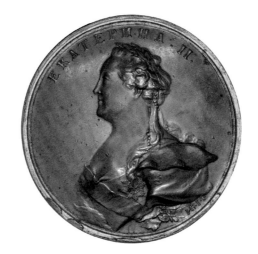 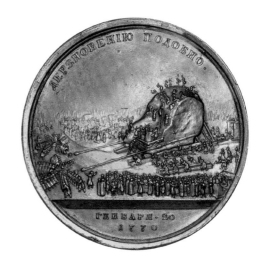

№. 43 D.
Bronze medal

Obverse: Catherine II, profile (looking right)
Reverse: inscribed "Peace treaty with the Ottoman Empire Signed July 10, 1774"
Private collection

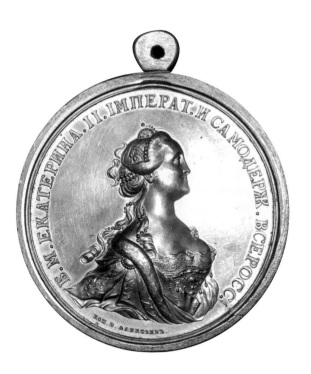
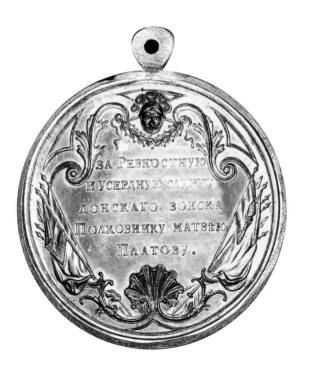

№. 43 E.
Silver medal

Obverse: Catherine II, profile (looking left)
Reverse: Monument of Peter I
Private collection

№. 43 F.
Silver medal

Obverse: Catherine II, profile (looking right)
Reverse: inscribed "For Labor/Efforts Reward"
Private collection

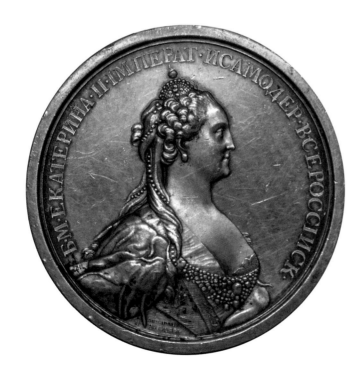
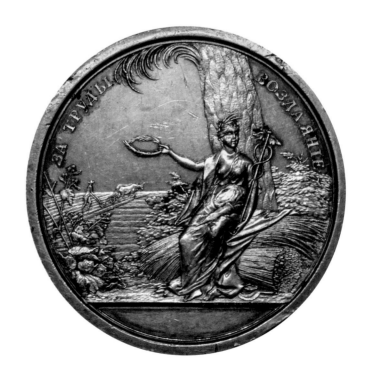

Nº. 44.

Bronze medal

Obverse: Count Gregory Orlov, Prince of the Holy Roman Empire, profile (looking left)
Reverse: equestrian Count Orlov, inscribed: "Russia Had Such Sons" 1771
Private collection

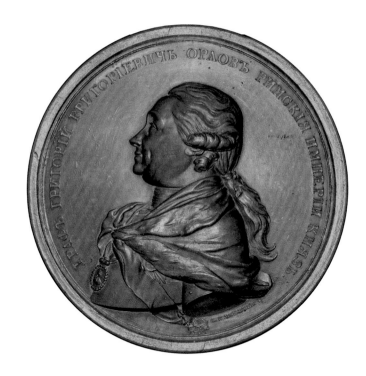 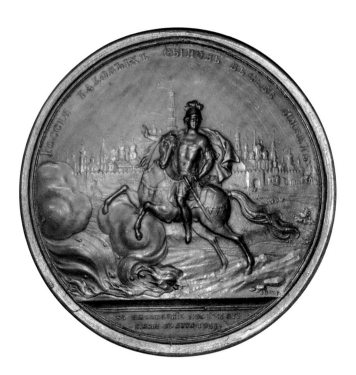

No. 45.
Cameo of Faustina the Younger (ca. 125–175 CE)

Banded agate
Michael C. Carlos Museum, Emory University, Carlos Collection of Ancient Art
2003.41.1

No. 46 A.
Cameo bead of a frog

Hematite
Michael C. Carlos Museum, Emory University, Gift of the Estate of
Michael J. Shubin
2012.32.276

No. 46 B.
Carved frog with head raised

Rock crystal
Michael C. Carlos Museum, Emory University, Gift of the Estate of
Michael J. Shubin
2012.32.102

No. 47.
A group of 26 carved stones:

Capricorn. Roman, Augustan. Carnelian in original gold setting, child's ring. 2008.31.42.

Minerva, standing. Roman, 2nd–3rd century AD. Garnet set in original gold ring. 2005.80.87.

Minerva standing. Carnelian in modern silver roundel. 2008.31.27.

Minerva after the Phidian Parthenos. Roman. Carnelian in modern gold frame. 2008.31.51.

Minerva and Jupiter. Roman. Nicolo. 2008.31.320

Ringstone with Minerva holding owl. Yellow-brown glass. 2012.32.266

Minerva, after the Phidian Parthenos. Roman. Carnelian. 2012.32.174.

Minerva, bust. Carnelian. 2012.32.246.

Perseus with the head of Medusa. Roman, Trajanic. Carnelian. 2008.31.60.

Portrait bust of a youthful prince, wreathed. Hellenistic. Carnelian or agate. 2008.31.7.

Portrait of Elagabalus. Roman. Carnelian. 2008.31.103.

Cameo portrait of a woman. Roman, Flavian or Hadrianic. Jasper in original gold setting. 2012.32.220.

Portrait of a bearded man. Roman, perhaps Trajanic. Carnelian. 2007.30.4.

Portrait of a bearded ruler. Sassanian. Agate. 2008.31.169

Portrait of a bearded ruler. Hunnish. Lapis. 2008.31.208.

Portrait of Pescennius Niger. Roman. Carnelian stone in modern setting. 2008.31.96

Victory. Augustan. Agate in Victorian setting. 2008.31.252.

Portrait of a woman, Antonine. Emerald in original gold ring. 2012.32.33.

Cameo of a male head. Roman. Amethyst. 2008.35.2.

Cameo of boar. Eastern Roman or Parthian. Onyx in gold setting. 2008.31.90.

Cameo of a satyr with pedum. Roman. Banded agate. 2005.49.2.

Cameo with sacro-idyllic scene. Roman, 2nd century AD. Agate. 2005.80.2

Ptolemaic portrait cameo of a woman. Roman, 2nd century AD. Agate. 2005.80.75.

Medusa cameo. Roman. Banded agate. 2008.31.91.

Medusa cameo. Roman. Agate. 2008.31.52

Medusa cameo earrings. Agate, green stone, and pearl. 2008.31.334a–b.

All Michael C. Carlos Museum, Emory University, Carlos Collection of Ancient Art

No. 48 A.
Fly or dragonfly or cicada in top view engraved on gold ring

South Italian Greek
Michael C. Carlos Museum, Emory University. Gift of the estate of Michael J. Shubin
2012.32.223

No. 48 B.
Crab in top view in emerald set in original gold ring

Michael C. Carlos Museum, Emory University. Gift of the estate of Michael J. Shubin
2008.31.11

No. 48 C.
Lion face in top view

Roman
Red jasper
Michael C. Carlos Museum, Emory University. Gift of the estate of Michael J. Shubin
2008.31.99

$\mathcal{N}_{\!\!o}$. 49.
Potpourri vase with classical figures

1768
Jean Pierre Ador (1724–1784)
Gold and enamel both en plein (one solid color) and painted enamel en camaïeu (rendered to look like cameos)
27.8 x 14.9 x 11.7 centimeters (10 15/16 x 5 7/8 x 4 5/8 inches)
Casting, chasing, and chiseling
The Walters Art Museum, Baltimore, Maryland, 57.864
Bequest of Mr. Henry Walters, formerly in the collection of Count Orlov-Davidoff

INSCRIBED: Ador à Saint Petersbourg

HALLMARKS: on the bottom of the vase 1) a
crown with five rounded tips and within its
field the initials IA, standing for Jean Pierre
Ador; 2) three anchors, for Saint Petersburg
with the year 1768; 3) the Cyrillic initials ИѲ,
the phonetic value of which corresponds to IF
in English and designates Saint Petersburg's
assayer Ivan Frolov (1738–1779).

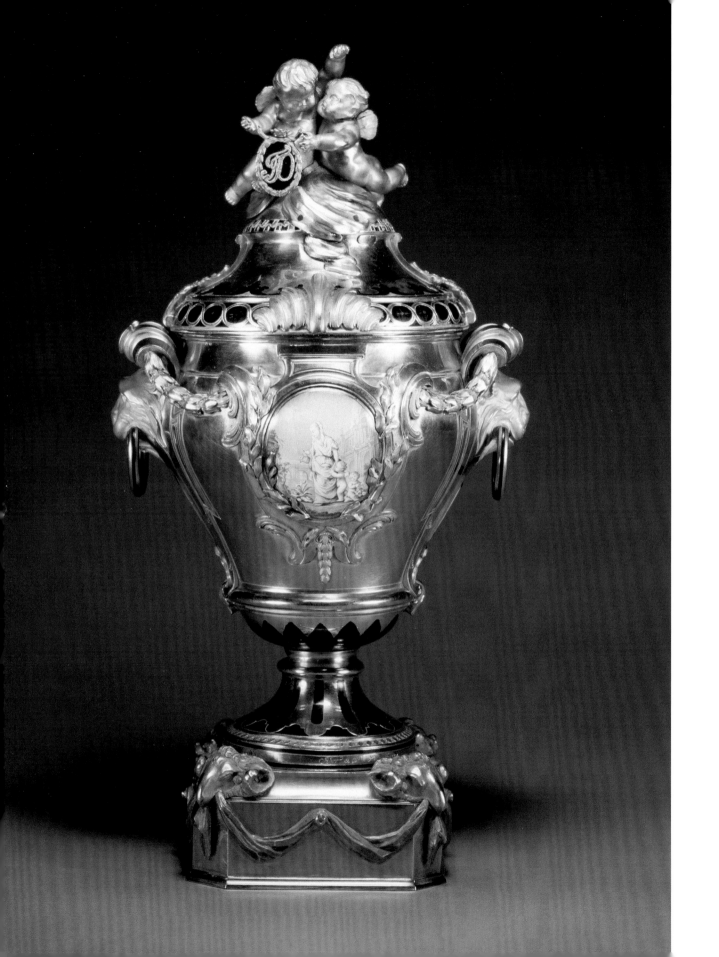

No. 50.
Archangel Michael (obverse) and a Warrior Saint (reverse)

Middle-Byzantine, 11th–12th century
Bloodstone
6 x 3.2 x 1.3 centimeters (with loop) (2 3/8 x 1 1/4 x 1/2 inches)
The Walters Art Museum, Baltimore, Maryland, 42.6

Actual Size

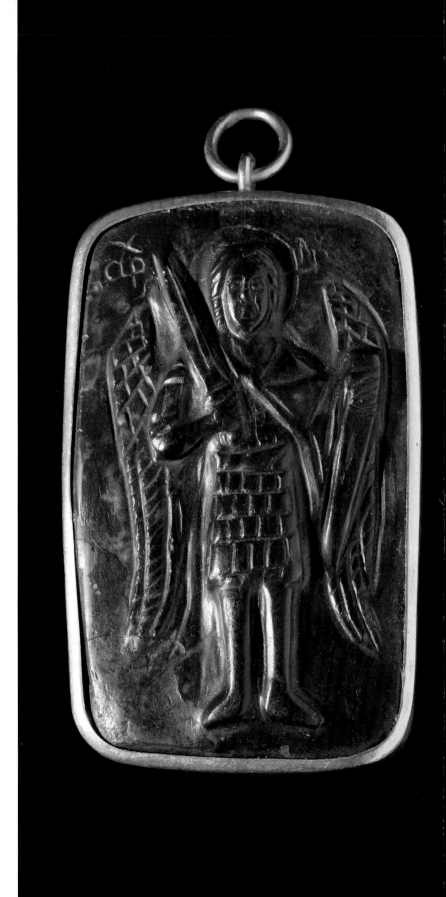

Sam Browne

VITRUVIUS BRITANNICUS,
or
The British Architect,
Containing
The Plans, ELEVATIONS, and Sections
of the Regular Buildings *both*
PUBLICK and PRIVATE,
IN
GREAT BRITAIN,
With Variety of New Designs; in 200 large Folio Plates, Engraven
by the best Hands; and Drawn either from the Buildings themselves,
or the Original Designs of the Architects;
In II VOLUMES
VOL. I. by Colen Campbell Esqr.

VITRUVIUS BRITANNICUS,
ou
L'Architecte Britannique,
Contenant
Les Plans, ELEVATIONS, & Sections
des Bâtimens Reguliers, tant
PARTICULIERS que PUBLICS
de la Grande Bretagne;
Compris en 200 grandes Planches gravez en taille douce par les
Meilleurs Maitres, et tous ou dessinez des Bâtimens memes, ou
copiez des Desseins Originaux des Architectes:
EN DEUX TOMES.
TOME. I. Par le Sieur Campbell.
CUM PRIVILEGIO REGIS.

L'antiquité expliquée et représentée en figures, vols. 2 and 3

Folio DE57.M78

No. 53.

Supplément au livre de L'antiquité expliquée . . . , vol. 4

Folio DE57.M782 Suppl.

No. 54 A-B.

Encyclopédie; ou dictionnaire raisonné des sciences, des arts et des métiers, vols. 4 and 11

Folio AE25.E56

No. 55.

Encyclopédie, ou Dictionnaire raisonné des sciences, des arts et métiers. Recueil de planches, sur les sciences, les arts libéraux, et les arts méchaniques, avec leur explication, vol. 1

Folio AE25.E56 Plates

Pl. VII.

*fig. 1.*ere

fig. 2

Albogalerus
à été porté sur la
Planche IX. Fig. 9.

1

2

3

Apex
à été p'orté sur la
Planche IX. Fig. 14

Benard Fecit.

Antiquités.

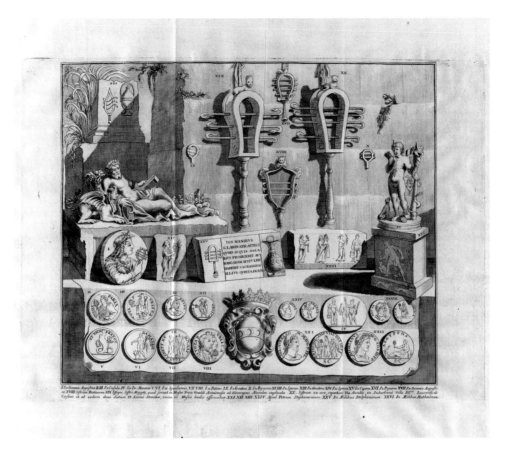

DIS MANIBVS
C.LARINATIS.ATTICI
QVOD SI QVIS OSSA
RIVS PROIECERIT AVT
HASCE.ARAM.ASPORTVERIT
HABERIT SACRARIDIS
ILLIVS QVIETA.IRAM

I Ex Gemma Augustini II.III. Ex Cofalio. IV Ex Ex Macario V VI. Ex Spanhemio VII VIII. Ex Patino IX. Ex Grutero X. Ex Pignorio XI XII. Ex Spania XIII. Ex Grutero XIV Ex Spania XV Ex Cupero XVI. Ex Pignorio XVII. Ex Gemma Augusti
ni XVIII. Siftrium Betinianum XIX. Effiges Isftri.Aegypti, quod fervati in Mufeo Franc.Gualdi Ariminenfis ab Hieronymo Alexdro explicata XX. Siftrum ex are, expertum Via Aurelia, in Suburbana Villa Ill.mi Laurentii de
Lorfimi et ab eadem dono datum D.Leoni Strozae, cuius in Mufeo hodie affervatur XXI XII XIII XXIV Apud Petrum Stephanonium XXV In Aedibus Delphinorum XXVI In Aedibus Mathaeorum.

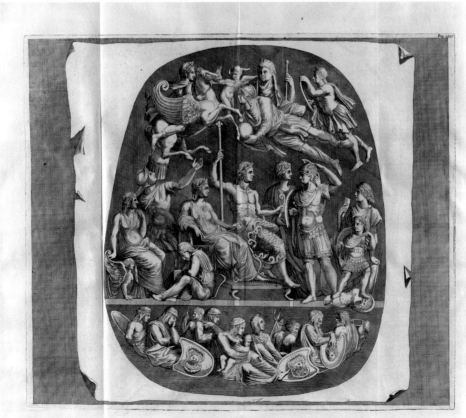

Folio NK5515.S3

XXIII

HERCULES JUVENIS

IOH. WINKELMAN

Maron pinx. *G. Carattoni inc. Rome*

The Gentleman's Magazine, vols. 38 and 40

AP4.G338

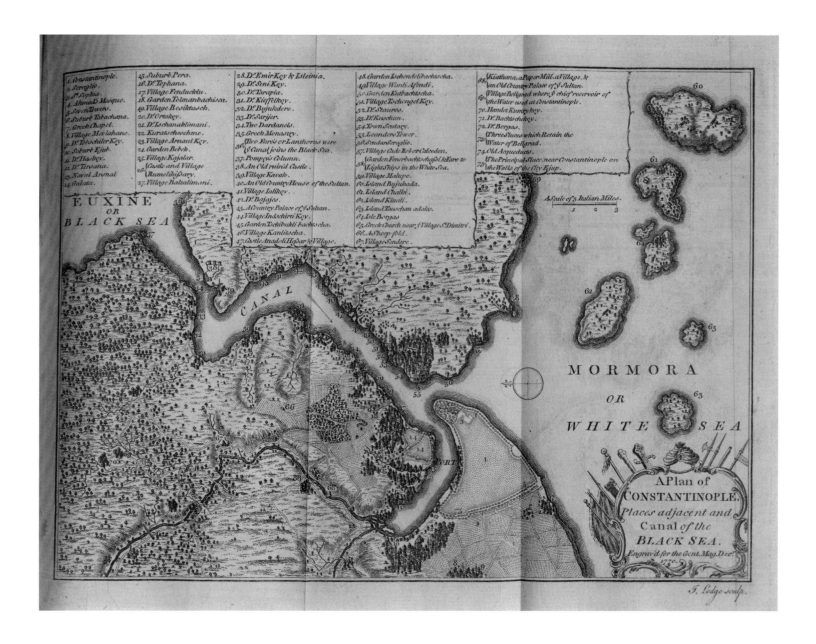

THE

EMPEROR

Marcus Antoninus

HIS

CONVERSATION

With Himself.

TOGETHER

With the Preliminary DISCOURSE of the
Learned GATAKER.

As also,

The Emperor's LIFE, Written by Monsieur D'acier,
and Supported by the Authorities Collected by
Dr. STANHOPE.

To which is added the Mythological Picture of
CEBES the *Theban*, &c.

Tranflated into *English* from the Refpective Originals.

By JEREMY COLLIER, M. A.

The Second Edition Corrected.

LONDON:
Printed for RICHARD SARE, at *Grays-Inn Gate* in
Holborn, MDCCVIII.

M.V.A. ANTONINVS IMPERATOR. &c.
London Printed for R. Sare 1701.

Lettres de Marie Rabutin-Chantal, marquise de Sévigné, a madame la comtesse de Grignan sa fille, vols. 1 and 2

The Countess of Pembroke's Arcadia / written by Sir Philip Sidney, Knight; with his Life and Death; a brief Table of the principal Heads; and some other new Additions. 13th edition. London: Printed for George Calvert, 1674

The true Portraicture of that Learned, & Valiant, ⁓
S:ʳ Philip Sidney, Governour of Flushing, & yᵉ Castle of
Ramekins, who was Slaine at Zutphen the 17.ᵗʰ of Octobᵣ
1585 & Honourably Interred at Sᵗ Pauls London.

BIBLIOGRAPHY

Adams, Elizabeth Bryding. *The Dwight and Lucille Beeson Wedgwood Collection at the Birmingham Museum of Art*. Birmingham, AL: Birmingham Museum of Art, 1992.

Adams, John. *The Works of John Adams*. Edited by Charles Francis Adams. 10 vols. Boston: Little, Brown & Co., 1850–56.

Akerman, John Yonge. *Descriptive Catalogue of Rare and Unedited Roman Coins: The Earliest Period of the Roman Coinage, to the Extinction of the Empire under Constantinus Papaologos*. London: Effingham Wilson, 1834.

Alexander, J. T. *Catherine the Great: Life and Legend*. New York: Oxford University Press, 1989.

Allen, Brian, and L. Dukelskaya, eds. *British Art Treasures from Russian Imperial Collections in the Hermitage*. New Haven, CT: Yale University Press, 1996.

Alpers, S. *The Art of Describing: Dutch Art in the Seventeenth Century*. Chicago: University of Chicago Press, 1983.

Andrews, Carol R. *Amulets of Ancient Egypt*. London: Trustees of the British Museum by the British Museum Press, 1994.

Andrews, Malcom. *Landscape and Western Art*. Oxford: Oxford University Press, 1999.

Anthony, K. *Catherine the Great*. Garden City, NJ: Garden City Publishing Company, 1925.

Architectural Space in Eighteenth-Century Europe. Edited by Denise Amy Baxter and Meredith Martin. Surrey: Ashgate Publishing, 2010.

Architectures of Russian Identity: 1500 to the Present. Edited by James Cracraft and Daniel Rowland. Ithaca, NY: Cornell University Press, 2003.

Arend, Liana Paredes. "Gold Boxes at Hillwood." *Magazine Antiques* 163 (March 2003): 108–13.

Aristophanes. *Frogs*. Edited by K. Dover. Oxford: Clarendon Press, 1993.

Arnould, D. "Les grenouilles de Sériphos." *L'Antiquité classique* 69 (2000): 257–60.

Auzépy, Marie-France, ed. *Byzance en Europe*. Paris: Presses Universitaires de Vincennes, 2003.

Avseenko, V. N. *Istoriia goroda S.-Peterburga v litsakh i kartinkakh 1701–1903. Istoricheskii ocherk*. Saint Petersburg: Sotis, 1993.

Badeslade, J., and John Rocque. *Vitruvius Britannicus or The British Architect*. Vols. 1–4. New York: B. Blom, 1967–72.

Baehr, Stephen Lessing. *The Paradise Myth in Eighteenth-Century Russia: Utopian Patterns in Early Secular Russian Literature and Culture*. Stanford, CA: Stanford University Press, 1991.

Barsukov, Nikolai, ed. *Dnevnik A.V. Khrapovitskago, 1782–1793*. Moscow: Universitetskaia tipografiia, 1901.

Bartlett, Roger P., A. G. Cross, and K. Rasmussen, eds. *Russia and the World of the Eighteenth Century*. Columbus, OH: Slavica Publishers, 1988.

Batalden, S. *Catherine II's Greek prelate: Eugenios Voulgaris in Russia, 1771–1806*. New York: Columbia University Press, 1982.

Batorevich, Nataliia I. *Chesmenskii dvorets*. Saint Petersburg: Beloe i chenoe, 1997.

Beauvoir, Simone de. *The Second Sex*. Translated by H. M. Parsley. London: Jonathan Cape, [1949] 1972.

Belokurov, Sergei A. *Arsenii Sukhanov*. Moscow: Universitetskaia tipografiia, 1891.

Berger, R. W. *The Palace of the Sun: The Louvre of Louis XIV*. University Park: Pennsylvania State University, 1993.

Boardman, J. *Archaic Greek Gems: School and Artists in the Sixth and the Early Fifth Centuries BC*. London: Thames and Hudson, 1968.

Bolgar, R. "The Classical Tradition: Legend and Reality." In *Byzantium and the Classical Tradition*, edited by M. Mullet and R. Scott, 7–19. Birmingham, UK: Centre for Byzantine studies, University of Birmingham, 1981.

Bolin, K., and P. Bulatova. *Bolin in Russia: Court Jeweller Late XIX–XX Centuries*. Exhibition catalogue. Moscow: Kremlin, 2001.

Borisova, E. A. *Russkaia arkhitektura v epokhu Romantizma*. Saint Petersburg: D. Bulanin, 1997.

Brandt, Elfriede, and Evamaria Schmidt. *Antike Gemmen in Deutschen Sammlungen, Band I: Staatliche Münzsammlung München*. Munich: Prestel, 1972.

Bremer-David, Charissa. *Decorative Arts: An Illustrated Summary Catalogue of the Collections of the J. Paul Getty Museum*. Malibu, CA: J. Paul Getty Museum, 1993.

Brickhouse, Thomas C., and Nicholas D. Smith. *Socrates on Trial*. Princeton, NJ: Princeton University Press, 1989.

Brikner, A. *Istoriia Ekateriny Vtoroi*. Saint Petersburg: A. S. Suvorin, 1885.

Brown, Peter. *The World of Late Antiquity*. London: Thames and Hudson, 1971.

Bruess, G. L. *Religion, Identity and Empire: A Greek Archbishop in the Russia of Catherine the Great*. New York: Columbia University Press, 1997.

Bullen, J. B. *Byzantium Rediscovered: The Byzantine Revival of Europe and America*. London: Phaidon Press, 2003.

Burke, P. *The Fabrication of Louis XIV*. New Haven, CT: Yale University Press, 1992.

Bushkovitch, Paul. "The Clergy at the Russian Court, 1689–1796." In *Monarchy and Religion: The Transformation of Royal Culture in Eighteenth-Century Europe,* edited by Michael Schaich, 105–28. New York: Oxford University Press, 2007.

Butler, William E., and Vladimir A. Tomsinov, eds. *The Nakaz of Catherine the Great: Collected Texts*. Clark, NJ: Lawbook Exchange, 2010.

Carnegie, H. *Catalogue of the Collection of Antique Gems Formed by James, Ninth Earl of Southesk, K.T.* London: B. Quaritch, 1908.

Caseau, Beatrice Agnes. "Euódia: The use and meaning of fragrances in the Ancient world and their Christianization (100–900 AD)." Ph.D. Dissertation, Princeton University, 1994.

Cassidy-Geiger, M. "*Hof-conditorei* and Court Celebrations in 18th Century Dresden." *The International Ceramics Fair & Seminar* (14th–17th June, 2002): 20–35.

Castell, Robert. *The Villas of the Ancients Illustrated*. New York: Garland Publishing, 1982.

Catalogue des pierres gravées du cabinet de feu son Altesse Sérénissime Monseigneur le Duc D'Orléans, Premier Prince du sang. Paris: Barrois, 1786.

Catherine the Great: An Enlightened Empress. Edited by G. Vilinbakhov. Edinburgh: National Museums Scotland Enterprises Limited, 2012.

Catherine the Great, Empress of Russia. *The Antidote or an enquiry into the merits of a book, entitled* A Journey Into Siberia, *made in 1761 in obedience to an order of the French king, and published, with approbation, by the Abbé Chappe D'Auteroche, of the Royal Academy of Sciences. In which many essential Errors and Misrepresentations are pointed out and confuted; and many interesting anecdotes added, for the better elucidation of the several matters necessarily discussed: BY A LOVER OF TRUTH. Translated into English by a lady, and dedicated to Her Imperial Majesty the Czarina*. London: Printed for S. Leacroft, Opposite Spring-Gargen, Charing-Cross, 1772.

___. *Zapiski Ekateriny II*. London: Trüner & Co., 1859.

___. *Collected Works: Sochineniia Imperatritsy Ekateriny II na osnavanii podlinnykh rukopisei*. Edited by A. N. Pynin. Saint Petersburg: Afmarks, 1901.

___, W. F. Reddaway, and Voltaire. *Documents of Catherine the Great: The Correspondence with Voltaire and the Instruction of 1767, in the English text of 1768*. Edited by W. F. Readdaway. Cambridge: University Press, 1931.

___. *Memoirs of Catherine the Great*. Translated by Katharine Anthony. New York: Tudor Publishing Co., 1935.

___. *Autobiography*. Edited by A. N. Pypin. Osnabrück: Biblio Verlag, 1967.

___. *Two comedies by Catherine the Great, Empress of Russia*. Translated and edited by Lurana Donnels O'Malley. Australia: Harwood Academic Publishers, 1998.

Catherine the Great & Gustav III. Edited by Magnus Olausson. Stockholm: Nationalmuseum; Saint Petersburg: State Hermitage Museum, 1999.

Cavina, A. O. *Geometries of Silence: Three Approaches to Neoclassical Art* (translation by A. McEwen). New York: Columbia University Press, 2004.

Ceffalonie, Marin Carburi de. *Monument élevé à la gloire de Pierre-le-Grand, ou relation des travaux et des moyens méchaniques Qui été employés pour transporter à Pétersbourg un rocher de trois millions pesant, destiné à servir de base à la statue équestre de cet empereur, avec un examen physique et chymique du même rocher par le comte Marin Carburi de Ceffalonie, ci-devant lieutenant-colonel au service de S.M. l'impératrice de toutes les Russies, lieutenant de police et censeur, ayant la direction du corps noble des cadets de terre de Saint Pétersbourg*. Paris: Nyon et Soupe, 1777.

Chantreau, P.-N. *Philosophical, Political, and Literary Travels in Russia, During the years 1788 & 1789; translated from the French of Chantreau with a Map and Other Plates*. Vols. 1–2. London: Vernor and Hood, 1794.

Charlesworth, Michael. "The Sacred Landscape: Signs of Religions in the Eighteenth-Century Garden." *Journal of Garden Studies* 13 (1993): 56–67.

Chicago, Judy. *The Dinner Party: A Symbol of our Heritage*. New York: Anchor, 1979.

Christian Relics in the Moscow Kremlin. Edited by Alexei Lidov. Moscow: Radunitsa, 2000.

Clark, Grahame. *Symbols of Excellence: Precious Materials as Expressions of Status*. Cambridge: Cambridge University Press, 1986.

Clark, J. C. D. "The Re-Enchantment of the World? Religion and Monarchy in Eighteenth-Century Europe." In *Monarchy and Religion: The Transformation of Royal Culture in Eighteenth-Century Europe*, edited by Michael Schaich, 41–75. New York: Oxford University Press, 2007.

Classen, Constance, David Howes, and Anthony Synnott. *Aroma: The Cultural History of Smell*. London: Routledge, 1994.

Clifford, T. "Anglomania: Catherine's Patronage of British Decorative Arts." *British Art Journal* 1–3 (2000): 110–20.

Coffin, D. R. *Magnificent Buildings, Splendid Gardens*. Princeton, NJ: Department of Art and Archaeology and Princeton University Press, 2008.

Conan, M. "Éloge de la grenouille: le paysage dans les jardins à la Française au XVIIème siècle." *Journal of Garden History* 4 (1991): 191–98.

Corberon (baron de), M. D. B. *Un diplomate français a la cour de Catherine II, 1775–1780. Journal intime du chevalier de Corberon, chargé d'affaires de France en Russie, publié d'après le manuscrit original, avec une introduction et des notes par L.-H. Labande*. Paris: Plon-Nourrit, 1901. www.archive.org/stream/undiplomatefran02corbuoft#page/206/mode/2up.

Corrigan, Kathleen. *Visual Polemics in the Ninth-Century Byzantine Psalters*. New York: Cambridge University Press, 1992.

Countess Golovine. *Memoirs of Countess Golovine: A Lady at the Court of Catherine II*. London: David Nutt, 1910.

Coutts, H. and I. Day. "Sugar Sculpture, Porcelain and Table Layout 1530–1830." *Henry Moore Institute, Online Papers & Proceedings*, October 8, 2008: www.henry-moore.org/hmi-journal/homepage/view-occasional-papers/sugar-sculpture/page-5 (last visited July 21, 2013).

Cracraft, James. *The Petrine Revolution in Russian Architecture*. Chicago: University of Chicago Press, 1988.

Cross, Anthony G. *Russia Under Western Eyes, 1517–1825*. New York: St. Martin's Press, 1971.

___, ed. *Russia and the West in the Eighteenth Century*. Newtonville, MA: Oriental Research Partners, 1983.

___. "Catherine the Great and the English Garden." *New Perspectives on Russian and Soviet Artistic Culture* (1990): 17–23.

___. "Russian Gardens, British Gardeners." *Garden History* 1 (1991): 12–27.

___. *Engraved in the Memory: James Walker, Engraver to the Empress Catherine the Great, and His Russian Anecdotes*. Oxford: Berg, 1993.

___. "The English Garden in Catherine the Great's Russia." *Journal of Garden Studies* 13 (1993): 172–80.

___. *Peter the Great Through British Eyes: Perceptions and Representations of the Tsar since 1698*. Cambridge: Cambridge University Press, 2000.

___. *Catherine the Great and the British: A pot-pourri of essays*. Nottingham, UK: Astra, 2001.

Cross, S. H., and O. P. Sherbowitz-Wetzor, eds. *The Russian Primary Chronicle: Laurentian Text*. Cambridge, MA: Medieval Academy of America, 1953.

Cuddihy, William J. *The Fourth Amendment: Origins and Original Meaning, 602–1791*. Oxford: Oxford University Press, 2009.

___. "'A Man's House is His Castle': New Light on an Old Case." Review of *The Writs of Assistance Case* by M. H. Smith. *Reviews in American History* 7, no. 1 (March 1979): 64–69.

Culture and Transcendence: A Typology of Transcendence. Edited by Wessel Stoker and W. L. van der Merwe. Leuven: Peeters Publishers, 2012.

Cunnally, John. "Of Mauss and (Renaissance) Men: Numismatics, Prestation, and Genesis of Visual Literacy." In *The Rebirth of Antiquity: Numismatics, Archaeology, and Classical Studies in the Culture of the Renaissance*. Edited by Alan M. Stahl, 27–47. Princeton, NJ: Princeton University Library, 2009.

Cutler, Anthony. "Under the Sign of Deesis: On the Question of Representativeness in Medieval Art and Literature." *Dumbarton Oaks Papers* 41 (1987): 145–54.

D'Auteroche, L'Abbé Chappe. *A Journey into Siberia, Made by the Orders of the King of France. By L'Abbé Chappe D'Auteroche, of the Royal Academy of Sciences at Paris, in 1761. Containing an Account Of the Manners and Customs of the Russians, the Present State of their Empire; with the Natural History, and Geographical Description of their Country, and Level of the Road from Paris to Tobolsky*. London: 1770.

Damisch, Hubert. *The Origin of Perspective*. Cambridge, MA: MIT Press, 1994.

Daniel, R. P. G. *Histoire de la milice françoise, et des changements qui s'y sont faits depuis l'établissement de la Monarchie Françoise dans les Gaules, jusqu'à la fin du Regne de Louis le Grand*. Tome II. Paris: Denis Marette, Jean-Baptiste Delespine, Lean-Baptiste Coignard, 1721.

Derzhavin, G. R. *Stikhotvoreniia*. Leningrad: Sovetskii pisatel', 1957.

Dixon, Simon. "Religious Ritual at the Eighteenth-Century Russian Court." In *Monarchy and Religion: The Transformation of Royal Culture in Eighteenth-Century Europe*, edited by Michael Schaich, 217–48. New York: Oxford University Press, 2007.

___. *Catherine the Great*. New York: Ecco, 2009.

Djurić, V. J. "Le 'Nouveau Josue'." *Zograf* 14 (1983): 5–15.

Dmitriev, Iu. N. "Stenopis' Arkhangel'skogo sobora Moskovskogo Kremlia." In *Drevnerusskoe iskusstvo. XVII vek*, 138–59. Moscow: Nauka, 1964.

Dolgova, S., N. Bolotina, and A. Konova. "...Kak vremia katitsia v Kazani zolotoe..." *Nashe nasledie* 74 (2005): www.nasledie-rus.ru/podshivka/7402.php (last visited July 20, 2013).

Draper, James David. *Cameo Appearances*. New York: Metropolitan Museum of Art, 2008.

Du Cange, C. *Traité historique du chef de S. Iean Baptiste: contenant une discussion exacte de ce que les auteurs anciens & modernes en ont écrit, & particulierement de ses trois inventions*. Paris: Paris Cramoisy, 1665.

Duffy, Stephen, and Christoph Martin Vogtherr. *Miniatures in The Wallace Collection*. London: Paul Holberton, 2010.

Ekaterina II i ee okruzhenie. Edited by A.I. Iukht. Moscow: Pressa, 1996.

Emerson, S. B., and R. F. Inger. "The Comparative Ecology of Voiced and Voiceless Bornean Frogs." *Journal of Herpetology* 4 (1992): 482–90.

Ennès, P. "Un vase avec des cygnes et deux vases 'à jet d'eau'." *La Revue du Louvre et des Musées de France*, 3 (June 1987): 201–6.

———. "Étienne-Maurice Falconet, créateur de modèles de vases?" In *Falconet à Sèvres 1757–1766 ou l'art de plaire*, 185–87. Sèvres: Musée national de Céramique, 2001.

Esbroeck, M. van. "The Virgin as the True Ark of the Covenant. In *Images of the Mother of God: Perceptions of the Theotokos in Byzantium*, edited by M. Vassilaki, 63–68. Aldershot, Hants, England: Ashgate, 2005.

Evangelatou, M. "The Symbolism of the Censer in Byzantine Representations of the Dormition of the Virgin." In *Images of the Mother of God: Perceptions of the Theotokos in Byzantium*, edited by M. Vassilaki, 117–32. Aldershot, Hants, England: Ashgate, 2005.

Evans, Joan. *Magical Jewels of the Middle Ages and the Renaissance, Particularly in England*. Oxford: Clarendon Press, 1922.

Evgeniia, Igumeniia [Abbess]. *Istoricheskoe opisanie pervoklassnago Voznesenskogo devich'ego monastyria v Moskve, s planami I risunkami*. Moscow: V. A. Gattsuk, 1894.

Evsina, Natal'a Aleksandrovna. *Russkaia arkjhitektura v epokhu Ekateriny II: klassitsizm, neogotika*. Moscow: Nauka, 1994.

Exhibition of Russian Art. London: Oliver Burridge, 1935.

Fainshtein, M. [sp. Fajnstejn] "Ekaterina II i razvitie iazykoznaniia v Rossii" In *Katharina II. Eine russische Schriftstellerin*, edited by M. Fajnstejn and F. Göpfert, 27–36. Wilhelmshorst: F. K. Göpfert, 1996.

Fedotova, M. A. "Istochniki Zhiitiia Dimitriia Rostovskogo." In *Russkaia agiografiia: Issledovaniia, materialy, publikatsii*. Vol. 2, 180–222. Saint Petersburg: Pushkinskii dom, 2011.

Fichtner, P. S. *The Habsburg Monarchy, 1490–1848: Attributes of Empire*. New York: Palgrave Macmillan, 2003.

Filimon, A. N. "Briusov kalendar'." *Zemlia i vselennaia/Earth and Universe* 1 (1993): 45–53.

———. *Iakov Brius*. Saint Petersburg: Chistye vody, 2003.

The First Russian Emblem Book. Edited and translated by Anthony Hippisley. Leiden, The Netherlands: E. J. Brill, 1989.

Fisher, A. W. *The Russian Annexation of the Crimea, 1772–1783*. Cambridge: Cambridge University Press, 1970.

Florida International Museum. *Treasures of the Czars from the State Museums of the Moscow Kremlin*. London: Boothe-Clibborn Editions, 1995.

Fossing, Poul. *The Thorvaldsen Museum. Catalogue of the Antique Engraved Gems and Cameos*. London: Oxford University Press, 1929.

Freedberg, David. *The Eye of the Lynx: Galileo, His Friends, and the Beginnings of Modern Natural History*. Chicago: University of Chicago Press, 2002.

Furnishing the Eighteenth Century: What Furniture Can Tell Us About the European and American Past. Edited by D. Goodman and K. Norberg. New York: Routlege, 2007.

Furtwängler, Adolf. *Die Antiken Gemmen. Geschichte der Steinschneiderkunst im klassischen Altertum*. Amsterdam: Zeller, 1965.

Gabelić, S. *Cycles of the Archangels in Byzantine Art*. Belgrade: Serbian Academy of Arts and Sciences, 1991.

Galashevich, A. A. "M. F. Kazakov v Tveri." In *Matvei Fedorovich Kazakov i arkhitektura klassitsizma*, 7–12. Moscow: NIITAG, 1996.

Galeries nationales du Grand Palais. *La France et la Russie au Siècle des Lumières: relations culturelles et artistiques de la France et de la Russie au XVIIIe siècle*. Paris: Association Francaise d'Action Artistique, 1986.

Gellius, Aulus. *The Attic Nights*. Edited by J. C. Rolfe. Cambridge, MA: Harvard University Press, 1948.

Gerasimova, J. *The Iconostasis of Peter the Great in the Peter and Paul Cathedral in St. Petersburg (1722–1727)*. Leiden: Alexandros Press, 2004.

Gilles, Pierre. *The Antiquities of Constantinople*. Translated by John Ball. New York: Italica Press, 1987.

The Genius of Wedgwood. Edited by Hilary Young. London: Victoria and Albert Museum, 1995.

Girouard, Mark. *Life in the English Country House: A Social and Architectural History*. New Haven, CT: Yale University Press, 1978.

Gossman, Lionel. *Medievalism and the Ideologies of the Enlightenment; the world and work of La Curne de Sainte-Palaye*. Baltimore: Johns Hopkins Press, 1968.

The Green Frog Service. Edited by Michael Raeburn, Ludmila Voronikhina, and Andrew Nurnberg. London: Cacklegoose Press, 1995.

Hayden, P. "British Seats on Imperial Russian Tables." *Garden History* 1 (1985): 17–32.

Hays, D. L. "Landscapes Within Buildings." *Harvard Design Magazine* 29 (2008–9): 114–21.

Head, B. V. *Historia Numorum; a manual of Greek numismatics*. Chicago: Argonaut, 1967.

Heckscher, W. S. "Relics of Pagan Antiquity in Medieval Settings." *Journal of the Warburg Institute* 1 (1937–38): 204–20.

Hellman, M. "The Joy of Sets: The Uses of Seriality in the French Interior." In *Furnishing the Eighteenth Century: What Furniture Can Tell Us About the European and American Past*, edited by D. Goodman and K. Norberg, 129–53. New York: Routlege, 2007.

Hellman, M. "Enchanted Night: Decoration, Sociability, and Visuality after Dark." In Paris: *Life & Luxury in the Eighteenth Century*, edited by C. Bremer-David, 91–113. Los Angeles: J. Paul Getty Museum, 2011.

Henig, M. *The Content Family Collection of Ancient Cameos*. Oxford: D. J. Content, 1990.

Herrin, Judith. *Women in Purple: Rulers of Medieval Byzantium*. Princeton, NJ: Princeton University Press, 2001.

Hickey, D., S. Tallman, and B. Bloom. *The Collections of Barbara Bloom*. New York: Steidl, 2008.

Hine, D. *The Homeric Hymns and the Battle of the Frogs and the Mice*. New York: Atheneum, 1972.

Homeric Hymns, Homeric Apocrypha, Lives of Homer. Edited by M. L. West. Loeb Classical Library. Cambridge, MA: Harvard University Press, 2003.

Hunt, John Dixon. *Gardens and the Picturesque: Studies in the History of Landscape Architecture*. Cambridge, MA: MIT Press, 1992.

___. *The Picturesque Garden in Europe*. New York: Thames and Hudson, 2002.

Hunter-Stiebel, P., ed. *Stroganoff: The Palace and Collections of a Russian Noble Family*. New York: Harry N. Abrams, Inc., 2000.

Hussey, C. "Longford Castle. The Seat of the Earl of Randor." *Country Life*, December 12, 1931, 648–55.

Hyde, M., and J. Milam. "Introductions: Art, Cultural Politics and the Woman Question. In *Women, Art and Politics of Identity in Eighteenth-Century Europe*, edited by M. Hyde and J. Milam, 1–19. Burlington, VT: Ashgate, 2003.

Iakovleva, A. I. "Kramovyi obraz 'Arkhangel Milhail' s deianiami angelov." In *Arkhangel'skii sobor Moskovskogo Kremlia. Gosudartvennyi istoriko-kul'turnyi muzei-zapovednik "Moskovskii Kreml'"*, 259–84. Edited by N. A. Maiakova. Moscow: Krasnaia prloshchad', 2002.

Ianin, V. L. "Eshche raz ob atributsii shlema Iaroslava Vsevolodovicha." In *Drevnerusskoe iskusstvo. In Khudozhestvennaia kul'tura domongol'skoi Rusi*, 235–44. Moscow: Nauka, 1972.

Imhoof-Blumer, F. W., and P. Gardner. *Ancient Coins Illustrating Lost Masterpieces of Greek Art*. Chicago: Argonaut, 1964.

Íñiguez, D. A. *Murillo*. Vol. 3, *Láminas*. Madrid: Espasa-Calpe. S.A., 1981.

Isager, Jacob. *Pliny on Art and Society: The Elder Pliny's Chapters on the History of Art*. London: Routledge, 1991.

Ivanova, Elena. *Porcelain in Russia, 18th–19th Centuries: The Gardner Factory. In Celebration of the Tercentenary of Saint Petersburg*. Saint Petersburg: Palace Editions, 2003.

Jacobsthal, P. *Greek Pins and Their Connexions [sic] with Europe and Asia*. Oxford: Clarendon Press, 1956.

Janin, R. "Les églises Byzantines du Précurseur a Constantinople." *Echos d'Orient* 37 (1938): 312–51.

Jay, Martin. "In the Realm of the Senses: An Introduction." *American Historical Review* 116, no. 2 (2011): 307–15.

Jenner, Mark S. R. "Follow Your Nose? Smell, Smelling, and Their Histories." *American Historical Review* 116, no. 2 (2011): 335–51.

Jenkins, G. Kenneth. *Ancient Greek Coins*. New York: Putnum, 1972.

Joie de vivre in French Literature and Culture: Essays in Honour of Michael Freeman. Edited by Susan Harrow and Timothy Unwin. Amsterdam: Rodopi, 2009.

Jones, Richard Foster. "Ancients and Moderns: A Study of the Background of the Battle of the Books." *Washington University Studies—New Series—Language and Literature*, no. 6 (1936): 1–287.

Kahn, A. "Marinus A. Wes, 'Classics in Russia 1700–1855' (book review)." *Slavic and East European Journal* 37 (1993): 571–73.

Kalavrezou, I. "Helping Hands for the Empire: Imperial Ceremonies and the Cult of Relics at the Byzantine Court." In *Byzantine Court Culture from 829 to 1204*, edited by H. Maguire, 53–79. Washington, DC: Dumbarton Oaks Research Library and Collection, 1994.

Kamen, Henry. *The Escorial: Art and Power in the Renaissance*. New Haven, CT: Yale University Press, 2010.

Kamer-fur'evskie zhurnaly: 1695–1818, Vols. 1–100. Saint Petersburg, 1855–1917. Facsimile edition. Saint Petersburg: Al'faret, 2009.

Kaufmann, T. D. *Court, Cloister, and City: The Art and Culture of Central Europe 1450–1800*. Chicago: University of Chicago Press, 1995.

Kerber, P. B. "Perfectibility and Its Foreign Causes: Reading for Self-Improvement in Eighteenth-Century Paris." In *Paris: Life & Luxury in the Eighteenth Century*, edited by C. Bremer-David, 75–89. Los Angeles: J. Paul Getty Museum, 2011.

Kettering, Karen L. "The Northern Palmyra: Saint Petersburg at Three Hundred." *Antiques* 163 (March 2003): 98–99.

Khachaturov, Sergei Valer'evich. *"Goticheskii vkus" v russkoi khudozhestvennoi kul'ture XVIII veka*. Moscow: Progress–Traditsiia, 1999.

Khmetevskii, Stepan P. "Zhurnal Stepana Petrova syna Khmetevskogo o voennykh deistviiakh russkogo flota v Apkhipelage i u beregov Maloi Azii v 1770-1774 godakh." *Literaturnyi zhurnal Sovremennik* 49 (1855): 37–82 and 111–170.

King, C. W. *Handbook of Engraved Gems*. London: G. Bell, 1885.

Kirin, A. "Contemplating the Vistas of Piety at the Rila Monastery Tower." *Dumbarton Oaks Papers* 59 (2005): 95–138.

___. "Eastern European Nations, Western Culture, and the Classical Tradition." In *Classics and National Cultures*, edited by Susan A. Stephens and Phiroze Vasunia, 141–62. Oxford: Oxford University Press, 2010.

___. "The Edifices of the New Justinian: Catherine the Great Reclaiming Byzantium." In *Approaches to Byzantine Architecture and Its Decoration: Studies in Honor of Slobodan Curcic*, edited by Mark J. Johnson, Robert Ousterhout, and Amy Papalexandrou, 277–98. Farnham, Surrey, England: Ashgate, 2012.

Kitromilides, Paschalis M. "On the Intellectual Content of Greek Nationalism: Paparrigopoulos, Byzantium and the Great Idea." In *Byzantium and the Modern Greek Identity*, edited by David Ricks and Paul Magalino, 25–33. Aldershot, Hampshire: Ashgate Publishing, 1998.

Kliuchevskii, V. O. *Istoricheskie portrety*. Moscow: Pravda, 1991.

Komelova, G. N., and G. A. Printseva. *Portrait Miniatures in Russia, XVIII–Early XX Century from the Collection of the Hermitage*. Leningrad: Khudozhnik RSFSR, 1986.

___. *Russian Enamel Miniatures of 18th and 19th Century*. Saint Petersburg: Iskusstvo-SPB, 1995.

Kondakov, Nikodin Pavlovich. *Ikonografia bogomateri*. Vol. 2. Saint Petersburg: Tipografiia imperatorski akademii nauk, 1915.

Korshunova, Militsa Filippovna. *Iurii Fel'ten*. Leningrad: Lenizdat, 1988.

Kostiuk, Ol'ga Gregor'evna. "Zhan-P'er Ador i ego raboty v Ermitazhe." In *Zapadnoevropeiskoe iskusstvo XVIII veka: publikatsii I issledovaniia*. Leningrad: Iskusstvo, 1987.

___. *Peterburgskie iuveliry XVIII–XIX vekov*. Saint Petersburg: Slaviia, 2000.

___. *Shedevry evropeiskogo iuvelirnogo iskusstva XVI–XIX vekov iz sobraniia Ermitazha*. Saint Petersburg: Izdatel'stvo Gosudarstennogo Ermitazha, 2010.

Kovalev-Sluchevskii, K. *Bortnianskii* [Dmitrii Stepanovich Bortniainskii]. Moscow: Molodaia gvardiia, 1989.

Kraay, Colin M. *Greek Coins*. New York: H. N. Abrams, 1966.

Krauel. R. "Prince Henry of Prussia and the Regency of the United States, 1786." *American Journal of History* 1 (October 1911): 44–51.

Kudriavtsev, A. I., and G. M. Shkoda. *Aleksandro-Nevskaia lavra*. Leningrad: Khudozhnik RSFSR, 1986.

Kudriavtseva, T. V. *Orlovskii serviz Imperatorskogo farforovogo zavoda v Peterburge. Soobshcheniia Gosudarstevnnogo Ermitazha* 49. Leningrad: State Hermitage, 1984.

___. *Russkii imperatorskii farfor*. Saint Petersburg: Slaviia, 2003.

Kuttner, A. "Looking Outside Inside: Ancient Roman Garden Rooms." *Studies in the History of Gardens & Designed Landscapes* 1 (1999): 7–35.

Lavin, Irving. "The House of the Lord. Aspects of the Role of Palace Triclinia in the Architecture of Late Antiquity and Early Middle Ages." *Art Bulletin* (March 1962): 1–27.

Le Camus, A. *Abdeker Or, the Art of Preserving Beauty*. (reprint of the 1754 ed., printed for A. Millar, London) New York: Garland Publishing, 1974.

Le destin d'une collection: 500 pierres gravées du cabinet du Duc d'Orléans. Edited by Iulia O. Kagan and Oleg Neverov. Saint Petersburg: State Hermitage, 2001.

Le Labyrinthe de Versailles: Parcours critiques de la Molière à La Fontaine. Edited by Martine Debaisieux. Amsterdam: Rodopi, 1998.

Lajoye, Patrice. "Panagia Tricherousa: A Celtic Myth Among the Slavic Popular Beliefs?" *Studia Mythologica Slavica* 13 (2010): 249–54.

Lazarev, Viktor N. *The Russian Icon: From Its Origins to the Sixteenth Century*. Edited by G. I. Vzdornov, translated by Colette Joly Dees. Collegeville, MN: Liturgical Press, 1997.

Levitt, Marcus C. *The Visual Dominant In Eighteenth-Century Russia*. DeKalb: Northern Illinois University Press, 2011.

Levshin, A. A. *Istoricheskoe opisanie pervonachal'nogo v Rossii khrama Moskovskogo bol'shogo sobora*. Moscow: Meyer, 1783.

Lichtenstein, J. *The Blind Spot: An Essay on the Relations between Painting and Sculpture in the Modern Age*. Translated by Ch. Miller. Los Angeles: Getty Research Institute, 2008.

Lomonosov, Mikhail Vasilievich. *Poems* [http://rvb.ru/18vek/ lomonosov/01text/01text/010dy_t/019.htm].

Lopatin, V. S., ed. *Ekaterina II i G. A. Potemkin. Lichnaia perepiska 1769–1791*. Moscow: Nauka 1997.

Lopato, Marina N. *Iuveliry starogo Peterburga*. Saint Petersburg: Russkii Iuvelir, 2006.

Lotman, Iuri M., and B. A. Uspenskii. *The Semiotics of Russian Culture*. Ann Arbor: Dept. of Slavic Languages and Literatures, University of Michigan, 1984.

Lotman, Iuri M. *Universe of the Mind: A Semiotic Theory of Culture*. Translated by Ann Shukman. Bloomington: Indiana University Press, 1990.

___. *Ocherki po istorii russkoi kul'tury XVIII–nachala XIX veka*. [Series Iz istorii russkoi kul'tury, tom IV) Moscow: Shkola iazuki russkoi kil'tury, 1996.

___. *Culture and Explosion*. Edited by Marina Grishakova. Translated by Wilma Clark. Berlin: Mouton de Gruyter, 2009.

Lucian. *Dialogues. Razgovory Lukiana Samosatskogo*. Translated into Russian by I. Sidorovskii and M. Pakhomov. Vols. 1–3. Saint Petersburg: 1775–84.

Madariaga, Isabel de. *Catherine the Great: A Short History*. New Haven, CT: Yale University Press, 1990.

Madison, James. *The Papers of James Madison*. Edited by William T. Hutchinson et al. Chicago: University of Chicago Press, 1962–77 (vols. 1–10).

Magdalino, Paul. "The Byzantine Aristocratic Oikos." In *The Byzantine Aristocracy, IX to XIII Centuries*, 92–111. Edited by Michael Angold. Oxford: B.A.R., 1984.

Maguire, Henry. *The Icons of Their Bodies: Saints and Their Images in Byzantium*. Princeton, NJ: Princeton University Press, 1996.

Majeska, G. P. *Russian Travelers to Constantinople in the Fourteenth and Fifteenth Centuries*. Washington, DC: Dumbarton Oaks Research Library and Collection, 1984.

Major Problems in the History of Imperial Russia. Edited by James Cracraft. Lexington, MA: D. C. Heath and Company, 1994.

Makarenko, Nikolai. "Vystavka tserkovnoi stariny v muzee Barona Shti-glitsa." *Starye gody* (July–August 1915).

Maksimova, M. I. *Antichnye reznye kamni Ermitazha. Putevoditel' po vystavke. Gosudarstvennyi Ermitazh*. Paris: Centre Culturel du Pantheon, 1926.

Maksimovic-Ambodik, Nestor M. *Emblemy i simvoly (1788): The First Russian Emblem Book*. Edited by Anthony Hippisley. Leiden: E. J. Brill, 1989.

Mango, C. "Byzantium and Romantic Hellenism." *Journal of the Warburg and Courtauld Institutes* 28 (1965): 29–43.

Mango, C. "Discontinuity with the Classical Past in Byzantium." In *Byzantium and the Classical Tradition*, edited by M. Mullet and R. Scott, 48–102. Birmingham, UK: Centre for Byzantine Studies, University of Birmingham, 1981.

Marcellinus, Ammianus. *The Later Roman Empire: A.D. 354–378*. Edited by B. Radice. Middlesex, UK: Penguin Books, 1986.

Mariette, P. I. *Description sommaire des desseines des grand maistres d'Italie, des Pays-bas et de France, du cabinet de feu M. Crozat. Avec des Réflections sur la maniere de deffiner des principaux Peintres*. Paris: Pierre-Jean Mariette, 1741.
___. *Description sommaire des pierres gravées du cabinet de feu M. Crozat*. Paris: Pierre-Jean Mariette, 1741.

Markina, L. A. *Portretist Georg Khristof Groot [Georg Christoph Grooth] in nemetskie zhivipistsy v Rossii serediny XVIII veka*. Moscow: Pamiatniki istoricheskoi mysli, 1999.

Masal'skii, K. "Tainyi nakaz, dannyi pri tsare Aleksei Mikhailoviche pervomu russkomu posol'stvu v Ispaniiu, i zapiski russkikh poslannikov, vedennye imi v 1667 i 1668 godakh v Ispanii I vo Frantsii." *Syn otechestva* 6 (1891): www.vostlit.info/Texts/Dokumenty/Spain/XVII/1660-1680/Tajnyj_Nakaz/text8.htm, last visited, July 29, 2013.

Mashnina, V. *Arkhangel Mikhail: The Archangel Michael; icon "The Archangel Michael with scenes from his miracles" from the Archangel Michael Cathedral in the Moscow Kremlin*. Leningrad: Aurora, 1968.

Massie, Robert K. *Catherine the Great: Portrait of a Woman*. New York: Random House, 2011.

Massie, Suzanne. *Pavlovsk: The Life of a Russian Palace*. Boston: Little Brown, 1990.

Matthaei Ch. F. *Notitia codicum manuscriptorum Graecorum bibliothecarum Mosquensium Sanctissimae Synodi Ecclesiae Orthodoxae Graeco-Rossicae cum variis anecdotis, tabulis aenis et indicibus locupletissimis*. Moscow: University of Moscow, 1776.

———. *Index codicum manuscriptorum Graecorum bibliothecarum Mosquensium Sanctissimae Synodi Ecclesiae Orthodoxae Graeco-Rossicae*. Saint Petersburg: Academy of Sciences, 1780.

McConnel, A. "Catherine the Great and the Fine Arts." In *Imperial Russia 1700–1917, State, Society, Opposition. Essays in Honor of Marc Raeff*, edited by Mendelsohn and M. S. Shatz, 37–57. DeKalb: Northern Illinois University Press, 1988.

Memoirs of the Princess Daschkow, Lady of Honour to Catherine II, empress of all the Russians, written by herself, comprising letters of the empress and other correspondence. Edited by W. Bradford. Vols. 1–2. London: Henry Colburn, 1840.

Menaker, D. "Lorenzo Bartolini's Demidoff Table." *Metropolitan Museum Journal* 17 (1984): 75–86.

Michael C. Carlos Museum. *Highlights of the Collections*. Atlanta: Michael C. Carlos Museum, 2011.

Mikhail Lomonosov and the Time of Elizabeth I. Exhibition catalogue. Saint Petersburg: State Hermitage Publishers, 2011.

Moriakov, V. I. *Russkoe prosvetitel'stvo vtoroi poloviny XVIII veka. Iz istorii obshchestvenno-politicheskoi mysli Rossii*. Moscow: University of Moscow, 1994.

Moscow: Treasures and Traditions. Exhibition catalogue. Washington, DC: Smithsonian Institution Traveling Exhibition Service in association with University of Washington Press, 1990.

Mosley, James. "Médailles sur les principaux événements du règne de Louis le Grand, 1702: The Making of the Book." *Bulletin du bibliophile*, no. 2 (2008): 296–348.

———. "The 'Romain du Roi': A Type Made for the Royal Printing-House of Louis XIV." In *Printing for Kingdom, Empire, and Republic: Treasures from the Archives of the Imprimerie nationale*. New York: Grolier Club; Paris: Imprimerie nationale, Éditions de l'atelier du livre d'art et de l'estampe, 2011.

Musée des beaux-arts de Marseille. *Pierre Puget, peintre, sculpteur, architecte, 1620–1694*. Marseilles: Musées de Marseille, 1994.

Musée du Louvre. *Musées de papier : l'Antiquité en livres, 1600–1800*. Edited by Elisabeth Décultot. Paris: Louvre éditions, Gourcuff Gradenigo, 2010.

Nartov, Andrei Andreevich. *Rasskazy Nartova o Petre Velikom*. Edited by L. N. Maikov. Saint Petersburg: I. Glazunov, 1891.

Nashchokina, M.V. "Petrovskii dvorets v Moskve (k istorii sozdaniia)." In *Matvei Fedorovich Kazakov I arkhitektura klassitsizma*, 27–35. Moscow: NIITAG, 1996.

Neverov, Oleg. "Zlokliucheniia petrovskogo kubka." *Iskusstvo* 6 (1986): 53–54.

———. *Antichnye kamei v sobranii Ermitazha. Katalog*. Leningrad: Iskusstvo, 1988.

___. "Gems from the Collection of Princess Dashkov." *Journal of the History of Collections* 1 (1990): 63–88.

___. "Catherine the Great: Public and Private Collector." *British Art Journal* 1–3 (2000): 121–26.

Oblensky, Dimitri. *Byzantium and the Slavs: Collected Studies*. London: Variorum Reprints, 1971.

Odom, Anne. *Russian Enamels: Kievan Rus to Fabergé*. Baltimore: Walters Art Gallery; Washington, DC: Hillwood Museum; London, Philip Wilson Publishers, 1996.

___, and Liana Paredes. *A Taste for Splendor: Russian Imperial and European Treasures from the Hillwood Museum*. Alexandria, VA: Art Services International, 1998.

___. *Russian Imperial Porcelain at Hillwood*. Washington, DC: Hillwood Museum and Gardens, 1999.

___. *Hillwood: Thirty Years of Collecting, 1977–2007*. Washington, DC: Hillwood Museum and Gardens, 2007.

___, and Wendy R. Salmond. *Treasures into Tractors: The Selling of Russia's Cultural Heritage, 1918–1938*. Washington, DC: Hillwood Estate, Museum and Gardens, 2009.

___. *Russian Silver in America: Surviving the Melting Pot*. Washington, DC: Hillwood Museum and Gardens, 2011.

Olausson, Magnus. *Den Engleska parken i Sverige under gustaviansk tid [The English Landscape Garden in Sweden During the Gustavian Era]*. Stockholm: Piper Press, 1993.

Oleson, John P. *Greek numismatic art: Coins of the Arthur Stone Dewing Collection*. Cambridge, MA: Fogg Art Museum, Harvard University, 1975.

O'Malley, Lurana Donnels. *The Dramatic Works of Catherine the Great: Theatre and Politics in Eighteenth-Century Russia*. Burlington: Ashgate Publishing Company, 2006.

Orloff, Alexandre, and D. Chvidkovski [Shvidkovsky]. *Saint-Pétersbourg: l'architecture des tsars*. Paris: Éditions de Mengès, 1995.

Oxford Dictionary of Byzantium. Edited by Alexander P. Kazhdan et al. Vols. 1–3. Oxford: Oxford University Press, 1991.

Paredes, Liana. *Sèvres Porcelain at Hillwood*. Washington, DC: Hillwood Museum and Gardens, 1998.

Pavlova, Zhermena. *Imperatorskaia biblioteka Ermitazha, 1762–1917*. Saint Petersburg: Izadatel'stvo Gosudarstevnogo Ermitazha, 1988.

Peltomaa, L. M. *The Image of the Virgin Mary in the Akathistos Hymn*. Leiden: Brill, 2001.

Pérouse de Montclos, Jean-Marie. *Versailles*. New York: Artabras, 1991.

Picchio, Riccardo. "Predislovie o pol'ze kning tserkovnykh M. V. Lomonosova kak manifest russkogo konfesional'nogo patriotizma." In *Sbornik statei k 70-letiiu prof. Iu. M. Lotmana*, 142–52. Tartu: Tartuskii universitet, 1992.

Piotrovski, M. B. *Treasures of Catherine the Great*. London: Thames and Hudson; New York: Abrams, 2000.

Pis'ma Imperatritsy Ekateriny II k Grimmu (1774–1796). Ia. Grot, ed. *Sbornik Imperatorskogo Russkogo Istoricheskogo Obshchestva* 23 (1878). [http://archive.org/stream/sbornik59obshg00g#page/n1/mode/2up]

Pitiurko, Iu. M. "Imperatritsa—palomnitsa: Ekaterina II v Aleksandro-Nevskom monastyre." In *Vek Ekateriny II: Rossiia i Balkany*, edited by I. I. Leshchinlovskaia, 372–83. Moscow: Nauka, 1998.

Plato. *Collected Dialogues Including the Letters*. Edited by Edith Hamilton and H. H. Cairns. New York: Pantheon Books, 1961.

Pliny, the Elder. *Natural History*. Edited by H. Rackham. Cambridge, MA: Harvard University Press, 1938–67.

Polnoe sobranie russkikh letopisei. Tom I: Lavren'evskaia letopis' I Suzdal'skaia letopis' po akademicheskomu spisku. Moscow: Izdatel'stvo vostochnoi literatury, 1962.

Postnikova-Loseva, M. M., N. G. Platonova, and B. L. Ul'ianova. *Zolotoe i serebrianoe delo XV–XX vekov.* Moscow: Nauka 1983, nos. 1157 and 1158.

Povest' vremennykh let. Biblioteka rossiiskaia istoricheskaia: Soderzhashchaia drevniia letopisi i vsiakiia zapiski, sposobstbuiushchiia k obuiasneniia istorii i geografii rossiiskoi drevnikh i srednikh vremen. Saint Petersburg: Imperatorskaia Akademiia nauk, 1767.

Praz, Mario. *On Neoclassicism.* Translated by Angus Davidson. Evanston, IL: Northwestern University Press, 1969.

___. *Gusto Neoclassico.* Milano: Rizzoli, 1974.

Prince, Sue Ann, ed. *The Princess and the Patriot: Ekaterina Dashkova, Benjamin Franklin, and the Age of Enlightenment.* Transactions of the American Philosophical Society, vol. 96. Philadelphia, PA: American Philosophical Society, 2006.

Procopius, Caesarea. *Procopius.* Translated by H. B. Dewing. Cambridge, MA: Harvard University Press, 1961.

Proskurina, Vera. *Creating the Empress: Politics and Poetry in the Age of Catherine II.* Boston: Academic Studies Press, 2011.

Quarenghi, Giacomo. *Disegni di Giacomo Quarenghi.* Venezia: Pozza, 1967.

Radishchev, A. N. *A Journey from St. Petersburg to Moscow.* Cambridge, MA: Harvard University Press, 1958.

Ragsdale, Hugh. "Evaluating the Traditions of Russian Aggression: Catherine II and the Greek Project," *Slavonic and East European Review* 66 (1988): 91–117.

Randall, M. "On the Evolution of Toads in the French Renaissance." *Renaissance Quarterly* 1 (2004): 126–64.

Ransel, David L. *The Politics of Catherinian Russia: The Panin Party.* New Haven, CT: Yale University Press, 1975.

Rapin of Gardens: A Latin Poem in Four Books: English'ed by Mr. Gadiner [Rene Rapin, James Gardiner]. London: Bernard Lintot, 1728.

Rasmussen, Karen. "Catherine II and the Image of Peter I." *Slavic Review* 37, no. 1 (1978): 51–69.

Reading Landscape: Country, City, Capital. Edited by Simon Pugh. Manchester: Manchester University Press, 1990.

The Rebirth of Antiquity: Numismatics, Archaeology, and Classical Studies in the Culture of the Renaissance. Edited by Alan M. Stahl. Princeton: Princeton University Library, 2009.

Reflections on Russia in the Eighteenth Century. Edited by Joachim Klein, Simon Dixon, and Maarten Fraanje. Cologne: Bohlau Verlag Koln, 2001.

"Reverence for Red: Russian Arts of a Crimson Hue." In *Fifty-fourth Washington Antiques Show: Art and Antiques in Red, January 8–January 11, 2009, the Katzen Arts Center at American University.* Washington, DC: Washington Antiques Show, 2009.

Rice, Tamara Talbot. *A Concise History of Russian Art.* New York: Prager, 1963.

Rich, J. W. *Cassius Dio: The Augustan Settlement.* Edited by Dion Cassius. Warminster, England: Aris & Phillips, 1990.

Richter, Gisela Marie Augusta, and Metropolitan Museum of Art. *Animals in Greek Sculpture.* New York: Oxford University Press, 1930.

Robinson, Sidney K. *Inquiry into the Picturesque.* Chicago: University of Chicago Press, 1991.

Rogger, Hans. *National Consciousness in Eighteenth-Century Russia.* Cambridge, MA: Harvard University Press, 1960.

Rohland, Johannes Peter. *Der Erzengel Michael: Artz und Feldherr.* Leiden: E. J. Brill, 1977.

Roosevelt, P. R. *Life on the Russian Country Estate: A Social and Cultural History*. New Haven, CT: Yale University Press, 1995.

Rosasco, B. "Masquerade and Enigma at the Court of Lous XIV." *Art Journal* 2 (1989): 144–49.

Ross, Marvin C. "Golden Vase by I. Ador." *Gazette des Beaux-Arts* 22, no. 909 (1942): 122–24.

___. *The Art of Karl Fabergé and His Contemporaries*. Norman: University of Oklahoma, 1965.

___. *Russian Porcelains*. Norman: University of Oklahoma, 1968.

Rounding, Virginia. *Catherine the Great: Love, Sex, and Power*. New York: St. Martin's Press, 2006.

Ruby, Scott. "The Power of Porcelain: The Gardner Order Services for the Empress of Russia." *Ars Ceramica* 8–9, no. 23 (2007).

Rudoe, J. "The Faking of Gems in the Eighteenth Century." In *Why Fakes Matter: Essays on Problems of Authenticity*, edited by M. Jones. London: British Museum Press 1992, 23–27.

Runciman, Steven. "The Country and Suburban Palaces of the Emperor." In *Charanis Studies: Essays in Honor of Peter Charanis*, edited by A. E. Laiou-Thomadakis, 219–26. New Brunswick, NJ: Rutgers University Press, 1980.

Russian Silver of the Centuries (16th–Early 20th). Saint Petersburg: State Hermitage Museum, 2004.

Sabatier, Gerard. "Religious Rituals and the Kings of France in the Eighteenth Century." In *Monarchy and Religion: The Transformation of Royal Culture in Eighteenth-Century Europe*, edited by Michael Schaich, 249–81. New York: Oxford University Press, 2007.

Salmond, Wendy R. *Russian Icons at Hillwood*. Washington, DC: Hillwood Museum and Gardens, 1998.

___. "Russian Icons at Hillwood." *Magazine Antiques* 163 (March 2003).

___. *Tradition in Transition: Russian Icons in the Age of the Romanovs*. Washington DC: Hillwood Museum and Gardens, 2004.

Sassoon, A. "Two Acquisitions of Sèvres Porcelain by the Getty Museum, 1981." *The J. Paul Getty Museum Journal* 10 (1982): 87–94.

___. *Vincennes and Sèvres Porcelain. Catalogue of the Collections. The J. Paul Getty Museum*. Malibu, CA: J. Paul Getty Museum, 1991.

Savill, R. "'Cameo Fever': Six Pieces from the Sèvres Porcelain Dinner Service made for Catherine of Russia." *Apollo* 11 (1982): 304–11.

Scarisbrick, Diana. *Portrait Jewels: Opulence and Intimacy from the Medici to the Romanovs*. New York: Thames & Hudson, 2011.

Schenker, Alexander M. *The Bronze Horesman: Falconet's Monument to Peter the Great*. New Haven, CT: Yale University Press, 2003.

Schepkowski, N. S. *Johann Ernst Gotzkowsky: Kunstagent und Gemäldesammler im friderizianischen Berlin*. Berlin: Akademie Verlag, 2009.

Schnapper, A. "The King of France as Collector in the Seventeenth Century." In *Art and History: Images and their Meanings*, edited by R. Rotberg and Th. K. Rabb, 185–202. Cambridge: Cambridge University Press, 1988.

Schönle, Andreas. "Garden of the Empire: Catherine's Appropriation of the Crimea," *Slavic Review* 60 (2001): 1–23.

___. "Pronstranstvennaia poetika Tsarskogo Sela v Ekaterininskoi prezentatsii imperii." *Tynianovskii sbornik* 11 (2002): 51–63.

Schultze, J. *St. Petersburg um 1800. Ein goldenes Zeitalter des russischen Zarenreichs. Meisterwerke und authentische Zeugnisse der Zeit aus der Staatlichen Ermitage, Leningrad*. Recklinghausen: Bongers, 1990.

Sebag Montefiore, S. *The Prince of Princes: The Life of Potemkin*. New York: Thomas Dunne Books/St. Martin's Press, 2001.

Seltman, C. *Greek Coins: A History of Metallic Currency and Coinage down to the Fall of the Hellenic Kingdoms*. London: Methuen, 1955.

Shchukina, E. S. *Dva veka russkoi medali*. Moscow: Terra, 2000.

Sheedy, K. A. *The Archaic and Early Classical Coinages of the Cyclades*. London: Royal Numismatic Society, 2006.

Shinkarenko, P. V. *Vozrozhdennyi Feniks: ocherki deiatel'nosti Vol'nogo Ekonomocheskogo Obshchestva 1765–2005*. Moscow: Ibis, 2005.

Shliapkin, I. A. *Dimitrii Rostovskii i ego vremia (1651–1709)*. Saint Petersburg: A. Transhel', 1891.

Shvidkovsky, D. "Arkhitektura Anglii i Rossii v epokhu klassitsizma. Vzaimosviazi i paraleli." In *Matvei Fedorovich Kazakov i arkhitektura klasitsizma*, edited by N. F. Gulianitskii, M. B. Mikhailova, and I. A. Bondarenko, 82–87. Moscow: NII teorii arkhitektury I gradoustraistva, 1996.

___. *The Empress & The Architect: British Architecture and Gardens at the Court of Catherine the Great*. New Haven, CT: Yale University Press, 1996.

___. *Russian Architecture and the West*. New Haven, CT: Yale University Press, 2007.

Sir Philip Sidney, *The Countess of Pembroke's Arcadia: The New Arcadia*. Edited by Victor Skretkowitz. Oxford: Clarendon Press, 1987.

The Smell Culture Reader. Edited by Jim Drobnick. Oxford: Berg, 2006.

Smith, Charles Saumarez. *Eighteenth-Century Decoration: Design and the Domestic Interior in England*. New York: Harry N. Abrams, Inc., 1993.

Snegirev, Vladimir Leont'evich. *Aristotel' Foravanti i perestroika Moskovskogo Kremlia*. Moscow: Izdatel'stvo Vserussiiskoi Akademii arkhitektury, 1935.

Solov'ev, S. M. *Istoriia Rossii s drevnykh vremen* [www.kulichki.com/inkwell/text/special/history/soloviev/solv28p1.htm]

Sorabji, R. "Aristotle on Demarcating the Five Senses." *Philosophical Review* 1 (1971): 55–79.

Spaeth, Barbette Stanley. *The Roman Goddess Ceres*. Austin: University of Texas Press, 1996.

Spasskii, I. G., and E. S. Shchukina. *Medals and Coins of the Age of Peter the Great*. Leningrad: Aurora Art Publishers, 1974.

Speller, Elizabeth. *Following Hadrian: A Second-Century Journey Through the Roman Empire*. New York: Oxford University Press, 2003.

Spier, J. "Byzantine Magical Amulets and Their Tradition." *Journal of the Warburg and Courtauld Institutes* 56 (1993): 25–62.

___. *Late Antique and Early Christian Gems*. Wiesbaden: Reichert, 2007.

State Tretiakov Gallery. *Zhivopis' Domongol'skoi Rusi*. Moscow: Sovetskii Khudozhnik, 1974.

Stepennaia kniga. Kniga Stepennaia Tsarskogo rodosloviia, soderzhashchaia Istoriia rossiiskuiu s nachala onyia do vremen gosudaria tsaria i velikago kniazia Ioanna Vasil'evicha, sochinennaia trudami preosviashchennykh mitropolitov Kipriana i Makariia. Edited by Nikolai Novikov. Vols. 1–2. Saint Petersburg: G. F. Miller, 1775.

Stephenson, Paul. *Constantine: Roman Emperor, Christian Victor*. New York: Overlook Press, 2010.

Sterligova, I. "Vizantiiskie sviatini i gragotsennosti moskovskikh gosudarei." *Nashe nasledie*, 93–94 (2010): www.nasledie-rus.ru/podshivka/9401.php (last visited July 22, 2013).

Stuart, Nancy Rubin. *American Empress: The Life and Times of Marjorie Merriweather Post*. New York: Villard, 1995.

Summerson, John. *The Architecture of the Eighteenth Century*. New York: Thames and Hudson, 1986.

Svoronos, J. H. "Batrachos seriphios." *Journal international d'archeologie numismatique* 1 (1898): 205–11.

Tarle, Evgenii V. *Sochineniia v dvenadtsati tomakh*. Vol. 10. Moscow: Izd-vo Akademii nauk SSSR, 1959.

Tatishchev, Vasilli Nikitich. *Istoriia rossiiskaia*. Vols. 1–7. Moscow: Izdatel'stvo Akademii nauk, 1962.

Taylor, Katrina V. H. *Russian Art at Hillwood*. Washington, DC: Hillwood Museum, 1988.

Terekhova, A. M. "Novye dannye o proizvedeniiakh peterburgskogo serebrianika Ivara Bukha [Iver Windfeldt Buch]." In *Gosudarstvennye Muzei Moskovskogo Kremlia. Materialy i issledovaniia*, 127–31. Moscow: Sovetskii khudozhnik, 1976.

Teteriatnikov, N. "The Role of the Devotional Image in the Religious Life of Pre-Mongol Rus." In *Christianity and the Arts in Russia*, edited by W. C. Brumfield and M. M. Velimirovic, 30–40. Cambridge: Cambridge University Press, 1988.

Tillander, Ulla. *The Russian Imperial Award System During the Reign of Nicholas II, 1894–1917*. Helsinki: Suomen Muinaismuistoyhdistys, 2005.

Tiurina, G. A. "Khristian Fridrikh Mattei [Christian Frederick Matthaei] I grecheskaia filologiia v Rossii vo vtoroi pol. XVII–nach. XIX veka. *Filologiia* 3:2 (2006): 157–68.

Tolstaia, Tatiana Vladimirovna. *Uspenskii sobor Moskovskogo Kremlia: k 500-letiiu unikal'nogo pamiatnika russkoi kul'tury*. Moscow: Iskusstvo, 1979.

Toynbee, J. M. C. *Animals in Roman Life and Art*. Ithaca, NY: Cornell University Press, 1973.

Treasures of Imperial Russia from the State Hermitage Museum, St. Petersburg: Catherine the Great. Exhibition catalogue. Edited by G. N. Komelova. Saint Petersburg: State Hermitage Museum, 1990.

Troyat, Henri. *Catherine the Great*. New York: Dutton, 1980.

___. *Alexander of Russia: Napoleon's Conqueror*. New York: E. P. Dutton, Inc., 1982.

Uspenskii, A. I. *Imperatorskie dvortsy*. Moscow: Pechatnya A.I. Snegirevoi, 1913.

Uspenskii, B. A. *Semiotika istorii, semiotika kul'tury* [*Izbrannye trudy*, tom I] Moscow: Shkola Iazuki russkoi kil'tury, 1996.

Veltman, A. "The Sisyphean torture of housework: Simone de Beauvoir and the inequitable divisions of domestic work in marriage," *Hypatia* 19, no. 3 (Summer 2004): 121–43.

Venturi, Franco. *The End of the Old Regime in Europe, 1768–1776: The First Crisis*. Princeton NJ: Princeton University Press, 1989.

___. *The End of the Old Regime in Europe, 1776–1789: II. Republican Patriotism and the Empires of the East*. Translated by R. Burr Litchfield. Princeton, NJ: Princeton University Press, 1991.

Vigarello, Georges. *Histoire de la beauté, le corps et l'art d'embellir de la renaissance à nos jours*. Paris: Éditions du Seuil, 2004.

Vikan, Gary. *Early Byzantine Pilgrimage Art*. Washington, DC: Dumbarton Oaks Research Library and Collection, 2010.

Vincentelli, M. *Women and Ceramics: Gendered Vessels*. Manchester: Manchester University Press, 2000.

Waldner, Henriette Louise von, Barone d'Oberkirch. *Memoirs de la Baronne D'Oberkirch, countess de Montbrison*. London: Colburn and Co., 1852.

Walpole, Horace. *The Castle of Otranto and the Mysterious Mother*. Great Britain: Printed at the Chiswick Press for Houghton Mifflin and Constable, 1925.

___. *Memoirs and Portraits*. Edited by M. Hodgart. New York: Macmillan, 1963.

Walters Art Gallery. *Early Christian and Byzantine Art: an exhibition held at the Baltimore Museum of Art, April 25–June 22*. Baltimore: Trustees of the Walters Art Gallery, 1947.

Walters, H. B. *Catalogue of the Engraved Gems and Cameos, Greek, Etruscan and Roman in the British Museum*. London: Printed by the order of the Trustees, 1926.

Walther, C. "The Invention of John the Baptist's Head in the Wall-calendar at Gracanica. Its Place in the Byzantine Iconographical Tradition." *Zbornik za likovne umetnosti* 16 (1980): 71–80.

Walton, Guy. *Louis XIV's Versailles*. Chicago: University of Chicago Press, 1986.

Wes, Marinus Antony. *Classics in Russia 1700–1855: Between Two Bronze Horsemen*. Leiden: E. J. Brill, 1992.

Wheatcroft, Andrew. *The Habsburgs: Embodying Empire*. London: Viking, 1995.

Whitman, Nathan T. "Myth and Politics: Versailles and the Fountain of Latona." *Louis XIV and the Craft of Kingship*, edited by John C. Rule, 286–99, figs. 3–10. Columbus: Ohio State University Press, 1969.

Whittow, Mark. *The Making of Byzantium, 600–1025*. Berkeley: University of California Press, 1996.

Williamson, Tom. "The Landscape Park: Economics, Art and Ideology." *Journal of Garden Studies* 13 (1993): 49–55.

___. *Polite Landscapes. Garden and Society in Eighteenth-Century England*. Baltimore: Johns Hopkins University Press, 1995.

Wilton, Andrew, and Ilaria Bignamini. *Grand Tour: The Lure of Italy in the Eighteenth Century*. London: Tate Gallery Publishing, 1996.

Winckelmann, Johann Joachim. *Description des pierres gravées de feu Baron de Stosch*. Florence: André Bonducci 1760.

Woodbridge, K. *Landscape and Antiquity: Aspects of English Culture at Stourhead 1718 to 1838*. Oxford: Claredon Press, 1970.

Wortman, Richard S. *Scenarios of Power: Myth and Ceremony in Russian Monarchy*. Vol. 1: *From Peter the Great to the Death of Nicholas I*. Princeton, NJ: Princeton University Press, 1995.

___. *Scenarios of Power: Myth and Ceremony in Russian Monarchy*. Vol. 2: *From Alexander II to the Abdication of Nicholas II*. Princeton, NJ: Princeton University Press, 2000.

Wright, Alison. *The Pollaiuolo Brothers: The Arts of Florence and Rome*. New Haven, CT: Yale University Press, 2005.

Yonan, Michael. *Empress Maria Theresa and the Politics of Habsburg Imperial Art*. University Park: Pennsylvania State University Press, 2011.

Zabelin, I. E. *Istoriia goroda Moskvy ot Iuriia Dolgorukogo do Petra I*. Moscow: Veche, 2007.

Zagraevskii. S. V. *Zodchestvo Severo-Vostochnoi Rusi kontsa XIII=prevoi treti XIV veka*. Moscow: Alev-v, 2003.

Zemtsov, Stanislav Markovich and V. L. Glazunov. *Aristotel' Foravanti*. Moscow: Stroiizdat, 1985.

Zhitiia sviatykh na russkom iazyke izlozhennyia po rukovodtvu Chet'ikh-minei sv. Dmitriia Rostovskogo. Vol. 10. Moscow: Typography of the Holy Synod, 1913.

Zhivopis' domongol'skoi Rusi, Gosudarstevnnaia Tretiakovksaia Galereia. Moscow: Sovetskii khudozhnik, 1974.

Zhurnal vysochaishago puteshestviia eia Velichestva Gosudaryni Imperatsitsy Ekateriny II Samoderzhitsy Vserossiiskoi, v Poludennyia Strany Rossii v 1787 gody. Moscow: N. Novikov (1787).

Zoloto Kremlia. Russkoe iuvelirnoe iskusstvo XII–XX vekov. Exhibition catalogue. Munich: Hirmer Verlag, 1989.

Zorin, Andrei L. *Kormia dvuglavogo orla ...Literatura I gosudarstvennaia ideologia v Rossii v pos;ednei treti XVIII–pervoi treti XIX veka*. Moscow: Novoe literaturnoe obozrenie, 2001.

Zorin, Andrei L. "Poslednii proekt Potemkina: Prazdnik 28 aprelia 1791 g. i ego politicheskaia emblematika." *NLO Nezavisimyi filologicheskii zhurnal* 43 (2000): http://magazines.russ.ru/nlo/2000/43/s7.html (last visited July 21, 2013).

Zuliani, M. D. de. *Russia e mondo classico nel secolo XVIII*. Florence: Licosa Editrice, 1980.

Zwierlein-Diehl, Erika. *Die Antiken Gemmen des Kunsthistorischen Museums in Wien*. Munich and Vienna: Prestel, 1972.

___. *"Interpretatio christiana'*: Gems on the Shrine of the Three Kings in Cologne." In *Engraved Gems: Survivals and Revivals*, edited by C. M. Brown, 63–75. Washington, DC: National Gallery of Art, 1997.